PICTURE-WORK

History and Foundations of Information Science

Edited by Michael Buckland, Jonathan Furner, and Markus Krajewski

Human Information Retrieval by Julian Warner

Good Faith Collaboration: The Culture of Wikipedia by Joseph Michael Reagle Jr.

Paper Machines: About Cards & Catalogs, 1548–1929 by Markus Krajewski, translated by Peter Krapp

Information and Intrigue: From Index Cards to Dewey Decimals to Alger Hiss by Colin B. Burke

Indexing It All: The Subject in the Age of Documentation, Information, and Data by Ronald E. Day

Bibliometrics and Research Evaluation: The Good, the Bad, and the Ugly by Yves Gingras

Search Foundations: Toward a Science of Technology-Mediated Experience by Sachi Arafat and Elham Ashoori

The Information Manifold: Why Computers Can't Solve Algorithmic Bias and Fake News by Antonio Badia

Documentarity: Evidence, Ontology, and Inscription by Ronald E. Day

The Infographic: A History of Data Graphics in News and Communications by Murray Dick

The Typographic Medium by Kate Brideau

Power of Position: Classification and the Biodiversity Sciences by Robert D. Montoya

Picture-Work: How Libraries, Museums, and Stock Agencies Launched a New Image Economy by Diana Kamin

PICTURE-WORK

HOW LIBRARIES, MUSEUMS, AND STOCK AGENCIES LAUNCHED A NEW IMAGE ECONOMY

DIANA KAMIN

THE MIT PRESS CAMBRIDGE, MASSACHUSETTS LONDON, ENGLAND

© 2023 Massachusetts Institute of Technology

This work is subject to a Creative Commons CC-BY-NC-ND license.
Subject to such license, all rights are reserved.

Chapter 3 is adapted and extended from article "Cards, Cabinets, and Compression in Early Stock Photography" which originally appeared in *Information and Culture: A Journal of History* Volume 56, Number 3, pp. 229–250. Copyright 2021 by the University of Texas Press. All rights reserved.

The MIT Press would like to thank the anonymous peer reviewers who provided comments on drafts of this book. The generous work of academic experts is essential for establishing the authority and quality of our publications. We acknowledge with gratitude the contributions of these otherwise uncredited readers.

This book was set in Stone Serif and Stone Sans by Westchester Publishing Services. Printed and bound in the United States of America.

Library of Congress Cataloging-in-Publication Data

Names: Kamin, Diana, author.
Title: Picture-work : how libraries, museums, and stock agencies launched a new image economy / Diana Kamin.
Description: Cambridge, Massachusetts : The MIT Press, [2023] | Series: History and foundations of information science | Includes bibliographical references and index.
Identifiers: LCCN 2022059845 (print) | LCCN 2022059846 (ebook) | ISBN 9780262547000 (paperback) | ISBN 9780262377034 (epub) | ISBN 9780262377041 (pdf)
Subjects: LCSH: Visual sociology. | Visual communication. | Signs and symbols.
Classification: LCC HM500 .K36 2023 (print) | LCC HM500 (ebook) | DDC 302.23—dc23/eng/20230109
LC record available at https://lccn.loc.gov/2022059845
LC ebook record available at https://lccn.loc.gov/2022059846

10 9 8 7 6 5 4 3 2 1

For Gary and Addie

CONTENTS

ACKNOWLEDGMENTS ix

PROLOGUE: PICTURE-WORKERS xiii

INTRODUCTION: PICTURE-PROBLEMS 1

1 **CIRCULATING COLLECTION STYLE: PICTURES AS DOCUMENTS AT THE NEW YORK PUBLIC LIBRARY** 25

2 **THE MUSEUM WITHOUT WALLS: THE MUSEUM OF MODERN ART AND PHOTOGRAPHY'S DOUBLE DUTY** 79

3 **"YOUR STORY IN PICTURES LEAVES NOTHING UNTOLD": H. ARMSTRONG ROBERTS AND THE RISE OF AMERICAN STOCK PHOTOGRAPHY** 131

4 **THE NEW UNIVERSAL COLLECTION: FROM PICTURES TO DIGITAL ASSETS** 187

CODA: ANGELS OF HISTORY 231

NOTES 239

BIBLIOGRAPHY 279

INDEX 301

ACKNOWLEDGMENTS

At the MIT Press, I thank Gita Devi Manaktala for taking an interest in this project and Michael Buckland, Jonathan Furner, and Markus Krajewski for seeing a home for it in the History and Foundation of Information Science series. Books published in this series were so influential to me as I conceptualized this research, and I was thrilled that you found a place for it here. Thank you also to Suraiya Jetha for her kind and diligent communication throughout the manuscript preparation and production process. To the three anonymous reviewers: I can't thank you enough for your careful, critical attention to the manuscript; your sharp and productive reviews helped me to see the project more clearly at the time I most needed it.

This work began as a dissertation in the Department of Media, Culture, and Communication at New York University and was shaped into a book at the Department of Communication and Media Studies at Fordham University. I'm grateful to both of these communities for their networks of intellectual and material support as this project came together.

At Fordham, I have been enriched by the conversation and support of colleagues including Gregory Donovan, Lewis Freeman, Julie Gafney, Matthew Hockenberry, Jennifer Moorman, Jacquelyn Reich, Claudia Rivera, Michele Prettyman, Margaret Schwartz, Ralph Vacca, and Tim Wood. I'm grateful for the support of the Center for Community Engaged Learning, which has funded crucial teaching and research needs over the past three

years. In 2020, a caregiver solidarity group formed to advocate for equity and support for COVID-impacted faculty and students, and I was honored to organize alongside Carey Kasten, Karina Hogan, Asato Ikeda, Kathryn Reklis, Margaret Schwartz, Kirsten Swinth, and Christiana Zenner. I'm further grateful to the organizing that Fordham Faculty United has done on behalf our union membership to secure key resources, in particular, the work of Josh Jordan and Ashar Foley. I also received exceptional research support from student research assistants Reem Farhat and Saumya Grover.

At NYU, I benefited enormously from a dissertation committee of uncommonly kind, wise, and generous thinkers. Marita Sturken guided my work since the very beginning of this project, pushing me to refine, clarify, and ground my ideas. Mara Mills modeled the highest standards of professionalism and rigorous media history scholarship and advised me from day 1 of the PhD program with wit and savvy. Shannon Mattern's generosity of mind and spirit continues to inspire; I leave every conversation or piece of writing from her with new ideas and a more dynamic way of thinking. Outside the committee, I am grateful to readers Lisa Gitelman and Lev Manovich and their contributions to my work, in their own scholarship and in their comments and discussion. Early conversations with Lily Chumley and Ben Kafka, as well as a rewarding research assistantship with Charlton McIllwain, also clarified my thinking at crucial times. I was so lucky to learn among supportive cohorts of generous readers and exciting thinkers, including Shane Brennan, Yoav Halperin, Ella Klik, Liz Koslov, Rachel Kuo, Xioachang Li, Ben Mendelsohn, Daniel Wiley, Carlin Wing, and Hannah Zeavin.

Portions of chapter 3 were published in *Information & Culture* in 2021, and the superb editing and reviews helped refine key ideas. Workshopping that article at the Max Planck Institute for the History of Science, Berlin in 2019 for the workshop "Compression: Size, Storage, and Transmission in the History of Knowledge" was extremely generative, in particular the discussion and continued engagement with Hansun Hsiung, Ulug Kuzuolglu, Anna-Maria Meister, and Craig Robertson. I'm also grateful for the community found at Princeton-Weimar Summer School for Media Studies in 2014 and the insights of Daniel Irrgang, Ido Ramati, and Katarzyna Włoszczyńska. Working with Marvin Taylor, Glenn Wharton, and Deena Engel on the Artists Archives Initiative at NYU deepened my thinking about

information infrastructure and visual archives as I finalized the dissertation. Former colleagues at the Whitney Museum of American Art whose conversations or mentorship continue to influence my work include Kim Conaty, Anita Duquette, Beth Huseman, Carol Mancusi-Ungaro, and Dana Miller.

This project would not be possible without the archivists and librarians who assisted me, including Tal Nadan at the Manuscripts and Archives Division, The New York Public Library; Christina Eliopoulos and Michelle Harvey, Museum Archives, Museum of Modern Art; Renee Pappous, Rockefeller Archive Center; and Eva Hyvarinen, Minneapolis College of Art and Design. I am also grateful to the librarians, programmers, artists, photographers, museum workers, and business owners that graciously took the time to be interviewed. I owe particular thanks to H. Armstrong Roberts III and Roberta Groves, who hosted me multiple times in Philadelphia and made their unprocessed archives available to me, while providing hours of interviews and several Chinese takeout lunches. The Picture Collection at the NYPL has brought me into dialogue with an inspiring group of devotees, and I'm excited for continued conversations with Joshua Chuang, Jessica Cline, and Anthony Troncale.

Finally, I'm deeply grateful for the support of my family. Particularly after my daughter was born in January 2017, my parents, in-laws, and siblings stepped up with emotional and practical support of all kind, and I am forever grateful.

Most of all, I thank my companions throughout every stage of this book, who held me up and held me together in ways large and small—this book is dedicated to the two most brilliant and kind people I know, my husband Gary Carrion-Murayari and daughter Addie.

PROLOGUE: PICTURE-WORKERS

I graduated college in 2006 and started working in the curatorial department of the Whitney Museum of American Art shortly thereafter. That first summer, I did a lot of collection research, walking downstairs to the department of rights and reproductions, pulling heavy binders of slides organized by exhibition date off the shelf, or sliding open creaky metal file cabinets to sift through folders labeled by artist and leaf through transparencies in crinkly glassine. Each time I went, I tried to appear practiced, quiet, and efficient so as not to disturb the longtime manager of rights and reproduction, Anita Duquette. Anita sat at a desk piled high with notes and transparencies and kept a watchful eye on all comers. She was tiny in stature, yet imperious and forbidding. Along with the cabinets filled with transparencies and discs, binders of slides, and stacks of photographers' logbooks that together formed the intellectual property of the museum, she was the de facto keeper of the institution's history, having worked at the museum since 1973 when she began as "a young woman with a long braid," in the words of Flora Miller Biddle, granddaughter of Whitney founder Gertrude Vanderbilt Whitney, in her memoir *The Whitney Women and the Museum They Made*.[1]

In 2006, the collection database was only partly illustrated, sometimes only with grainy black and white scans, and so I was instructed to make color scans of slides when I had time, in a slow process that required me

to perch by the curatorial scanner (surely a hard-won budgetary triumph) installed in an old closet space, painstakingly cropping and uploading to the museum's collection database. Soon those scans would be superfluous: by the time I left the museum in 2012, I had seen the museum go through most of a collection documentation project creating high-res digital photography for the entire collection and had helped launch the Whitney's first selection of collection images online. I had also formed a friendship with Anita, who worked as late as I did. When no one else was in the office, we would gossip about long-told Whitney rumors while trying to identify the exhibition in an old, unlabeled slide (she would sometimes half-close her eyes and then suddenly blurt out the exhibition title, "Image World!"). After leaving the Whitney, I continued to collaborate with her on projects as a freelance picture researcher for art publications before she retired in 2021. In many ways, her job had completely changed, as requests were filled digitally; metadata were created at the moment of photography, some of them automatically; and the images were stored on servers far from her own desk, which was still piled high with papers. She continued to keep vigilant care over the old slides and transparencies, which were regularly consulted by curators and conservators for evidence of installation preferences or condition changes, and I'm told she's still "on speed dial" by current curatorial staff.

I started this project because I was invested in the type of work Anita did, in the type of knowledge she embodied, and in the collection of reproductions that she managed, which doubled and shadowed the collection of artworks more commonly recognized as the museum's primary assets—I was interested in the centrality of her work to the museum and in the dramatic way it had changed in a matter of just a few years. When I presented a paper about the Whitney's collection of image reproductions at the Princeton-Weimar Summer School for Media Studies in 2015, one participant responded to my brief mention of Anita with a spark of recognition—she talked about the familiar figure of the gatekeeper of an archive or a collection, often a woman, usually a long-time staffer, who possesses that glowering affect that comes with the knowledge that she holds the keys to materials researchers desperately seek. Another participant spoke somewhat optimistically about the fading relevance of this type of figure, how digitization was loosening the access to the world's archival treasures. My

PROLOGUE

response was an impulse to pursue a project that sought out these collection workers, told their stories, and elucidated their philosophies of the image, which had undergirded the work of image circulation for so long. What I found was not gatekeepers standing in front of closed portals but workers enthusiastically spinning revolving doors, encouraging streams of images into and out of collections. These workers dealt with mountains of images and wide networks of people who wanted to see them. As a result, they saw images as constantly on the move, changeable, replaceable, reusable, only ever possessed temporarily. They saw that images in use were references to countless other images, networked through data like artist, subject, or distributor but also through the nature of representation itself. They understand that the history of photography is a history of accumulating and distributing collections of photography. The work they do to label, store, and circulate photographs is the subject of this book.

INTRODUCTION: PICTURE-PROBLEMS

To collect photographs is to collect the world.
—Susan Sontag, *On Photography* (New York: Farrar, Strauss & Giroux, 1973), 1

If you work with pictures wouldn't you like to know: What your colleagues all over the country are doing? *What picture-problems—mechanical or philosophical— are being worked out elsewhere?*
—Committee for an Association of Picture Librarians, *Picturescope* 1, no. 1 (1952), n.p. (emphasis added)

"What picture-problems—mechanical or philosophical—are being worked out elsewhere?" This question introduced the first issue of *Picturescope*, a quarterly published by the Picture Division of the Special Libraries Association from 1952 to 1987. While founded within a library association, the division intended to serve a community that stretched beyond the library, to workers in government archives, newspaper morgues, corporate collections, museums, and historical societies. This community is what I call picture-workers—the librarians, curators, cataloguers, picture editors, picture researchers, and eventually programmers and database administrators who encounter pictures on a professional basis, as stewards of picture collections.

The variety of the Picture Division's activities capture the breadth of this work. As part of its community-building efforts, the group visited

photography collections housed in institutions as varied as Standard Oil, *Look* magazine, the Metropolitan Museum of Art, and Bell Labs. They heard invited lectures from photographers, executives, journalists, television producers, and activists about the vital work of sifting through millions of pictures in search of the right illustration. They heard curator and photographer Edward Steichen announce his impending exhibition *Family of Man*, culled from three million photographs, which he promised would to showcase photography "giving an account of itself."[1] They heard from a textbook publisher about the important use of "pictorial 'bait' to hold teenagers' attention."[2] They approvingly reprinted a trade article arguing that "every organization, large or small, should maintain a photo library, and profit from the publicity and public relations benefits it can yield."[3] They declared themselves "anti-automationist" but welcomed presentations from technologists promising miniaturization.[4] They saw themselves as experts at the precipice of a new age, their labor essential to its bringing about, if only they pooled resources. While the Picture Division members' work with pictures encompassed a broad range of endeavors, the coverage in *Picturescope* repeatedly affirmed their common purpose and common predicament, the "picture-problems" they faced together.[5]

"Picture-problems" for this community meant challenges related to the acquisition, classification, storage, and circulation of pictures—activities that these specialists struggled with on a daily basis as they managed special collections of visual material within systems often designed for the circulation of text. The phrasing of this question reflexively situates these techniques as both theoretical and practical, asserting that philosophy is never far from mechanics. Moreover, the philosophical and mechanical problems that these workers encountered continue to have far-reaching consequences for a public whose daily exposure to pictures is the result of the comprehensive and pervasive work of cataloguing, classifying, retrieving, and releasing images. The new age *Picturescope* contributors expected did indeed arrive, as more than four billion social media users interact with billions of indexed images every day, though perhaps not led by the librarian labor force they imagined. But their essential insight holds true: circulating image collections create conditions of possibility for what pictures can do, and their architects and managers enact a philosophy of images with every organizational decision.

The particular philosophy that picture-workers explore and materialize through their work is parallel to yet distinct from theories of the image in art history, cultural criticism, and media studies. It is a philosophy that holds the image as inherently mobile, as defined by its diverse uses among networks of past and future users, and thus as existing in an economy in which availability and accessibility are determinant of value. In other words, a philosophy of the image that captures the fleeting, fugitive, simultaneously democratized and commoditized spaces of image exchange in visual culture today. This book takes seriously the following questions, inspired by the midcentury community of practitioners: What mechanical and philosophical problems does the circulation of images pose, and how were they addressed over the twentieth century? How did these problems migrate and transform as collections were digitized in the twenty-first century? How have picture-workers themselves framed and attempted to answer this question over the past hundred years: *What picture-problems are being worked out elsewhere?* Attention to these questions will offer a greater understanding not just of theoretical implications of the circulating image but also of the prehistory that conditions our current information environment. And it posits a history and theory of photography told through the lens of the picture-worker.

To accomplish this, this study will address the interconnected histories of three exemplary picture collections: the Picture Collection at the New York Public Library; the Museum of Modern Art, New York; and stock photography agency H. Armstrong Roberts. All three collections were founded in New York City and Philadelphia between 1915 and 1929 and continue circulating pictures today. By looking to the material workings of these collections, this study demonstrates that throughout the twentieth century, institutions like the museum, the library, and the stock photography agency defined the public's cultural understanding of what the photographic image is and how it is to be used. They did this by assembling large-scale *circulating* collections, from which patrons or clients could search, select, and borrow. Through the circulation of pictures, the public interfaced with systems of classification and protocols of search and retrieval, as well as the technological and legal constraints of the photographic image, in ways that communicated ontological and epistemological arguments about the nature of photography. These interactions have in turn shaped contemporary image

culture, including concepts of authorship, art, property, and value, as well as logics of indexing, cross-referencing, tagging, and hyperlinking.

Taken together, collections like these contributed to an image economy predicated on the availability of circulating images. This reflects a broader conception of the image as *alienable content*, or nonmedium specific, characterized by indeterminate meaning, packaged for networked travel, and adaptable to various and multiple uses.[6] Though each institution did ascribe some monetary value to the pictures (in reproduction licenses, replacement fees, outright purchase of prints), the concept of availability need not be understood as entirely commercial. The library offered a collection of pictures as historical documentation for pictorial fact-finding, promising an availability of visual document. The museum stipulated that art appreciation and inspiration were not limited to direct experience and that the pictures available through the global art museum necessarily escaped bounds of geographical place and time. The stock photography agency promised "The Right Picture Right When You Want It," a pictorial universe of gestures, experiences, and relationships available for whatever story a customer might be eager to tell.[7]

In libraries, circulating collections are distinguished from reference collections, special collections, or archives by a simple criterion: circulating material can be checked out of the institution. A circulating image collection is a collection from which one can take an image "home" (i.e., can remove it from the space of collection and bring it into another space). While circulation is conceived differently across a library, a museum, and a commercial photography agency (and differently associated with the circulation of newspapers and magazines), this essential distinction from library practice is key: the circulating image is an image that is physically checked out for individual use. A history of the circulating image collection holds particular significance today, as the digitization of cultural archives (libraries, museums, private collections) and the increasing reach of image search platforms like Google Images have produced a sea change: the act of "checking out" an image is now as routine and effortless as clicking on the desired image onscreen. Although bringing an image home is phenomenologically and ontologically transformed, and this shift has profound implications for the way we conceptualize what images are and what they do, often these changes are framed as a trend toward dematerialization

or as a new seamlessness between user and collection. Somewhere in the transition from the collection site to the collection website, the rhetoric of dematerialization obscures a material and institutional reality: in order for images to circulate, they have to be coded to do so. This process of coding is productive and reflective of broad epistemological and ontological understandings of the image. Further, coding does not begin with the digital database. The cataloguing of images with the goal to determine their subsequent performance is a historical project. Techniques of classification that schematize description into various units of data, as well as copyright structures that create layers of distinct property concentrated in a single image, developed in the context of analog picture collections. Significantly, the processes of coding, organizing, and describing images in order to facilitate their circulation not only reifies perceived genres but also *produces* genres. Categories of commercial photography, documentary photography, or documentation photography were established by the collections surveyed here and communicated to the public via circulation. These genres persist even as the digital environment has loosened some of the previous barriers between so-called art images and commercial images. Analog processes of coding images, as well as the search for solutions to storing and circulating visual material, are an essential aspect of the development of so-called digital culture as we know it.[8]

By looking at the history of the professional practice of circulating images across fields, I seek to contribute a material, technical, and practical dimension to the study of images and photography, one that will refract the concepts that digitization has troubled—such as distinctions between original and copy or public and private—through a historical lens. Further, I hope to explore how the professionals who posed and solved problems of image circulation laid the groundwork for technological and legal developments that resulted in a digital culture defined by the collection and dissemination of multimedia objects. Finally, I hope to surface lessons for the architects of twenty-first-century picture collections. At a time when our image economy is driven by the innovations of a tech industry animated by the mantra to move fast and break things, how can we reintroduce the voices of librarians, collection managers, and photographers who built their image-sharing social networks through paper and touch?

PICTURES ACROSS FIELDS AND HISTORY

The images under review in this study are organized in environments designed for their circulation, environments whose conceptualization begins at a particular place and time. The concentration of fashion, advertising, studio art, publishing, and theater in the New York City area from the late nineteenth century on is a key factor that drives the development of the three historical case studies. These industries relied on the varied activities of picture research, from the artist or designer seeking reference images to the publisher or advertiser seeking readymade illustrations. The New York Public Library (NYPL), Museum of Modern Art (MoMA), and H. Armstrong Roberts all responded to specific needs of communities who were energized by new forms of circulating media. Illustrated magazines, cinema, clothing manufacture, and a thriving theater scene drove designers and artists to the NYPL for reference images, prompting the opening of the Picture Collection in 1915.[9] Art books and art reproductions imported from Europe inspired MoMA's founding director, Alfred Barr, throughout his education in the 1920s and influenced his mission for the museum when it opened in 1929; MoMA's library of available artwork for reproduction was used in exhibitions on art and design that traveled to university galleries and department stores across the country and was mined by designers, publishers, and advertisers in New York. And young entrepreneur H. Armstrong Roberts first started in commercial photography by selling his own photographs to accompany his syndicated articles licensed to various national magazines in the 1910s, and after he founded an agency in 1920 his photographs were licensed by the largest advertising firms in the country over the next decade, including J. Walter Thompson and Newell Emmett Co. in New York, Williams and Cunnyngham in Chicago, and Young & Rubicam in Philadelphia. All of the collections thus interacted to different degrees with the advertising and publishing industries centered in New York and Philadelphia.

Along with the professional users, each of these collections was also oriented in some way toward the American general public. At the NYPL, Picture Collection director Romana Javitz passionately advocated for her collection's accessibility, often extolling the taste and vision of the general public against members of the elite art institutions or industries: "I

INTRODUCTION

believe that the public taste is far higher than the mythical target of public preference at which the art director aims and for which the artist is forced to slick, polish and devitalize his output."[10] A frequent target of her ire, MoMA, was also founded with the American general public in mind and sought to make remote European modern art accessible to people across the country. An early circulating exhibition, *A Brief Survey of Modern Painting in Color Reproductions* (which circulated to eighty-six venues in the 1930s), was accompanied by a cheery brochure, "For Your Own Collection of Modern Paintings," which encouraged the public to purchase color facsimiles for their homes.[11] In many ways, MoMA defined modern art against what it was not. When it came to photography, this meant promoting straight photography against the aesthetic of the type of staged commercial photography that H. Armstrong Roberts produced. While Roberts sold his photography to advertisers and publishers, his ultimate audience was the public, who viewed stock photography like his on a daily basis far more than they might visit a library or museum. Roberts positioned himself as a populist photographer, which translated to mostly domestic scenes that communicated a clear story quickly to the viewer.

Taken together, these collections trained the public in what an image was for: what images belong in a magazine and what images belong on a wall, what images are meant to serve as transient inspiration and what images are meant to be preserved as valuable property. But they also trained viewers in the essential ability for photography to jump contexts. At MoMA, photographic reproductions are alternately documentation, artistic reference, or artworks themselves. At the library, advertising images and art reproduction alike are cut up and filed for future historical reference. At the stock agency, the same photograph might be licensed as a greeting card, an advertisement, a fine art poster, a textbook illustration, and a public health brochure.

The range of collections under study here represents three different conceptions of the circulating image, as each one posits the photograph as proxy for something else. The library proposes the picture as document, a phrase that its longtime director Romana Javitz uses continuously to position the picture collection within the library ecosystem. The museum proffers the photograph as artwork—either through using the reproduction as a stand-in for absent artwork in exhibitions, as Alfred Barr does with a famous Picasso painting in his landmark exhibition *Cubism and Abstract*

Art, or as an auratic artwork in itself. Though it could be used as historical document or artwork depending on the client, H. Armstrong Roberts primarily posited the photograph as story—he preferred the term "library of stories" to "stock photography," seeing the camera as a means to construct a series of generic visual stories at scale.[12] Yet, despite the difference in ends, the three case studies here share an understanding of the means: photography as a tool that allows for the rapid accumulation of images, requiring the development of systems to manage that accumulation. All three collections wrestle with the relationship between meaning-making and scale in the circulating visual archive.

The institutions under study here were hardly the only exemplary picture collections of the twentieth century, their architects not the only picture-workers captivated by the vision. To begin with, they are all based in the United States. Picture collections in public institutions (museums, libraries) also emerged in Europe during the period of investigation, including collections housed in research institutions like Ernest de Potter and Paul Otlet's International Institute of Photography in Paris, or the Photo Library of the Kunsthistorisches Institute in Florence, and picture collections like the Hulton Picture Post Library in London.[13] In the United States, the Times Inc. Picture Morgue, the Bettmann Archive, and the Frick Art Library, as just a few examples, all grew collections that sought to organize the avalanche of twentieth-century visual culture into something useable for their communities, many of whom were also users of the collections under study here, and each continues to shape picture-work today.[14] By focusing on just three collections, representing three ostensibly different industries and missions, I seek a deep engagement with the words of a variety of picture-workers and a thick description of how picture-work changed over the decades.

My approach, drawing on the perspectives and methodologies of art history, media studies, and history of information technology, will argue for the importance of looking at the relationship between the routine labor practices of picture-workers and their epistemological consequences. As Greg Mitman and Kelley Wilder assert, "'[m]eaning' and 'fact' lie not simply inside the photographic material but in a set of relationships formed between the maker, the user, the object, and the archive;" picture-workers actively make these relationships legible.[15] I am guided in this

INTRODUCTION

project by the recent work being done across media studies that has traced the development of modern forms of information management, systematically exploring the histories of industries from publishing houses to newspaper clippings bureaus, genres from files to documents, and "intellectual furnishings" from card catalogues to filing cabinets.[16] These studies take labor, bureaucracy, and paperwork seriously, exploring the exchange between equipment, technique, and broader social and discursive fields, and their continued impact in the present. As Craig Robertson argues, "Concepts people use in the twenty-first century to comprehend data and information originated in a particular moment in the history of capitalism, a moment that led to a gendered, raced, and classed understanding of efficiency becoming pervasive."[17] Circulating image collections are also rooted in various models of gendered, raced, and classed understandings of efficiency set in place in this period, not solely in relationship to information or text but rather to the manner in which the world is documented, reproduced, and accessed visually.

This work is thus rooted in a broader approach to history of photography that counters prevailing narratives around inventors and artists in favor of broader social and economic contexts. Like Michelle Henning, I seek to explore the photographic image as "migratory, journeying, wandering and vagabond, against the grain of a theoretical and historical discussion which tends to represent photographs as static, fixed, and relatively unchanging, at least until the advent of the digital image."[18] Doing so requires a focus on the labor of working with pictures, on the work that pictures do. Thy Phu and Matthew Brower identify this approach as continuing in John Tagg's tradition of locating photographic history in "the institutional and discursive spaces of photographic production, and especially, their circulation."[19] Thierry Gervais's edited collection *The 'Public' Life of Photographs* foregrounds methods of circulation as various interfaces with publics that are actively produced, centering "those responsible for the dissemination of images" and emphasizing "the collective practices of image sharing."[20] Artist Walead Beshty's *Picture Industry: A Provisional History of the Technical Image* (2018) eschews the term "photography" in favor of the technical image, which shifts attention away from the photographer to the production and circulation by particular assemblages of people and technical apparati.[21] Elizabeth Edwards and Sigfrid Lien

explore photography as the "crucial museum ecosystem" that supplements work across the institution as both tools and objects.[22] Art historian Nadya Bair coins the term the "decisive network" (a riff of Henri Cartier-Bresson's famous invocation of the photographer who captures the "decisive moment") to emphasize the labor, material, and technical networks that bring iconic photographs into being.[23] Zeynep Devrim Gursel offers a thick ethnography of "image brokers," or workers in newsrooms, wire services, and agencies that shape the selection and distribution of news images, arguing that they "collectively frame our ways of seeing."[24] Vanessa Schwartz and Jason E. Hill similarly reveal the historical networks of aesthetic, market, and social relations in which the news picture is "formed and selected rather than merely transcribed."[25] Paul Frosh calls attention to the stock photography industry, "an elaborate system of manufacture, distribution and consumption that is itself largely concealed from view," as a key site for understanding the historical sweep of visual culture as market-driven image production.[26] Estelle Blaschke has published essential work on the history of the Bettmann Archive and Corbis to trace the transformation from picture agency to "image bank."[27] Forthcoming work by Nina Lager Vestberg looks at the transformation of the labor of picture research from the nineteenth century to the present.[28] Artists, archivists, and image collection stewards have engaged in active analysis of their material practices as well. *The Lives of Images: An Aperture Reader Series*, edited by artist and critic Stanley Wolukau-Wanambwa, and accompanying symposium series at the International Center of Photography similarly center the circulation of reproducible images within broader circuits and economies.[29] As head of Photothek at the Kunsthistorisches Institute, Costanza Caraffa has positioned the photographic archive as "laboratory," overseeing research, symposia, and publications that bring together the perspective of academics across fields and center the expertise of the archivist.[30] This book is indebted to these scholars, who demonstrate that the history of photography is a history of producing, building, and maintaining collections. Like these works, I seek to center my focus on use, embracing Carolyn Marvin's definition of media:

Media are not fixed objects: they have no natural edges. They are constructed complexes of habits, beliefs, and procedures embedded in elaborate cultural codes of communication. The history of media is never more or less than the

INTRODUCTION 11

history of their uses, which always lead us away from them to the social practices and conflicts they illuminate.[31]

To attempt a media history of the circulating image collection, I thus provide an account of the social practices around circulating images and the conflicts illuminated therein. Rather than looking at this from the perspective of the public who interact with these collections as users or the artists who populate the collections, I take the view of the collection workers themselves.

As with many history projects, this story does not cohere into a rupture narrative, though there are elements of rupture. Nor is it a neat story of remediation, though there are echoes of remediation throughout. Rather, it is narrative of what came before, an account of spaces and practices, and a description of people and the plans, ideas, and dreams that played out as they shuffled through material. It is an eye on dusty archives, a story of discarded materials. In this way, it is a call for similar attention to be paid to the new groups of laborers under the digital paradigm of circulating collections.

CIRCULATING, IMAGE, COLLECTION, AND OTHER USEFUL TERMS: A SHORT GLOSSARY

When I first proposed a project on the circulating image collection among a group of other graduate students and our faculty advisor in the department of Media, Culture, and Communication at New York University, I was met with a room of confused stares. Eventually, a friend gently ventured, "What do you mean by circulating collection?" allowing me, with relief, to explain the library definition (items that can be checked out) and how I meant to extend it theoretically, probing the different ways a collection might be built to allow a user to take an image home. Drawn from fields that deal both practically and theoretically with the study and organization of images, many of the terms throughout this book perform double duty as straightforward descriptions and as conceptual frames. Part of the aim of this project is to highlight the complex epistemologies embedded within the bureaucratic terms and techniques of image circulation, to define the circulating image collection in a way that communicates the philosophies

and practical considerations of the picture-worker to a broader audience. I offer a short glossary here in order to ground the main concepts of this book in the working language of picture-work.

CIRCULATING

Reference to the increasing circulation of images often serves as shorthand for new, globalized conditions of cultural exchange and shifting structures of knowledge production, in a theoretical tradition that spans from Walter Benjamin to Jean Baudrillard to the present. In short, this argument suggests that as images circulate more easily, their value (auratic and otherwise) and connection to real-world referents decrease, while access and use are democratized to various ends. This broader use of the term "circulation" emphasizes that image circulation happens outside of the bounds of the traditional institutional channels, an insight that has sustained essential work across fields. My own concern with circulation is necessarily narrower. One question animating this study is, what theories of photography and visual communication are elaborated by the class of workers whose daily practices enable the scholarly, artistic, and commercial usages of images? For this reason, in my study, circulation is taken literally, as the concern of library and collection workers tasked with ensuring its continued functioning. From a library and information science perspective, a circulation department is charged with maintaining "the flow of materials in and out of the library. . . . Its concern is dispensing or receiving library materials."[32] For this study, the term "circulating images" refers to the movement of pictures from collection site to other public and private spaces. This delimiting gesture allows me to shift the locus of attention from the theorist of the image to the practitioner of its actual and potential circulation.

At the same time, circulation is also inextricably linked with capitalist distribution, in which profits accrue to those actors that act as distributors by facilitating circulation. By using the term "distributor," I invoke the vocabulary of the stock photography industry (the most explicitly capitalist venture surveyed here) in which distribution partnerships or agencies extend the reach of smaller collections. But I also intend to reframe the librarian, curator, exhibitions manager, and rights and reproduction

INTRODUCTION

administrator as distributors in a larger landscape. Through this frame, we can see how the role of distribution is occupied by different professions and facilitated by different technologies over time.

IMAGE

Attentive readers will have noticed my slippage between "picture" and "image." W. J. T. Mitchell, whose seminal question "What do pictures want?" is of primary importance to my study, has distinguished between picture and image thusly: "The picture is the image plus the support; it is the appearance of the immaterial image in a material medium."[33] Alternatively, art historian Douglas Crimp, when reflecting on his generation-defining 1977 exhibition *Pictures*, asserted that the term "picture" corresponded to a deliberate *lack* of media specificity that was important for a new group of artists not confined by earlier media hierarchies.[34] Framed in straightforward material terms by Mitchell and in antihierarchical terms by Crimp, the difference between picture and image is less oppositional in communities of practice, reflecting instead a linguistic shift over time as "image" is used today where "picture" might have been used in the past.[35] In the context of Mitchell and Crimp's definitions, the movement from the colloquial use of picture to the emphasis on image would seem to be linked to a discursive dematerialization of the material support as defined by Mitchell, suggesting that the language of dematerialization in art criticism and media theory has seeped into the broader vernacular.[36] Yet focusing on the language in practice reveals that the term "picture" was used by picture-workers as a capacious catchall in a similar manner to "image" today and that those working with the circulating image today consider the image in its materiality (as digital file or otherwise) as a matter of course. While I move between the two terms in order to embrace the language of my archival and informant sources, any use of the term "image" is invested in this trajectory. By this, I mean that my use of the term "image" is always related to the term "picture," always incorporating an association with a material support of some kind. Specifically, the images under consideration in this project are reproductions, mostly photography—images that are conceived as copies in advance.

COLLECTION

For art history, library science, and museum studies, "collection" is a practical term designating a group of objects with defined provenance, location, and classification system. Work on the collection as a theoretical construct has tended to focus on the collection either as a central historical phenomenon of the seventeenth and eighteenth centuries in fields of material culture, art history, or history of science or as an expression of the psyche of the collector in the fields of literary or cultural studies.[37] In the former, the collection is treated as a technique of ordering and a lens on historical epistemology, while in the latter, it is often individualized or pathologized. Cultural theorist Couze Venn brings these strains together in his definition of the collection:

As a category then, the collection stands at the threshold of a number of domains: it is part of technologies of the social, participating in the formation of identities and of publics, yet at the same time it functions as the visible trace intimating the invisible and haphazard history of knowledge whilst remaining as testimony to yearnings and pleasures that weave biographies into the history of communities and their deeds.[38]

It is this tension, between the historically specific and the appeal to more universalized human drives, between the order and pathos, between the systematic and the personal, that makes the "collection" ripe for a reinsertion into conversation around shifting techniques of knowledge production, following Venn. In practical terms, I take the collection as any ordered and stored set of items, in which the order is interpreted flexibly (from the standardized to the idiosyncratic). Drawing from the nomenclature of library and information science, I take these items as being in any one of four categories: (1) tangible materials (i.e., physical objects), (2) intangible materials (i.e., electronic resources), (3) tangible materials not owned by collection (i.e., objects tracked but owned by other libraries or collections), and (4) intangible materials not owned by collection (i.e., materials available on the web).[39] Further, collections can managed by lists, index cards, bound books, or databases but are not reducible to any one particular method of cataloguing. I find that this concept of the collection, while drawing on historical framing, is particularly useful in connection with web culture. It allows for certain kinds of inquiries: How is Google Images organized as a picture collection? How do we interact

INTRODUCTION

with collections as part of our daily navigation through the web? How are the politics of collection differently charged as the legal and material conditions of collecting shift with digitization? Daily interactions with the internet involve a wide range of collections as social media feeds are organized into groupings by keywords or geotags, and our computer caches collect impressions of our itinerant paths and activities online. The broad definition also highlights the importance of considering the collection—any collection—as a network unto itself. Catalogued, arranged, and grouped, a collection's network of tangible and intangible objects is built out of meshes of links between things and ideas. These links follow structures determined by various strategies: the creation of metadata, indexes, documentation, and classification schemes.

INDEX, RECORD, DOCUMENT

Looking at the collection leads me to a consideration of classification, indexing, documentation, and metadata as technical terms as well as orienting concepts that bridge past and present. Metadata, in its simplest formation, is data about data. This recursive description, like a dog chasing its tail, captures the challenges of unpacking the collapse of process and object in media studies. According to some dictionaries, to index is to record in an index, to document is to create documents. Media techniques are literally defined by their objects and vice versa. Further blurring the terms, across the case studies in this project, words recur with different meanings. An index is a collection of cross-references, a typewritten list of sources, a standard format card, and a semiotic term designating a physical relationship between representation and referent. A catalogue is a piece of furniture holding an organized collection of index cards, a promotional brochure listing items for sale, a scholarly publication documenting an exhibition, and a verb designating the work of a picture-worker tasked with describing an object. The document is a designation that artists and picture-workers use throughout this book to alternately confer aesthetic, professional, or informational value, changing the meaning of what it is to document and what a document consists of each time. All of these terms are subsumed under the process of classification, which includes the organization, placement, arrangement, description, marketing, or historicization

of the pictures at hand. These all equally represent or require "intellectual furnishings"—those shelves, cabinets, drawers, desks, stands, files, and other myriad equipment that create the scaffolding for knowledge production, to use Shannon Mattern's term.[40] I do not seek to rigidly delimit these terms but let them play out their meanings in the words and technical processes of the actors surveyed.

The *index*'s linguistic identity as noun and verb, as well as its meaning as description of a metaphysical relationship between lived reality and representation, demonstrates the epistemological arguments about the world threaded throughout information management. Practically, an index is a list, which, as Liam Cole Young points out, can function "variously as a communicative device, a cultural form, an operational mode of writing, a storage or archival device, a poetic form, and a mediator."[41] An index can be a list of topics in the back of a book or a list of subject headings in a card catalog. It is also, more broadly, "that which serves to direct or point to a particular fact or conclusion; a guiding principle," and "a sign, token, or indication *of* something."[42] In semiotics, the index is a privileged type of sign—an index indicates that link between representation and reality that is based on a physical connection, "a deposit of the real."[43] For all its practical applications and challenges for information scientists, this connection to reality permeates its practical use as an information management tool. Google is, of course, first and foremost, an index to the webpages accessible online. Its ubiquitous use among web users promotes the fiction that it *is* the internet. In fact, like all other collections, Google's indexing priorities reflect editorial decisions, as results filtering out spam, illegal activity, and other results shaped by a shifting set of company priorities.[44]

Indexes appear in the library and stock agency cases as the lists of subject headings used to organize the collection (at the museum, pictures are generally ordered by medium, then by artist, obviating the need for extensive subject indexing). Subject indexing is a fraught process. As Nina Lager Vestberg has put it, indexing a picture invites "the constant problem of adequately attending to the different levels of content in any picture . . . accounting for what a picture shows is never the same as describing what it depicts."[45] Further, from the perspective of library science, visual indexing is doomed by the fact that it requires interpretation (interpretation being a dirty word among a profession that seeks neutrality): "not only is the

initial interpretation inescapable, the entire indexing process is made up of multiple inescapable interpretations."[46] One professional distinction that seeks to guard against unannounced interpretation is the contrast between "ofness"—an account of the objects or subject on view in a picture—and "aboutness"—an approximation of the concepts conveyed. These correspond to Erwin Panofsky's pre-iconographic and iconographic strata of meaning, in which aboutness requires some level of decoding and cultural knowledge and, thus, interpretation.[47] Even describing an image according to the standards of "ofness" comes with particular challenges in analog conditions in which a subject heading determines a single picture's location and thus its accessibility.

One created, *records* stand as ontological substitutions for the image in question. As Cornelia Vismann has explored the strange urgency with which researchers seek "presence" from files, users of the catalogue and indexes treat their lists and databases as a shadow collection of objects, trawling the virtual shelves in search of their picture of interest.[48] Further, files have the tendency to "take on ontological categories."[49] Through these ontological categories, they direct their custodians, users, patrons, and clients. The insurance forms in the museum, the invoice for the stock agency—these ontologizing records accompany images, constrain their use, and announce their value.

Before a piece of recorded information is called upon to perform work as a record, it is simply a *document*, which Lisa Gitelman describes as "epistemic objects" defined by their "know-show" function.[50] In my case studies, the document relates to a range of practices: the museum's use of photographic documentation, the Picture Collection's use of the term to convey their approach to collecting images as reference rather than art, and the straightforward documentary photography celebrated as an art historical genre by MoMA. This reflects the different currencies of the "document" at play in the 1920s and 1930s, from the library documentation movement to the "documentary style" promoted by MoMA's librarian, curator, and photographer Beaumont Newhall as "often brilliant technically and highly artistic, but primarily . . . pictorial reports."[51] More than any other term surveyed here, the competing definitions of the document are at the heart of the theories of photography that are communicated by these collections and will be surveyed in greater detail throughout the chapters.

Bringing these valences of the document together, I expand on a general theory of the document to incorporate creative work, a flexible concept of information, and a greater agency on the part of the user.

PICTURE-WORK

Picture-work is, simply put, work with pictures. More specifically, it is the work that pictures *require* in order to circulate. By looking to labor practices, I turn to a group that, as I have noted, I call picture-workers. Picture-workers, including librarians, archivists, cataloguers, and curators, are a professionalized group who actively reflect upon their practice and often serve communities of users and producers with whom they might overlap. Users appear in this study either as they are constructed by picture-workers or as picture-workers themselves: the professionals whose own use of pictures influences the functioning of the collections. In making this delimiting gesture, I do not want to dismiss the essential insight of visual culture studies that viewers (or users) are active producers of meaning rather than passive consumers.[52] Indeed, the active participation of users or viewers in the construction of collections is attested to by the picture-workers themselves. The exchange between the users and practitioners of these collections is essential to the way they have evolved, and I will pay particular attention to the ways in which users influence standards and practices.

The professionalization of picture-work and the grouping of certain kinds of labor practices are traced throughout the book as I chart how professional communities are legitimated through professional organizations and publications. This kind of networked professionalization is linked to the networked images themselves, which invite collaboration and the sharing of resources across communities, one of the results being the trend toward the large, aggregated collections contemporary libraries, museums, and stock agencies are pursuing in the digital environment.

Despite its range in genre, my selection of case studies thus reflects specific interests that differ from the broader phenomenon of circulating images in the twentieth century that has drawn attention across fields. The images that I'm looking at are for the most part banal. They circulate not so much to do the work of representing scientific phenomena, bodies, state subjects, or as expressions of personal identity and expression but rather to function as citations for other images, to proliferate into other images.

They represent artworks to be copied down by art history students, or visual sources for a graphic designer, or stock images sufficiently generic to serve as a backdrop for a variety of advertising messages. They circulate as material objects, but their visual content is part of a larger circulation and mutation of forms in postmodern visual culture. Across these case studies, pictures are adjacent to the objects of higher value within the ecologies of the institutions, yet comparatively ephemeral, modest, and mundane; they are "uncertain images," to use Elizabeth Edwards and Sigrid Lien's term.[53] In the same manner that I mean to bring attention to the role that information workers' labor and everyday practices play in the cultural politics of the image, I similarly explore the overlooked part that a particular kind of image plays in larger value systems—the reference image, the commercial photograph, the art reproduction. In this way, I wish to historicize the value of the circulating image by tracing it back through the twentieth century.

CHAPTER OUTLINE

In chapter 1, I examine the NYPL's Picture Collection, a collection of millions of clipped pictures that has been in operation for over a century. The collection was founded in 1915 as new class of modern workers was seeking reference images to support their production, which increasingly required eye-catching imagery or period-specific visual accuracy, and the Print Collection was overwhelmed with requests for valuable holdings that could only be consulted onsite. As an alternative, the Circulation Department started collecting clippings from old books, discarded photographs, and postcards, and in the fall of 1915, the Picture Collection, where visual researchers could go to search for an image by subject and check it out, opened to the public. These visual researchers included (and continue to include) artists, designers, publishers, historians, educators, government researchers, and general users who check pictures out for purposes from reference to inspiration to recreation and appreciation. As such, it is organized in such a way to be intuitive to users who are looking for images of particular topics, rather than artwork. Specifically, clipped pictures are gathered in folders by subject and organized alphabetically, demonstrating that the general subject searching contemporary users are familiar with on Google Image search has long been a feature of our information culture.

To elucidate the significance of the Picture Collection, I look specifically at the work of the head of the Picture Collection from 1929–1968, Romana Javitz. Javitz wrote extensively about the administration of picture collections in bureaucratic reports and professional journals alike, expounding on a philosophy of the image she described as "pictures as documents." I argue that the structural logic of the collection she produced, which she frequently described as "live," "living," and "contemporary," anticipates features of the digital image collection and Google Image search, but rooted in the context of a public library. For Javitz, the "picture as document" means that the picture exists to be used: its status as document resides in the potential for a user to find information within it. The value of a collection of "pictures as document" is thus measured by both scale and findability, qualities increasingly relevant to the contemporary collection that can be at odds with each other. Javitz achieved these through a flexible, straightforward organization system that empowered the user. This is crucially not an evidentiary model in which the authoritative photograph communicates a truth prescribed in advance. Rather, Javitz's "picture as document" is enacted for use for information, inspiration, or pleasure by its user; its applications cannot be foreseen in advance. She articulated this conception of the picture widely among her network of artists, curators, and other picture-workers, and her ideas were influential to prominent documentary photographers like Walker Evans and architects of government archive projects like Roy Stryker, demonstrating that a discourse of the documentary that is interactive and generative rather than authoritative has a long genealogy.

In chapter 2, I look at the history of MoMA to trace how the virtual circulation of art and the dematerialization of the museum's walls were central preoccupations of the museum long before the web, highlighting MoMA's early activities circulating exhibitions of artwork reproductions and maintaining a slide rental library, as well their continuous production of photographic material in photography studios onsite and through their rights and reproductions department. I further argue that the circulation and production of photographic prints were key methods through which MoMA established a context for photography as art to be exhibited in the 1930s and, by the 1970s, as an art to be collected while maintaining documentation photography as a strictly nonart genre.

INTRODUCTION

Exploring MoMA's history through this lens decenters figures like first director Alfred Barr and highlights the contributions of the head of the circulating exhibitions department, Elodie Courter, and first director of the rights and reproductions department, Pearl Moeller. These women performed crucial roles within the museum, facilitating the flow of visual information within the museum but also between the museum and the outside world. One of the central interventions of this chapter is the argument that theories of the museum that are based around an essential cleavage between the space of everyday life and the space of history are insufficient. Rather, I reframe the museum's walls as membranes that permit a constant diffusion and assimilation of objects and pictures. The result of this circulation of pictures, supported by various forms of paperwork and the labor of Courter and Moeller, was the creation of a canon of modern art. This canon affirmed photography as modern art, insisting on its auratic value as objects to be collected and displayed. Allan Sekula has gestured toward the connections between "the archival mode of photography and the emergence of photographic modernism," but in reference to crime scene photography and government archives.[54] This chapter explores how the museum itself engaged in both the production of an organized photographic archive and the production of photographic modernism, wherein the former consolidated the value of the latter. Further, photography plays a key role in naturalizing the aesthetic ideology of modernism, including its appropriation of the non-Western culture, for a US audience.

Next, in chapter 3, I excavate the history of H. Armstrong Roberts Company, an early stock photography agency that anticipates the visual culture industry that flourishes in the postwar period. Here, I analyze the conditions that shaped the development of an industry and the unusual semiotic status of the stock image as free-floating signifier—stock photographs are designed to function as generic and specific at the same time, in order to fulfill, in advance, the distinct and varied needs of advertisers or publishers in search of a readymade illustration. In particular, I investigate the influence of syndicated publishing, the early advertising industry, and amateur photography culture on H. Armstrong Roberts from the teens through the 1930s and review the structural conditions of his early networked offices (though the company was based in Philadelphia, there were branch offices across the United States and Europe by 1930). I look at their central card

index as a proto-image database that generates stories and narratives using a recombination of props, settings, and themes.

The case captures the professionalization of a type of photography practice, in which the photographer is transformed into a distributor, and in which the genre of stock photography comes to dominate print visual culture. Roberts was first an amateur traveling photographer, then a studio manager and producer, and finally an agent for multiple photographers selling under his name. The stock photography agency he created was a factory-like setting for the large-scale production of a product. This product was shaped by media infrastructures from industries like publishing and advertising, to the communication technologies like the telephone and telegram, to office techniques like the marketing catalogue and the filing cabinet. And the commodity that emerged from this constellation of media infrastructures was a photographic genre that posits the image-as-story, an easily deconstructed, simple message with a wide variety of possible applications. The widespread market for these images trained generations of viewers in what to expect from the majority of commercial images we are exposed to: real but constructed scenes, meant to be visually decoded, and generated in part by a market system.

Finally, chapter 4 explores how the circulating image collection has been reconceived with digitization. Based on interviews with long-time staff members in each case study, I create a new glossary of terms to bookend the ones rehearsed here in order to trace the digitization projects of each of the three cases. Common themes abound: a trend toward interoperability, outsourcing of labor to digital asset management systems and outside firms, and a new importance placed on metadata. I further identify the mess of things, the starts and stops, and the uneven reach of digitization projects. While digitization has undoubtedly transformed the work of each of the institutions surveyed here in dramatic and everyday ways, there are no clean breaks in their digitization narratives; each collection still circulates and manages analog material, their classification systems (now referred to as "legacy" systems) are jerry-rigged into digital schemes if they cannot be easily translated, and the same staff members are trained in new technology or processes. Each case thus demonstrates the gaps, code-switching, and patchwork that go into smooth digital space of an online collection. At the same time, each case reveals the importance of

INTRODUCTION

new actors: companies that design internal databases and programmers that link these with public-facing webpages.

The picture-workers who observed these changes shepherded their collections through heady days of digitization, witnessing the total transformation of their jobs and learning new equipment just to observe it quickly become outdated. As they consider the changes to come, workers predict greater interoperability between library and museum collections, the creation of three-dimensional museum catalogues, the increasing release of metadata as both an artistic and a commercial resource, and the use of artificial intelligence (AI) to assist with indexing and copyright management in ways that will automate much of licensing and legal enforcement of image usages. It remains to be seen whether or how quickly these changes will bear out, but they reveal the continued prominence of values of the documentary, open-ended, constructed, and decodable nature of the photographic image that the collections in this book developed throughout the twentieth century.

Each case of this project thus demonstrates ways in which early twentieth-century institutions shape today's image flows. The user-centered library establishes a model for the user-generated content of the internet (without the commitment to the public interest), the museum's unacknowledged yet central role as a producer and distributor of images is central to its consolidation of cultural authority, and the stock agency's transformation of the photographer into a manufacturer and an agent anticipates the aggregator logic of the contemporary visual content industry that is steadily driving down the value of the individual image itself.[55] Across these three case studies, picture-work produces new genres—such as the generic commercial image or the fine art photograph—and new types of workers—such as the picture researcher or the database administrator. Yet as new applications of circulating image collections develop, the fundamentals of picture-work—classification, storage, and circulation at scale—remain.

"AN EXHILARATING CONTINUITY"

Libraries, museums, and stock agencies now find themselves at a critical juncture: the world of universal image collections that they labored to construct has been realized in such a way that their influence is

underacknowledged, and the expertise that was once foregrounded is now obscured by online interfaces. Paradoxically, the circulating image collections surveyed here, with missions ranging from preservation of cultural heritage to pursuit of commercial profit, produced an ethos of the available image, an ahistorical, non-medium-specific phenomenon that is both informational and aesthetic, free for public use and an object of potential exchange value. This understanding of the image is dominant in a culture in which images shared to a free platform like Instagram or Flickr are often appropriated, monetized, or repurposed in ways intended by the original authors or not. At the same time, the historical collections surveyed here are increasingly structured and constrained by technological solutions built by outside companies. Looking back at earlier environments for image circulation enables us to see that the image economy was built not just through the accumulation and indexing of images but through the cultivation of communities and the social interactions between people, image, and material. This insight deemphasizes the authority and agency of the technological system in favor of the interpersonal interactions that a circulating picture collection promotes. To collect and organize pictures is already to presume the possibility of collecting and organizing the world, to paraphrase the Susan Sontag quote that opened this introduction. Bringing lessons of the analog circulating picture collection into the present centers the insight of the public librarian that this world-building is collective, public, creative, and ongoing. In a 1936 Annual Report, Romana Javitz captures this vision:

There is so exhilarating a continuity in the usefulness of this type of library service that both the organization of the material and its development is never static. It keeps both staff and public alert and arouses a lively stream of cooperative reports from the public from whom we receive an amazing percentage of constructive and understanding suggestion, always in the spirit of keeping the collection one of live preservation and availability.[56]

Our current project of collectively maintaining the digital circulating image collections would do well to hold this early description close, centering cooperation, preservation, and availability in our contemporary world-building efforts.

1

CIRCULATING COLLECTION STYLE: PICTURES AS DOCUMENTS AT THE NEW YORK PUBLIC LIBRARY

A correspondent of the Manchester Guardian, arriving at the Picture Collection one day, apologized for suddenly covering his eyes. He said it was all too, too colossal and quite horrible to see such potential power, such organization of quantity. To him these pictures were like disease ready to go into the population and penetrate its life. He saw these files as germs of limitless ideas.
—1937 Annual Report, Picture Collection, NYPL, box 7, folder 5, The Picture Collection Records

In a cartoon that appeared in a 1944 issue of *The New York Times Book Review*, a child with a large pair of scissors and a scrapbook tucked beneath his arm approaches a librarian (figure 1.1). "Where Will I Find Some Picture Books?" reads the caption. It's funny, sort of—because the cultural perception of librarians' overzealous devotion to order enables us to imagine extreme exasperation roiling behind the librarian's raised eyebrows, and indignation is funny—but also because of what we know to be the library's most central mission: the preservation of books. The little boy and his huge scissors represent a direct affront, comic because of the child's lack of awareness about how diametrically opposed his intended activity is to the proper function of a library. And yet, at the very time this cartoon ran, in Room 100 in the hallowed, marble halls of the New York Public Library's main building on 42nd Street and 5th Avenue, a team of librarians was busily snipping away at books, discarding the bindings, and filing away the

1.1 "Where Will I Find Some Picture Books?" Cartoon by Jeffrey I. Monahan, originally printed in *The New York Times Book Review*, November 12, 1944.

clippings for future circulation. They did this as a matter of course, as they had every week since 1915, when the Picture Collection was founded, and as they continue to do today, in Room 119 of the same marble building (figure 1.2). Here, longtime users, recently converted enthusiasts, teachers with visiting classes, and curious tourists still mingle, engaged with the act of physically searching for images. During COVID-19 closures in 2020, Picture Collection staff sifted through folders with patrons over video calls. In 2021, when the NYPL announced plans to remove the collection from circulation and store the clippings offsite, artists and other users organized a public campaign to challenge the decision, and library leadership reversed course, keeping the collection and its longtime librarians in place, snipping, filing, and circulating old and new pictures.[1]

In the century since librarians prepared 17,000 clippings for circulation in 1915, the Picture Collection has ballooned to several million pictures and been trimmed to the comparatively leaner 1.4 million available today. It has been used by visual researchers from Diego Rivera to the State Department, but primarily by artists, designers, illustrators, and educators—active users who have directly and indirectly influenced its development. It is made up of pictures clipped from discarded books and

1.2 The Picture Collection in its most recent home in Room 119, Stephen A. Schwarzman Building, New York Public Library. Photo by author, 2022.

magazines, from book proofs and film prints, from postcards and travel brochures, from discharged personal and institutional photo archives. Each picture is inscribed with one of 12,000 subject headings, an evolving list of search terms that the librarians have cultivated over decades. It is a *living collection* (to draw from the terminology of botanical gardens and emphasize the distinction from the photographic morgues from which some of the stock was procured) tended to by overlapping communities of users and caretakers. Its development and precarious homeostasis depend on an organizational structure set in place in the 1930s and reflect a distinctive philosophy of images that extends from the beginning of the twentieth century into the present day. This philosophy is animated by what I call the *ethos of the circulating image*. In the ethos of the circulating image, images are primarily defined by their *availability*. While the availability of digital images is rendered transparent today through the ubiquity of copy-and-paste functions, the idea of the picture as publicly available content is grounded in the model of the public library, in which

content circulates out to the community. By locating the ethos of the circulating image first in a public library collection, I offer a model for evaluating today's image culture outside of authorship and markets. Rather than property (material or intellectual), circulating collections and the ethos of the circulating image posit the image as *alienable content*, defined by availability for diverse use.

The ethos of the circulating image demands a philosophy of images as alienable content. A central intervention of this book is to uncover the philosophies of the image articulated by picture-workers, decentering the academic voices that have traditionally dominated in favor of the workers who supported and facilitated their study of pictures. This chapter looks to Romana Javitz (1903–1980), head of the Picture Collection from 1929 to 1968, as a key philosopher of the image (figure 1.3). Over the course of her leadership, the Picture Collection came to be recognized as the foremost picture collection in the country. Javitz was responsible for implementing the system that obtains today, in which clipped pictures are arranged in folders, placed in open bins or stacks, and organized under alphabetical subject headings, "from Abacus to Zodiac."[2] Since the administration of picture collections proved (and continues to prove) challenging to standardization, Javitz continually fielded questions from major research institutions about all matters of picture collection development and organization and relentlessly promoted her methods through teaching, lecturing, and publishing. Javitz's approach flowed from a central insight into image reproductions, a perspective she defined by the phrase "pictures as documents."[3] By the 1920s, libraries and museums were professionalized and the medium of photography historicized. Yet, Javitz's understanding of the "document," connected as it was to the discourses that had consolidated those fields, paradoxically allowed Javitz to envision an approach to collection management that was anti-bibliographic, anti-museographic, and nonmedia specific.

This chapter will tell the history of the Picture Collection by drawing on the words of its custodians, in an attempt to bring out the way that this collection, and the practice of circulating pictures in general, was theorized by the women and men (most frequently the former) who oversaw its management. This story begins in 1915 and is ongoing today, as the Picture Collection continues to circulate its physical clippings even as

CIRCULATING COLLECTION STYLE 29

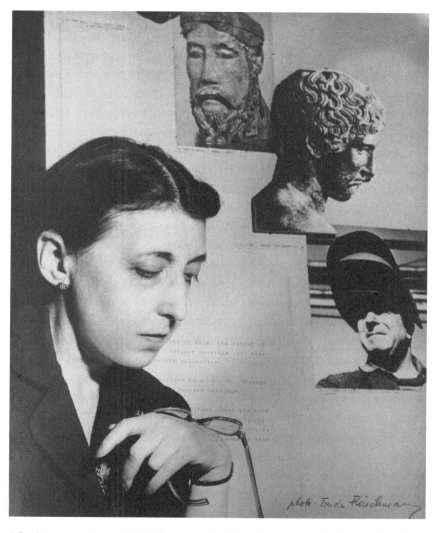

1.3 Romana Javitz, ca. 1941. Photograph by Trude Fleischmann; Collection of Anthony Troncale.

sections of its collections have been haltingly digitized over the past two decades. In the image that opened this chapter, there are two figures, a horrified librarian-gatekeeper and a mischievous child armed with scissors. Through today's eyes, and through the rhetoric of the "end of the library" (a phrase that has titled click-bait tech articles, exhibitions, and special issues of library journals alike[4]), this could be seen as an allegory for the

confrontation of the old guard by a new digital paradigm. In this chapter, I suggest that in fact it is the child who best embodies the function of the library, a place where information is chopped up and remixed, where flux is often encouraged over permanence, and where play and experimentation continually generate new knowledges. The Picture Collection was designed to support artists and researchers' work as they copy and paste, morph and transform, annotate and elaborate—techniques of interacting with images that are fundamental to the way contemporary users consume and produce images today. This social life of images would not be possible without the facilitation of places like the New York Public Library's Picture Collection. Our contemporary ethos of the circulating image is enriched by understanding this relationship with images as a central function of public life and the library as a space to facilitate and guide this work.

Two themes anchor this history: "living collection" and "pictures as documents," which title the following sections. "Living Collection" introduces the collection and surveys the daily practices of the Picture Collection in the context of contemporary forms of information management and media theory, particularly through the concepts of user-generated classification and digital indeterminacy. "Pictures as Documents" explores how Javitz defined the units that make up this collection, looking at the historical ideas that gave rise to her theories. Ultimately, Javitz's definition of the picture *requires* the organization represented by the Picture Collection, anticipating information structures associated with the organization of visual material on the internet, and reveals the currency of postmodern conceptions of the image, in which meaning emerges in acts of interpretation and images cross-mediate across platforms, within the decidedly modernist milieu of 1930s America.

LIVING COLLECTION

Romana Javitz was the superintendent of the Picture Collection from 1929 to 1968, indelibly shaping its holdings, processes, and culture. Born in 1903 in Minsk, Russia, to Polish parents, Javitz immigrated to the United States as a child.[5] Both parents had an interest in art and design; her mother was a hat milliner, and her father was an importer of fine woods who had gone to art school in his youth. Javitz followed in her father's footsteps,

starting art school at Cooper Union and then studying painting at the Art Students' League. She began working part-time in 1919 at the Children's Collection at the New York Public Library to support her painting study and then moved to the Picture Collection in 1924. A trip to Europe to study library and museum picture collections in 1925 and 1926 intensified her interest in the organization of pictures as historical documents and records of visual culture. When she took over as superintendent of the Picture Collection in 1929, she had a clear vision for a comprehensive pictorial library that would support the research required by the artists, designers, and publishers working in the cultural industries of New York City and provide inspiration and visual education for the public.

Picture collections in public libraries were not entirely novel—the first such collection was founded in 1889 at the Denver Public Library by John Cotton Dana, a pioneering librarian who sought to re-create libraries as vibrant community centers, advocating for the public's right to open stacks and founding the first collection devoted to children's literature.[6] Dana established the picture file in Denver as an art reference collection and went on to create a similar collection at the Newark Public Library, where he served as director from 1902 until his death in 1929.[7] In the first decade of the twentieth century, librarians were in broad discussion about the practice and challenges of managing picture collections in library journals like *Public Libraries*, *Special Libraries*, and *Library Trends*, sharing tactics for sourcing, mounting, storing, and conserving pictures.[8] Across cases, librarians stressed the importance and value of the collection within the larger library ecosystem, arguing that picture collections enhance the public library's mission to "to become, as it should, a center for happiness, as well as an educational institution."[9] Pictures expanded the vision for what a library could offer a community. In 1906, Melvil Dewey proclaimed,

Both in theory and in practice, by adding pictures to their collections and catalogues, libraries are rapidly accepting the doctrine for which we have contended for many years, that what we call books have no exclusive rights in a library. The name 'library' has lost its etymologic meaning and means not a collection of books, but the central agency for disseminating information, innocent recreation, or best of all, inspiration among the people.[10]

In this quote, Dewey connects the library's role as a central disseminator of information with the use of pictures: their presence in libraries is

a theoretical and practical challenge to a book-centered paradigm and a source of recreation and inspiration. Yet many librarians struggled with implementing and growing their collections beyond small collections in children's libraries or art reference files. By cultivating a community of users in a city in which access to images was a professional necessity for the city's largest industries, Javitz turned the New York Public Library's collection into the largest and foremost collection in the country, circulating hundreds of thousands pictures a year, realizing the democratic potential Dana championed.[11] She saw the collection as a vital resource to both the working artist and the general user whose appreciation of images was more wide-ranging than the elitist, aesthetic views presented by the museum or gallery. She advocated for the use of the collection among working-class and immigrant populations, regularly including anecdotes in annual reports about the working-class users of the collection and promoting the use of the collection among her community of non-English-speaking users by encouraging requests to be drawn as pictures.[12]

Javitz's social milieu shared her belief in the political potential of democratic modes of disseminating and interpreting visual culture. Though her own publishing and political activities were circumscribed in library work and administration, her circle included activists, writers, and artists who embraced radical politics. Muriel Rukeyser, poet, leftwing journalist, and political activist, was a longtime friend.[13] Another regular interlocutor was Jay Leyda, a documentary filmmaker and historian who was a crucial link between the Soviet avant-garde and American intellectuals. Javitz was also very close with the family of anthropologist Franz Boas; she had a decades-long affair with son Ernst Boas and was also friends with daughter Franziska Boas.[14] Ernst, a doctor, and Franziska, a dancer, were both concerned with racial justice and worked publicly to integrate their profession. Javitz recognized the role of imagery in combatting racism and regularly wrote about the importance of building up their collections of representations of Black history and life. She also assisted Arturo Alfonso Schomburg in building out the Library's Division of Negro History, Literature and Prints in the 1930s.[15]

Throughout the 1930s and 1940s, Javitz built the bones of the structure of organization of the collection that persists today, making her philosophy of images durable through the material infrastructure of the

CIRCULATING COLLECTION STYLE

collection. Javitz's belief in the inherent multiplicity of meaning in pictures and its correlative democratic character was drawn from direct observation. Watching artists and designers work with pictures, as visual reference tools, models, conceptual illustrations, or fact-finding documents, led her to an intuitive understanding of the way images, outside of the material print, circulate and proliferate. Javitz observed the same image put to different use, copied, altered, rephotographed, reprinted, and interpreted widely, as when the same sixteenth-century drawings of beggars by Hieronymus Bosch were used by "an orthopedist who was tracing the introduction of hand-grips on crutches; a fashion designer who used a bag worn by the beggars as the basis for a new type of purse, [and] a public health lecturer who used the same print to illustrate the medieval community's neglect of the disabled."[16] She witnessed cycles of style and interest, the way a particular subject file would rotate in and out of demand. In a newspaper profile, she declared, "We can feel the pulse of change. We have worked with artists before they have finished their work, we know what dress the designers are working on."[17] Due to the centrality of the collection in the work of artists throughout industries in New York, Javitz regularly interacted with a wide range of people, from working artists and designers to amateur historians and hobbyists, all of whom expected different kinds of information from the image and all of whom put it to use in different ways. Bolstered by her intuition about the social lives of images in contemporary life, Javitz aimed to create a system that would best support her users, one that would be flexible, responsive, and generative.

The role of the individual user in determining meaning is a recurring theme across Javitz's writing, often captured in anecdotal observations.[18] Her desire to address this inherent flux was translated into a system of classification and physical arrangement that would best empower users to find pictures, pictures that would be put to diverse ends by users indifferent to either the author or the librarian's intention. To create this system, Javitz openly challenged the bibliographic hierarchy of information set in place by the "Newark model," the dominant manual for picture collection headings that had been published by John Cotton Dana at the Newark Library.[19] Specifically, the "Newark model" was an alphabetical list of subject headings with selected subheadings, which followed bibliographic hierarchies that would be logical to a professional cataloguer but impenetrable to the

average user (for instance, bays or oceans would be found under F, "Forms of Land and Water—Oceans"). The NYPL adopted this system at its founding, but Javitz did her best to dismantle it when she started, reflecting in 1937, "Too much knowledge is expected of the user. It is not popular, live, nor flexible enough to keep pace with technological, scientific, and news developments."[20] Javitz instead envisioned a responsive system, one that would allow direct interaction between user and collection, without continually requiring the mediation of a librarian translating the request into cataloguing terms. She rejected the hierarchical subject system, instead favoring straightforward subject terms and minimal subcategories.

In addition to the revision of the subject classification, Javitz reimagined the practical layout of the collection by implementing an open-stack model in 1929. Where previously patrons had to make the request through the librarian, who could then translate the language of the request into the language of cataloguing, the new arrangement allowed patrons to browse directly through the files (figure 1.4). Empowering the user required both

1.4 People using the Picture Collection, New York Public Library, 1947. Wurts Bros. (New York, N.Y.)/Museum of the City of New York. X2010.7.1.9210.

CIRCULATING COLLECTION STYLE

a revision of subject terms and physical reorganization, demonstrating the knowledge-making classification systems are never independent of spatial relationships. Inviting a new physical relationship to the files meant that the space itself communicated what it meant to be a user of the collection. Users are searchers; they physically traverse the collection.

With these changes, the collection took on roughly the form that it still takes today. Now, a patron enters into the collection in Room 119 of the main building on 42nd Street. There, they are greeted by rows and rows of shelving with upright archival standing folders (figure 1.5). Each folder is labeled on the outside with its subject—such as "Accidents," "Butter," or "Curiosity." Sometimes they are subdivided—"Animals— Fighting," "Animals—Fox," "Animals—Humans as." They are arranged alphabetically, such that one knows exactly how close they are getting to the folder "Witches" as they watch the letters of the alphabet advance as they walk down the aisles. Each folder is stuffed with clipped pictures, some glued to sheets of archival paper, which could have been added yesterday or one hundred years ago (figure 1.6). The more yellowed pages indicate age, but the markings capture the same metadata over time: a penciled subject heading, a source code indicating where the picture was clipped from, and a N.Y. Public Library Picture Collection inked stamp. The room has a table and chairs where patrons can bring their folders to spread out pictures. A librarian sits behind a desk, where they also have a typed list of all of the subject headings that can be consulted for reference, and a card catalogue collecting cross-references that librarians have added throughout the years, such as "Computers—see also, Census," or other bits of information they saw fit to save, such as fabric swatches glued to the card labeled "Army-Confederate States of America. Actual samples of Austrian material used in the Confederate uniforms." The entire space is optimized for the public to move through it and explore in multiple different ways.

Javitz's early system for arranging the collection was thus pivotal to the trajectory of the collection, and her language in the 1930 annual report captures her vision and illuminates the central concerns of image collections that reverberate today. The report notes, "The public does not cease to comment on the privilege it enjoys in having picture files open for 'browsing' and borrowing. The public is realizing that the Picture

1.5 Pulling the folder "Puppets-Stringed" from stacks, Picture Collection, New York Public Library. Photo by author, 2022.

1.6 Clippings from "Puppets-Stringed" folder, Picture Collection, New York Public Library. Photo by author, 2022.

Collection is not an art file but a picture encyclopedia."[21] Two significant terms in this quote—*encyclopedia* and *browsing*—demonstrate that the Picture Collection, organized by search terms in open stacks, captures fundamental ideas about images as active, networked spaces of creativity and knowledge production.

The encyclopedia was an important metaphor for networked information for the documentation reformists of the twentieth century. Historian of information science W. B. Rayward argues that Belgian bibliographer Paul Otlet, who argued in 1903 for the idea of a permanent networked encyclopedia and founded the Mundaneum in 1910, saw the universal encyclopedia as the ultimate goal of an international documentation movement.[22] Javitz's 1930 invocation of the "picture encyclopedia" can be evocatively set against Otlet and against the contemporaneous musings of H. G. Wells on the "World Encyclopedia," or "World Brain," which has been quoted extensively by information scientists and techno-utopianists since Wells's essays on the subject were published in 1938.[23] Significantly,

Wells's model is dispersed, the means of production and reception scattered across the globe, where users are both consumers and contributors of information.[24] Like Otlet and Wells, Javitz had a vision that was also global. As she wrote in a general description, the collection "may be likened to a giant encyclopedia," one that contains "the entire panorama of world history, of architecture, of science, of apparel, sports, news events, and the contemporary scene."[25] She mused in 1939, "If pictures of all of the art of the world were collected, organized by classification and cataloguing into a subject-indexed file, it could all function as document."[26] This global vision animated her thinking throughout her career. While often stymied by the limits of resources, space, and time, Javitz advocated for a worldwide centralized image resource and argued to her superiors that NYPL was the place for it. In 1956, in a proposal prepared for the library administration, she argued for reinvestment in the Picture Collection in order to expand it from a circulating collection to "a central pool of information on the subject content of pictures."[27] This would involve exponential growth, both through acquiring microfilm copies of the holdings of the Library of Congress and by dramatically ramping up the acquisition of other archives: "The twentieth century could be recorded by accepting the gifts of collections discarded by major news agencies."[28] For Javitz, the library would form an essential repository for the cast-off and out-of-date visual material of journalism and industry, at the ready to index and make available for further use to a global community.

While Otlet explicitly positioned his Mundaneum as a vehicle for world peace, a potential "nucleus of a great Institution of World Peace and Progress" to be shared by scientists and leaders across the globe, Javitz's global vision involved a network of individual users, caught as they might be within the webs of geopolitical conflict.[29] In the 1930s, she organized a picture exchange with documentary filmmaker Jay Leyda while he was studying in Moscow with Sergei Eisenstein, accepting Soviet pictures that Leyda had sourced into the collection and offering him long-term loans from the Picture Collection.[30] During World War II, researchers from the State Department made regular visits to the collection, necessitating the move of all of the Geography files to a secure and private location for exclusive use by the military. Javitz wrote excitedly that the Air Corps used images

from the Picture Collection to locate shipyards previously unknown to the army and that pictures of cow barns assisted the Signal Corps with technological design.[31] Artists in the military wrote from all over the world with requests, which her staff dutifully filled, sending materials to camps worldwide of pictures ranging from particular insects for health manuals to patterns for camouflage or symbolic representations of democratic ideals for propaganda materials. Because of the lack of staff, she often had to limit reference research, but she retained an ethos that any user was equally important to the life of the collection, whether onsite or writing in. Rather than seeing a broad, universalized collection as superseding or subsuming community-oriented organization and flexibility, she saw the two as mutually beneficial. Javitz sought to create a global network of users and suppliers, which could only be supported by a flexible, user-oriented model. As she insisted to library students, "One of the reasons that we have been able to build up the [international] public that we have . . . is that the very organization of [the collection] stems from what is needed by potential users. . . . There is nothing inflexible about a subject heading. If there is, there is something wrong with what you have done."[32] By planning for continual expansion, she saw the possibility for truly capturing the knowledge inherent in "all of the art of the world," to be democratically available to all, and to catalogue it, she insisted on keeping the user at the very center of all planning.

What structures need to be set in place for this dispersed intelligence to realize itself? The quotation marks around "browsing" in her 1930 text suggest that the term was being applied in a novel fashion at this time. Browsing derives from a Middle English word, *brouz*, which initially referred to the branches of trees and shrubs fed on by certain animals, and "to browse," a verb to describe the eating of this kind of foliage. The online etymology dictionary indicates that the figurative extension to signify the perusal of books occurred in American English in the 1870s. However, the 1913 edition of Webster's dictionary includes only the earlier definition, "To eat or nibble off, as the tender branches of trees, shrubs, etc." In addition, a perusal of Google Books' digitized corpus reveals that the published usage of "browse" and "browser" between 1870 and 1930 almost always referred to the agricultural domain. Two evocative exceptions capture the spirit in

which browsing was applied outside of its literal meaning. In an 1895 memoir, John Hollingshead proclaimed, "I was a browser, an idler, and not a student."[33] In a 1900 issue of *Scribner's*, a writer mused on the character of the stern librarian:

Let us assume the browser meets the cold glance of the young woman in shirtwaist and eyeglasses, who, at the circulating desk, is handling books with up-to-the-minute movements that indicate that this is no world to moon in. The browser's mood changes, and with the result that he finds it difficult to draw the two ends of the magic circle that before encompassed him together again.[34]

In both of these quotes, browsing is set against serious education and scholarly pursuits. The browser is not a student but occupies a subjective "magic circle." It was this magic circle that Javitz, in contrast to the cold librarian above, sought to encourage, creating an environment that encouraged exploration outside of received models.

For users onsite, this magic circle was created through an ambulatory way of knowing, as the only way to get to know the Picture Collection was by physically moving through it. A preliminary list of the complete subject headings was not prepared until 1940 and at that time consisted of an unwieldy and unlikely-to-be-consulted three thousand typewritten sheets with seventeen thousand main headings.[35] The primary way of searching in the collection was thus by walking through it, physically running one's fingers across the folders to view the appended subject heading. Whether in wooden bins as the collection was stored in the 1930s or on shelves, as the collection is currently organized, the close packing of the folders requires this physical interaction. It is necessary to browse in order to find. Unlike in a digital environment, a subject heading specifies a physical location that the browser must move through space to access, and alphabetical order creates unlikely neighbors among diverse concepts through physical adjacency. While main headings like costume and animal offer logical (and thus expected) subdivisions by decade and location, the flattened alphabetical nature of the majority of the collection provokes unanticipated discoveries. A user exploring the Cs, for example, would pull out, one by one, "Cupids," "Curacao," and then "Curiosity," moving from the iconographical to the geographic to the abstract. The users' fingers in this way function literally as index, the contact point with the collection realized in

CIRCULATING COLLECTION STYLE

a physical, tactile manner. Browsing, in this manner, has much in common with the primary etymological meaning, as users graze the collection like an animal at pasture.

Apart from this earlier history of "browsing," the association to any modern internet user is clear. "Browser" is, of course, the term used by Tim Berners-Lee and Robert Cailliau to describe "a program which provides access to a hypertext world" in their 1990 *WorldWideWeb: A Proposal*.[36] But the term has an earlier appearance in the history of computing. In 1969, J. H. Williams Jr. created a system that offered an alternative search strategy to Boolean phrasing: BROWSER (BRowsing On-Line With SElective Retrieval) allowed for natural language queries, allowing users to use their own search terms.[37] In other words, the search interface did not require the searcher to learn specialized keywords or Boolean query syntax (the use of AND, NOT, and OR commands). Williams was motivated by the desire to create a man–machine information retrieval that was truly interactive. His desiderata for the system eschewed a single universal user but instead recognized that information retrieval takes place in situated circumstances. For Williams, an interactive system should

provide different levels of services to experienced and inexperienced searchers, recognize the difference between a narrow and broad query, furnish clues as to the next direction to be searched, reorganize the data base dynamically as the searcher changes his viewpoint, provide a ranking of responses in the most likely sequence and offer the searcher the option of overriding the ranking when a particular term is of extreme significance.[38]

While the environment specific to computer programming differed significantly from that of the Picture Collection, both Williams and Javitz sought alternatives to an entrenched logical system of organization, one that would be responsive to a wider range of users.

Like BROWSER, the Picture Collection sought to incorporate the language of the public into its indexing. This was a practical matter to assist with the open-stack arrangement, but it also came out of a deep engagement with the public on a daily basis. Javitz relished the rehearsal of diverse requests from the public, including such lists in nearly every annual report during her tenure and often connecting them to contemporary events to suggest the way that the zeitgeist was captured by the activities at the

collection. In the 1931 annual report, she offers a list of requests in which expected contemporary preoccupations are interspersed with the absurd, incidental, and macabre:

The year's fads, slang, news events, scientific interests, world politics, diseases, fashions, and depressions appear in a day's questions: requests for pictures of panhandlers, men on bread lines, beauty contests, interplanetary warfare, Goder brides, racketeers, gangster's machine guns, "gun molls," hungry man eating, frail boy, hand knitting, baseball suit of 1898, degraded human being, illustrations of bartering, body floating in water, newspaper boy crying out Extra, donkey braying, baby carriage in Victorian period, flying geese showing feet in position, butcher cutting meat, theater-goers in 17th cent France.[39]

In 1932, she elaborated, "Through the recorded everyday picture needs, numberless ideas, technics, attitudes, economic influences, stage conventions interweave to an extent that shows the live, contemporary character of the collection and its influence in the community."[40] The record of requests was an essential representation of the collection as community.

In order to impart the "live, contemporary" character directly into the collection's structure, Javitz encouraged the incorporation of the language of the public's request into the subject classification terms through ongoing cross-indexing and reclassification. She summed up her approach in one undated manuscript:

Words used by the public to describe the pictures they need are graphic. Neither bibliographic nor cataloguing terms appear in their requests. . . . The scheme presented here is one of expediency and while not logical is efficient and practicable. . . . It arose directly from the way in which the public uses pictures. The subject headings were determined mainly by their nearness to the language employed by the public in asking for pictures.[41]

This approach to indexing, couched in practical language, was somewhat radical for a library professional. From the earliest picture collections, librarians sought to develop useful indexing approaches that could systematize their work in the same manner as their book organization. Picture files generally used one of five systems for classification and indexing or, more likely, some mixture of them: (1) a bibliographic system like Library of Congress or Dewey; (2) a numbering system supplied by an outside body, like a publisher; (3) a topical system developed by the library or using the "Newark" system developed by John Cotton Dana; (4) a serial or

accession-based numbering system; and (5) an alphabetical system by artist or title.[42] The system that a library chooses to use reflects understandings about the purposes and values of the images contained within it and the users' expertise. Organizing a collection by artist name, for instance, presumes a model of art history in which the artist's authorship defines its value and specifies users who would be searching on that basis. Alternately, a museum organizing picture material by accession number presumes a user community of museum staff. The topical systems used for general files like the Picture Collection explicitly break with collection-based or art-historical paradigms yet seek to imagine a model that would be broadly intuitive.

In addition to incorporating the language of the public, the collection also invited public engagement through their acquisition processes. An average of one hundred thousand pictures a year were given to the collection throughout the 1930s, sometimes by users who returned more than they had borrowed.[43] These gifts ranged from several hundred clippings of European royalty given by an amateur collector, photographs of railroads given by the widow of the former vice president of the Baltimore and Ohio railroad, to a selection of Lewis Hine prints from the Russell Sage Foundation. Javitz warmly recalled an artist, disappointed in the dearth of skunk images, going to the Bronx Zoo to photograph the animals in order to donate the prints to the Picture Collection.[44] The tradition of user donations continues: in 2021, a Midwestern tourist who happened upon the Picture Collection room while visiting the Schwartzman building followed up later to donate their collection of historical postcards from restaurants and hotels in New York City.[45]

This interaction between the users and librarians was openly lauded by Javitz, who repeatedly connected it with liveness and vitality. I opened this book with a representative passage by Javitz that captures her understanding of the life of the collection as an unfolding organism:

There is so exhilarating a continuity in the usefulness of this type of library service that both the organization of the material and its development is never static. It keeps both staff and public alert and arouses a lively stream of cooperative reports from the public from whom we receive an amazing percentage of constructive and understanding suggestion, always in the spirit of keeping the collection one of live preservation and availability.[46]

This character of "live preservation" points to my interpretation of the Picture Collection as a *living collection*: one that is always in process, to be completed, and unfixed. This characterization is drawn from Javitz's writing but is supported by observations at the current Picture Collection, where the structures set in place in the 1930s are still in evidence. Here, books and magazines continue to be collected for clipping, and as recently as 2015, physical pictures were still added to the collection at the rate of over 1,000 per month, according to senior librarians Jay Vissers and Penny Glenar.[47] Each librarian applies their own judgment in determining under which subject a picture should be filed; there are no codified instructions and minimal oversight. As Javitz herself, who was not trained as a librarian but rather as a painter, noted, the most important credential of a picture librarian is not a formal degree but rather the possession of imagination and an "ability to visualize."[48] Vissers suggested that at the Picture Collection, each librarian makes classifications based on their own interest in the collection, seeking to address perceived gaps based on their past experience with users. Further, images are occasionally reclassified as the collection grows. In one example, Vissers relayed that when he found a duplicate image of a urinating cow in the "Cow" file, he promptly moved it to the "Urination" file, having noted a sustained public interest in the latter. Duplication in general is sought after, allowing for the same picture to appear in multiple relevant subject files. Both Vissers and Glenar noted that duplication allows them to populate the more "whimsical" folder titles, like emotions and poses (one such folder, titled "Rear Views," primarily contains images of the back of the human figure).[49] Sometimes whole folders are reclassified or reconsidered amid shifting discursive and political contexts. In the early 2010s, the librarians created "Transgenderism" (following a Library of Congress subject heading) to respond to public inquiry and to redress previously harmful classification decisions, such as the placement of images of drag performances under "Impersonators." Supervising librarian Jessica Cline acknowledges the challenges of making these decisions, as she and her team worked to revise the heading again in 2022 when it became clear to her that "transgenderism" was not the preferred term in the transgender community.[50] Librarians respond to contemporary events as well: during the COVID-19 pandemic, they worked to fill out the new "Diseases—COVID-19" folder with representative

images culled from specially purchased magazine issues. Here they have to respond to the particular ephemerality of print culture: "We try to keep in mind that the information will not always be available. Those COVID magazines, that subject, aren't as easy to find now that we're a little further on," Cline noted in 2022.[51] When surrounded by items plucked from the never-ending avalanche of visual print culture and placed in safe keeping in the library's archival folders, it's easy to forget that often these sources are not meant to be saved.

One structural aspect that allows for this flexibility and dynamic reshuffling is that the pictures in the Picture Collection are not tracked as individual objects (the way that books are). That is to say, when books are checked out, their exact title, along with other metadata, would be recorded, whereas at the Picture Collection, only the number of pictures checked out is recorded, rather than metadata about the picture's content. This places as few obstructions as possible to the free circulation of images, the constant influx of new stock, and the continuous weeding out of old stock. The decision not to track item by item flows directly from Javitz's prioritizations, which consistently emphasized the importance of scalability. In her undated manuscript "Organization of Still Pictures as Documents," Javitz noted,

Pictorial record is enriched when it is available in quantity and when its organization is encouraged to grow on a comprehensive rather than a selective scale. Limitations on the type of picture of picture to be included should be kept at a minimum; all restrictions should be towards efficiency in availability, not on the grounds of taste or artistic merit. Selection should be left to those who will use a documentary collection, not to those who gather and organize it.[52]

Javitz brings a librarian's focus on the user to the curation to the picture collection, which centers quantity and "efficiency in availability" as the primary goals and makes participation of the public and a system that encourages constant growth essential. At the Picture Collection, acquisitions have been carefully calibrated with the goal to maximize efficiency, and the result is a sort of aesthetic of quantity. Pulling a file and seeing the wide range of images that a century of librarians have applied to a term offers a vision of that term that exceeds the meaning of any one image. In each folder, meaning does not inhere in the individual object but in the cumulative effect. The folder ideally offers not too many pictures (nothing

like the thousands of pages of results a Google Image search might yield) and never too few. There must be a broad enough range to reflect the multiplicity of interpretations. Each folder is a record of the librarians, users, and imagined users that have coalesced around a term over time and have been captured as an ephemeral snapshot, a fact that the librarians relish.[53]

This open structure prefigures, in some respects, the contemporary mode of metadata creation popularly referred to as "folksonomy" (portmanteau of "folk" and "taxonomy"), a term intimately connected with the set of discursive and technical practices associated with Web 2.0. Folksonomy broadly refers to the use of user-generated metadata as indexing tools for the search and retrieval of internet content. Without rehearsing a summary of the development of the concept, select quotes from information science texts provide provocative comparisons with the Picture Collection's approach. As Isabella Peters argues, folksonomic strategies are mutually dependent with the growth of user-generated content on the web and "turn the classification system from a criteria-centric into a resource-centric approach."[54] Per a heavily cited conference paper on the subject, "social tagging systems rely on shared and emergent social structures and behaviors, as well as related conceptual and linguistic structures of the user community."[55] That is to say, folksonomy encourages static, criterial structures to be replaced by emergent, processual descriptions, express goals of Javitz's. At the Picture Collection, accepted controlled vocabularies for subject indexing are supplemented and tweaked by the terms shaped by a local community, though mediated through the librarian.

There is an admitted difference between the cacophony of user-generated tag clouds (a common feature of Web 2.0 that has declined in popularity) and the contributions of an engaged community of users mediated through librarians. But noting the similarities between the ideal functioning of the folksonomic and the Picture Collection affirms the latter as social and emergent structure. This is due to the flexibility Javitz introduced in terms of terms but also to dynamic changes to the collection on a daily basis through the active clipping completed by librarians and weeding out by circulation and use. In 2015, Glenar and Vissers explained that generally at least an hour out of the day was spent clipping books or magazines. In addition to the magazine subscriptions that supply a ready stock, their offices contained bookshelves filled with books awaiting

clipping. Vissers noted that while training in subject classification, he was given books with a clear subject matter, like "water towers or dolls," but over time, he would challenge himself by taking a single subject book and trying to see how many alternative subjects could be identified. When I asked how the collection roughly maintains its size given the new clippings added each month, Glenar and Vissers were unworried. They don't frequently weed files by actively discarding items but suggested that the collection shrinks through "natural attrition." Images are stolen, damaged, misfiled, checked out, or simply might disappear. When parts of the collection are identified as valuable, they are removed from circulation (such as a set of original Works Progress Administration (WPA) photographs removed from circulation in the late 1950s and placed in a reference collection).[56] Because of the lack of item-by-item tracking, it is difficult to be sure of the rate or causes of such attrition. And due to circulation, the collection is never the same; it changes day to day. These emergent, changeable conditions, often connected with a digital paradigm, are fully operational in the analog collection.

Despite material constraints, the Picture Collection was able to scale over the decades because Javitz committed to facilitating flexibility, change, and variability, qualities that she observed in the viewer at the file who creates meaning in the moment of encounter. Digital media scholars often highlight the event-based character of electronic texts, images, and collections, as opposed to their analog antecedents. N. Katherine Hayles has described textual materiality as an "emergent property" determined by the user's interaction.[57] Johanna Drucker argues for a contemporary reconception of the text as event, in which the event "is the entire system of reader, aesthetic object and interpretation—but in that set of relations, the 'text' is constituted anew each time."[58] Lev Manovich insists, "In software culture, we no longer have 'documents,' 'works,' 'messages,' or 'recordings' in twentieth-century terms. Instead of fixed documents . . . we now interact with dynamic 'software performances.'"[59] Daniel Rubinstein and Katerina Sluis argue that "previous understandings of the photographic image as an indexical, discrete or enframed semantic unit appear increasingly inadequate when faced with the inter-network with its boundlessness, simultaneity and processuality."[60] The above arguments all draw on an initial insistence on the event-like structure of the digital database, as opposed

to traditional modes of understanding stable cultural objects stored in the archive. To be sure, the authors are making essential observations about fundamental material shifts between paper and electronic materiality. Yet the evolving, responsive nature of the Picture Collection indicates that the condition of flux and responsiveness can be as social as it is technological.

At the Picture Collection, material form of the pictures, informational infrastructure, and social interaction between user and picture are intertwined: the folders encourage transport, the alphabetical subject headings prescribe wayfinding, the tables and chairs invite a temporal and spatial engagement, and the paper-mounted prints allow for certain gestures of flipping, focusing, shuffling, and remixing. This is all to say: the physical makeup of an archive is inseparable from the social interaction between user and collection. Shifting attention to the social mirrors an argument by art historian Robin Kelsey's discussion of "archive style" in geographical surveys in the nineteenth-century United States. Kelsey argues that when producing images for an archive, the individual confronts and acts within and against institutional structure, and that meaning, language, and style are determined in the act of interaction. This interactive model reframes discourses of the archive that focus on authoritative meaning-making: "Instead of treating the archive as a repository of intuitive precursors or as a stable reserve of formal systems, we might think of it as a different economy for testing the adequacy of the picture in modern times."[61] The idea of the archive as testing ground for the picture would resonate deeply with Javitz. Even more than the government archives surveyed by Kelsey, the Picture Collection is a social space where users and librarians are constantly interacting with each other, with images, and with information structures in an ongoing dialogue about what images mean and how they communicate.

This interactive model is defined by Javitz's specific understanding of the documentary value of images, or what Ronald Day refers to as "documentarity."[62] Day has theorized the shift in the notion of "documentarity"— that is, the techniques and frameworks through which documents are understood, named, and called on to communicate—between the nineteenth and twentieth centuries, from a positivist epistemology in which documentarity is defined by the well-ordered collection of facts (with the corresponding model of the museum, library, or encyclopedia) toward an

experiential epistemology informed by fields of anthropology and ethnology. While Day's examples are centered on European and literary work of Paul Otlet and Georges Bataille, Javitz, who was steeped in American anthropology—personally and professionally engaged with Franz Boas and his embrace of the essential plasticity of culture and necessity of ethnographic research that embraced standpoint specificity—offers an American version of documentation that embraces flux and experience.[63] Javitz's living collection, oriented toward global circulation and influenced by her professional and personal connection with interlocutors, including the Boas family, depends on an experiential, embodied epistemology, in which pictures communicate in variable ways depending on the relationship between their historical context of creation and the specific individual searching them for information. Javitz's ability to realize this understanding of an experiential documentarity within the positivist space of the library required her to repeatedly articulate her understanding of the "picture as document." The next section surveys her use of this term across decades of work at the Picture Collection.

"PICTURES AS DOCUMENTS"

By describing pictures as documents, Javitz was responding to distinct yet parallel discussions around the "document" and its relation to photography that were taking shape in the early decades of the twentieth century, among photographers and museum curators, on one hand, and among librarians and archivists, on the other. While photography has been used to document people, events, and objects since its invention, in the 1920s and 1930s, photographers, publishers, and curators identified documentary photography as a specific genre through exhibitions and publications. Alternately exemplified by an aesthetic style of coolly sterile documentation by photographers like Walker Evans or by the strident social documentary of projects like Jacob Riis's *How the Other Half Lives*, and subsequently critiqued from both angles, the documentary genre continues to be interrogated.[64] The question of photography's relationship to the document shoots through the history of theorization about the medium, from its indexicality, its aesthetic value in relation to other mediums, and its authorial status. Javitz was close with many photographers, who used

the Picture Collection, donated to it, or worked at the collection through the WPA work program in the 1930s, and her discussion of pictures as documents drew from these connections while also impacting her interlocutors. In addition, the term "document" is a conceptual quandary in the growth and development of library science in the twentieth century, in which librarians on either side of the Atlantic wrestled with their work to organize the information of the modern world. With the phrase "pictures as documents," Javitz makes a two-pronged argument that challenges both the aesthetic framework for interpreting pictures and the textual framework for interpreting documents. Further, Javitz's definition of pictures as documents is profoundly social and dynamic. By looking at the tradition of library documentation, as well as theories of reproductions and the archive brought up by Walter Benjamin, Rosalind Krauss, Robin Kelsey, Mark Goble, and photographers Eugène Atget and Walker Evans, I argue Javitz's picture as a document challenges the traditional model of the archival document, reframes the politics of social documentary, and produces the model of the living collection outlined above.

In library science, documentation describes a broad range of information management techniques, including bibliography, records management, and archival practice. It is a term imported from Europe, where a late nineteenth-century and early twentieth-century documentation movement that sought to reform libraries vigorously discussed the category of the document.[65] Paul Otlet and Suzanne Briet, two leading figures who shaped this movement, significantly expanded the term "document" to apply to nontextual material, including three-dimensional objects, pictures, and audiovisual materials.[66] Briet took the more radical stance that a document need not be described by its materiality at all but that it is construed as such by its inclusion in an information network. In a memorable passage in her 1951 *Qu'est-ce que la documentation*, she included a simple definition of documents by describing three objects: "Is a star a document? Is a pebble rolled by a torrent a document? Is a living animal a document? No. But the photographs and the catalogues of stars, the stones in a museum of mineralogy, and the animals that are cataloged and shown in a zoo, are documents."[67] In this matrix, an animal in the wild is not a document, but an animal in a zoo is; a stone in a river, no, a stone in a museum, yes. Interestingly, the third example, a star in the sky (no)

or a photograph of a star (yes), implies that photography is inherently a networked informational space in the same manner as a zoo or museum, always already a structured enclosure.

In the United States, documentation as a formal category of information work was not embraced as it was in Europe until the late 1930s; rather, the discussion around library work and the organization of nonbook materials took place in the special libraries movement. A special library is a broad category, defined by the specialization of its resources, users, or services.[68] The Special Libraries Association (SLA), founded in 1909 by John Cotton Dana, includes librarians who administer business archives and scientific libraries as well as picture collections and museum slide libraries. While early members argued over the appropriateness of the term "special libraries" and were aware of the documentation movement overseas, the name Special Libraries stuck.[69] When the American Documentation Institute (ADI) was founded in 1937, they had overlapping membership with the SLA but diverged in their self-definition. As Robert V. Williams argues, ADI members strove to distance themselves from "librarianship" and reframe the practice as information management, particularly after World War II.[70] At this time, the SLA, in turn, may have retrenched and focused increasingly on industrial and scientific collections in order to claim turf from the documentalists: in 1952, Javitz's and others' work to establish the Picture Division of SLA was motivated by the perception that the SLA was neglecting the needs of the general picture file in favor of specialized scientific and business collections.[71] Thus, by using the term "pictures as documents," Javitz is, explicitly or not, taking a position in a live discussion within librarianship. Though she primarily used this term in the context of defining her approach against a purely aesthetic approach to pictures, she was aware of the larger discussion in her field. The idea of "pictures as documents" participates in this discussion by arguing that nontextual material requires the systematic organization and professional attention that texts do, that pictures are a particular kind of document, and that the library is the place where these questions must be worked out. In lectures, public-facing addresses, and internal memos, Javitz repeatedly insisted that the library must abandon book-centric thinking in favor of other media forms (as just one example, in a letter to the editor at the *New York Times* in 1953, she chided, "New York City maintains no photograph collections

open to the public that parallel the importance of library resources in terms of books. *The establishment of adequately supported public collections of the photographic record of the past is overdue.").*[72] She believed that the relative lack of attention to the cultural heritage of the history of picture-making in libraries was a crucial blind spot impeding historical understanding and creative output.

While Javitz promoted her ideas through teaching, lecturing, writing, and publishing in professional journals, much of her thinking appeared first in bureaucratic genres: the annual report, the memo, and the grant application.[73] The first mention of the notion of pictures as documents appears in the Picture Collection records in a 1935 annual report:

> Museums and art collections maintain collections of pictures selected as ends in themselves. It is only in a public library that pictures are organized as documents, not as good or bad art. Here the public come to make their own selection and find inspiration, stimulation, factual data, and opportunity for comparisons.[74]

Here, Javitz draws important conceptual lines. To begin with, by opposing the art collector's approach, which considers pictures as "ends in themselves," to the library's approach, pictures-as-documents are contrastively defined as pictures-as-means. This implies that a picture is to be valued for its role in transmission of information and, further, that its preservation as an object is immaterial. In turn, the definition of pictures and corresponding theories are shifted from an ontological plane that asks what they *are* to a pragmatic mode that seeks to understand how they *operate*. It is this emphasis on access over preservation, epistemology over ontology, which demands the collection management strategies outlined in the "Living Collection" section above. This quote also emphasizes the public's role in making selections, as opposed to the author or expert, and highlights the inherent multiplicity of meanings and desires contained within a picture by listing the various uses to which a picture can be put.

Both of these positions align Javitz with a theorist of images contemporary to her who looms large in any engagement with the materiality and politics of image reproductions. Indeed, Javitz takes the same positions at the same time as Walter Benjamin's "The Work of Art in the Age of Technological Reproducibility," which has inspired reams of critical interpretation since its first iteration was published in German

CIRCULATING COLLECTION STYLE

in 1936. In this formative, oft-cited, and sometimes misinterpreted text, "aura," an ineffable quality of authenticity and authority, is used to distinguish the original work of art (which has aura) from the reproduction (which does not). Benjamin's rumination on the decay of aura, which advances with the technological development of image reproductions, as well as the political potentialities inchoate in these shifts in production and reception, aligns with the seeds of Javitz's thinking present in the quote above. The social basis for the decay of aura can be found, Benjamin argues, in the "desire of the present-day masses to 'get closer' to things and their equally passionate concern for overcoming each thing's uniqueness by assimilating it as a reproduction."[75] This desire is driven by the increasing availability of reproductions (streaming forth from newspapers and film reels), which are defined by "transitoriness and repeatability" as opposed to the "uniqueness and permanence" of the auratic image.[76] This binary, between reproduction and auratic object, is analogous with Javitz's pictures-as-document versus pictures-as-ends. The document's value, for Javitz, is defined by its availability, ready-at-handness, and capacity to be circulated, rather than by its authorial or aesthetic value. Further, for both Benjamin and Javitz, the daily possession and disposal of these reproductions and the collective experience of cinema had trained the public into this new form of perception and thus into a new understanding of the relationship between images and production. As Javitz bluntly put it, "More people have seen more than ever before."[77] Both also locate the cinema as training ground for collective visual literacy. Javitz writes, "It is through attendance at moving picture projections, above all other factors, that our observation has become experienced and alert. . . . A mass audience shares this visual simultaneously in true democratic unity."[78] To Javitz, a public conditioned to democratic visual communication requires a collection adequate to the task, one that frees pictures from the auratic condition of being confined to a particular place and time (Benjamin's aura as "strange tissue of space and time") and makes them available for taking hold of by anyone with a library card.[79] Each reproduced image is a potential tool, and the freedom to browse and select from a collection of images and to take an image home to introduce into new configurations is necessary to realize its democratic potential.

While Benjamin identifies the democratic potential of more people laying hands on more reproductions, he elides the mechanism through which this could be accomplished. Javitz, as a public librarian, names it— picture libraries: "Once pictures could leave the sacredness of the original behind them and become duplicated, then we were ready for libraries of pictures."[80] The latter quote is key for distinguishing Javitz's contributions beyond Benjamin. For Javitz, the potential to circulate through libraries is the central criterion of the document liberated from aura. This addition is key to realizing the democratic use of pictures: cultivating public collections resistant to both commercialism and fascism. Benjamin elsewhere centers the private collector or the photographer as a primary figure to illustrate the radical potential of interpreting popular art through historical materialism, but it is in the public collection where masses can participate in this ongoing and collective appraisal.[81]

Benjamin's description of aura from "The Work of Art in the Age of Technological Reproducibility," along with the invocation of the masses' increasing desire for reproductions, also appears, in almost exactly the same language, in an earlier, relatively less-studied essay from 1931, "Little History of Photography."[82] In this piece, the famous passage on aura quoted above is sandwiched between ruminations on the photography of Eugène Atget, known for obsessively photographing the transformation of the urban landscape in Paris at the turn of the century.[83] Atget, Benjamin writes, "initiates the emancipation of object from aura," in part by "almost always passing by the 'great sights and so-called landmarks'" in favor of the everyday glimpses of Paris street life, such as brothels and store windows. The definition of aura and the difference between reproduction and original that follows are not his central argument but rather are elaborated as a clarification of Atget's nonprecious approach to photography. Atget is a model of the liberation of aura because he set his gaze on the humble and the everyday and because he sought to capture and document the city of Paris in innumerable glimpses rather than solitary masterpieces. Atget's prints are not original auratic objects, because both in content and in quantity, his corpus repels this kind of treatment. In Benjamin's later essay, "The Work of Art in the Age of Technological Reproducibility," the discussion of Atget is excised in favor of a description of the decay in aura that is coextensive with technological developments at the scale of the society

CIRCULATING COLLECTION STYLE

at large, but in this initial formulation, the artist's choice of subject matter and comprehensive production practice directly enacts a rejection of aura.

Here again, the document, aura's decay, and (implicitly) the library are linked. Atget repeatedly invoked the "document" as the measure of his photography practice, famously tacking the sign "*Documents pour artistes*" above his studio, including the phrase on his carte de visit, and disallowing his name to be printed in the caption of his photographs in the magazine *La Révolution surréaliste* because, according to Man Ray, he insisted they were merely "simple documents."[84] Atget confined his role as a photographer to providing subject matter for artists, decorators, archives, and libraries, refusing to identify as an artist in his own right. He was not successful in the latter goal, as his work, promoted posthumously by the American photographer Berenice Abbott (another friend of Javitz, who sold her an Atget print), was deeply influential to what Benjamin alludes to in 1931 as the "latest school of photography," namely, documentary photography.[85] In the 1937 catalogue *The History of Photography: From 1839 to the Present Day*, Beaumont Newhall ends his history of the medium with the genre of documentary photography and begins this section with a long discursus on Atget, concluding, "His work has no reference to any graphic medium other than photography. The example of his work inspired many younger photographers and greatly influenced the development of documentary photography."[86] This lack of referentiality outside of photography is key: it suggests that Atget initiates a new aesthetic and that documentary is the genre most original to photography as a medium.

Since this initial anointment, Atget (and documentary photography in general) has proven somewhat difficult to comfortably integrate within art history, revealing the tension between the document, the documentary, and photography as an artistic medium. Rosalind Krauss explores these issues in her 1982 article "Photography's Discursive Spaces: Landscape/View."[87] In this piece, Krauss uses the example of Atget to question the applicability of art history's discursive structures to photography. She wryly rehearses art historians' handwringing over the opacity of Atget's negative numbering system and their attempts to deduce an aesthetic argument behind it, a code that would unlock the artistic intention behind his unwieldy and inconsistent body of work. She points out that his negative numbers in fact derive from the card files of the libraries and collections

that commissioned his work.[88] Searching for "aesthetic anima," Krauss writes, these scholars instead found "a card catalogue."[89] This paradox reveals the contested positions of the understanding of the word "subject" within art history:

Subject is the fulcrum in all of this. Are the doorways and the ironwork balconies Atget's subjects, his choices, the manifest expression of him as active *subject*, thinking, willing, intending, creating? Or are they simply, (although there is nothing simple in this) *subjects*, the functions of the catalogue, to which Atget himself is *subject*? What possible price of historical clarity are we willing to pay in order to maintain the former interpretation over the latter?[90]

Ignoring the discursive space of the archive and its structuring models for organizing photography undermines our understanding of the medium and its practitioners. That organizing structure, for Atget, for the Picture Collection, and for the photographers who formed the early stock photography industry surveyed in chapter 3, is the subject index, mapped onto some form of storage. The subject index thus works together with the card catalogue or the cabinet to create an ideology of the photograph as document, foundational to the ethos of the circulating image. In the words of John Tagg, "The archival apparatus at issue here is a composite machine—a kind of computer—in which the camera, with its less than efficient chemical coding system, is hooked up to that other great nineteenth-century invention, the upright file."[91] The archive, as Tagg and Krauss warn art historians, is not an aesthetic concept but rather a constellation of practices, furniture, indexes, and documents.

Given Krauss and Tagg's emphasis on interlocking processes, I gently question why "archive" has been the preferred term of art historians probing the relationship between photography and collections. While the archive, understood by librarians as a collection of unique, historical records, emphasizes preservation and storage, the *circulating collection* points to use and users. Briet, Benjamin, Krauss, and Tagg all suggest that photography is intrinsically and historically associated with the social space of the library rather than the auratic tradition of the original art object. But by connecting these thinkers with Javitz and her *circulating* archive, I emphasize that the visual knowledge represented by the photographic medium is dynamic and emergent, rather than restrictive and authoritative. When Atget called

CIRCULATING COLLECTION STYLE

his pictures documents, he signaled their place in a network of information channels that ran from libraries and publishers *to* artists and designers, a network committed to amassing visual information about Paris. In the same way, the Picture Collection participated in a network of visual production that privileged the needs of present and future users.

Javitz's theoretical understanding of the role of the reproduction in modern life was always directly informed by the practical experience of being a public librarian. The decision to reject the Newark system of subject classification (the hierarchical system designed by John Cotton Dana and described above) was derived directly from an understanding of the public's desire to take control over their visual experience and the ways in which public culture had shaped their expectation of their ability to do so. She argued that the emergence of new forms of media changed the conditions in which the public searched for images:

Since the Newark list was first published, the great tide of picture magazines, tabloids, and moving pictures of documentary interest has changed the role of pictures in a library. Today, they are organized as documents, as fact-indicating tools, as comparative basis and as stimulating idea source. This is contrastive to the earlier idea that considered pictures primarily as art, as adjuncts to art-appreciation, or as visual educational aids.[92]

Once again, Javitz opposes pictures as documents to pictures as art and here ascribes this shift to the development of new modes of picture transmission, including documentary films and "picture magazines." For a Picture Collection librarian, invoking these new forms of image consumption implies not just new conceptions of the picture but also new sources—magazines such as *Life* magazine (whose first pictorial issue was published in 1936) and film stills populated the collection with new material. Javitz added to this account of the Picture Collection in her 1939 Annual Report:

Beginning with the decade of the Thirties, the candid camera and picture magazines such as *Life* and *Look* came into being with a trail of encouragement in the use of pictures throughout all phases of living. There was an extension of the fields in which picture information was necessary. Federal Art and Theatre projects brought an increased familiarity with our cultural heritage to a general public, followed by interest in pictorial document in Arts, History, and Science. . . . In 1929, the pictures stock was 222,828, at the end of 1939 it reached 937,816. In 1929, the circulation was 174,510, in 1939 the circulation was 854,551.[93]

In the decade of the 1930s, increasingly image-saturated media both trained the public in the "use of pictures" and supplied the Picture Collection with new stock and an influx of labor through the WPA, as out-of-work artists joined the Picture Collection to assist with mounting and cataloguing pictures.

Javitz depicts the increased visual literacy and recognition of the uses of pictures-as-documents as a cresting wave, which the Picture Collection could direct as a tidal undercurrent and on which it could be lifted to a national level of visibility. In 1940, Javitz's account of this sea change led to a grant from the Carnegie Foundation to produce a manual for the classification of pictures. The grant, paid out over three years, allowed her time to devote research into the history and various models of picture collections, as well as resources to analyze and consolidate the Picture Collection's own approach into a publishable list of subject categories. Javitz's interim reports over the next three years indicated that she planned to produce two manuals, one a theory of classification of images that would include "pictures as documents; their uses; theory of classification; basis of terminology; pictorial and established aspects of subject indexing; adaptation for general use; adaptation for special use," and the other a practical guide to the subject index and the physical care of pictures, along with a bibliographic appendix.[94] These manuals would be a boon to the growing network of picture collections and would ease Javitz from the constant stream of requests from other institutions asking for a nonexistent copy of her subject heading list for use in their own picture collections. But most importantly to her, they would address the "scarcity of literature on the subject of the printed picture as social document and educational tool," an underexplored history that Javitz felt was necessary to "precede any formulation of a theory of organization for printed pictures."[95]

While neither manual was completed, a draft manuscript titled "Organization of Still Pictures as Documents" captures her philosophical approach to images, in which a newly inundated public is primed to make use of visual research, in which pictures do real work in the production of knowledge. She begins by once again dramatizing the changes wrought by the reproducibility of the camera image:

The great stream of pictures issuing from the camera focused on the life of the individual and on the life of the masses, leveled at the chorus legs in a burlesque

show, leveled at the body strewn scene of a murder, leveled at the faces of people driven from home by fire, driven from country by war, impinges upon the eyes and mind, the thinking and the memory of all people. The power of cheap and inexpensive printing in monstrous quantity of duplication makes each pictured image influence millions of people with each printing.[96]

The cinematic urgency of her imagery is purposeful—Javitz focuses on how photographic capture can shift scales and bend time, bringing disaster close at hand, all accessible to the viewer at a "monstrous quantity." To Javitz, this dynamic stream had in turn led to the public's "restlessness for visualization."[97] Further, pictures are not merely aesthetic, and any picture contains within it the potential for documentary use: "All types of pictures influence our lives; the drawing that illustrates a joke in a magazine of humor and a drawing that sells corsets, both document the customs of our day. The civilization of the ancients can be visualized through a study of pictures of their clothes and of their gods."[98] In other words, the documentary potential of an image exists outside authorial intent or aesthetic evaluation; cartoons, fashion advertisements, and mythology are not frivolous foils to the more serious historical documentation of leaders, wars, and landscapes. She further elaborates on this innate potentiality in an address to an audience of librarians around the same time, arguing,

These pictures are not art, they are not pictures on exhibition, they are pictures at work. They are documents, momentarily cut off from their aesthetic functions to be employed for their subject content. Any picture is a document when it is being used as a source of information instead of being searched for its content of beauty.[99]

The association of the words "work," "employment," "information," and "document" against "art," "exhibition," and "beauty" reproduces the constellation of concepts, which would have been familiar to any audience, around New Deal investments in documenting the American experience, a project in which Javitz was also active. Her idea of "pictures at work" is a potent rejoinder to simultaneous efforts at the Museum of Modern Art to define the aesthetic value of these same pictures.

Walker Evans is a key figure to illustrate the simultaneous shaping of the genre of documentary photography by government investment in national documentation and MoMA's active role in articulating documentary photography as aesthetic genre. The first exhibition of

photography at the Museum of Modern Art, in 1933, was Evans's series of American Romantic Revival homes, commissioned by Lincoln Kirstein, who described the work in a MoMA bulletin at the time as "perfect documents."[100] In 1935, Evans took a commission from the US Department of the Interior and soon became an information specialist with the Resettlement (later Farm Security) Administration. Like Atget, Evans's style emerged through working against and within the structural requirements of the documentary archive, demonstrating how the museum and the government archive worked in tandem to define what a documentary photographer did and what these photographs looked like. This relates to Robin Kelsey's argument that nineteenth-century photographers whose work seemed to anticipate modernist aesthetics ("archive style") were working in a dynamic and socially situated dialogue with the archival regime and that the proto-modernist aesthetic that resulted was a product of this exchange, rather than purely aesthetic or medium-oriented experimentation. [101] In Evans's own words, reflecting on his career in an interview with Paul Cummings for the Archives of American Art, he admits that his style developed over the course of commissioned documentary projects for Kirstein and for the US government but insists that this was "an accident."[102] Further, Evans observes that documentary style came to be recognized as such by the art world not through any particular aesthetic development but through the recognition that came with his 1938 MoMA exhibition. The "document" is transformed into "documentary style" not through the camera or photographer but through the discursive space of the museum.[103]

While I previously argued that Javitz took inspiration from the attitude of the Atgetian documentarian who seeks to record everyday details rather than historic sites, it is important to note here that the influence between photographer and collection flowed both ways. Evans was a regular visitor to the Picture Collection, and Javitz was an early collector of his work. In her biography of Evans, Belinda Rathbone suggests the photographer's growing interest in anonymous images was fostered by visits to the Picture Collection, which was in turn essential to the development of his style: "For him, things that were cast off, washed up, were there to be rescued by the sensitive eye. They contained clues to the transparent simplicity he was trying to achieve in his photography."[104] This

CIRCULATING COLLECTION STYLE

common commitment to the power of the sensitive eye likely formed a basis for the relationship between Evans and Javitz, which in turn reveals that the development of documentary photography and the pictures-as-document approach of the Picture Collection were mutually informative of each other. They also shared a sense of humor. When Evans was commissioned to photograph the NYPL for a feature article in *Vogue* on the occasion of NYPL's 100th anniversary, he included a full-page selection from the Picture Collection's folder of "Rear Views," which playfully collected images of figures shot from behind (figure 1.7).

The pictures selected by Evans capture the Picture Collection's multimedia, subject-oriented, nonaesthetic approach to pictures. The *Vogue* spread includes a 1937 Thomas Hart Benton lithograph *Goin' Home*, a panel from the nineteenth-century satire of an aesthete in search of the picturesque ("Dr. Syntax"), and a 1920s commercial photograph of a baby in a washtub by the stock photography pioneer H. Armstrong Roberts (the subject of chapter 3), all united by the subject of "Rear Views." By suggesting that Evans's style emerges in part from a promiscuous approach to the collection of imagery, we have another example of "archive style," in which the photographer is conditioned by the structures of the archive, but one that is more social and populist than the models of government and library archives discussed by Kelsey or Krauss. This suggests, once again, the misnomer of "archive." While more of a mouthful, "circulating collection style" might be more apt.

At the same time that Evans's work was evaluated on aesthetic grounds by the museum apparatus, his work was also explicitly put to use in the service of the construction of national identity through New Deal arts programming. These efforts marked one front of America's search for a "usable past," a period in which historians, cultural critics, artists, and librarians wrestled to create a shared understanding of the American past in order to progress, which Alfred Kazin defined as the "drive toward national inventory [that] began by reporting on the ravages of the depression and ended by reporting on the national inheritance."[105] This pivot between, on the one hand, documentary photography as an aesthetic and, on the other, documentary photographs as vehicles of political rhetoric and national history is traced by Mark Goble in relation to national archival and propaganda projects. Goble defines 1930s

1.7 Page 96 of *Vogue* 114, no. 2, August 1, 1949, showing a Walker Evans selection from the Picture Collection's "Rear Views" folder, accompanying a feature article on the New York Public Library.
Vogue, © Condé Nast.

American modernism by "its many attempts to translate such formal-ist projects into fully operational, historical aesthetics," pointing to the exchange between the clinical aesthetic of documentary photography and the desire to document, and thus produce, a national culture and common history.[106] Goble highlights the photographs generated by the Farm Security Administration (1935–1944) and the illustrations produced by WPA artists for the American Index of Design (1935–1942) as exem-plary programs—both of which Javitz helped to shape.

From 1934 to 1941, the Picture Collection had an average of thirty-five WPA (initially CWA) workers assisting with clipping, mounting, cata-loguing, rehousing, and reclassifying pictures. WPA workers created card indexes, built custom shelving, and researched subjects from Russian history to fascism to laboratories to dry-cleaning, deepening the subject files that the public demand indicated a need for, and organizing sub-categories for subjects like flowers and plants.[107] Through associations with these WPA workers, administrators, and friendships with artists like Evans and Dorothea Lange, Javitz also cultivated a relationship with Roy Stryker, head of the Farm Security Administration (FSA) photography project. Javitz recalled that during his repeated visits to the Picture Col-lection to discuss questions of indexing and organization, she would "gripe about certain things I could never find pictures of, such as ice cream cones and other Americana, privies and so on."[108] In 1936, at the advice of artist Ben Shahn and as a safeguard against the inevitable weeding of the images by government archivists, Stryker began surrep-titiously sending Javitz prints for inclusion in the Picture Collection. "As you notice, no mark of identification has been put on them, and we prefer that no source be given," Stryker warned, seemingly seeking to avoid detection.[109] He later suggested to Javitz that he was working to evade "some senators" whose eagerness to impound the duplicate or rejected prints had been reason for the initial secrecy.[110] For him, pre-serving as much of the photographic output from the project as pos-sible was more important than the provenance and authority of the government archive. Moreover, Javitz recounted that many of the prints Stryker sent included subjects that she had initially mentioned to him as a Picture Collection need: "I would complain, and very shortly I would

get a picture of that."[111] All in all, Stryker sent 41,000 prints to Javitz, which circulated to library patrons through the Picture Collection until they were moved into the reference collection in the late 1950s. It was only in 2005 that librarians discovered there were thousands of prints in the NYPL's collection that were not in the Library of Congress's FSA collection, dividing the overall FSA archive between Washington and New York and entrenching Javitz in its historical trajectory.[112] Stryker's actions sending prints to Javitz belie the ruthlessness suggested by his editing practices elsewhere, in which he discarded sheet film or punched holes through negatives of photographs that were not selected for the FSA archive to prevent future prints, leaving punctured voids in the place of faces, animals, or homes (figure 1.8).[113] While Stryker was criticized as an autocrat by many of the FSA photographers (Ben Shahn referred to him as a vandal, Walker Evans as an obstructer), his apparent desire to preserve collections of the rejected photographs outside of the government archive and his responsiveness to Javitz's editorial suggestions

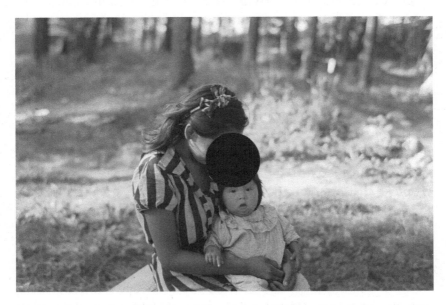

1.8 Untitled photograph by Russell Lee, showing hole punch to indicate negative should not be printed. Farm Security Administration—Office of War Information Photograph Collection (Library of Congress).

CIRCULATING COLLECTION STYLE

suggest he imagined a more expansive role for the archive than the government was able to facilitate, and he turned to Javitz to help him fulfill this possibility.[114]

Javitz and Stryker's correspondence indicates the complexities of the search for a usable past, a search undertaken explicitly to cultivate national unity, which was nonetheless conceived and implemented by individuals with distinct agendas. Using snippets of correspondence between Javitz and Stryker, as well as Javitz and Alfonso Schomburg, photography historian Mary Panzer has speculated about how Javitz's complaints to Stryker might have manifested in more than just additional photographs of ice cream cones.[115] During the period of Stryker's correspondence with Javitz, she was also working to assist Alfonso Schomburg as he developed what is now the Schomburg Center for Research in Black Culture. In one letter, Javitz directly pressures Stryker to share FSA prints capturing Black American life with Schomburg, noting, "I need not reiterate their importance to us and to our public both from the point of view of document and of interest."[116] Panzer thus suggests that Javitz's conversations with Stryker might have had a direct impact on his sense of the specific pictorial needs to shore up national representation, including the necessity to build out Black American representation.

In addition to building out her own photographic files and assisting Schomburg, Javitz also advocated for new tools for use by the artists and designers whose needs she was in direct dialogue with. Goble uses the American Index of Design, a visual archive of 18,000 watercolor renderings produced by WPA artists of American decorative arts objects from the colonial period through the nineteenth century, as a key example of an "extreme version of formalism, one in which historical artifacts are isolated and decontextualized, turned into icons of 'American Design.'"[117] While Goble does not include Javitz in his history of the project, she was the source of the original proposal, as acknowledged by Holger Cahill, director of the Federal Art Project—Javitz proposed the index directly to Cahill after struggling with a lack of pictorial representation of American design at the Picture Collection, proposing the project specifically as a resource for artists and designers.[118] The suggestion to employ artists to create watercolor images of historical design objects rather than document the object

through photography captures Javitz's belief in the documentary value of *pictures*, not just photography, in constructing a visual encyclopedia of American design.

The point of reviewing Javitz's role in these paradigmatic examples of the national programs in the 1930s is that in each case, her role complicates the top-down narrative of New Deal government programs and demonstrates the broader web of actors in which each program was involved. Goble critiques the American Index, arguing that the use of the humanistic medium of watercolor in the mechanical format of the American Index was paradoxical and that the insurmountable gap between the impersonal archive and the intimate hand-painting ensured the project's failure.[119] This perceived incompatibility, however, is reconciled in Javitz's idea that the documentary is in the eye of the beholder, not in a particular technology. For this reason, she had a fundamentally different view of how the documentary is cultivated—not through the particular technology of photography (though that technology could make pictures more accessible) but through a commitment to the communicative possibilities of the document. Her perspective on the use of pictures in the Picture Collection informed the perceived use of the index. These pictures were not just bound for the airless space of the archive but were to be put to work by future designers. The gestural watercolors were not antithetical to a cool "archive style" but a representation of "circulating collection style." Further, the idea that the Library of Congress had tightly enclosed the FSA images into a highly controlled time capsule in the archives of history is challenged by the furtive dealings of Stryker and Javitz, which allowed the original prints to circulate freely to the public for decades, at the Picture Collection and the Schomburg Division. If these two projects are used to define the relationship of documents, documentary, and the archive at this time, then revealing Javitz's role in them opens up the definition of the term to allow for contingency, openness, and variability, and most importantly, circulation and movement. The critiques that have been leveled at the rhetoric of social documentary since the 1930s, centering on its ultimate lack of political efficacy and its exploitative methods, can be productively and gently confronted by this alternative history.

CIRCULATING COLLECTION STYLE

Because of its open-ended and user-centered organization, the Picture Collection offers a model of social documentary birthed in the 1930s that is less assimilable to either the rationalizing gaze of the state or moralistic appeals to elite classes at the expense of the exploited.[120] Martha Rosler has incisively critiqued the genre of documentary photography from the latter perspective, arguing that "documentary, as we know it carries (old) information about a group of powerless people to another group addressed as socially powerful."[121] For Rosler, the split temporality of documentary in which the "instrumental" moment gives way to the "aesthetic-historical" moment forecloses its initial radical premise.[122] Jonathan Kahana has indirectly challenged this critique, arguing that it is precisely this dual temporal nature that allows for the "allegorical displacement" that constitutes the "power of social documentary."[123] Kahana highlights the important boundary work that social documentary performs, bridging official, national narratives and publicly produced, vernacular ones. Late curator and writer Okwui Enwezor seeks to redeem the documentary by incorporating Roland Barthes's concept of the scriptable, arguing that documentary "turns the reader into a kind of writer, that is it makes the reader wish to carry further the act of writing, encouraging the imitation of the act of writing."[124] The account of the Picture Collection reframes the concept of documentary in a slightly different way, though in the spirit of Enwezor. With the Picture Collection, I propose a genealogy of documentary that incorporates the idea of pictures-as-documents put to varied use by a broad public and sees these documents as being predicated upon a collection that is always at play in circulation. This sense of the documentary encourages a mode of engagement with images that is interactive and generative rather than didactic. The idea that viewers make meaning, to borrow a phrase from Marita Sturken and Lisa Cartwright's *Practices of Looking*, is a key intervention of visual culture studies.[125] This invitation to create meaning is communicated by the environment of encounter, which can be an advertisement, a library reading room, or a social media app. The Picture Collection presents pictures as living documents and subject terms as actors in a living collection, a potent record of the life of images as they proliferate and cross-mediate, in a manner similar to W. J. T. Mitchell's anthropological description of the lives of pictures, in

which pictures are "quasi life-forms (like viruses) that depend on a host organism (ourselves), and cannot reproduce themselves without human participation."[126] Indeed, in the epitaph that opened the chapter, Javitz approvingly quotes from a journalist who describes the collection as "germs of limitless ideas" organized in order to penetrate the population at large.

For Javitz, "pictures as documents" defines images as meaning-generating objects whose informational value is latent, activated in the moment of interpretation, and she viewed the library as a living collection actively produced by social encounters. These ideas, as Javitz knew well, are mutually constitutive. That is, Javitz's understanding of the picture demanded a particular system of organization: her belief in the flattening of hierarchical value and media distinctions necessitated topical, flexible cataloguing; her democratic conception of the nonexpert user called for open-stack browsing; and her desire for comprehensiveness required collecting in quantity and welcoming duplication. In broader terms, the picture as document *requires* the living collection and vice versa. The document does not function outside of the circulatory mode, nor does the archive function without the circulating document. Javitz's ontological definition of photography flows from this relationship: the photograph *is* a living document in a living archive.

CONCLUSION: CIRCULATING COLLECTION STYLE

Rather than exploring how artists interrogate the archive by reading against the grain (as has been done by Hal Foster and Okwui Enwezor, among others), I will conclude by considering how artists have worked along the grain of what I term "circulating collection style."[127] Over its history, artists have consistently used the Picture Collection as a tool but also responded intuitively to Javitz's vision of visual communication and research. In addition to photographers like Evans, Leyda, and Lange, Javitz formed other strong relationships with artists over her four decades at the Picture Collection. Dorothea Lange once said that it was the only place where she could see the inside of her head.[128] According to Javitz, Diego Rivera told her that "the form of his conceptions was often fixed by the accident of material available in [the Picture Collection's] files." Another

CIRCULATING COLLECTION STYLE

longtime user was Joseph Cornell, an artist and a filmmaker most well known for his constructed boxes, which feature collages and assemblages out of disparate bits of ephemera he collected. To gather materials, Cornell would ambulate the city's antique stores and museums for inspiration, and the Picture Collection was a favored location. Over decades, he and Javitz exchanged letters and artwork that communicated a shared sensibility: among his papers at the Archives of American Art is an envelope with pressed flowers, leaves, and a single feather, signed RJ on Picture Collection stationery. Letters Cornell wrote to what he once addressed as the "Needle-in-the-Haystack Dept." include esoteric requests for specific 1920s movie stills, nineteenth-century mailboats in Maine, and "unusual" portraits of Edgar Allen Poe, along with references to small gifts he left for Javitz. In one letter, he praised her library display of pictures of toys: "So often a thing like that is good only in one or two ways and you supply yourself for the intense love of the parts what is lacking in the whole. But I found everything about the display board delightful and going beyond intriguing possibilities of correspondences and relationships that satisfy after the visual surprise is ov[er]."[129] Attentive to the poetic interplay between mundane objects, Cornell recognized in Javitz another sensitive eye, and their relationship was cultivated through expressions of a common sensibility. Scholarship on Cornell often centers on his work's refusal to resolve into a coherent meaning—some have interpreted this ambiguity through the frame of Surrealism and the poetics of association, others through the model of the Wunderkammer, suggesting that Cornell is appropriating the display structure of the museum.[130] Instead, I would argue that the picture library, which deliberately subverts and effaces distinctions between high and low imagery, is a more apt model. Rather than sealed-off, museal objects that relate only to one another within the constructed box, these works communicate the public exchange of objects, representative of the social life of the city. Rather than asserting rarity or preciousness, the objects in Cornell's boxes were taken hold of and shared.

Another artist-user of the collection, Andy Warhol, is well known for illustrating the slipperiness of meaning-making in the face of contemporary image flows between commercial, artistic, and documentary registers. Warhol began his career in illustration, and like any illustrator who worked in

New York City throughout the twentieth century, he likely depended on Picture Collection resources as a part of his daily work. He continued to use the collection for the avant-garde work that followed, though he was not a model user. He reportedly advised a friend about opportunities to raid the collection for the cost of a late fee, suggesting, "Oh you just go to the library and take out as much as you want, and you just say you lost them, or they were burned. And you only have to pay two cents a picture."[131] He developed a romantic friendship with Carlton Alfred Willers, a clerk at the Picture Collection, who recalled that Warhol incurred hundreds of dollars in fines.[132] Multiple Picture Collection clippings were discovered in a series of time capsules of studio detritus discovered after his death, which capture source imagery for some of his most famous works.[133] One example is a Coca-Cola advertisement purloined from the Advertising folder (the NYPL Picture stamp and penciled subject category on the original mount are still visible) (figure 1.9). Warhol kept the page and original mounting intact but taped two cutouts of Campbell's soup can on the verso, transforming a piece of the Picture Collection into an iconographical skeleton key into his work at the time, or perhaps an artwork in itself. Warhol was a consummate observer of image circulation and proliferation in the twentieth century who recognized that images gain power through their reproduction and explored every way to transform an image while leaving its essential visual features intact—through time, through medium, through scale and coloration. In this way, his work, too, alludes to or at least dovetails with the life of images as captured at the Picture Collection. At the Picture Collection, images are "put to work," as Javitz would say, made available for work by a structure that recognizes that their meaning awaits. Subject classification is a means to an end; the meaning itself is produced in every individual encounter.

The Picture Collection has continued to inspire and supply artists since Javitz passed away in 1968. For many, it continues to be a vital tool for their professional practice, as images inspire new fashion designs or serve as reference for historically accurate set pieces.[134] For others, it's the place they can "see inside their head" (in the words of Lange) or grasp at something about the nature of image-making in the twenty-first century. Eric Timothy Carlson, a Brooklyn-based artist and designer, works with found

CIRCULATING COLLECTION STYLE 71

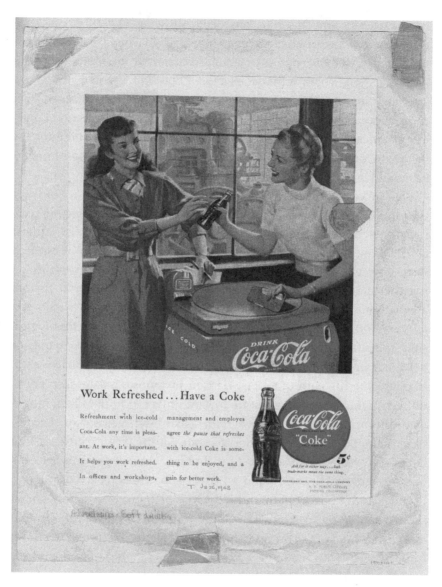

1.9 Andy Warhol, Collage (Campbell's Soup/Coca-Cola) [verso], ca. 1961–1962. The Andy Warhol Museum, Pittsburgh; Founding Collection, Contribution The Andy Warhol Foundation for the Visual Arts, Inc. 1998.3.8565. © 2023 The Andy Warhol Foundation for the Visual Arts, Inc./Licensed by Artists Rights Society (ARS), New York.

images to create artworks in various media. His series *NYPLPC* (2013–2016) is the result of a years-long engagement with the Picture Collection. Carlson was first introduced to the Picture Collection by another artist friend in 2012 (among young artists, the Picture Collection is passed around like a secret). Carlson had previously worked with found images scoured from the internet, but the scale and physicality of the Picture Collection immediately impressed him, and he embarked on a multiyear project mining the collection for images in a project that eventually took on multiple forms of prints and limited-edition books.[135]

For one year, Carlson returned to the Picture Collection once or twice a month, spending three or four hours at a time, carefully selecting sixty images to check out and scan at home, the maximum allowed. Almost all of the eleven hundred images he gathered after the year of research were scanned and used in *NYPLETC01–04*, an artist book that draws together a sequence of disparate images to explore universal themes about human mark-making. From the opening passage in which aerial views of nature give way to aerial views of villages, archaeological sites, tilled farmlands, and then geoglyphs, to the concluding sequence depicting images of religious ecstasy and ending with an image seemingly tracing the path of a UFO, Carlson juxtaposes images to produce unlikely connections and gesture toward universal human activities of confronting nature (pulling from folders like "Archaeology" or "Excavations") and processing it in order to create culture ("Fur," "Textiles,") or language ("Protests," "Mascots") and, in turn, nature's response ("Flooding," "Mold") (figures 1.10 and 1.11). Overall, the book is a distillation of the Picture Collection on multiple levels: without words, it illustrates the human desire to create a meaning through visual communication and to take hold of the resulting creations. It also is a record of the hours Carlson spent with the folders, spread out on a table amid other visual searchers, carefully sorting through folders, counting out the sixty he would take home for that session.

Another artist preoccupied with the human urge to collect and label images also developed a lengthy engagement with the Picture Collection over the same period as my own research. Taryn Simon had been visiting the Picture Collection since she was a child, and in 2012, she began

1.10 Pages 222–223 from Eric Timothy Carlson, *NYPLPCETC 01–04* (First Edition), 2016. Laser-artist's book, edition of 25. The spread shows an installation photograph of Efrat Natan, *Roof Work*, 1979 (installation photo by Judith Itach) from the folder "Photographs," and a c. 2005 photo from the folder "Janitors."

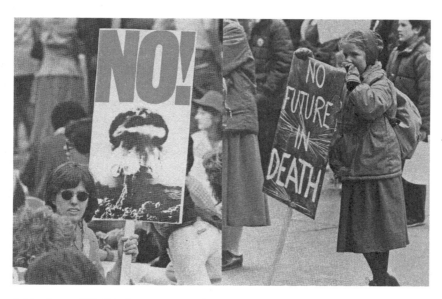

1.11 Pages 250–251 from Eric Timothy Carlson, *NYPLPCETC 01–04* [First Edition], 2016. This spread shows a c.1985 photo from the "Anti-War Movements" folders and a photo from the folder "Demonstrations–US–1990s."

a series of large-scale photographs with the intent to capture its strange flux. Selecting folders like "Chiaroscuro," "Accidents," and "Abandoned Buildings," she rephotographed selections arrayed on a white background and titled the works simply by their folder title. Some resulting images reveal the striking juxtapositions within folders (like the range between slapstick and morbid in the Accidents or Broken Objects folders), and others coyly hold back pictorial content as the stacks of pictures reveal only edges and borders, suggestive of communicative glitches (figures 1.12 and 1.13). The series initially seemed to refer to the theoretical issues brought up by the collection: gaps between word and image and the excess of meaning that the range of images captured under a single heading presents in the face of that label. Simon has previously worked with other examples of taxonomies and classification, exploring what escapes ordering systems and what dangers labels can incur in projects like the

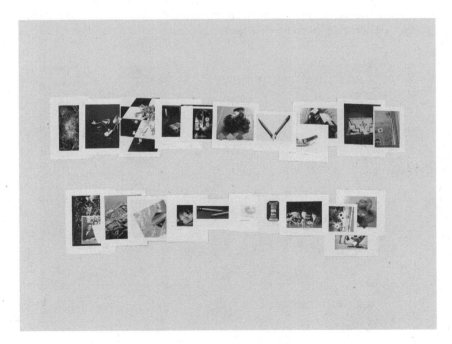

1.12 Taryn Simon. *Folder: Broken Objects*, 2012 archival inkjet print, 47 × 62 inches, (119.4 × 157.5 cm) edition of 5 + 2 APs.
© Taryn Simon. Courtesy Gagosian.

1.13 Taryn Simon. *Folder: Night scenes*, 2012 archival inkjet print, 47×62 inches, (119.4×157.5 cm) edition of 5+2 APs.
© Taryn Simon. Courtesy Gagosian.

Innocents (2002, which documents wrongful convictions in the United States), *An American Index of the Hidden and Unfamiliar* (2007, which captures inaccessible objects or sites like the CIA art collection and a bear in hibernation), or *Image Atlas* (2012, with Aaron Swarz, which captures the difference in Google image results for specific search terms depending on global location). Simon's Picture Collection series was initially interpreted in light of this past work critiquing archives, or the limits of archival documentation. In an essay written in 2015 but included in Simon's 2021 catalogue *The Color of Flea's Eye: The Picture Collection*, art historian Tim Griffin argues that the series reveals the inconsistencies at the heart of the Picture Collection's classification system, suggesting they unintentionally prefigure a postmodern instability of meaning.[136] He contrasts this instability with the universalizing goals outlined by Javitz, alluding to dissonance between the two. Yet the irony of this

tension is that for Javitz, it didn't exist: fluidity and transience were not in opposition to the universal aims of a comprehensive visual catalogue but in fact the conditions of its possibility.

As Simon continued to explore the Picture Collection, she began to dig into the Picture Collection records in the NYPL's Manuscript and Archives Division, and increasingly, Javitz herself became a primary subject in Simon's presentation of the series. The work culminated in 2021–2022 installation in the Edna Barnes Salomon room at the NYPL Schwartzman building, just upstairs from where the Picture Collection was originally founded. Simon's prints ringed the walls, presenting a sharp contrast to the setting of the Beaux-Arts–style room, originally designed by Carrere & Hastings as a nineteenth-century picture gallery and hung with nineteenth-century portraits of previous library benefactors from the Astor and Lenox families. Here, Simon's *Untitled (Men)*, with pictures of unidentified men (in suits, undershirts, leather jackets, underwear, kilts, or nothing at all; eating, reclining, smoking, gazing) clipped from ephemeral publications over decades, seemed to confront the oil portraits, like an interjection from an alternative visual regime (figure 1.14). The center

1.14 Installation view, TARYN SIMON // *The Color of a Flea's Eye*: The Picture Collection, Salomon Room, Stephen A. Schwarzman Building, NYPL.
© Taryn Simon. Courtesy Gagosian.

of the room housed vitrines with reams of correspondence between Javitz and artists; photographs by artists like Gordon Parks, Evans, and Lange that once circulated through the collection; and annual reports like the ones I've been quoting throughout this chapter. When I toured the installation, tourists, researchers, and school groups milled the room, engrossed in the correspondence preserved in the vitrines, backs turned to the oil portraits. The friction between Javitz's democratic vision and the formal nature of the Gilded Age room was a fitting representation to the challenge Javitz spent her life posing: creating spaces for a circulating collection style that could feed the public's increasing hunger for images they could take hold of, spaces that it was a library's rightful role to embrace. While the exhibition was temporary, Simon gifted *Untitled (sunshine)* to the Picture Collection, where it hangs in the collection's new home in Room 119 (figure 1.15).

In December 1954, Warhol sent a hand-painted watercolor holiday card for Javitz (figure 1.16). Knowing that she was Jewish, he wrote

1.15 Taryn Simon. *Folder: Sunlight*, 2012, installed in Room 119, Stephen A. Schwarzman Building, New York Public Library. Photo by author, 2022.

1.16 Greeting card designed and signed by Andy Warhol, 1954. Original item held in The Picture Collection, New York Public Library. Photo by author.
© 2023 The Andy Warhol Foundation for the Visual Arts, Inc./Licensed by Artists Rights Society (ARS), New York.

simply "Happy December R.J." and included an image of children playing a circle game by holding hands and twisting around each other. Perhaps this was an inside joke or a simple expression of joy, but I like to see this image as a representation of the structure that Javitz intended for the Picture Collection, a structure that can bend, twist, and turn, a structure at play. A structure that creates a community to support the curiosity of a child with scissors and a scrapbook.

2

THE MUSEUM WITHOUT WALLS: THE MUSEUM OF MODERN ART AND PHOTOGRAPHY'S DOUBLE DUTY

The field of modern art is not a pluralistic field but a field strictly structured according to the logic of contradiction.
—Boris Groys, *Art Power* (Cambridge, MA: MIT Press, 2008), 2

In 1997, the international group Archives & Museum Informatics founded the Museums and the Web Conference to promote the exchange of information about burgeoning opportunities online. At that point, as the organizers announced, "in the three years since the appearance of the first museum web sites, hundreds of museums have established a presence on the World Wide Web."[1] Since then, with the number of museum websites now in the ten thousands, the Museums and the Web Conference proceedings, archives, and community forums have become an essential resource for museum and library workers, technologists, and researchers. Like many tech-oriented gatherings, the copy surrounding the yearly conference, from thematics to specific panels, often centers on "the new": new digital tools or applications, new modes of interactivity. Throughout this rhetoric of the new, one old metaphor persists. As a 2013 conference paper states, "In this sense, we could consider the global museum 'without walls,' as it has been conceived by André Malraux, as the first example ante litteram of virtual museum."[2]

With *Le musée imaginaire* (1947), André Malraux introduced a prescient metaphor for the contemporary interactive world of images enabled by digital technologies. For Malraux, photographic reproductions of art objects, divorced from their material realization, can enter a dynamic, modular space, an "imaginary museum," or "museum without walls" that allows for contemplative distance and pedagogical opportunity. It is this metaphor that is often invoked when discussing the wider geographic reach and reinvigorated mission statements inspired by the potential of the museum website. The virtual museum allows for new audiences, new architectures, and new kinds of spaces. Yet the implied irony of drawing on an old metaphor to describe a new condition masks the truth behind its applicability: the photographic reproduction has always been the dominant mode for extending the museum's mission and allowing for reach beyond its walls. Museums are not newly confronted with the world beyond their physical plant by engaging with the web; most have always sought a broader reach and have always used the photographic reproduction as a tool to this end. Few museums have done this with a clearer and bolder mission than the Museum of Modern Art, New York (MoMA), utilizing the photographic reproduction to various ends while at the same time promoting photography as a fine art and developing a discursive framework to assimilate it into the canon of modern art.[3] This chapter will explore the tangled relationship between photography, education, circulation, consumption, and value by looking at the institutional history of MoMA and the work of circulating reproductions as practiced in multiple departments across the museum.

In the epigraph that opens this chapter, Boris Groys insists that the museum is built on the logic of contradiction—between old and new, sanctified and profane, and most significantly between the space of the museum and the everyday beyond its walls.[4] This aura around the charged architecture of the museum is echoed by other literature, from sociologist Tony Bennett, who defines the museum as a site for spectacle and public display of authority, to historian James Clifford, who identifies the museum as a distinct zone to host the exchanges and clashes of culture.[5] Even critiques of the authority of this boundary recognize the power of its architecture, as in Douglas Crimp's *On the Museum's Ruins*, which argues that art's value is constructed through seclusion in enclosed museal spaces.[6] But

THE MUSEUM WITHOUT WALLS

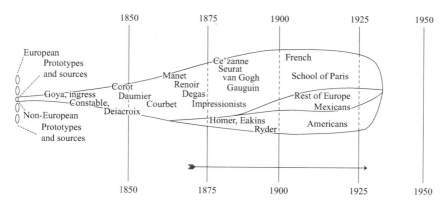

2.1 "Torpedo" Diagram of Ideal Permanent Collection. Alfred H. Barr Jr. Papers, 9a.7A. The Museum of Modern Art Archives, New York. 1933.
Digital Image © The Museum of Modern Art/Licensed by SCALA/Art Resource, NY.

the history of MoMA shows that no matter the architecture, from panes of glass to solid marble, the division between the museum and the everyday is continually permeated by the movement of reproductions. The circulation of images was a founding condition of MoMA and key to its central role within US and international culture. From the outset, the museum conceived of itself as a circulatory system, rather than a storage hull: founding director Alfred Barr famously envisioned a torpedo model for the collection, where older works from the collection would be shed and transferred to the Metropolitan Museum of Art, as the museum barreled ahead into the future, acquiring only those works that represented the contemporary spirit (figure 2.1). At the same time, the museum immediately began circulating photographs, models, and reproductions in order to educate the American public about the value of modern art and design.

Previous studies of MoMA include histories of installation design,[7] feminist critiques of the collection,[8] in-depth looks at specific exhibitions,[9] studies of particular curatorial departments,[10] and biographical or historical surveys.[11] In contrast, this chapter will explore the function of circulation and the art reproduction in the practical and conceptual ecology of the Museum of Modern Art. While not an exhaustive accounting of the uses of the reproduction in the history of the museum (which are countless), this analysis will weave through departments and decades, highlighting those moments when definitional boundaries of photographs and reproductions

were drawn or elided. The disparate uses of the reproduction reveal its multiplicity; it is almost always instrumentalized but not in a homogeneous way. The reproduction consolidates art history by performing as illustration to textual narratives, promotes the museum's authority by performing as a didactic tool, maintains order in the museum's records by performing as a stand-in for the artwork, and produces value by performing as a collectible object, sometimes but not always at the same time.[12] This interpretation of the reproduction necessarily interrogates theories of photography that divide the medium into its documentary and aesthetic functions: the reproduction is both document and art surrogate at once.

This chapter will touch on a variety of activities and departments at the museum across its history to explore this argument. Though this narrative will dwell at times on the intellectual force of a handful of figures familiar to other histories of MoMA (Alfred Barr, Beaumont Newhall, and John Szarkowski, for example), I will situate these thinkers within the media and labor context of their time to demonstrate the influence of the media environment on theory. Throughout, this history will challenge the rhetoric of the new in discourse of museums on the web and theories of the museum that depend on strictly policed boundaries, exploring the various ways that the ontology of the virtual image was conceived and enacted, as well as how the virtual image in turn consolidated the authority of the museum.

Through this history, I will explore what I call *iterative ontologization*, a process by which the same object is defined according to incommensurable ontological rules in different iterations. I am taking this term in part from Annemarie Mol's work on "multiple ontologies" and in part from a concept in computer science known as "iterative ontology learning."[13] For Mol, the concept of multiple ontologies describes the manner in which the same phenomenon or concept is enacted differently in different contexts and how the apparent unity of that concept is an enactment in itself. In computer science, an ontology is a "formal description of knowledge" that takes the form of a set of schema, and iterative ontology learning is an automated program that seeks an equilibrium between different sets of data each time a new definition is introduced.[14] Applying this concept to the museum context means redefining the ontology of the photograph away from the concept of a unique receptive surface and toward the sets of schema (or descriptions of what that photograph is) that are produced

by academic arguments as well as by forms and paperwork (such as classifying a photographic reproduction as either a fine art print or an educational study print for the purposes of insurance). Competing descriptions are often introduced, and equilibrium must be achieved between these sets on a continual basis. This equilibrium between ontological definitions is accomplished through collaboration and feedback between support staff and artists, curators, and directors, in which the former are responsible for making material behave according to concepts enunciated by the latter and vice versa. Photography invites these kind of contradictions in ontological descriptions, as two case studies involving Walker Evans and Eugène Atget will demonstrate. These photographers, whose work was central to articulating Javitz's conception of the picture-as-document in the previous chapter, are also central to MoMA's ideology of straightforward photography as quintessential modern art and the ways in which the museum produced photographic material that made alternating claims toward original artwork, simple documentation, or reproduction as they sought to make photography legible within art history.

Photographs are an essential part of a value structure that forms the bedrock of museums as an institution, which the unique object anchors and the reproduction amplifies. As Elizabeth Edwards and Sigrid Lien write, museums are "saturated by a processually invisible layering of photographs in which they are used in a myriad of significant ways as both tools and objects."[15] At the moment when an artwork passes from private collection to public collection, we can say that something happens to its image: while always separable from the object, with the painting's incorporation into an institutional context, its image reproduction takes on new, specific responsibilities. The artwork image is used by various museum staff to identify, to locate, to track, and to teach and is used by the public through reproductions in books, slide lectures, souvenirs, and eventually websites. The accessibility of the image is an extension of the accessibility of the painting held in the public trust. Caring for a collection requires the cultivation of a second collection of image reproductions, which circulate out to the public via slide lectures, educational materials, or books and circulate internally via cataloguing systems, installation photographs, condition reports, or research files.

Photography is invoked in art history in two ways: the archival order of the art publication or slide archive and the aesthetic order of the gallery

wall. Many theorists of photography, including John Tagg, Allan Sekula, and Rosalind Krauss, have discussed this contradiction, framing it as an irreconcilable paradox.[16] The attempt to reclaim the medium as purely aesthetic, or at least always potentially aesthetizable, takes place at different points in the history of MoMA. This struggle can be traced through the development of the Photography Department, the first photography department in an American modern art museum when it was founded in 1940 and widely understood to be at the forefront of active effort to secure discursive space for photography within the ideology of the museum and art history. Christopher Phillips has written about the history of the department as a dialectic between two poles: (1) an aestheticizing impulse that emphasized auratic qualities of the print and the creative genius of the photographer and (2) a popularizing impulse that celebrated photography as a mass medium, with the former becoming dominant when curator John Szarkowski took over in the 1960s. Douglas Crimp concurs with Phillips, arguing that photography was "discovered" in the 1960s and 1970s as an art form through the efforts of Szarkowski. According to Crimp, this reframing of photography was a rejection of the multiplicity of photographic practice in favor of emphasizing photography's "essence." In other words, in order for photography to be fully incorporated into the museum, photography had to be ontologized in a way that allowed the photograph, all photographs, to be understood by "a single, all-encompassing *aesthetic*," requiring a disavowal of competing definitions of photography.[17] Crimp warns against two related but potentially contradictory results of the claim that photography is inherently aesthetic: (1) other forms of photographic practice are phased out—photography books literally torn up in order to extract the newly valuable tipped-in photographic plates, and (2) the epistemological coherence of the museum, which was initially built on the photographic artwork reproduction, collapses.

And yet, contra Crimp, the museum is not in ruins; as a cultural institution, it attracts more cultural attention than ever. And at the very time in MoMA's history that Crimp identifies in which the photography department was consolidating its definition of photography, photographic reproductions were circulating from the museum at a higher rate than ever and continuing to do the work of maintaining the museum's epistemological authority. Arguably, the auratic power of the reproduction has similarly

THE MUSEUM WITHOUT WALLS

only grown over time, as high-resolution photographic reproductions have increasingly become de rigueur on museum websites. Given this concurrence of activities, I seek to explore the resulting problematic: if the epistemological coherence of the museum *should* collapse and does not, how is this break denied or repressed? How is equilibrium among contradictory concepts achieved? I argue that rather than any particular scholar, artist, exhibition, or text, it is the material *circulation* of photographic material that sets the terms for the value of the photograph, through techniques of iterative ontologizaton that artist, public, scholar, librarian, and photographer all participate in. These activities allow for the museum's authority to be reproduced across vast networks, while setting the terms for how to interpret the ambiguous reproduction.

ALFRED BARR, THE REPRODUCTION IN THE 1920S, AND *LES DEMOISELLES D'AVIGNON*

The story of the formation of the Museum of Modern Art cannot be told without the story of the formation of its founding director, Alfred Barr.[18] Born in 1902, Barr's approach to modernism, art, pedagogy, and public engagement was forged in the particular educational and intellectual climate of the 1920s. At this time, art historical research was bolstered by physical travel, the cultivation of social networks, and the compilation of personal libraries of books and art reproductions (in the pages of small art journals like *The Dial* and *Hound & Horn* or portfolios of reproductions). Barr's grounding during this period as an educator, researcher, and lecturer would guide his approach to museum work for the rest of his life and deeply engrain itself within the MoMA's DNA. Barr's approach to art can be defined by (1) his belief that nontraditional art forms (from industrial design to film to architecture) were worthy of aesthetic study, (2) a corresponding formalist model of interpretation that allowed for this grouping of different media under a single aesthetic program, (3) a pedagogical approach that privileged both direct contemplation of the object and schematic explanations of artistic development, and, significantly, (4) a wholehearted embrace of all available modern forms of mass communication to accomplish these goals. Above all, Barr was committed to the education of the public, and he relied heavily on educational tools of art

history at the time as visual aids, including lantern slides, large printed reproductions, and photographs of works of art.[19] His deep belief in the importance of prolonged viewing compelled the use of these aids: art could not be appreciated if it could not be gazed upon, and if the artwork could not travel to the lecture hall or gallery space, then the reproduction (either as a slide projection or a printed image) had to do. A review of Barr's educational and professional background, and the striking use of a particular reproduction in Barr's signature exhibition, will set the stage for the development of the museum and the multiply sited activity of the reproduction to follow.

Barr began his studies in the department of art and architecture at Princeton in 1918. One of his early mentors there was Charles Rufus Morey, a medievalist who was deeply influenced by the German art historian Alois Riegl's concept of *kunstwollen*, an interpretive framework that relativizes aesthetic evaluatives in favor of exploring art's broader connections to the cultural, spiritual, and psychological currents of an era.[20] This method traced developmental currents in art production in order to identify and describe iconographic shifts. In 1917, Morey initiated the Index of Christian Art, composed initially of shoeboxes of black and white photographic reproductions and cross-listed subject cards, together illustrating iconographic subjects.[21] Barr assisted with this project, and though he evidently found it "too mechanical" and soon gave up his interest in medievalism in favor of modern painting, his biographer Sybil Kantor suggests that his work with Morey forged a proclivity for identifying evolutionary growth tracked via chronological charts and a respect for the embeddedness of Western art within a long iconographic tradition.[22] Further, I would argue that the physical handling of these reproductions and the embodied sorting and labeling activities are a practical expression of the art historical approach that seeks to reveal by way of arrangement. In this approach, bringing together images to reveal previously unseen patterns generates new knowledge.

After receiving a master's degree from the department at Princeton in 1923, Barr began his doctoral studies at Harvard in the fall of 1924. At Harvard, Barr was inducted into what became known as the "Fogg method" (after the Fogg Museum on campus), a version of connoisseurship that approached the artwork as an object to be read, broken down into structural

THE MUSEUM WITHOUT WALLS 87

elements in a semantics of form. The synthesis of the Fogg method with
Princeton's evolutionary analysis characterized Barr's methodology mov-
ing forward. In practice, this meant that the concept of tracing *kunstwollen*
was stripped of its connection to social and political contexts and centered
instead on tracing artists' exposure to the formal innovation of others and
the subsequent spread of new pictorial techniques.

In his teaching, Barr was invested in the ability of the reproduction to
make remote work present in the classroom. In 1927, Barr developed one
of the first modern art courses in the United States at that time and, in
an innovative move, contextualized modern painting within the industrial
arts.[23] Using slides, color reproductions, everyday objects, and contemporary
advertising, he included examples from graphic design, music, film, and
photography alongside paintings and sculpture. The course would not have
been possible without the availability of reproductions. As Barr reflected
decades later, "I used large colored reproductions for teaching purposes. . . .
Artists were better reproduced on the whole at that time than they are
now [1947]. . . . These were mostly through German publishers though our
own Dial portfolio was good too."[24] By the Dial portfolio, Barr was refer-
ring to *Living Art: Twenty Facsimile Reproductions after Paintings, Drawings and
Engravings and Ten Photographs after Sculpture by Contemporary Artists*, pub-
lished in 1923 by the editors of the New York–based journal, the *Dial*, which
included a range of photographic reproductions, including black and white
photographs and large color collotypes.[25] Barr also used his connection with
dealers such as German émigré J. B. Neumann to procure materials, books,
and reproductions for his course, and they worked together to produce a
bibliography for books and reproductions of modern art for use by other
researchers. In his correspondence with Neumann, Barr acknowledged that
the awareness of modern art in Boston was lamentable, "but there are many
who would be interested if they could see good originals or perfect repro-
ductions."[26] The example of the *Dial* portfolio and Barr's relationship with
Neumann serve to underscore the dependence on reproductions and the
activity, scholarship, and personal networks required to secure them. The
development of modernism at the turn of the century was based on net-
works and reproductions of multiple kinds—objects, people, and texts.

Barr spent 1927 and 1928 traveling through Europe gathering research
for his dissertation. Aside from assembling research and contacts that

would serve him for the next several decades, Barr was also inspired by two museological innovations: the study of industrial arts and the didactic wall label, which later became hallmarks of MoMA.[27] These imported practices end up establishing a model for what it means to look in the modern museum. Walking through a museum, visitors enact a triangulation between the label, the object, and the outside world, as the label points to a larger landscape for the viewer, such as a wall description that contextualizes a Picasso painting within his overall practice and milieu. Further, the multidepartment plan, part of his original 1929 plan for MoMA, in which departments of photography, film, architecture, and design are placed on equal footing with traditional media, ensures that painting and sculpture are not contemplated outside of the world of objects and architecture that surround them. This view demands that these buildings, machines, and distant paintings and sculpture be ready at hand in the form of an image. Barr's education and teaching experience showed him the ability of the photographic reproduction to stand in for its original. Just as a print could presence a remote work of art in a classroom, it could do the same in a gallery, in a notable instance at his landmark exhibition at MoMA, *Cubism and Abstract Art*.

Cubism and Abstract Art (1936) was distilled from Barr's years of research and teaching and constituted his signature contribution to the study of modern art. It was the first exhibition to approach global modern art as a progression of international styles (epitomized in the exhibition catalogue cover, a diagram that suggests universal formal language, mutual influence, and progressive modernism). Influenced by the Bauhaus study of industrial art, the exhibition included everyday objects, posters, furniture, and typography along with painting and sculpture without dividing the installation strictly by media. Installation views demonstrate the physical and conceptual proximity: in one view of *Cubism and Abstract Art*, furniture, posters, paintings, and sculpture are included in a single tableaux to indicate the overlap in formal interests that led to breaking with organic shapes (figure 2.2).

But it was in painting where these explorations were primarily being articulated, and Barr located the impulse to dissolve the organic form with the Cubist movement. By beginning his exhibition with Cubism, Pablo Picasso was installed as the origin of modern art and his 1907

2.2 Installation view of the exhibition *Cubism and Abstract Art*, March 2, 1936, through April 19, 1936. The Museum of Modern Art, New York. Photographic Archive. The Museum of Modern Art Archives, New York. Photographer: Beaumont Newhall. Digital Image © The Museum of Modern Art/Licensed by SCALA/Art Resource, NY.

painting *Les Demoiselles D'Avignon* patient zero. Barr was anxious to include this work, which he had seen during his travels to Paris, but he was unable to secure a loan. In an unusual move, he exhibited a black and white photograph instead (figure 2.3). Enlarged and cropped to size, the mounted, unframed photograph was included in the section "Early Cubism 1906–1910," which opened the exhibition. The rest of the section, according to the installation instructions for the traveling version of the show, consisted of two painted portraits and a sculpture by Picasso, a study for *Demoiselles*, a painting by George Braque, and two photographs of African artifacts (a mask from Cameroon and an ancestral figure from Gabun).[28] At the start of Barr's story, three photographs presenced works that could not be there. These photographs were both contextual (illustrating the types of objects that Picasso had acknowledged as influences in his studio at the time) and central: the painting itself.[29] Above all, they announced that form could be studied outside of context, outside of physical presence.

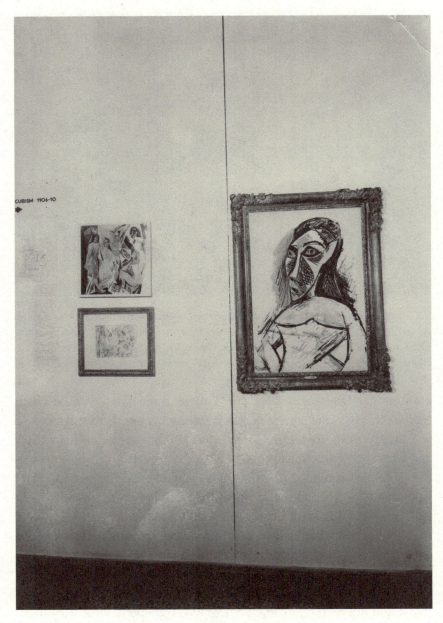

2.3 Installation view of the exhibition *Cubism and Abstract Art*, March 2, 1936, through April 19, 1936. The Museum of Modern Art, New York. Photographic Archive. The Museum of Modern Art Archives, New York. Photographer: Beaumont Newhall. Digital Image © The Museum of Modern Art/Licensed by SCALA/Art Resource, NY.

Paradoxically, the development of a canon of modern art that celebrated the cult of the original thus required the mechanically reproducible image, which left an indelible mark on the discourse of modern art interpretation. About the painting, Barr exclaimed, "Picasso's *Demoiselles d'Avignon* is one of the very few paintings in the history of modern art that can justly be called epoch-making."[30] It was originally titled *The Philosophical Brothel*; early studies of the painting indicated that it was meant to function as an allegory for a modern memento mori, with a male figure in the foreground holding a skull pulling back the curtain into the room of a brothel. As Picasso developed the painting, the man and skull disappeared, leaving the confrontational stares of five women, two of whom appear to be wearing masks inspired by African artifacts. This origin point crystallizes an encounter between Picasso and the African sculptures at the Musée d'Ethnographie du Trocadéro in Paris that has since haunted modern art history, as Picasso himself, critics, and art historians have debated the nature of African influence on the work and subsequently critiqued the essentializing approach of that discourse. For Hal Foster, the painting is the "primal scene of primitivism," a "fetishistic discourse" that reveals the West's anxieties.[31] Simon Gikandi describes the "schemata of difference" that Picasso's charged encounter with Africa (as abstract emotion rather than as a concrete place or peoples) enforces within modernism, buttressed by a "logic of coherence and symmetry favored by practitioners of modern art" that has imprisoned its historians.[32] This schemata of difference is doubly reinforced by the photographic medium that flattens three-dimensional objects into two-dimensional reproductions, which can be contemplated and compared by their formal qualities alone.

Indeed, before Foster and Gikandi's critiques, as Leo Steinberg noted, the body of criticism interpreting this work for decades after its first showing in the United States as a photograph elides the subject content of the painting in favor of discussion of form and composition, demonstrating a critical "triumph of form over content; to see the work with intelligence was to see it resolved into abstract energies."[33] This way of looking at a painting, as an experiment in form rather than in content, fits exactly with Barr's pedagogical approach to art analysis. That the interpretation of this painting has been so consistent with Barr's aesthetic program (i.e., the breaking up of organic form) demonstrates his role in establishing its emblematic

place as an origin story for twentieth-century art. This was a feat Barr was able to accomplish by harnessing the circulating function of photographic reproductions. Just as the painting itself signified "epoch-making" formal innovation to Barr, that its inclusion in his landmark exhibition was a photograph rather than the painting itself demonstrates another epoch-making event. And just as the male figure was painted over, producing an ambiguity of meaning that was read as formal innovation while repressing the encounter with the racialized other, the inclusion of *Demoiselles* as a photographic reproduction in Barr's signature exhibition lies just under the surface of modern art's history.

CIRCULATING MODERNISM

No doubt inspired by his experience curating modern art exhibitions for university galleries as a doctoral student, Barr immediately made circulating exhibitions one of MoMA's central activities, and the popularity and wide influence of these exhibitions shaped the American museum for the rest of the century. At that time, there were isolated examples of European collections preparing exhibitions for travel, and scientific and ethnographic museums like the American Museum of Natural History circulated educational exhibitions in the early twentieth century, but this was not common practice for art, especially not modern art. In 1917, librarian and museum director John Cotton Dana lamented, "The habit of lending subjects from and by museums of art is almost unknown in this country."[34] Twenty-seven years later, reflecting in 1954, a museum director mused, "Though the idea of loan exhibitions is not necessarily a new one, loan exhibitions of true value to the college in America did not exist until the Museum of Modern Art began its system of traveling exhibitions."[35] These exhibitions ranged in content and reach from small groups of reproductions rented out to local schools to major loan exhibitions that traveled the country and covered every genre of art represented by the museum. They traveled to university galleries and regional museums, department stores and commercial galleries, and elementary and secondary schools from the 1930s on. Crucially, they communicated MoMA's theories of modern art through the circulation of photomechanically reproduced material—promoting the idea that modern art connoisseurship could be made available democratically.

The reproducibility of the exhibitions and their circulation communicated an ideology of the Western art museum that James Clifford describes as its "possessive individualism," in that the reproductions available at hand to distant communities encouraged viewers themselves to see themselves as collectors. I survey two examples: *A Brief Survey of Modern Painting* (circulated 1931–1939), in which reproductions were promised as stand-ins for absent originals to a newly imagined American consumer hungry for modern art, and *Photographs of African Negro Art by Walker Evans* (circulated 1935–1956), which consolidated a vision of photography that prized a promised objectivity and reified the colonialist approach to African art within the modernist project. In both cases, intermediary photomechanical reproduction processes were elided in order to emphasize the auratic work of art, whose aura is conferred by the authority of the museum. At the same time, the subjectivity of the people involved with the practice of handling objects was also suppressed, which is why the section concludes with a description of the contributions of the first head of the Circulating Exhibition Department, Elodie Courter.

The first exhibitions developed for circulation in 1931, two years after the museum's founding, were not composed of original works of art. Rather, they were a painting show without paintings (comprising color collographic reproductions) and an architecture exhibition without architecture (comprising models and photographs). The first, *A Survey of Modern Painting* (later circulated as *A Brief Survey of Modern Painting*), was a collection of sixty color reproductions, subdivided in individual rentable sections, and accompanied by didactic panels with commentary by Barr. When the exhibition was shown at the museum in 1932, the press release explained:

The Museum has been faced with the problem of arranging loan exhibition for schools, clubs, and colleges which cannot afford the heavy expenses of insurance and shipping involved in such large loan exhibitions as those in the Museum itself. It has been felt that exhibitions of any but first-rate originals would not adequately serve an educational purpose. It has, therefore, been decided to experiment with large color reproductions of modern paintings, most of them printed in Germany in the last ten years, and some of them approaching the perfection of a facsimile.[36]

The exhibition was initially circulated to New York City high schools, but its popularity soon led to duplication and resulted in an extensive tour

over the next nine years that included regional museums and public galleries, university galleries, private galleries, and department stores.

The didactic panels, reproduced in an exhibition catalogue, gently walk an imagined American viewer through what is assumed to be a very unfamiliar encounter with European art: "We dislike pictures we don't understand to be 'radical' or 'bolshevik.' Fifty years ago there were radicals in painting just like there are today," notes the text introducing the Impressionists.[37] Greeted with a "we," viewers were genially interpellated into an American identity position with political (anti-Communist) and philosophical (pragmatic) registers. Ironically, Barr was employing the method of didactic labels he'd admired during a research trip to Moscow in 1928.[38] Along with section panels introducing new schools in modern art, each artist was introduced through an introductory text panel, and a short descriptive text for each picture.[39] Throughout, the tone is folksy, encouraging viewers looking at the most contemporary work in the show to "forget prejudice. . . . Give the picture, itself, a chance to live!"[40] The pictures that the public would be looking at as they ambulated the temporary walls, presumably expanding their provincial expectations for modern art, would not be the paintings themselves but color reproductions.

In significant ways, this exhibition highlights the fuzziness between original and reproduction and between education and commerce that characterized the work of the museum. In the 1934 exhibition catalogue, which would have been sold separately at the museum or elsewhere, the first lines indicate that the exhibition is *available*—for exhibition or purchase:

The Exhibition, A Survey of Modern Art in Color Reproductions, is available for circulation. During its itinerary, begun in October 1932, it has been displayed in 33 cities in museums, colleges, schools, women's clubs and department stores. For information, please write to the Museum of Modern Art, 11 West 53rd Street, New York. Many of the color reproductions included in the exhibition can be purchased from the Museum.[41]

A brochure that circulated with the exhibition from 1932 also encourages the purchase of reproductions similar to those shown in the exhibition. Titled, "For Your Own Collection of Modern Paintings," the text begins: "Have you not left with reluctance the halls of a museum . . . wishing you could gather together the pictures you most enjoyed and live with them daily? It is not impossible. . . . You can build a collection at a modest cost

which will reflect your taste and bring continuous pleasure."[42] The brochure goes on to tout the quality of the reproduction itself ("Color facsimiles which reproduce the every brush stroke of the master with amazing faithfulness are within the reach of all lovers of art") and to frame the sale of reproductions as a response to the public demand.

Here, duplication and mediation happen on multiple levels. The original painting is duplicated in the form of a color facsimile. These so-called facsimiles (printed collotypes) were photographic in nature but used no screens or systems of dots or dashes. Rather, the collotype process uses gelatin-coated glass plates in primary colors, carefully applied and hand worked. This was publicized by the museum; the draft press release provided to exhibition venues, titled "The Art of Printing Color Reproductions," details the collotype process and compares it to fine art: "The method of reproduction this accomplishes, is in effect just what the artist does when he reduces his oil pigment with white, or reduces his watercolor with water."[43] Rather than an endlessly reproducible copy, the implication goes, these facsimiles are original objects produced in a manner analogous to painting. Further, in other promotional material for the exhibition and in the sales brochure discussed above, the geographic origin was also highlighted: "In 1931, Alfred H. Barr, Jr., while in Europe, made a selection of color facsimiles from among the finest prints obtainable."[44] This emphasis on provenance embraced the language of print connoisseurship. The museum also sold color facsimiles of the works included in the exhibition, and despite the allusion to European craftsmanship, the museum contracted local New York City business Raymond & Rissling (later Raymond & Raymond) to produce any purchased prints.[45]

The term "facsimile" does not have a clear definition across these texts: it was applied in some copy as an authoritative term and in others as a descriptive quality. The conceptual confusion around facsimile—what constitutes facsimile and what processes are required to produce them— allowed for a variety of usage. These reproductions served as educational adjuncts that allowed for art history to circulate to spaces where the original works could not travel and also as commodities that allowed the middle-class American to express their taste, mediating their identity as a modern subject and consumer of high culture. The aura of the prints was established in terms of their materiality. The text that described the print

process and detailed the geographic origin created the conception of a new form of original—not original painting, but not copy either. The very term "facsimile" creates a new hybrid category.

While exhibitions like *A Brief Survey of Modern Painting* used photographic material, MoMA's first monographic exhibition of photography was *Walker Evans: Photographs of 19th Century Houses*, which was shown at the museum in 1933 and circulated between 1934 and 1936.[46] At least, this fact is often cited as evidence of MoMA's early adoption of photography as fine art in a time when photography was not yet accepted as such.[47] Yet, Evans himself reflected, "I don't consider that business about architecture a show."[48] A small project focused on the subject of nineteenth-century architecture rather than an artist-driven show, the series was commissioned and selected by Junior Advisory Member Lincoln Kirstein, who ultimately gifted the work to the museum, initiating their photography collection. The exhibition contains the seeds of the discursive uncertainty around photography: in *Walker Evans: Photographs of 19th Century Houses*, photography exists somewhere between document, prototype, historical record, and fine art object. The photograph itself is meant to stand in for the absent building, the commission is intended to produce an archival survey (similar to a government project), and photography is cast as a primary tool to preserve national identity and contribute to a living history of the present. It was commissioned, and yet the authorial mark was maintained. It was neither entirely an architecture show nor a photography show; these paradoxes are glossed over.[49]

In 1938, the museum showed another monographic exhibition of Evans onsite (and circulated it until 1940). This time, the exhibition, titled *Walker Evans: American Photographs*, was explicitly announced as such: "The first one-man photography exhibition ever given by the Museum of Modern Art."[50] Evans was further touted as "one of the greatest living American photographers."[51] In the period between the 1933 and 1938 exhibitions of Evans's work, the museum had grappled with the exhibition of photography in significant ways. Beaumont Newhall, initially MoMA's librarian and an occasional research assistant to Barr, had invested in the study and promotion of photography through his library acquisitions, and in 1937, the museum turned over the entire building to Newhall's exhibition *Photography 1839–1937* (and later circulated a smaller exhibition to schools across the country) (figure 2.4). With Newhall's 1937 survey and Evans's

2.4 Installation view of the exhibition *Photography 1839–1937* at the Franklin Institute, Philadelphia, May 15, 1937–June 12, 1937. Photographic Archive. The Museum of Modern Art Archives, New York. Photograph by Beaumont Newhall.
Digital Image © The Museum of Modern Art/Licensed by SCALA/Art Resource, NY.

1938 solo exhibition, the museum set a clear agenda for its treatment and canonization of photography as art. In 1940, Newhall founded the Department of Photography at the museum and became its first curator.

Many theorists and historians have turned to this pivotal moment at MoMA to articulate its influence on the treatment of photography in the decades to come. Phillips argues that Evans's retrospective was an early and influential step in a process by which the institution denied the inherent multiplicity of photography in order to emphasize "singularity, rarity, and authenticity," underscoring the aesthetic qualities of the technically

superior prints.[52] Margaret Whitehead argues that over the course of revising his *History of Photography*, Newhall increasingly insists on "straight photography," characterized by sharp focus and unaffected composition, as the most institutionally valid genre of photography.[53] In doing so, Newhall and MoMA championed Evans over more socially conscious photographers like Margaret Bourke-White, Berenice Abbott, and Lewis Hine.[54] Even Evans recognized the importance of MoMA's exhibition for the practice of photography moving forward: "more than I realized it [*American Photographs*] established the documentary style as art in photography. . . . The Museum is a very influential place."[55] Evans's style, and "straight photography" in general, is collapsed with the very *definition* of modern in the 1938 press release: "The word modern, in its truest sense, aptly characterizes Mr. Evans' work as it is 'straight' photography, so factual that it may almost be called functional."[56] Here, functionality, factuality, modernity, and formal purity are equated in a way that supports similar arguments being made throughout the museum around modern architecture and design.

Thus, between Evans's commissioned project in 1933 and his retrospective in 1938, MoMA made dramatic leaps toward defining photography as an artistic medium. With this in mind, an intervening Evans exhibition that circulated as a document of a landmark show of African art in 1935 takes on extra significance.[57] The original exhibition, *African Negro Art*, was curated by Barr and James Johnson Sweeney and consisted of over six hundred objects on loan from European and American collectors, which involved an international network of institutional and private collections. The exhibition took off from the idea Barr had pursued since his graduate studies about the influence of non-Western art—so-called primitivism, wherein the "primitive" artist or "primitive" art was a label applied to precolonial as well as to contemporary non-Western cultural production and to European or American folk artists (broadly those deemed outside institutional structures of modern art). The exhibition materials promised to reframe the study of African art away from ethnographic context and toward aesthetic appraisal: "The art of the primitive negro in its mastery of aesthetic forms, sensitiveness to materials, freedom of naturalistic imitation and boldness of imagination parallels many ideals of modern art."[58] Sweeney intended to challenge prevailing racist misconceptions about African art, and the exhibition was directly oriented around trying

to convince an imagined public that non-Western art forms represented a more sophisticated understanding of plastic forms than contemporaneous work in the West. In so doing, however, the exhibition stripped artifacts of their cultural context in order to extol and appropriate their formal qualities as perceived by the Western artist or collector, in turn replicating the Eurocentric approach that Sweeney purported to challenge.

This encounter with the African art object is embedded in the history of modern art and MOMA, captured by the centrality of Picasso and African influence in Barr's evolutionary account as represented in the discussion of *Les Demoiselles D'Avignon* above. The "schemata of difference" Gikandi identified in Picasso's troubled history of prizing African objects while declining to engage with culture and people was not confined to the Spanish painter or to modern artists alone. Gikandi argues that the ambivalence around Africa "maintains and haunts" modernism, in a paradox in which the "Other" is present but never constitutive and historians of modernism are compelled to explain the relationship through fetishistic or psychoanalytic frameworks or ignore it.[59] The haunting stretches across history: MoMA confronted the need to revise their past history with "primitivism" in the 1984–1985 exhibition *Primitivism' in 20th Century Art: Affinity of the Tribal and the Modern* and was widely criticized for framing in which, as captured by artist Rasheed Araeen, the show labored to convince "the so-called 'primitives' how the West admires (and protects and gives values to) their cultures and at the same time tell the modern artist, who could only be the Western artist, the importance of this in his continuing historical role as an advancing force."[60] Foster argues that this suppression of "the imperialist precondition for primitivism" persisted at the museum through concepts of affinity and formalism that were never shed.[61] These concepts, of affinity and formalism, depend on the decontextualization of objects through photography. Like the original *Demoiselles* photograph, which indicated a new portability of international cultural flows, the role that Walker Evans plays in the 1935 exhibition entrenches photography and its signification of modernity as an essential tool deployed to the end of decontextualizing, fetishizing, and commoditizing African culture.[62]

Photography made the *African Negro Art* exhibition portable and replicable. Circulating the initial exhibition was a priority, and in a grant application, MoMA argued, "The exhibition of African Negro Art assembled for the Museum . . . is the most important of its kind ever held. . . . It would be

a great waste were this exhibition to be dispersed without adequate documentation."[63] The application proposed a photographic project documenting 450 of the 600 objects on view, with the goal to produce a portfolio of photographs to be offered for free to Black colleges and at a nominal fee to other institutions, as well as a circulating exhibition of a selection of enlargements. The application was successful, and following a grant from the General Education Board, Walker Evans was engaged to photograph the objects in the exhibition. At night, after the museum had closed, Evans worked with curator Dorothy Miller to methodically shoot the work on view, in the galleries.

The exhibition design displayed the African objects against bare white walls, emphasizing the forms of the sculptures removed from social and cultural context, literalizing the decontextualization and removal of African bodies and context (figure 2.5). Evans extended this with his photographic

2.5 Installation view of the exhibition *African Negro Art*, March 18, 1935, through May 19, 1935. The Museum of Modern Art, New York. Photographic Archive. The Museum of Modern Art Archives, New York. Photographer: Soichi Sunami.
© Soichi Sunami.

THE MUSEUM WITHOUT WALLS

2.6 Walker Evans. [Figure, Belgian Congo]. 1935. Gelatin silver print, 24.0 × 10.8 cm (9 7/16 × 4 1/4 in.). Gift of Samuel and Marilyn Stern, 1992 (1992.5080). © Walker Evans Archive, The Metropolitan Museum of Art.

approach. He used an 8 × 10 format camera, setting up moveable stands and medium-tone seamless paper behind each object to ensure the illusion that the objects were floating in space, disconnected even from the white wall of the gallery. He used tight crops, centering each object in the frame with little surrounding space. He used a process in which portable lights were moved in a circular motion while the camera's shutter was open to obscure any one identifiable source of light, eliminating markers of physical space.[64] He also carefully selected the view in order to maximize formal impact, such as a figure from the Belgian Congo (figure 2.6). When

compared with previous photography, which is lit slightly from the side, on a pedestal, against a white background, Evans's shot is tightly cropped, floating against an indeterminate background and directly facing the camera. Through these various effects, the figure is estranged from any identifiable surrounding and optimized for the flat world of the photograph and book print.

Evans developed the negatives and prints himself at his studio, producing seventeen portfolios in total, with seven distributed for free to the institutions selected by the General Education Board.[65] After the portfolio was complete, enlargements circulated as an exhibition, subsidized by the General Education Board grant. The exhibition, titled *Photographs of African Negro Art by Walker Evans*, circulated from October 1935 to December 1936 and traveled to sixteen venues, primarily to Black colleges, across the country. The show consisted of seventy-five prints enlarged to 16×20. Original scale of the objects was thus disregarded, further encouraging the viewer to contemplate the plastic form above any other feature. The prints were unframed and mounted on white boards to be hung grouped together by geography, following the order of the portfolio. The installation at any given venue, carefully prescribed by installation instructions that traveled with the boards, was thus a strange hybrid of book, prefab architecture, and exhibition. Photographs were shipped on their mounts; unpacking each white board was like unpacking readymade walls. It was also a materialization of the book space as exhibition space, with plate sections spread across the walls. Indeed, after the exhibition stopped circulating and the portfolios distributed to their new collections, these images continued to circulate widely through reproductions in other books. As Sweeney, one of the foremost scholars on African art, continued to use Evans photographs in his catalogues, others requested them as well. MoMA's library kept negatives and fielded reproduction requests. The photographs thus exist as collectible Evans prints, as illustrations meant to represent the objects themselves in books and as something in between in the circulating exhibition. They were gathered together again in 2000 at the Metropolitan Museum of Art in the exhibition and publication *Walker Evans and African Art, 1935*.

This exhibition demonstrates one example of the concept of iterative ontologization. Through each assembly of the exhibition—within the walls

THE MUSEUM WITHOUT WALLS

of the museum, on the road, or within the packaging of the portfolio—a new ontology of the object was offered, through discursive and material framing. With each new circulating product, the categories of object, artwork, and image were intentionally recrafted and repacked. A heddle pulley that once served as simple adornment on a textile-maker's loom is repackaged as unique collectible object (what was once a part becomes a whole). That collectible becomes a small modern sculpture through its presentation at MoMA (what was ethnographic becomes aesthetic). With photography, the sculpture becomes an image (what had mass and scale becomes weightless and formalist). That image becomes a photographic work of art, valued for its technique, the quality of paper, and printing (what was informational becomes materially valued). Just as the African objects were actively moved from the realm of "culture" to the realm of "art," photography was moved from "machine" to "art." This movement also signals a dialectic between Benjamin's cult value, assigned to the auratic object, and exhibition value, an inherent product of technological reproduction. These qualities are not a priori to the medium but rather accrued to an object by interested actors.

This case study is a unique representation of the way objects can migrate across what James Clifford has articulated as the different "zones" of value, classification, and circulation that constitute collections.[66] Starting with the understanding that "cultural property" is defined through encoded values that are contested and political, he further establishes four primary zones of collections—technological, ethnological, consumer, and artistic—and emphasizes that objects can move within these zones depending on cultural context.[67] Distinctions of value are asserted through what can be owned, who can be named, what can be circulated, and what information travels with the object. Those who have the ability to set the terms of the informational context are curators, artists, and collectors but also librarians, cataloguers, and shippers. They do so through rhetoric but also through physically moving objects and through image capture (i.e., circulation and reproduction). Reframing thus depends on information labor of cataloguing and paperwork, physical labor of printing and packaging, and audience labor of consumption. While undoubtedly Evans and Sweeney were key actors in the dramatic reframing of the Western study of African art, as seen through the replication of their images and ideas in books

that fill the African art sections of US libraries, this was also accomplished through the circulation of the exhibition of photographic prints. That circulation would not have been possible without the activities of the Department of Circulating Exhibitions or the woman who ran it.

By the time the Evans's African art exhibition circulated in 1935, the Department of Circulating Exhibitions was in the capable hands of Elodie Courter (figure 2.7). Courter started at the museum in 1933; a recent Wellesley graduate desperate to work at the museum, she lied about her typing abilities in order to secure a volunteer job cataloguing a cache of 2,000 slides purchased in Europe. Sharing a broom closet with the mail clerk, Courter dutifully worked through the slides and whatever other tasks were assigned to her: at one point, she was asked to take over the telephone switchboard. Her efficiency and work ethic led to an expanding portfolio of responsibilities. Only two years after joining MoMA, she was managing the newly named Department of Circulating Exhibitions.[68]

I rehearse Courter's early odd jobs in order to emphasize the traditionally gendered labor of maintaining communication structures, from museums to telephone networks to library infrastructure. In his exploration of the role of identity, gender, and labor into the study of large-scale information infrastructures, Gregory J. Downey has argued for the (traditionally gendered) role of the librarian as an essential media technical worker, one who enables jumps in context "from the past to the future," "from one kind of knowledge institution to another," and "from one set of cultural meanings and expectations to another."[69] Librarians accomplish this work through various forms of "transcoding" processes: those that translate content across mediums and those that enable the circulation of materials. The attention to detail, fine motor skills, and administrative skill (often construed as feminine aptitudes) are essential to the informational labor of "transcoding." From typing up labels for slides and moving cables on a switchboard, Courter moved on to typing correspondence, maintaining schedules, producing forms, updating lists, putting in orders, shuffling photographs, making selections, writing instructions, moving boxes, and various other activities required to circulate what came to be approximately seventy-five exhibitions a year. Courter was someone who, as Barr put it, "was the kind who when she left the Museum it took four people to replace her."[70] In this comment,

THE MUSEUM WITHOUT WALLS

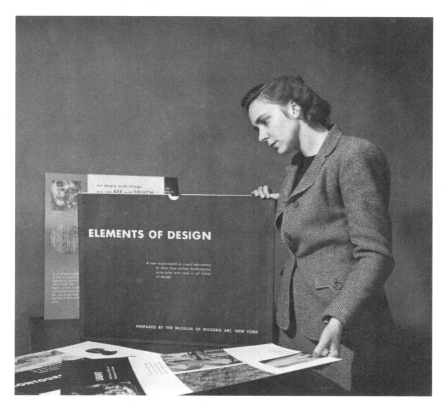

2.7 Elodie Courter, director, Department of Circulating Exhibitions, The Museum of Modern Art, New York, with panels from the circulating exhibition *Elements of Design*. Circa 1945. Photographic Archive. The Museum of Modern Art Archives.
Digital Image © The Museum of Modern Art/Licensed by SCALA/Art Resource, NY.

Barr calibrates the professional value Courter brought to the museum—recognizing her organizational skill while marking her work as practical and routine, something that could be accomplished by anonymous and presumably less skilled four additional workers.

Over time, Courter honed the procedures of the department, hiring staff and developing workflows to maintain the steady stream of material to and from the museum. By 1947, when she resigned, she left in place a tightly ordered machine. Reviewing the workflow documentation from this period reveals the complicated processes. The duties for the circulation manager, explicated in a typed multipage document from 1947, are particularly telling.[71] The circulation manager maintained a constant flow

of correspondence with institutions interested in circulating exhibitions, dutifully copying and filing (on the correctly colored paper) these letters in multiple places. An overall schedule of exhibitions was maintained, with reminders and required forms going out internally and externally at appointed times. Form letters, contracts, bills, and purchase orders were sent out in steady intervals. Each exhibition was sent with a press release, packing instructions, photographs, labels, and wall texts in addition to the works themselves; all of these needed to be checked and replaced if necessary, requiring orders to be put in at other departments. Photographs had to be obtained from MoMA's library or new prints made, which would later be returned to the museum or purchased by participating venues (generating a billing form). Multiple insurance policies had to be updated, as the museum maintained at least four policies: museum collection items under one policy, loaned items another, a policy just for color reproductions, and another for photographic material prepared for exhibitions.[72]

Though not part of the museum's official collection, the insurance policy for color reproductions and processes for managing them represents the important role they played in the museum's economy, indicating a more expansive view of what constitutes the museum's holdings. Color reproductions (as opposed to black and white prints, or slides) obtained for exhibitions, lectures, library resources, or otherwise would be passed through Courter's department for cataloguing: entered into a logbook and card catalogue and added to the ongoing insurance contract. Each reproduction was given an R-number for tracking. These reproductions could be included in other exhibitions or could be sold as circulating exhibitions to other institutions or directly to teachers. A 1945 press release about both circulating exhibitions and color reproductions for sale demonstrates the importance of reproductions to the circulating exhibitions and the twinned functions of commerce/education they served. In the release, quotes by Courter and publications head Monroe Wheeler alternate between arguing for the educational and aesthetic value represented by the high quality of the reproduction and the ultimate deficiency of the reproduction in relation to the original. Discussing a circulating photography exhibition for sale, Courter insists, "Technically the process retains more than any other method of mechanical reproduction the quality of the original photographic print."[73] Wheeler extols the reproduction and then cautions, "Color reproductions,

THE MUSEUM WITHOUT WALLS 107

like phonograph records, are a means of familiarizing a large public with the esthetic pleasure of art; their purpose is that of initiation and education. To be sure, some quality of the original is always lost, and perhaps one of their greatest merits is that, in the end, they teach one not to be satisfied with them or any substitute for an original work of art."[74] Both quotes carefully maintain that photographic reproductions—even of photographs—are ultimately inferior to the original, even if they offer some opportunity for democratization of "esthetic pleasure."

The differences MoMA balanced between color reproductions, photographs, painting, and sculpture were articulated through structures like insurance policies but were manipulated in the service of extending the museum's reach. Courter's ability to select and remix color reproductions to produce a steady stream of circulating exhibitions also contributed to this discourse. The volume of exhibitions she was able to manage increased the importance this material played in the museum's ecology and also the importance of the production of multiple types of photographic material onsite, much of which came through another understudied department in the museum: the library.

THE LIBRARY, RIGHTS AND REPRODUCTIONS, AND THE VALUES OF PHOTOGRAPHY

Just as the Department of Circulating Exhibitions was essential to Barr's didactic model and MoMA's mission to shape and disseminate the narrative of modern art, the library was an equally important part of this assemblage. As evidenced by Barr's own educational experience, at the time of MoMA's founding, awareness of modern art was primarily determined by access to books and periodicals, many of which were published abroad. In addition, MoMA's library was also responsible for maintaining the slide library and the photographic archive documenting the permanent collection and exhibition history. The librarian's control of acquisitions, organization, and access was thus highly consequential, shaping the knowledge bank that supplied the museum's intellectual content and leaving a broad impact on museum work, art history, and art libraries in the twentieth century.

From the start, MoMA's library was a multimedia hub of heterogeneous material, which expanded with the interests of particular donors. It was

founded in 1932 with major gifts of books from A. Conger Goodyear and Philip Johnson. In the next few years, an additional gift of Walter P. Chrysler's Dada and Surrealist library and the incorporation of the Film Library's collection of prints, publications, and ephemera further expanded the collection, and when the museum's new building opened in 1939, the library was opened to the public. At that point, one of the most popular services was a library of 2,500 slides, made up primarily by early gifts of slides from the Buffalo Museum of Science, Edward M. M. Warburg, and Philip Johnson.[75] The slide library grew systematically with the addition of material gathered from research and exhibitions, and by 1944, the library had 8,000 slides, organized in a rental library that circulated materials out to local and national patrons for educational purposes at the modest fee of 50 cents/week for 50 black and white slides.[76]

While slide rentals functioned as a public-facing service, internally, staff primarily worked with photographic prints. In addition to the slide rental service, the library also maintained a photographic catalogue of the collection and an archive of exhibition photography. The catalogue took multiple forms: bound albums of paper-mounted black and white prints (organized by medium and artist last name) and collections of carefully preserved negatives. Duplicate albums of prints of collection objects were kept by the collections department, but the library maintained the master set, constituting an illustrated collection database made up of bound albums.[77] Staff or outside researchers could peruse the albums and order prints on demand, which were used for research, publication, or even personal purposes. All of these services were directly oriented toward circulation.

MoMA's library developed within a museum dedicated to cataloguing and historicizing developments in art as well as modern communication media like photography and cinema. This makes it a particularly apt example to demonstrate the essential role that the library plays in creating discursive structures to interpret new media. The trajectories of the first three librarians at MoMA confirm this: (1) Iris Barry, librarian from 1932–1935, who founded and shaped MoMA's influential Film Library, essentially authoring the canon of film history through publications and readymade film courses as it was taught over the course of the twentieth century and continues to be taught in cinema studies programs across the world; (2) Newhall (discussed earlier), librarian from 1935–1945, who revised and

THE MUSEUM WITHOUT WALLS 109

reprinted his *History of Photography* five times between 1937 and 1982 and likewise authored the canon for the history of photography; and (3) Bernard Karpel, librarian from 1945–1973, who established significant standards for bibliography and had visionary ideas about the cataloguing of visual material.[78] The legacy of these librarians shaped the genealogies and frameworks for interpretation that made sense of new forms of media throughout the twentieth century and demonstrate the centrality of circulation to the same. While their work has been recognized in published histories of the museum, I turn now to another essential library worker, less discussed, who worked primarily with the museum's images as intellectual property: Pearl Moeller, first head of the rights and reproductions department.

When Moeller, a young economics and sociology graduate from Mount Holyoke, first took a job at the Film Library in 1941, she had no idea a temporary position would lead to a thirty-nine-year career at the museum and eventually the role of setting up a department of rights and reproductions in a modern art museum, the first that she was aware of in the country.[79] Moeller's evolution at the museum captures the development of systems of value around photography, reproductions, and archives in the postwar period. Over Moeller's thirty-nine years at the museum—from her work at the Film Library from 1941–1944 and museum library from 1944–1959, as supervisor of reproduction rights and photographic services from 1959–1969, and as special collections librarian from 1969–1981—she was at the center of discussions around photography and archives that ranged from the practical to the philosophical: "I met everybody, because sooner or later, everybody needed a photograph."[80] Through these discussions and her various duties at the museum, Moeller was central to the peculiar intellectual labor, tracked throughout this chapter, of smoothing out the paradoxes inherent in competing definitions of photography. Managing photographic services for different departments meant that Moeller provided the practical service of transcoding objects into different forms of transmissible images, slides, prints, publication illustrations, and internal databases. These transcoding processes, hidden from view, allowed the consolidation and dissemination of the museum's narratives about art, collecting, and modernism.

Moeller was hired in 1941 to assist with the Inter-American Affairs Cultural Program, managing the circulation of films to and from Latin America. She had trained as a painter but was immediately introduced to the

realm of photographic. After three years of working with the Film Library, Moeller moved across the hall to the library to take a job working with the library's photography collection. At this time, this meant managing the photographs of the collection and loaned objects (maintaining photographic albums and negatives and coordinating new photography) and servicing requests for photography to be used for research and publication. These activities were essential to document MoMA's collection and make information available to researchers but also for publicity, marketing, and generating revenue (through selling reproductions or reproduction rights). As Moeller recalled, in addition to servicing research requests for curators, the library was an open and welcoming place for nonmuseum staff as well: "So if you came in and wanted a photograph to hang on your bathroom wall or you were an editor over on Madison Avenue you could sit down and look at these photographs and order them."[81] Moeller's recollection that nonmuseum users could stop in and order pictures for personal use reveals MoMA embraced more of the ethos of the circulating collection present at the NYPL Picture Collection than is usually discussed. This circulation of pictures out of the museum increasingly became part of Moeller's work.

Throughout the 1950s, Moeller was responsible for a wide range of activities, producing negatives, prints, color transparencies, and ektachromes for publication; enlargements and blueprints for exhibitions; copy prints, Photostats, and slides for research; and even small snapshots on Leica cameras to be affixed to card catalogues of the collection objects.[82] Between supervising new photography, fielding requests from the public, and supporting MoMA staff research, Moeller acted as a conduit for image circulation. In some cases, she literally embodied this: for instance, when Steichen was feverishly working on research for *Family of Man* in 1954, Moeller served as a "runner," picking up prints from the loft he rented over a jazz club on 52nd Street and running them over to a Photostat company in Radio City in order to assist with selection.[83] Other studies have pointed out that modern communication networks began as networks of bodies, often female, who form essential nodes, switches, and lines in networks of telephone, telegram, and computer networks.[84] In Moeller's case, her day-to-day tasks formed the network of labor needed for image circulation.

Through these varied activities, as well as the ongoing work of documenting the collection and exhibitions at the museum, Moeller worked

closely with the photographers whose job it was to document the work of other artists and was often the first to learn of photographic innovations. Moeller acknowledged that her greatest teacher about film early in her career was the photographer Soichi Sunami, who documented MoMA's installations for over three decades (figure 2.8). Like Moeller, Sunami was equally important to the flow of images in and out of, and within, the museum, and his role in the history of MoMA has been overlooked. A Japanese immigrant, Sunami worked odd jobs in the Pacific Northwest before arriving in New York around 1922, where he traveled door-to-door offering to take photographic commissions. From 1923 to 1927, he studied painting at the Art Students League, where he photographed other artists' work for their portfolio and publicity needs. He honed his modernist style and pursued his interest in capturing motion in still photography; he became known for his portraits of modernist dancers, such as Martha Graham and Doris Humphrey (figure 2.9). He was offered a job at *Vogue* but turned it down in favor of taking on the role as chief photographer at MoMA.[85]

During his decades-long tenure, every work that entered the collection was photographed, and efforts were made to systematically document exhibition installations as well.[86] Sunami worked with 8×10 negatives and would provide a negative and several prints for each job, which were kept at the museum. Never officially on staff, Sunami was paid per negative, and he would frequently be called in to make additional prints. He kept a small photographic studio in his home on 15th Street.[87] Between the late 1930s and early 1960s, most of the installation and collection photographs taken at MoMA were printed in his apartment. Once printed, Sunami's prints circulated in multiple ways. Master prints were dry-mounted in albums with the negative number noted—these were the albums consulted by researchers or clients if they wanted to order prints. Prints of collection objects would be sent to the Department of Collection and individual curatorial departments, where they would be mounted in duplicate albums, also organized by artist last name. If an image was requested for publication elsewhere, the applicant would rent the 8×10 black and white gelatin silver prints or 4×5 negatives and, later, 5×7 and 8×10 color transparencies in order to reproduce the work. Across these multiple collections, the albums of master prints, department registries, and outside publications, MoMA's collection was reproduced.

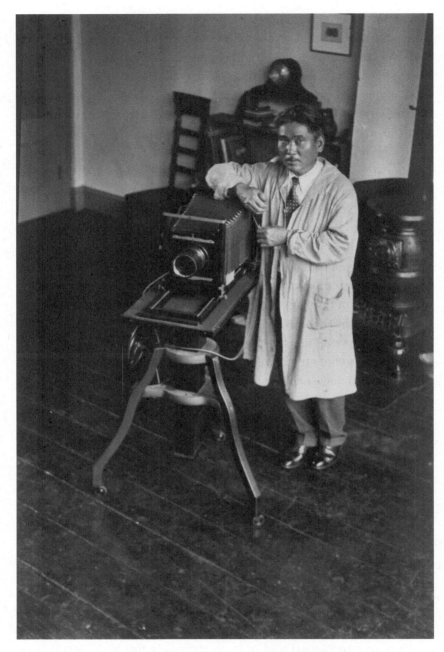

2.8 Soichi Sunami, self-portrait in his studio, circa 1928. Gelatin silver print. Photo by Soichi Sunami, private collection of the Sunami Family.

2.9 Soichi Sunami, Doris Humphrey, and company in *Life of the Bee*, 1929. Gelatin silver print. Photo by Soichi Sunami, private collection of the Sunami Family.

The albums kept by Moeller's department, divided by media and then artist last name (the species/genus organization of art history), served as a central image bank for the museum and thus a kind of shadow collection of its permanent collection. This shadow collection was in grayscale: Sunami was a black and white photographer, and the photography lab installed in the museum in the 1960s printed only in black and white. In these albums (now retired), the "museum without walls" is realized. Painting, sculptures, and photographs all appear in black and white, at the same size. Metadata vary, and some handwritten captions include dimensions, media description, or credit line, but all include artist name, artwork title, and negative number. Further anomalies present themselves when flipping through the albums. In the painting collection's album labeled "Picasso Paintings 79," *Les Demoiselles D'Avignon* appears on page after page, followed by details, now blown up to the same size (and conceptual significance) as the prints on the preceding pages. In the photography collection

albums, photographs *of* photographs are carefully pasted onto stiff board. Sunami's photograph of Atget's Woman with four baskets of fruit (now catalogued as *Femme de Verrières*), which was printed posthumously by the American photographer Berenice Abbott, is presented as the glossy reproducible version of a print that is itself a reproduction from an original negative (figure 2.10). These prints are not quite objects themselves but indexes of other prints, or promises of future prints; they represent the potentiality for further reproduction. And they were reproduced in a wide variety of contexts, from scholarly publications, promotional museum posters and postcards, and even advertising and nonacademic publications. These wide applications were controlled through copyright law, which required careful documentation of image licensing.

Moeller grappled with developments in copyright law from the beginning of her time at MoMA, as she fielded requests for reproduction as part of her work with photographic services at the library, actively discussing reproduction rights with photographers, artists, and historians. At the museum, Barr exhibited careful oversight over reproductions, initially requiring that all reproduction requests go through him and occasionally turning requests down if he was not satisfied with the context.[88] Later, curators reviewed reproduction requests and had to sign off on any prints made of collection objects, approving the density and contrast of master prints. Committed to the work of living artists, MoMA insisted that applicants clear reproduction rights with artists as well and, for commercial requests, would coordinate with the artist to share any fees. As Moeller recalled later, it was due to Barr's attention and concern about the misuse of reproductions that he saw need for a separate department for permissions.[89] In 1959, Barr appointed Moeller to the position of overseeing its development, and the department of permissions she started established the model for the museum for years to come.

Part of what precipitated Moeller's new role at the museum was a sea change in publishing and printing. Moeller recalls a researcher from Eastman Kodak who brought an example of the "first color negative," which she examined in Steichen's office, understanding right away that this would revolutionize color printing (likely the Ektachrome, released in 1946, which allowed for color printing to be done outside of designated Kodak labs).[90] In addition, arts publishing took off after the war: "Also, in the mid '50s,

THE MUSEUM WITHOUT WALLS 115

2.10 Documentation print by Soichi Sunami of Eugène Atget, *Femme de Verrières*, from Photography Collection albums. The Museum of Modern Art Archives, NY. Digital Image © The Museum of Modern Art/Licensed by SCALA/Art Resource, NY.

the whole publishing world changed, because there was money and all the art books that had been put aside during the war."[91] Moeller worked closely with Monroe Wheeler, head of publications, who oversaw the production and sales of the museum's publications, color reproductions, and postcards and wrote about the boom in demand as early as 1946.[92] Advertisers were increasingly drawing on the resources at the museum, and Barr and others were distressed at the perceived misuse of images. Per Moeller, "Some of those Madison Avenue graphic artists, they'd take a beautiful Picasso and chop it in half and run it off the page, bleeding off the page. So many of our artists were alive and it was just desecration, mutilation in many cases."[93] The need to devote attention to the management and control of uses of MoMA's images was clear.

The term "MoMA's images" is complicated. In the case of a reproduction request, petitioners would be contracting the museum for the loan of a slide, transparency, or print to create a new reproduction. In most cases, this material would be shot and produced by photographers or printers under contract with the museum, giving the museum the control over the right to reproduce. But the artwork itself would likely have its own copyright. Control over the image reproductions involved balancing the museum's authority and resources and artists' rights over the image itself, and the power dynamics changed over Moeller's tenure as she oversaw the dramatic shift in American approach to copyright in the 1970s. The 1976 Copyright Act broadened the definition of copyright from "published" works to "fixed" works. This meant that any original fixed image created from 1976 onward was automatically considered the intellectual property of the author, without requiring registration with the Copyright Office or formal publication. Prior to 1976, in contrast to European artists, American artists had to go through the extra step of registration or publication in order to secure copyright to their work. The "fixed" term in the 1976 law is particularly malleable as a definition: even if a drawing on a chalkboard was erased shortly thereafter, copyright of the erased image would still technically reside with the person who held the chalk, in a similar manner to which patent doctrine "assigned ideas and their embodiments to different ontic dimensions."[94] The law immediately shifted power to artists and drastically changed the work of the museum. As one longtime museum rights and reproductions manager recalled, by the late 1970s, museums

THE MUSEUM WITHOUT WALLS

became more litigious, employing in-house counsel and developing rights and reproductions offices with staff trained in various seminars in intellectual property.[95] Years before the artists' legal position was strengthened by a 1999 case that defined the artwork reproduction (i.e., the photograph of the work itself) as a "slavish copy" not available for copyright, Moeller, artists, lawyers, and would-be publishers of MoMA's vast collection of reproductions negotiated contracts that balanced the varied interests of different parties and established the museum's photographs of the works of art in their collection as copyrightable property in themselves.[96] This work generated revenue for the museum and for the artists.

In 1962, just three years after Moeller established the permissions department, she was asked to weigh in on a museum-wide survey about the "uses of photography and related processes," in order to determine what investments in equipment and space were required to deal with the museum's needs, including the possible installation of a studio and printing facilities.[97] The survey document is a rich time capsule of a technological juncture, as museum staff across departments bring the materialist epistemology of the museum cataloguer to bear on their administrative practices. Crimp has lamented the way that the museum's embrace of photography in the 1960s consolidated photography into a single aesthetic interpretive framework (in "The Library's Old/The Museum's New Subject"), but at that very time, museum workers themselves were well aware of the heterogenous material manifestations of photography and the varied roles they played in the museum. The report explains the specific media types under the umbrella of photography—negatives, copy negatives, contact prints, condition photographs, Leica photographs, and Photostats—and gathers detailed reports from departments across the museum about how they use photography, from the registrar to the publicity department. Moeller, as a primary contact point between all of the departments in the museum and the photographers, was highly aware of the weight her own reporting would have. In a bureaucratic medium filled with data about profits, circulation numbers, and inventory lists, Moeller introduced her department report by weaving together her practical advice with philosophical stakes:

It is my firm belief that definite conclusions cannot be formulated except by a meeting of all staff members directly concerned. . . . Photographers, themselves, are highly specialized today and zealously guard and take pride in this degree

of specialization. To a great extent, the Museum itself, by its unique exhibitions and continuous experimentation, has been responsible for this development.

It should be remembered that the Museum conceives the photograph, the lantern slide, the color transparency, as works of art in themselves. These media, today, are rewriting the history of the arts with a velocity and in a manner unprecedented in any other age or culture.[98]

Moeller credits MoMA for the broader cultural shift recognizing the art and specialization of photography, including documentation photography. In general, the 1962 report captures an inflection point in the internal photographic history of the museum, precipitated in part by the escalation in the circulation of their images through reproduction requests managed by Moeller. In the same report, staff photographer Rolf Peterson (who would have worked closely with Moeller) noted, "It is evident already that the Museum relies heavily on photography and the 'image.' Every department is woven into the whole, vast field of photography, in one way or another."[99] As a result of the report and the forceful arguments by Moeller and Peterson, by the next year, the museum was pursuing plans to install a studio with two darkrooms and a small copy room for rephotographing prints, confirming that the production of photographic images was at the heart of museum activities, and installing staff positions like Moeller and Peterson as overseers of the production process.[100]

THE ART LENDING SERVICE AND PHOTOGRAPHY: THE ATGET PORTFOLIO

The same year of the survey regarding the uses of photography *within* the museum, in 1962, a new curator was appointed to shape how the museum presented photography to the public: John Szarkowski, who the *New York Times* would later define as "a curator who almost single-handedly elevated photography's status in the last half-century to that of a fine art."[101] As a "vast field of photography" was suffusing the museum's day-to-day activity, and as the publishing field was multiplying an image's life, curators like Szarkowski attempted to wrangle the medium into something legible for the art-collecting public, promoting photography connoisseurship and cultivating a market for photography. Szarkowski did this through emphasis on the craftmanship of the printing process and continuing MoMA's legacy of defining straight photography as an art synonymous with modernity

itself. This section will survey the landmark restrike and sale of posthumous prints by Eugène Atget, a unique project that served both of these ends, even while collapsing boundaries between original and copy, fine art and commodity, to suit the museum's evolving schema around photography and value.

Atget is fundamental to the development of a photographic canon discussed throughout this chapter. Newhall's genealogy of straight photography begins with him, similar to Picasso's role for Barr. Newhall casts Atget as proto-modernist and the measure that contemporary photographers must meet in order to be counted as modern; the artists who MoMA promoted—Walker Evans, Edward Weston, Alfred Stieglitz, and Ansel Adams—are identified as continuing Atget's legacy. While Newhall first advanced his photographic canon with his 1938 exhibition and catalogue (in which he signaled out Atget as a key figure), it was in the 1948 edition of *History of Photography* that he consolidated this history. In this volume, he emphasizes the importance of "The Straight Approach" and attributes the development of American photographers' style to their exposure to Atget:

When Atget's photographs were first shown in America in 1930, many younger photographers found them an inspiration, for they revealed the power of the *straightforward, direct use of the camera*. The word "functional" was coming to be applied to architecture, machine art was being discovered, the esthetic of the moving picture was being investigated. This doctrine of "straight photography" brought about the esthetic recognition of Atget, as well as of Brady and Nadar; the historian learned of them through the practicing photographer.[102]

Newhall attributes Atget's value, and thus the value of the other artists included in the "straight approach," to the embrace of the pure potential of the medium, insisting that Atget "had no reference to any graphic medium other than photography" and that the straight approach was "not so much a discovery but a recognition."[103] This description of photography encourages artists to channel the inherent objectivity of the medium as an aesthetic choice. Newhall's allusion to straight photography, functional design, and machine art represents the coalescing ideas around the promise of technological modernism in the 1920s and 1930s, influenced by photographer Paul Strand and Alfred Barr, through which Atget's photographs were interpreted.[104]

Paradoxically, Atget might not have been visible to Americans without the intervention of an American photographer who was not promoted by

Newhall with the same enthusiasm reserved for the photographers listed above: Berenice Abbott. Atget himself was reclusive. From 1898 to his death in 1927, he roamed the streets of Paris, obsessively documenting a rapidly changing city, capturing storefronts, architectural details, and interiors. He did not see himself as an artist; rather, he worked for other artists, libraries, and government agencies, producing a work product that he saw as "simple documents" for others to make use of.[105] When the Surrealists took him up as a kindred spirit in the 1920s, his reaction was bemused resistance. Molly Nesbit has addressed the class politics at the heart of this—Atget was seen as a "man of the streets" (as he was defined in Pierre MacOrlan's preface for a 1930 monograph), thus representing a culture that Surrealists were fascinated by but decidedly outside of. By claiming Atget, they were claiming an alliance with a political class not their own.

Abbott learned about Atget through her association with the Paris Surrealists. She had moved to Paris in 1921 as a young artist and actress and worked as Man Ray's darkroom assistant before developing a photographic practice of her own, making portraits on commission. Atget's studio was near Man Ray's, and Abbott began to visit him, buying select prints and taking the only known portrait of the aging artist. In 1927, when she returned to his apartment to share the developed prints, Abbott learned of his death. After tracking down the executor of his estate, Andres Calmettes, who had sold a bulk of Atget's estate to the French government, Abbott, determined to safeguard his legacy, acquired the remaining negatives, prints, and slides: approximately 1,500 glass plate negatives and 8,000 prints.[106]

Shortly after this historic purchase, Abbott returned to the United States, and with her, a mountain of glass negatives moved across the ocean. Atget developed his negatives on 18×24-cm plates, just four of which weigh 12 lbs., and they had to be stored and packed carefully to prevent shattering. Abbott recalled cleaning, classifying, and packing each slide in a glassine envelope, a process that took several months.[107] Once in New York, Abbott edited and helped to publish the 1930 monograph *Atget: Photographe de Paris*, but months later, in financial straits after having watched her portraiture business flounder, she sold half of her interest in the Atget collection to gallerist Julian Levy.[108] Together with Levy, Abbott continued to promote Atget's work, writing articles, publishing monographs, selling and exhibiting prints, and producing a portfolio of new prints from his negatives.[109]

THE MUSEUM WITHOUT WALLS

According to Nesbit, Abbott echoed the Surrealists' fascination with Atget but within a new frame. Less sensitive to the nuances of the European class politics, she "turned Atget's cultural difference into a photographic one."[110] That is, Abbott defined his approach though his photographic aesthetic rather than his embrace of working-class subjects. This aesthetic was one of totality, of an unwavering commitment to the exhaustive cataloguing of Paris's urban environment: "Here is the great demonstration that photography is a cumulative art. . . . Only with Atget's photographs, the direct sight is at least seen, in intimate impact with a city, a civilization with all its amplifications, an epoch of history."[111] This kind of cumulative impact could only be achieved with an eye that was sensitive to the beauty of the everyday but neutral; Abbott described seeing Atget's work for the first time as the "shock of realism unadorned. . . . The real world, seen with wonderment and surprise, was mirrored in each print."[112] The photograph as "simple document" was without embellishment, mirror-like.

Abbott's assessment of Atget was echoed by other photographers and MoMA curators within the first decade of her return to the United States. In 1931, Ansel Adams wrote, "The Atget prints are direct and emotionally clean records of a rare and subtle perception, and represent perhaps the earliest expression of true photographic art."[113] For Adams, Atget's approach is representative of the ineffable "true" photography. In turn, Newhall insists Atget's importance is in his "straightforwardness" in his exhibition catalogue *History of Photography 1839–1937*, including more prints and objects by Atget (borrowed from Abbott) than any other photographer in the initial exhibition.[114] In 1950, MoMA acquired fifty prints from Abbott in 1950 through an anonymous donor, and in 1968, they acquired the full collection of Atget's studio from Abbott and Levy (including that mountain of glass). This commitment to representing Atget in the collection was a reflection of the continued assessment of Atget's influential place in the genealogy of photography and modern art, as Picasso was to painting. In the press release for the 1968 acquisition, Szarkowski states as a matter of fact Atget's role (never asked for or enjoyed in his lifetime) as primary exemplar for generations of photographers:

A documentary art work must appear to be unmanipulated, literal, clear, complete, and easy; it must not allow its art to show; it must not be obviously elegant or ornamental; it must at least pretend to objectivity. To those who have

explored and developed this aesthetic during the past forty years the work of Eugene Atget has served as both touchstone and benchmark—a standard against which to measure both the quality and the position of their own work.[115]

In these words, Szarkowski's passive voice suggests that the curator is a simple recording machine to capture the evolution of photography over decades while in the same passage, in an announcement about a museum's acquisition, providing the approved language to assess the value of "documentary art work."

Atget's photographs are repeatedly instrumentalized to make a claim for photography. First, the Surrealists saw in his images of Paris street life the fantastical and sinister edges lurking beneath the banality of commerce (reproducing his prints of mannequins and gathered people watching an eclipse in the journal *La Révolution surréaliste*). Then, with Abbott's voyage by ship, Atget was translated into a functionalist, pragmatist American order, allowing MoMA curators to claim him within a genealogy outside his immediate experience. Atget's photographs are thus continuously drawn into networks outside of the artist's intention. In many ways, by insisting on his role as a producer of documents, this is exactly the network relation Atget was encouraging for his work: by denying authorial intent, he invited others to find applications (and thus new networks of distribution) for his pictures.

Atget's role in the assimilation of photography into the discursive field of modern art involved the collaboration of multiple MoMA departments. In 1960, curators Grace Mayer and Edward Steichen worked with a relatively new volunteer group at the museum, the Art Lending Service (ALS), which allowed patrons to "rent" works of art for a set period with the hope that it would lead to a sale (the group was equally motivated by the museum's mission to produce citizens educated to appreciate modern art and the opportunity to generate revenue).[116] In an exhibition titled *Photographs for Collectors*, the curators explicitly sought to position photography as collectible fine art, fashioning the museum as art advisor and historian at once by encouraging members to purchase any of the prints on view through the ALS. Out of sixty-six photographers, Atget generated the most sales. Overall, the exhibition raised $2,200 for the museum but hundreds of photographs returned to the ALS for future circulation, and the committee remained frustrated by collectors' hesitance to explore

THE MUSEUM WITHOUT WALLS

the photography market.[117] A survey that year about interest in collecting photography captures the response of many patrons: "Photographs are in a sense reproductions and ought to be cheaper than they are, at least until a photography collecting public of some size can be encouraged. The MoMA can take the lead."[118] The anonymous respondent's assessment of the confusion around the value of photographs against other types of reproductions proved correct, and sales of photography through the ALS did not proceed at the pace desired. Correspondence with Szarkowski in the early 1960s demonstrates that the Junior Council frequently asked him for help refreshing their catalogue to remove unpopular stock and promote fresh sales.[119] By 1965, a total of 623 photographs had been handled by the ALS since October 1960, of which 230 were purchased.[120] In 1968, minutes from the Junior Council's Committee on Photography indicate the group was again investigating projects "for the purpose of encouraging the collection of photographs," considering the production of a special edition or a handbook for potential collectors of photographs.[121]

Despite slow progress, throughout this period, one photographer's sales were relatively consistent: Atget. With this mind, ten years after the Abbott-Levy Collection was acquired, MoMA did something unprecedented: they oversaw the production of an edition of posthumous prints for sale. This was unprecedented in part because of the prevailing discourse around photography at MoMA at the time. Though the museum had acquired glass negatives when they purchased the archive from Abbott, it wasn't clear what they would do with them—just as when Abbott moved them across the sea, the glass plates were not yet photographs in themselves but potential images. Making new prints, as Abbott had done, would have gone against Szarkowski's doctrine, which insisted on the role of the artist in the photographic printmaking process as a way to assert the photograph as an art object. Yet, Szarkowski was dedicated to the promotion of photography, and like Newhall, he located the key to photography's status as art in Atget's documents for hire, as when he asserted, "[Atget's] creative achievement has in large degree defined the direction of photography's endeavors."[122] The art historical importance demanded, or justified, creative approaches to rescuing or reviving the negatives that represented Atget's eye, beyond those which he was able to print in his lifetime.

One of Szarkowski's primary objectives in educating potential photography collectors was to assert the value of original prints. Through this attention to the skill of the artist and the historical specificity of photographic production, the perception of photographs as mere "reproductions" could be undermined. Printing Atget's negatives without his involvement required significant discursive work justifying the decision. One telling distinction between prints produced in the 1970s and those produced during Atget's time was the printing substrate. Broadly, in the history of photography, albumen paper, which requires a printing-out process (meaning no developing fluid is needed), was the most popular material for photographic printing in the nineteenth century. Albumen paper produces prints with a greater tonal range and less contrast between the whites and blacks of an image, resulting in a glow-like quality observed in original Atget prints. In the twentieth century, gelatin silver printing, which uses a developing-out process that is more stable than albumen, superseded the earlier printing process, and albumen paper went out of commercial production in 1929. During Atget's time, both papers were available commercially, but he used albumen paper more often than any other type. The museum could not attempt to re-create Atget's hand in the studio without the paper he favored.

The museum found a solution with Joel Snyder, a young photographer and art historian who sought to reproduce albumen prints in a bespoke process. In the 1960s, Snyder had turned to the recreation of nineteenth-century processes as part of his research as a master's student in the history of photography at the University of Chicago.[123] In 1976, with Doug Munson, he founded Chicago Albumen Works, re-creating nineteenth-century paper that had gone out of commercial circulation, like albumen and salt paper, by using old technical manuals and relentless experimentation. In 1977, Szarkowski became aware of Albumen Works and reached out to them to produce the new Atget prints. Ultimately, Albumen Works produced a new edition of one hundred prints from twelve Atget negatives selected by Szarkowski. Seven of the twelve negatives selected for reproduction in the edition were not available as extant prints, and all were selected "on the basis of their aesthetic quality and rarity."[124]

A glossy brochure touting the new Atget edition highlighted the reproduction of the albumen process and its historical patina. Short essays by

THE MUSEUM WITHOUT WALLS

Szarkowski and Snyder ran side by side. Snyder's essay details the process by which albumen prints are made, emphasizing the high degree of difficulty. Szarkowski's text praises the work, asserting, "I know of no posthumous Atget print—apart from the edition announced here—that could be mistaken for a print from Atget's hand by one reasonably familiar with his work."[125] In fact, due to the "astonishing similarity" to Atget's prints, Szarkowski was careful to note, "Each impression bears, on the image area, a blind stamp bearing the legend MOMA-1978_CAW, to prevent possible confusion with Atget's own prints."[126] In this case, metadata serves to inscribe an origin story; provenance is a longstanding epistemological tool of art history. By naming its supposed inauthenticity by acknowledging the prints were not crafted by the artist's hand, the stamp paradoxically ensured their place within the market. The edition was limited to 100 prints, numbered and registered, carefully delineated and optimized for insertion into the market that Szarkowski had so carefully cultivated over the past decade.

The Atget reprint could not have been made until a stand-in activity could replace that auratic touch. Here, labor, rarity, and specificity of place take the place of original artistic intention and replace authenticity with connoisseurship. Snyder notes in his essay, "The process it [albumen paper] involves is distinctly French. It is elegant, demands an authoritative though delicate touch, and is quite unpredictable. It is a process more in keeping with the practices of the kitchen than the darkroom."[127] Whether Atget, the rugged "man of the streets" who bought the paper off the shelf, would have interpreted the process in the same way is immaterial. It is the collector's eye that must be satisfied.

The edition included a range of Atget's subjects, from Paris street views of the vendors and store windows that had captivated the Surrealists, to interiors, architectural views, and landscapes. Yet despite Atget's primary characteristic as a chronicler of Paris street life, the most popular images in the first year of sales, were three views of nature.[128] The first to sell out, *Etang de Corot, Ville d'Avray* (before 1910), is dominated by a banked canoe illuminated by silvery light reflected off of a lake. The next two most popular, *Parc de Sceaux, Juin 7th, Matin* (1925) and *Vieux Puits, Petit Chemin, Reu de la Gare, Chatilloln* (1922), also feature vaporous light shining though trees. The misty light in these scenes makes the most of the effects of the

albumen process, but the fact that the most ethereal and romantic scenes were the most popular undermines Atget's legacy as a producer of "straight" documents.

Among the reviews of the edition, only art critic Andy Grundberg took up the question of what a "restrike" meant to the evolving process by which photography was incorporated into the art world. In an article for *Art in America*, he noted, "The project revises the question of whether attempts to duplicate any artist's spirit or sensibility are critically defensible."[129] He cites Robert Doherty, director of the International Museum of Photography at the Eastman House who equated the idea of restrikes to the production of "counterfeits." Yet, after introducing the controversy, Grundberg pivots to dispassionate speculation on the effect of the restrike on the Atget market while leaving questions of ontology and indexicality as mere provocation.[130] The suggestion is that ultimately, it is the market that anoints originals and counterfeits.

Elsewhere, theorists like art historians Krauss, Nesbit, and Wolfgang Bruckle address Atget's place in the discursive formation of photography—between archive, commodity, aesthetic object—without taking up the question of the restrike and the materiality of the albumen prints.[131] Per Krauss, Atget's work is inseparable from the archives with which he worked, yet per Bruckle, such a reading undervalues the aesthetic content and Atget's contribution to the subsequent recognition of documentary style. Nesbit approaches Atget's work with the greatest nuance and depth, exploring his works in the networks of communities who bought them, starting with the blunt idea that his works were intrinsically "commodity pictures," bound for varied and heterogeneous networks of use.[132] All of the scholars are motivated by a larger argument: to what degree is it appropriate to apply aesthetic frameworks to the documentary photograph? In essence, this is a question of ontology, as defined as a set of schema in which the author's and viewer's intentions are encoded and interpreted. Through iterative ontologization, glass negatives, original and posthumous albumen prints, lithographic reproductions in books and brochures, and gelatin silver prints are alternately unified under the concept "photographs by Atget" or dismissed as inauthentic. The discussion around Atget's value and theoretical contribution to photography happens regardless of the act of the restrike, but the iterative ontologization captured by the restrike points

THE MUSEUM WITHOUT WALLS

127

toward myriad material forms that undergird these discussions. Looking to these moments—of reproduction, reprinting, and sale—show that the theoretical questions of decontextualization, value, and authenticity, which are discussed in academic exchanges, are also addressed by committees like the ALS, which define the material qualities of authenticity. Motivated by the desire to circulate, authenticity is produced through the fabrication of supposedly authentic material. Attention to materiality and focus on the production of historical specificity buttress claims of faithfulness to artistic intention, and thus to aesthetic quality, while at the same time obviating the need for the original.

Throughout the 1960s and 1970s, as the museum was increasingly trafficking in reproductions (through the potential to produce restrikes and through the sale and circulation of published reproductions and image licenses), there was a corresponding intensification of attention to the material. The classic Benjaminian dialectic of duplication and circulation against authenticity and aura is reframed as a positive feedback loop. With the Atget restrike, organized by a committee with the imprimatur of its curator for both commerce and connoisseurship, aura was renewed through the controlled reproduction and circulation. In microcosm, this is the function of the museum. Control of the definition of property (virtual and material) is a reflection of the discursive work done throughout the museum, accomplished through photography and circulation.

CONCLUSION: THE MUSEUM WITHOUT WALLS

Museums have been theorized in terms of the authority accrued via the accumulation of capital in the form of their collection, the production of spectacle through architecture, and the ideological aspects of exhibition design—all interpretations that concentrate on the museum as a unified site.[133] Alternatively, the history of MoMA relayed here is centered on two ideas: (1) the primacy of the museum's circulation function and (2) the iterative ontologies produced by circulation. Throughout, the photographic reproduction simultaneously creates and resolves irreconcilable contradictions: between original and copy, educational tool and commodity, forces of democratization and elitism, the global art museum and the entrenchment of the ideology of Western supremacy.

Through the efforts of staff like Elodie Courter, the museum regularly exported the didactic tools for modern art appreciation, all neatly packed in shipping boxes, in order to educate the American public and global audience about how to be a model Western spectator to contemporary modern culture. These boxes were essential media objects for disseminating an ideology of museums and modern art across the world, and the physical work of circulating them has been inadequately valued. Lynes records Courter's decision to resign in 1947, soon after taking a leave of absence for having a child: "Her pediatrician, Dr. Benjamin Spock, when she told him that the time had come for her to make up her mind whether to go back to the Museum, asked her, 'What do you do at the Museum?' She explained what her department did, and he said, 'I think I'd let somebody else pack the pictures.' 'That seemed like such a blow to me,' she said."[134] By decentering the museum walls in favor of the boxes, slides, and envelopes that flowed in and out, I hope to retroactively and cosmically assure Courter of the magnitude of her work.

These exhibitions, contained in boxes, were not only educational—they set terms for the value and function of photography for an art-viewing public. The circulation of Evans's photographs demonstrates that the same set of photographic objects is drawn into configurations that are alternately called a book, a portfolio, an exhibition of African art or architecture, and an exhibition of photography. Further, photography is one powerful method used to both mark and assimilate "othered" categories, such as vernacular architecture and "primitivism," into the white cube space, claiming that which is photographed for the discursive space of the museum.

As a piece of media moves across different contexts, it is defined differently by different communities, leading to what I have called iterative ontologization. Throughout this chapter, the reproduction is used differently by photographer, librarian, curator, fundraiser, and collector, and the diverse uses lead to competing definitions of photography. Curators and insurance assessors alike seek to resolve competing definitions through evolving ideologies of photography. As Allen Sekula has written, "Photography needs to be won and rewon repeated for the ideology of romanticism to take hold."[135] This battle is waged not through the single auratic print but through the circulation of reproductions.

THE MUSEUM WITHOUT WALLS

129

At MoMA, the collection of photographs as fine art and collection of photographs as documentation developed in tandem. For both, documentation was an operative concept, but it functioned differently. MoMA photographer Soichi Sunami demonstrates this difference. Like Evans, Sunami created documentary work on commission. His work was valued by the museum for his neutral documentary style; in the words of Richard Tooke, who succeeded Moeller in 1969, "His kind of photography was what I've begun to think of as the right way to photograph works of art, especially sculpture; no theatrics were involved."[136] Evans and Atget, whose work is often defined by similar qualities—a lack of theatrics, a commitment to the spirit of the document—are represented in the permanent collection. Sunami is not. This is partly because of content, of course—Evans and Atget photographed the world outside, while Sunami photographed the world inside the museum's walls. But the curators and collectors who wrote about how photography was to be valued did not write about content; they wrote about, in Lincoln Kirstein's words, "perfect documents."[137] The perfect documents that populated their permanent collection and the perfect documents that documented that collection had to remain distinct.

The epistemological coherence of the museum as Crimp defines it depends on clear boundaries—between inside and outside, between original and copy. Throughout this chapter, we can see how these formal distinctions were maintained not by walls but by a variety of circulating objects. The more physical, conceptual, and legal walls they escaped from, the more people and paperwork were dedicated to the management of their circulation. Ultimately, the popularity of the concept of the "museum without walls" that opened this chapter has primarily served to promote the fiction that there is any such thing as a museum that operates only within walls.

3

"YOUR STORY IN PICTURES LEAVES NOTHING UNTOLD": H. ARMSTRONG ROBERTS AND THE RISE OF AMERICAN STOCK PHOTOGRAPHY

Every image of the past that is not recognized by the present as one of its own concerns threatens to disappear irretrievably.
—Walter Benjamin, "Theses on the Philosophy of History," in *Illuminations* (New York: Schocken, 1969), 255

A 2016 *New York Times* op-ed, "Does Decision-Making Matter?" was accompanied by an anachronistic image: a black and white photograph of a blindfolded, three-piece-suited man, arms outstretched comically over a desk scattered with papers[1] (figure 3.1). A contemporaneous feature in *New York Magazine*, a personal essay titled "I Breastfed an Adopted Baby for 7 Months," was illustrated with a similarly droll image of a chubby baby seated in an overstuffed leather armchair holding a rotary telephone to his or her ear.[2] Both photographs seem to have been selected by the respective art departments at the *New York Times* and *New York Magazine* for their irony. The props clearly reveal that the images are not contemporary, and their exaggerated setups perform a knowing wink to viewers for whom the construction, circulation, and critique of these types of media images are familiar features of visual culture. In other words, the consumer of these images knows that the photographs were not taken for these articles in particular but were rather selected from a pool of available photographic images known as "stock photography," defined by the fact that they are

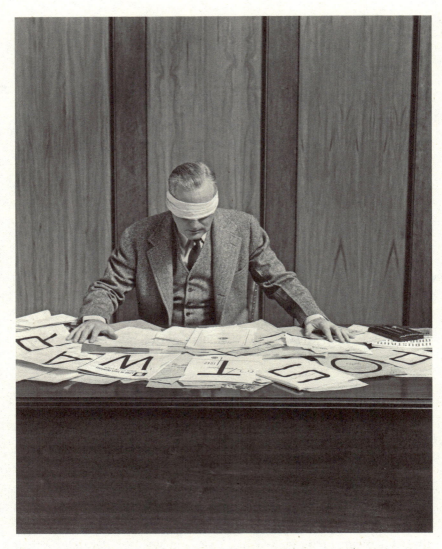

3.1 O1839. Circa 1945 photograph by H. Armstrong Roberts. A similar H. Armstrong Roberts photograph (taken from the same shoot, with the taped "Post War" letters missing or digitally removed) accompanies the editorial "Does Decision-Making Matter?" on the *New York Times* website (November 25, 2016). Courtesy Robertstock/Classicstock.

made available for purchase as readymade illustrations, most often author-less and without connection to any one specific context.

The use of the old stock photographs by the *Times* and *New York Magazine* is meant to be humorous. The performative staginess is funny; it's funnier still to imagine the historical consumer who wasn't in on the joke, who took these images at face value. Seeing these selections as funny thus depends on the mainstream awareness of broader critiques of advertising imagery that have emerged out of the field of visual culture over the past several decades that theorize the ideological and constructed nature of commercial images. The use of old stock photographs seems like a reminder of a time before the knowing irony of postmodern culture, and the aesthetics of early stock are newly strange in their reappraisal. Indeed, they seem to erupt into the present, like a Benjaminian "dialectical image," "failed images" from a past era that reappear in our own as allegory, which in turn reveal the mechanics of myth-making.[3] Such images, according to Benjamin, demand a materialist interpretation: What were the conditions of production of these images, and how did their creators conceive of their aesthetics and purpose? In fact, the shots selected in the *New York Times* and *New York Magazine* to illustrate their twenty-first-century op-eds were taken several decades ago under the name of a photographer whose hundreds of thousands of images have appeared in newspapers, magazines, print calendars and postcards, digital media, and art exhibitions throughout the twentieth century: H. Armstrong Roberts, architect and namesake of one the longest-running stock agencies in the United States, founded in 1920.[4]

Over the century since Roberts Sr. started his business, stock photography as an industry has emerged, ballooned, fractured, and transformed into the multibillion-dollar industry it is today, controlled by an ever-shrinking number of conglomerates.[5] And the industry is growing: market research indicates that the global still-image market will exceed 4 billion dollars in 2023, with a compound annual growth rate of over 5 percent.[6] Cultural attention to this billion-dollar industry is more acute than ever before: humor websites jokingly gather lists of absurd examples of stock photography, new startups encourage amateur photographers to sell their Instagram snaps as stock, and contemporary art exhibitions are organized around the aesthetics of stock photography.[7]

Across these examples, ideas about the role of stock photography in the politics of representation are central. The critique of stock representations of women is as at least as old as sociologist Erwin Goffman's 1979 *Gender Advertisements*, which coded a corpus of advertising images (of which stock photography makes up a large part) to demonstrate tropes of infantilization and subordination of women.[8] Contemporary artists like Anne Collier and Hank Willis Thomas echo Goffman's strategy in works that rephotograph and re-present collections of commercial images to reveal stereotypical representations of gender and race.[9] The market has responded to this critique as well. Stock startups like TONL and BlackStockPhotos.org explicitly seek to correct the widely noted lack of diversity in the stock industry, taking the homogeneity of dominant stock photo agencies as a given. In 2014, Getty Images launched a "Lean In" collection of "powerful" representations of womanhood, implicitly acknowledging the previous lack of these types of representations (the launch directly followed a moment of widespread cultural attention to representations of women in stock with the viral internet meme of "women laughing alone with salad," which inspired tumblrs, websites, think pieces, and multiple rounds of press).[10] In 2019, noting the rise in interest in media stories covering trans and nonbinary people but the dearth of available stock photography, the media company Vice released a free, gender-inclusive stock photo library Gender Spectrum, offering "a stock photo library featuring images of trans and non-binary models that go beyond the clichés."[11] The critique of stock is so well entrenched, media theorist Paul Frosh asks if stock photography is perhaps irredeemable, as its "operations so patently exemplify processes of standardization, commodification, alienation, illusion and stereotypical classification."[12] Across all cultural registers then, and even within the industry itself, stock is acknowledged as a pervasive force in visual culture, both generative and reflective of stereotypical conventions and representative of a base commodification of images.

And yet, despite the widespread critique of stock, there is relatively little sustained scholarship on the history of the industry. A "border activity" and "transient, commercially-driven undertaking," as one scholar describes it, stock photography seemingly flourished at the edges of the history of photography.[13] Stock photography differs from other forms of commercial photography, from photojournalism, and from fine art

"YOUR STORY IN PICTURES LEAVES NOTHING UNTOLD"

photography, all of which have received more scholarly attention. There is less attention to stock photography within scholarship on the history of photography, and in-depth histories of advertising minimize the role of stock photography.[14] This is particularly true of the period before companies like Image Bank, Stock Market, and Comstock were founded in the 1970s, which defined the modern stock company through their use of slick marketing and an overt focus on advertisers. Frosh, who has written the essential (and singular) investigation of the stock photography industry from the perspective of media and critical studies, refers to the pre-1970s period as the "primitive" stage, "consisting as it does of an inchoate mass of small agencies serving a diverse range of sectors and purposes."[15] This chapter aims to deepen this history by exploring the prewar example of the H. Armstrong Roberts Company, whose international operation possesses characteristics Frosh applies to later periods of stock photography, including a global orientation and focus on advertising and marketing clients. I thus hope to expand on existing literature on the stock industry by arguing, echoing scholar Estelle Blaschke, that stock photography is more properly understood in the context of emerging consumerism, business administration, and the culture of modernity of the 1920s.[16]

H. Armstrong Roberts, the man and the agency, presents a particularly rich case for studying the history of the industry. By 1930, Roberts ran one of the largest commercial photography businesses helmed by a single photographer in the country, managing a collection of almost one hundred thousand negatives, with branch offices across the United States and Europe.[17] While other photography collections from this period have been absorbed into mega-corporations like Getty Images, H. Armstrong Roberts, Inc. has been held in the same family since its founding, preserving early records and papers. The business passed from father to son to grandson, as H. Armstrong Roberts Jr. took over from his father in 1947, then passed it to his son H. Armstrong Roberts III in 1979. Roberts III continues to run the company, now called Robertstock/Classicstock, which still operates out of the large Victorian building in Philadelphia that Roberts Sr. purchased and expanded in the 1920s as a live and work space. The building thus houses the history of both a family and a business, which were often intertwined. Furniture in the living spaces supported family during their recreational time and models when photography shoots spilled over

into domestic spaces. Office cabinets purchased in the 1920s still house documents central to image management, and deep in the basement, cold storage vaults hold the negatives that serve as the business's most treasured assets. Roberts III and longtime staffer Roberta Groves currently reside in the building and run the company (Groves began working for the company in the New York office in the 1970s; she and Roberts III married in 2021). The institutional memory is thus inseparable from personal memory, business history from biography. Where previous chapters have touched on the feminized labor of collection management, this chapter examines the birth of a business within a domestic setting, a business that went on to make the imaging of domesticity one of its primary products.

In telling this story, I narrate how the emerging advertising industry, Roberts's home/studio and family network, and specific office and media technologies, including the card cabinet and the marketing catalogue, function together as a machine that constructs a particular type of picture-work (the professional role of the *distributor* of images) and a particular aesthetic (the genre of the stock photograph, which promises realism but foregrounds the mechanics of storytelling in commercial photography). The metaphor of the machine applies across the systems of staff, office equipment, and information infrastructure. Networks of photographers, advertisers, and their professional journals and groups serve as legitimating machines that recognize the value of amassing collections of photographs for sale. The studio and offices that Roberts Sr. designs function as architectural machines for the production of new images. And a central card cabinet that compresses inventory into atomized units serves as a machine for accumulation and circulation. I use "compression" intentionally here, taking Jonathan Sterne's insight that media history can be understood as a general history of compression, in which various media signals are accommodated to new infrastructures. Understood in this way, Sterne argues compression is a generative process whereby signal and infrastructure condition each other. In the case of H. Armstrong Roberts, the signal (a new visual genre, the stock photograph as a commodified image) and the infrastructure of four central technologies (the ledger, the studio, the card cabinet, and the catalogue) are mutually constitutive. In the sections below, I will first trace the *infrastructure* that shaped Roberts Sr.'s early business practices, including aspects of his own biography, before moving on

to the *signal* of the photographic content and stock photography as a genre that invites deconstruction. I have argued that the circulating picture collection posits the image as alienable content, available for diverse uses outside of authorial intent. The stock photograph embeds this understanding of images in the history of photography, leveraging its supposed indexicality to instead produce realism as one effect among many. Over a century of exposure to these kinds of images has in turn trained viewers in how to read and deconstruct photographs as narrative acts of communication, and to understand the photographic image as a mass-produced product.

INFRASTRUCTURE: THE LEDGER AND THE STUDIO

Roberts Sr.'s biography and formation as a young photographer offers a portrait of the modern, image-savvy subject in the early twentieth century. From an early age, Roberts Sr. was interested in the collection and marketing of stories. His youthful travels, exposure to theater and the motion picture industry, nonfiction travel writing and fictional adventure writing, and work with publishing syndicates all contributed to his understanding of the photographic image. Throughout his lifetime, he referred to photographs as stories—stories that could be staged, like the movie sets he aspired to work on, or stories that could be captured, like the impressionistic travelogue. Roberts Sr. thus conceived of the stock photography business through his activity as a farmer, traveler, and writer, parlaying his familiarity with pitching adventure stories and working with syndicated publishers into the production of syndicated photographic illustrations. Syndication—the licensing of material for publication in multiple different periodicals—is key. As his grandson Roberts III put it, "He was familiar with the ability of stuff on the shelf to sell."[18] Roberts Sr. brought this understanding of syndication, or the financial reserve of "stuff on the shelf," into his work with stock photography. He also brought a visually distinct sense of storytelling, a product of the increasingly visually dense popular culture he was steeped in.

Roberts Sr. grew up at the turn of the century amid rapid strides in the development of modern camera and printing technology. He was born in Philadelphia in 1883, the same city where two years before, Frederic Ives had patented the first successful commercial technology for halftone

printing, allowing for the proliferation of photographic reproductions in newspapers and books.[19] When he was five years old, the first Kodak camera came on the market, with the slogan "You push the button, we do the rest." The aggressive marketing campaign and innovative system (in which the consumer would send the film roll to Kodak for processing) had immediate and widespread results—amateur camera clubs and magazines sprung up, and by 1898, over 1.5 million roll-film cameras had been sold to amateur photographers.[20] Roberts first boarded a steamship bound for Liverpool at age fifteen and, after being certified as an able seaman, traveled around the world by gaining employment on various ships. In 1904, he traveled by ship on a 135,000-mile trip around the world, visiting seventeen countries. One early self-portrait from this period was taken when he was working with a theatrical troupe in San Francisco, where he was first exposed to studio photography.[21] In 1908, a local newspaper reported that Roberts Sr., along with two other young artists and writers, were embarking on foot to Mexico to "gather stories."[22] The article goes on to mention the limited equipment that the group brought with them, which significantly included a camera (likely his first camera, which still remains in the archives of H. Armstrong Roberts Company; a Rochester Poco Stereo camera). Following his trips to Mexico, he created an illustrated lecture on Mexico that he delivered across Eastern cities, drawing on his own photography to do so.[23]

Roberts Sr. continued to fashion himself as a visual storyteller and adventurer as he entered the next phase of his life. In 1911, he married Marguerite Alexander, purchasing a chicken farm in Beverly, New Jersey. Together, they raised chickens, developing a business breeding and selling eggs, while Roberts Sr. continued to cultivate writing and photography jobs. Over the next decade, as their family grew, Roberts Sr. increasingly invested in the photography business at the expense of farming activities, and they eventually moved from Beverly into Philadelphia. By 1924, Roberts Sr. was managing a collection of 30,000 negatives, with 2,000 negatives of babies alone. He was running his own custom-built production studio, housed under the same roof as his home, printing labs, and business administration.

An accounting ledger from 1913–1920 tracks the dramatic transformation of their commercial activities, as the Roberts's moved from farming

"YOUR STORY IN PICTURES LEAVES NOTHING UNTOLD" 139

to publishing to photography sales. I dwell on the early farming activities and the transition recorded by the ledger to demonstrate that the flexible format of the general ledger allowed the numerical, systemic sale of eggs, writing, and photography to be equally subsumed under economic logic of circulation. Each of these activities was oriented around the need to accumulate an inventory of stock of various kinds and also carried muddled senses of authorship (film production and syndicated publishing) and correspondingly complicated ownership structures. The ledger allows for the abstraction of items that is necessary for the administration of a collection: eggs, articles, and photographs are all reduced to a number, integrated into a system. This affordance of ledgers, in which diverse items can be reduced to homogeneous entries, is tracked by art historian Hannah Higgins in her book on grids, comparing the emergence of the double entry ledger in the Italian Renaissance with the contemporaneous development of perspective painting, noting that "both (at least in this foundational time), suggested ways in which the entire world could be conceived in homogenous and interrelated terms. In perspective, space is homogenous. In ledgers, capital is. The implications are vast."[24] Centuries later, the rationalization of both representational space and capitalism in Western culture converged in Roberts Sr.'s emerging business, in which the fine grid of halftone printing opened up the possibility to homogenize the printing of graphic elements like photographs, allowing for the commodification of the image license. Tracking the evolution of that business in time in the lines of the ledger captures in vivid detail the conditions that led to the founding of an early stock photography agency.

The ledger begins in February 1913, with carefully ruled lines designating the yield and sale of chicken eggs on the farm. By July 1914, the egg counts cease, and the lines begin to fill up with a different form of commodity. At that point, Roberts Sr. began selling stories about chicken farming to various publications, such as *The Country Gentleman*, and through companies like the Philadelphia-based McGuckin Syndication Co. (which was significantly also an advertising firm, founded by Eugene McGuckin, an advertising executive who had specialized in automobile advertising) and tracking publishing fees in the ledger. He pursued other forms of storytelling as well, including writing movie treatments. Family lore suggests that when Roberts Sr.'s family established themselves in Beverly, he

became friendly with people working in the motion picture business in West Orange, New Jersey.[25] While Thomas Edison's famous glass-enclosed studio, the Black Maria, had moved to New York City in 1901, the production hub of the Universal Film Company was located in Fort Lee, New Jersey, and the locus of the film industry had not yet shifted to California. Roberts Sr. was enthralled by the movie business and sought to contribute adventure stories for production, anticipating his interpretation of the role of photographer as a producer. Throughout the teens, Roberts Sr. wrote and sent out multiple film "scenarios," under multiple pseudonyms, to producers in California and New Jersey, with titles like "The Rustler," "The Cat's Paw," and "Back to the Farm." He dutifully tracked the submissions of these treatments in his ledger, though received few replies.

While his foray into motion picture making was not as successful, Roberts Sr.'s writing career flourished. The ledger for 1918 reflects several recurring monthly payments from the Philadelphia *Public Ledger*, the McGuckin Syndicate, and royalties on articles such as "Poultry Pointers." Many of these early articles, offering specifications about farm equipment, included technical drawings most likely produced by Roberts Sr. (he trained as a draughtsman at the Ben Franklin School of Naval Architecture). But they are increasingly replaced by his own photographs, as in the artfully cropped images of sacks, barrels, and bushels, for instance, for his 1918 story "Cashing In on Containers" for the *Country Gentleman*, which discusses the importance of marketing and packaging for shipment of produce. In Roberts Sr.'s own accounting in autobiographical manuscripts and interviews, his growing interest in photography stemmed from his need to illustrate his own articles.[26]

As the decade draws to a close, the lines of the ledger fill up with titles of prints sold to various publications, independently from his articles. In November 1919, for instance, Roberts Sr. sold prints to clients including the magazines *Rural New Yorker*, *Farm and Fireside*, *Motor Boat*, and *Power Boating*, as well as publishing companies Pheeps Publishing and the Osborne Company. This month, he also carefully tracked how much of his monthly haul came from photographs—the only subtotal he noted among the many endeavors in which he was engaged. He seemed to be weighing the viability of turning his supplementary venture into a full-fledged business. Around this time, he also carefully makes lists of his photographic clients,

"YOUR STORY IN PICTURES LEAVES NOTHING UNTOLD"

divided into "Publications that have bought photos," including *Good Housekeeping* and *National Geographic*, and "Advertisers that have bought photo," including Knapp & Co. in New York and Foley Advertising Agency in Philadelphia.

By 1920, business appears to be almost entirely photography based. At this time, the ledger records descriptions of the photos sold—"kids flying kite," "mother and boys go fishing," "duck shooting," "gunning," and "cow," among others. The reference to kids and mothers also alludes to how development of his business was continuously entwined with his growing family, as his children, born in 1915 and 1917, served as models and Marguerite served as model, photography assistant, and all-around administrator. Alongside the ledger, a contemporaneous portfolio demonstrates how the categories of his professional photography spilled into his family life and vice versa. A bound album of mostly family pictures also includes shots that were used for advertising campaigns. In these photos, sometimes the children are pictured with Marguerite, sometimes with a model posing as mother, with seemingly little distinction. The homogeneous space of representation Higgins observes in Renaissance painting equally absorbs Roberts Sr.'s real family life and the illusions of family life constructed for his business, newly extractable as commodities.

In the last shift captured by the ledger, the photographs that were initially tracked with titles such as "Sandy at the Beach" are replaced by a different kind of identification system, with sales recorded for "N-6" and "T-17" in July 1921. In these cases, the letter indicates the first letter of a type of subject, such as "Nurse" and "Tree." Letters are not limited to a single subject, as "A" can apply to both Angling and Ailments, and the number increases as new shots are categorized under that letter under various subjects. The identification scheme was optimized for efficiency, allowing for easy expansion. The abstraction of multiple subjects gathered under a single letter supports the growing collection's pervasive polysemy. By 1922, the numbering sequence is in the hundreds for several different letters, indicating the exponential growth of Roberts Sr.'s photo inventory. As numerical markers replace the narrative description of titles, the logical conclusion of the ledger as paper machine is reached. The tracking that the ledger was able to accomplish set conditions in place for the rapid accumulation of stock images churned out through an equally rationalized production process.

This accumulation was made possible by a new production studio, another key infrastructural element that enabled his business to scale. In the early 1920s, likely using the money from a small inheritance and the royalties from book sales about poultry farming, Roberts Sr. purchased a large Victorian duplex in West Philadelphia. There, in addition to living quarters, he constructed a studio, labs, printing facility, storage, and offices to support his growing business, creating a space that would sustain the business into the twenty-first century, where Robertstock/Classicstock still operates today. From here, he expanded his repertoire from the active outdoor shots of athletes, fishermen, hunting dogs, and children playing on the beach, for which he originally became known, to include staged studio photography depicting domestic and business settings. In the studio, Roberts could design cinematic scenes, producing photographs that exhibit a "potent combination of manipulated time, photographic realism, and constructed sets [that] was made familiar to early-twentieth-century consumers through cinema," as Elspeth Brown describes the dominant style in advertising photography in the 1920s.[27]

The references to cinema were deliberate, as Roberts borrowed production techniques from his experience on film sets. The centerpiece of the building was the glass-ceilinged studio built as an addition on the third floor. Constructed for the express purpose of photography shoots, the room was ringed with windows and shades to either let in natural light or strategically block it out from targeted sources (figure 3.2). A bay window and Juliette balcony offered an attractive setting for domestic interiors. It was also outfitted with portable lights, reflectors, and rolling platforms fitted with casters, allowing for a sophisticated production setup that could accommodate a variety of camera angles and lighting arrangements. Through large French doors (which also served as the backdrop for thousands of shots), a series of rooms served as dressing rooms for the models and storage for props. In addition to the studio, Roberts Sr. didn't hesitate to use all corners of the house. One bathroom was specifically constructed with two entryways, one of which opened through a doorway several steps above the floor, to allow for shoots from above such as B6703 (figure 3.3). Downstairs, living and office spaces served as backgrounds for domestic shots, such as H1605, which shows Roberts Sr.'s daughter and mother-in-law fixing a pie in the kitchen (figure 3.4). The domestic scenes also

3.2 U1491. Photography shoot at H. Armstrong Roberts Studios, 4203 Locust Street, c. 1928–1929. Staff photographer shooting Roberts Sr. and Becky Edmunds as models. Courtesy Robertstock/Classicstock.

suggest another influence beyond cinema—the illustrated magazine covers of newspaper Sunday supplements popular in the early 1900s, which frequently pictured illustrations of women engaged in domestic tasks.

With the studio came greater opportunity to use props, allowing for the production of shoots that could be directly pitched to various ad campaigns. Roberts III describes the shoots and how the photographer would use a variety of popular props in alternate shots in order to make the most of the time spent on the shoot. Tobacco, beer, milk, and bread, perennial commodities that were in constant demand by advertisers, could contribute to an evergreen stock of material for potential clients.[28] They were regularly incorporated into scenes for the day. Props, and the space to store and deploy them, were essential tools for Roberts Sr. to expand the genre of advertising photography, making sure that the investment in a single shoot would yield the greatest amount of appealing pictures for sale. With his studio and the various rooms of his home to photograph, Roberts Sr.

3.3 B6703. H. Armstrong Roberts photograph showing bathroom at 4203 Locust Street. Courtesy Robertstock/Classicstock.

did not wait for advertisers to approach him with specific requests but used props as anticipatory forms of the product shoots that formed the bulk of commercial work. This recurring use of a store of props, and the modular settings available within the home-cum-studio, represented the polysemy of the photographic image as conceived by Roberts Sr., where the addition of a telephone, cigarette, or top hat could drastically change a scene to attract different would-be buyers.

Roberts Sr. could not have grown his business without a growing demand from a growing advertising industry and the industry's gradual acceptance of

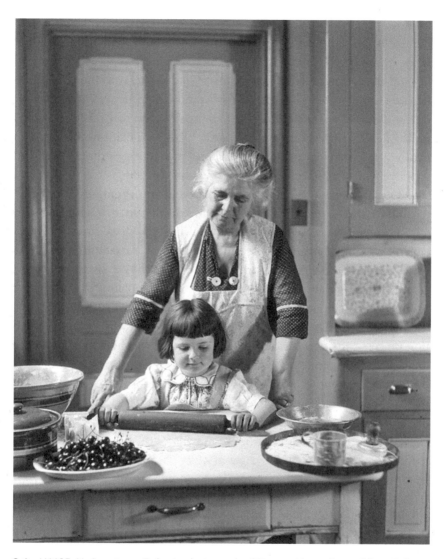

3.4 H1605. H. Armstrong Roberts photograph of Granny Alexander and Joan Roberts in the kitchen at 4203 Locust Street. Courtesy Robertstock/Classicstock.

photography. This broader commercial landscape is also essential infrastructure that shaped the early business. Between 1880 and 1920, advertising and marketing were consolidated as professional industries, and entrepreneurs like Roberts Sr. forged a new type of image in dialogue with these new businesses. During this period, the field of commercial photography boomed, differentiated from the portrait photography that had previously accounted for the field of professional photography.[29] Although halftone printing had allowed for photographic illustrations since the 1880s, photographers had to actively make their case for advertising photography.

While advertising agencies at the turn of the century employed in-house illustrators and art directors, they primarily turned to independent artists and photographers.[30] Even paintings and illustrations commissioned for advertising campaigns often used photography as a reference image.[31] In this way, image production for advertising campaigns was disarticulated, as an art director might supervise the production of a painting by one artist using a reference photograph by another. Thus, even with photography, the idea of plastic construction was built into the advertisement production process—the photograph was just one part in a whole that is collaged together. While photographers and illustrators represented two distinct professions sometimes at odds, both were independently employed and paid for their images by multiple agencies, adapting to the needs and tastes of a wide range of companies.

Photographers directly made the argument for the benefits of using photography in advertising in the pages of *Abel's Photographic Weekly* (a journal that initially addressed itself to professional portraitists, founded in 1907 by Juan C. Abel) and *Commercial Photographer* (founded 1925 by Abel's son, Charles Abel) and through the activities of the Photographers Association of America (founded 1880). As commercial photographers asserted their worth to advertisers, photographers who straddled artistic and commercial worlds paved the way. Edward Steichen cofounded the 291 Gallery in 1905 that established the intellectual and aesthetic stakes for art and photography in the United States for decades to come, before taking on the influential position of curator of photography at MoMA in 1947. Between 1924 and 1931, he worked for advertising firm J. Walter Thompson, opining about the uses and abuses of advertising photography for the executives there and creating iconic shots for companies like Jergen's Lotion and

Camel cigarettes.[32] Margaret Bourke-White, who went on to develop a high profile as a documentary photographer, began her career as a commercial photographer in the 1920s photographing factories and industrial design for in-house promotions, and spent the 1930s alternating between commissions for *Fortune* magazine and product shoots.[33] Using their cultural capital, these photographers helped to establish photography as a high-end, modernist option for advertising imagery.

By the 1930s, Michele Bogart argues, "Photographers managed to claim authority over representation in advertising."[34] This gradual shift in authority opened up the market for advertising photography to entrepreneurial amateurs as well as professionals during the first decades of the twentieth century. During that time, Roberts Sr. navigated identities of commercial, artistic, amateur, and professional that divided the photography world. He produced photography designed to appeal to advertisers and publishers, touting his artistic bona fides (including showing at galleries), and in turn was held up as a success story and model for other photographers in several publications in this period.[35] The earliest, in 1924, explains the business model: "Most important to our readers is the fact that Mr. Roberts sooner or later sells nearly every picture he makes at a good price, and when they are sold merely for illustrations the permission to publish is often sold several times."[36] Even as he began to hire other photographers, their work was sold under his name, using an artist's imprimatur like a brand. Using the identity of the artist-photographer, Roberts Sr. built his career as a *producer* of images and manager of a profitable *image collection* before these categories were available. In the words of a 1931 profile, "Today, H. Armstrong Roberts is no longer the name of an individual. He has become an international organization."[37] With photographic imagery now dominating visual culture, Roberts Sr. was able to build an international company selling photographic licenses.

In addition to the use of photography in advertising, photographic imagery in newspaper and magazine stories expanded as well. *Life* magazine, launched in 1936, is often held up as a key milestone in visual storytelling, developing the concept of the "photo-essay." The publisher's grand language emphasized photography as a new mode of communication that had ushered in a universalizing desire to see events from around the world. A 1936 advertisement for the magazine asserted, "The appeal of pictures is

universal. Pictures answer the Great Inquisitiveness which is born in every living animal, part of its lust for life."[38] The first issue sold out of newsstands on the first day, and production numbers and demand kept climbing, prompting Henry Luce to say in 1936, "Evidently it is what the public wants more than it has ever wanted any product of ink and paper."[39] As the magazine captured the attention of the public with its celebration of photographic storytelling, it treated its photographers as stars. Bourke-White, whose photograph of Fort Dam graced the first cover of *Life*, commanded a staggering $12,000/year salary and had her own office and staff.[40] This type of position and salary was not widely available, but more and more photographers were making a living in commercial photography.

The popularity of *Life* demonstrated that the legitimacy and allure of photography in print were well established by 1936, but when Roberts Sr. began working in 1920 as a producer of readymade photographic illustrations for the advertising and publishing industries, this context for commercial photography was just beginning to coalesce. By the time *Life* magazine capitalized on the cultural ethos in which "to see, and to be shown, is now the will and new expectancy of half mankind," Roberts Sr. had built an international business marketing himself as someone who had long been in the business of visual storytelling.[41] Ironically, for a magazine founded to promote the heroics of their commissioned photographers, *Life* used a stock photograph as the cover image for their first anniversary issue: a photograph of a smiling baby, courtesy of H. Armstrong Roberts (figure 3.5).

H. Armstrong Roberts, Inc. evolved out of family business and was able to grow because Roberts Sr. used his family members and living quarters as raw content to package for commercial images. His nuclear family and home-cum-studio were reducible to generic scenes that were commercially desirable at the time: scenes of domestic life that could serve as the backdrop for aspirational products for an American society that held consumption as its central identity. Roberts Sr.'s experience in storytelling through photography and cinema and scaling profits through syndicated publishing and farming, all of which created products reducible to commodities on the gridded page of the ledger, combined to create the contours of a viable business model based around the licensing of a library of images. To implement the vision in his new production studio/home/

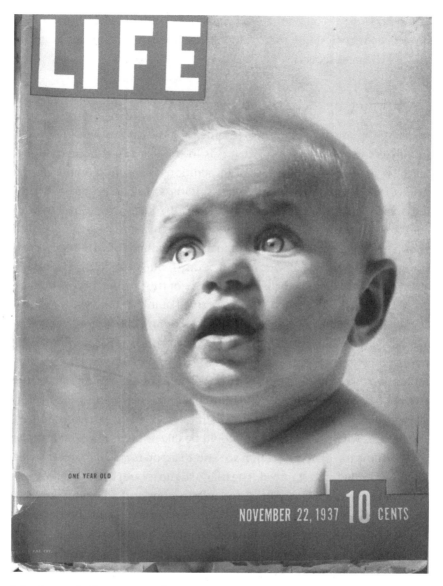

3.5 Cover of *Life* magazine's first anniversary issue (November 22, 1937), featuring a photograph by H. Armstrong Roberts. Courtesy Robertstock/Classicstock.

office, Roberts Sr. scoured the available office furniture catalogues to outfit his offices with systems that would streamline search and retrieval, the topic of the next section.

INFRASTRUCTURE: CARDS, CABINETS, CATALOGUES

Roberts Sr. required many things in order to grow his business of circulating images from the side project it was in the teens to the international business it became by the 1930s. In addition to the studio and lab, he needed people: photographers, models, darkroom, salespeople, researchers, accountants, and secretaries; people to file prints, ferry negatives to cold storage, develop film, seal envelopes, issue invoices, parry phone calls, show clients around the office, and maintain mailing lists. He also needed things: paper, boxes, typewriters, index cards, filing cabinets, telephones, stamps, ink. Roberts III recalls his memories of the bustling office when he was a child in the 1950s and 1960s: the smell of ink and solvent for rubber stamps, the ringing of phones, the hurried coming and going of people.[42] While a photography shoot might be happening on the third floor, with models busily preparing themselves in the dressing rooms and the photographer laying out various props, printers would be processing film in the basement in one of the multiple darkrooms, and researchers would be sorting through the card index on the main floor, tracking sales and returns. Phone calls with picture requests would be taken, prints shuffled in order to search for the perfect selection to send to a potential client, mail sorted and filed, folded, and stamped. The home studio is both a hub in a vast network of other people, locations, and publications and a network in itself. Each floor represents different ontological conditions of the photograph— the potential image in the studio, the stored image in negative vaults, and the copy being made in the printing lab. In the midst of all this activity, in order to keep the business running smoothly, staff was all oriented around a central machine. This machine was not yet the computer system that Roberts III would install in the late 1970s but a sophisticated card index that functioned as a complex "paper machine," following Markus Krajewski's description of file card technology.[43] This machine gathered picture content, inventory, and sales information on a single card, and the card's physical movement through the office coordinated a wide range of activity.

Roberts Sr. adapted the classic card index, an office technology that had successfully been transferred from the library context to the business setting by the early twentieth century, for his specific needs. A central card cabinet, organized by subject and identification number, housed a contact card for every image in the inventory (figure 3.6). Each contact card was associated via an identification number with a negative held in a storage vault and via subject with an 8×10 black and white print in boxes of prints organized by subject. The index was housed in a readymade piece of office furniture, with sliding drawers that hold thousands of cards. The cards were purchased from office supply store Garrett Beechman's Co., then sent out to be specially cut in order to hold a 4×5-in. contact print, allowing quick visual access alongside other essential information. The boxes that held the 8×10 circulation prints were also special-ordered, cloth-cornered Kraft candy boxes. All sales were noted on the card, as well as any time the image was included in a promotional catalogue (one of the primary access points for many clients) and information about the models, number of prints available, and any other significant information.

The contact card in the index serves as a map to where other versions of the image could be found. The contact print appended to the card itself was just a reference; a client would receive an 8×10 print, and a staffer might need to locate the negative to create a print. Thus, the contact card points toward these other items. For example, in the card for T-2238 (figure 3.7), T refers to the subject, Telephone, which is further divided "Telephone-Women"—indicating the subject name on the box where corresponding prints would be found. Models' names are listed on the bottom left (an important legal provision for commercial photographers who had to carefully secure and track model releases). While dates for the photographs were never tracked (mostly in an effort to preserve the veneer of the evergreen nature of the stock, a decision Roberts III now sees as a fatal flaw as he and his staff labor to recover the specific dating information valued by contemporary customers), information about the models indicates that the photograph was shot in the 1920s, as the Malcolmson sisters, Ruth and Lorna, were popular models for Roberts Sr. during that period (Ruth Malcolmson, from Philadelphia, was Miss America in 1924). The first sale of this image's reproduction rights was marked in 1931, in a direct-mail campaign. The image wasn't sold again until it

3.6 Contact card cabinet in the offices at 4203 Locust Street, Philadelphia, showing a card for B9535. Photo by Edward Bradford, 2017.

3.7 Contact card for T2238, with contact print and handwritten documentation. Courtesy Robertstock/Classicstock.

was used as a cover image for a 1959 Bell Atlantic catalogue, then again laid dormant until 1990, where its rights were granted for the duration of six months to be used in newspaper inserts for the Barker, Campbell and Farley advertising agency. The life of a circulating image—its commercial biography and production narrative—is thus captured on a single card as a living history.

Though the index card tracks the same inventory, as a moveable object, it offers dramatically different functionality than an entry in a ledger. Krajewski's concept of a paper machine helpfully alerts us to the complex logic of circulation embodied in the card index and the far-reaching consequences of its adaptations outside of its original library context:

[The index] is also a functional regulation that speeds up a far-reaching media change, a basic rearrangement of values. It translates words formerly linked to ledgers into numbers that, removed from strict sequence, become a movable basis for calculations. The book is dismissed as a medium in favor of a memory arrangement made up of movable paper slips that serve as a central point of operation.[44]

The ledger that Roberts Sr. used in his early days represented the limits of a business in which sales could be itemized and listed. With thousands and then hundreds of thousands of images that needed to be retrieved at a moment's notice and used multiple times over, Roberts Sr. needed a more complex organization system to accommodate the circulation of his huge collection. By adapting his records into a custom-designed card index that accommodated contact prints, was organized by control numbers, and contained a record of sales, Roberts Sr. was able to dramatically scale his business and adopt marketing tools such as catalogues that were interlinked with the card index. As he disarticulated his images from specific narratives and places—first through replacing the titles with a numeric code, then moving his inventory from the ledger to the index—the "memory arrangement" of the images shifted. Chronology, sequence, and specificity of place were all deliberately muffled to be replaced with an evergreen adaptability to new contexts. Growth of the collection is tracked not along a temporal axis with new inventory numbers added to the end of a list, but spatially through new subjects and subject categories growing as cards accumulate in multiple drawers simultaneously.

The furniture itself—a form of filing cabinet—is a technological innovation as significant as the leaps forward in printing and cinema Roberts Sr.

lived through as a child at the turn of the century, an "intellectual furnishing," to use Shannon Mattern's term, that proposes an ordered, modular world of information.[45] Craig Robertson studies the emergence of the filing cabinet in the early twentieth century as a critical moment in which paper storage was newly yoked to "the increasingly dominant late nineteenth century articulation of efficiency; it was mobilized to save time and space."[46] Further, "if, as efficiency advocates believed, the office had become a place of growth and progress, of efficiency and movement, then storage had to adapt . . . it needed to be alive and standing at attention."[47] Robertson draws the military metaphor in part from advertisements that pictured files as soldiers "at attention," but this connection between efficiency, military readiness, streamlined technology, and filing was also threaded through Roberts Sr.'s own thinking about filing, as filtered through interviews with his grandson. In our first interview, and in what would become a frequent refrain, Roberts III insisted, "My grandfather was an able seaman. He was a martinet about some things. Things around here were run in Bristol fashion. The way things operated around here, particularly in the recordkeeping, it was predicated on things being done a certain way."[48] Roberts III went on to make comparisons between the recordkeeping, carefully selected office furniture, and index card system and the efficiency of storage and movement on a ship. The filing system itself, as devised by the business's founder, was understood as a proxy for his own control over staff and the smooth functioning of the sliding drawers equivalent to a ship's engine room. The filing systems both transformed documents into bits of information that can be "standardized, atomized, and stripped of context," in Robertson's words, and transformed office labor through a new authority that accrued to the filing cabinet itself.[49]

The card cabinet affirms the importance of furniture to photographic culture, as work by John Tagg and Rosalind Krauss supports, and likewise represents an essential early form of the image database, a structural logic that governs the way we interact with almost all images today.[50] Lev Manovich cites the image database as a structural form that has fundamentally changed the way we process cultural information, replacing traditional narrative logic with the recombinatory logic of the collection.[51] Wolfgang Ernst argues the digital image database shifts the spatial order of the photographic archive into the temporal order, resulting in new patterns

of transmission and retrieval in which the database itself interprets the image.[52] The paper database at H. Armstrong Roberts Company formed an efficient system for organizing images around general subject categories that allowed for quick retrieval and circulation, as well as tracked complicated sets of data about publishing, prints, clients, and sales throughout a network of globally distributed offices. À la Manovich, it comprises a collection of unrelated images without beginning or end, which can be drawn into meaningful configurations through endless combinations of extraction and arrangement. À la Ernst, the temporal order of the paper database is suspended into a permanent availability, as Roberts Sr.'s early analog system is still operative today. The card index as paper machine could be programmed in advance and for different ends to satisfy the needs of the solitary academic or the business administrator. The index is productive as well. Krajewski emphasizes the way that cross-references contained within cards in sociologist Niklas Luhmann's card index helped to establish the structure for his later prose.[53] Roberts's system was productive in a different way: the movement of cards provoked actions by different staff.

The contact card, as a unique identifier tied to an image with many iterations (prints, negative, printed publications), oriented a range of activities: sales, invoicing, printing, mailing, catalogue production, shooting scripts, and generation of new ideas. Before computerization, the processes around making a sale remained largely unchanged, with mail, telephone, and telegram all potential modes of contact. If a client saw an image they liked in a catalogue, they might call the office and request it by number (identification numbers were printed under each image in the catalogue). The salesperson who fielded the call could then pull the contact card (for example, T2238) and use the full subject title (Telephone-Women) to identify the corresponding box of prints, pull the box, take out the print, and send it to the client along with a contract and invoice. Once a sale had been made and negotiated, the contact card would be marked and included in a batch of cards that would be directed to accounting for follow-up. Every night, contact cards that had been pulled to notate sales were stacked and ferried to the desk in the head office, where Roberts Sr. and then his son and finally grandson would review them in the morning. The stacks of contact cards indicating sales served as reminders for the Robertses of popular subjects in need of reshoots. Separate card files were kept with suggested

"YOUR STORY IN PICTURES LEAVES NOTHING UNTOLD" 157

ideas for future shoots, organized alphabetically. Roberts III recalled how his father always had a supply of 3×5 index cards in his shirt pocket. He would use these as a place to jot down new ideas and also pull them out during shoots to make sure to add extra props to shoots or create new settings in order to capture the ideas he wanted to fill in in the collection. As Roberts III explains, "The point is that that system not only reflected what was shot and where it was put, and a control card created to record the sales of it, but that category then went on a list of things to be shot, to be renewed."[54] Decision-making and prioritizing were outsourced to the movement of cards.

The varied use of cards throughout the office, interlinked with a central index, is one of many examples of ways in which index cards in the twentieth century served as means to wrangle bits of information into participatory structures, from Otlet's Mundaneum to computer programs, as Shannon Mattern catalogues in "The Spectacle of Data: Centuries of Fairs, *Fiches*, and Fantasies," as tools for what she calls "generative 'visioning.'"[55] Cards, as Mattern points out, are not just an office accessories but serve as aesthetic and imaginative tools, sometimes at the same time as they perform the functional work of administration. At the H. Armstrong Roberts offices, cards served for decades as essential links between words, existing images, and new images. They also contributed to the function of the pictures themselves as recombinant semiotic statements that could circulate out while retaining a permanent anchor in the collection.

The robust record system represented by the card index in Philadelphia allowed for global circulation over time. In the 1920s, Philadelphia was a major publishing center, but the business quickly scaled up outside of the immediate city. Traveling salesmen and mail order allowed for pictures sales outside of Philadelphia (sales trips to New York were recorded as early as 1920, and the company employed at least two salespeople to do about twelve weeklong trips a year by the 1940s), but having large collections of prints near the art directors, publishers, and other picture clients in major cities would greatly improve the likelihood of potential sales. The earliest branch offices stateside were in Chicago and New York, opened in 1930 and 1931, respectively, allowing Roberts Sr. to take advantage of the publishing centers in those cities. New York City in particular increasingly became a hub for advertisers and in turn a center for other stock agencies

and commercial picture archives. Neighbors in or near the Graybar building at 420 Lexington Avenue, where H. Armstrong Roberts Inc. maintained offices until 1985 (at which point they moved down to 28th Street), included Ewing Galloway Agency, Charles Cushing Collection, Shostal Associates, and the Culver Pictures Archive.[56] With the New York office, the H. Armstrong Roberts Company maintained a clear presence where clients in the advertising and publishing industry could browse photos and be attended to directly by researchers.

A 1930 advertisement additionally heralds offices in Berlin and London, from which the copy claims the company "dominate[s] the German and English periodicals with our pictures."[57] Roberts Sr. traveled to Europe twice in the 1920s and 1930s. The first time, around 1927, he shot photography in France and likely met with agents securing distributors for his work. A few years later, Roberts Sr. made a similar trip in Germany.[58] The arrangement with the European distributors is not clear, but he likely identified agencies that offered similar picture services and arranged to have those businesses serve as distributors for his work.[59] By supplying prints, indexed by their alphanumeric number, and catalogues, other agencies could sell his photos on commission. Records from this time do not confirm the exact locations of these offices or the nature of the business structure, but the branch offices in the postwar period offer some insight, as catalogues from the 1950s, 1960s, and 1970s show that he had offices (or, rather, agreements with other agencies) in London, Copenhagen, Venice, Buenos Aires, and Sydney. This international outlook anticipates the global reach of contemporary stock firms, prior to digital forms of networking, indicating that the form of the stock photograph itself demands proliferation.

The products in a stock photography agency are not just pictures but the reproduction rights to those pictures. In order to cover the production investment in creating a massive library, the pictures are designed to be used over and over again, and they require an organization that allows for the ability to scale ever upward. In response to W. J. T. Mitchell's classic question, "What do pictures want?": stock photographs want global circulation.[60] Stock photography's value depends on its repeated reproduction across time and space, and the international circulation rests on the idea that visual communication is universal. Opening branches in other cities allowed for new hubs of activity from which the pictures could travel.

"YOUR STORY IN PICTURES LEAVES NOTHING UNTOLD" 159

When working with an agent abroad, all that was required for pictures to become available to new audiences was an initial shipment of prints and the careful tracking of contact cards. All accounting was routed through the central hub in Philadelphia, where each contact card accumulated information about global sales. These kinds of agency relationships anticipate the dramatic changes of the 1990s, where large companies like Getty Images serve as central clearinghouses for what used to be individual collections all over the world.

The stock photograph was portable internationally because it was broadly recognized as a modern commodity. As Igor Kopytoff has observed, "The production of commodities is also a cultural and cognitive process: commodities must be not only produced materially as things, but also culturally marked as being a certain kind of thing."[61] One of the key ways that the photograph was communicated culturally as a commodity was through its assimilation into the mail-order catalogue, a marketing tool that became dominant in the United States by the end of the nineteenth century, when rural America did most of its shopping by mail.[62] As Matthew Hockenberry charts, the rise of the catalogue coincides with a transformation in commodity culture in which the anticipation and promise of vast stores of reserves are communicated to the remote consumer: "Merging visual representation with textual listing, the mail-order catalogue brought the anticipation of availability to the work of supply."[63] Here, Hockenberry highlights the basic promise of the catalogue as *availability*, intertwined implicitly with the promise of *repeatability*. In their exploration of the emergence of invention in patent law, Alain Pottage and Brad Sherman similarly locate the mail-order catalogue as a key apparatus through which the ideology of the commodity was communicated, defining the "catalogue aesthetic" as "the understanding that goods could be 'repeated exactly,'" a quality that is essential to the underlying allure of new modes of manufacture built up in Europe and United States in the nineteenth century.[64] This dual promise of availability and repeatability was uniquely transferable to photographic reproduction, essential to developing the ethos of the image as alienable content that created a recognizable market for the stock photograph.

Roberts Sr. was regularly circulating catalogues with reproductions of hundreds of images in his collection as early as 1930, pioneering this format as a sales technique for photography and promising the same availability

and repeatability of photography as a consumer could expect from material goods (figure 3.8).[65] His stock was particularly suited to the organization of the catalogue layout: Roberts Sr. could lay out catalogue design at his desk using contact prints, swapping out the identically sized rectangles as he arranged his tableaux.[66] The resulting catalogues, organized around grids of images arranged thematically, were the media object through which the paper machine of the index was communicated to the public and provided a way for the public to give feedback in return, through sales placed by mail or telegram. While the next section will explore the content represented in the themes as they developed between the 1930s and 1950s, as the success of certain catalogues reinforced the popularity of certain images and, in turn, certain archetypes, I want to first dwell on the media format itself. By dividing his photographs into themes, Roberts Sr. implicitly conveyed the range of the collection, with the minimal copy explicitly promising vast reserves: "Needless to add, we have more than this type of photograph. We have photographs on almost every topic, the oldest and largest collection of all especially designed for advertising purposes."[67] By offering a visual array of images as potential products to the clients, the catalogues reinforced the impression of the image as commodity and communicated the database of images that lay in reserve. The catalogue foregrounded its own administrative organization, identifying the image by contact card number or, later, by an additional call name, which facilitated ordering and also communicated the idea of organized inventory to the client. The contact card number underneath each image assumed the client would value the efficiency of requesting J-4978 rather than "Child standing on bed holding teddy bear." The number also announced the image's place within a larger structured system, preceded by the single letter that identified its subject category. And the ability to order by phone or telegram extended the reach of his customer base beyond those that could visit his offices or be reached by traveling salesmen. The "catalogue function," as Hockenberry describes it, is a promise of supply, the transformation of an artifact into a representation of availability that need not yet be materialized. While Sears, Roebuck, and Co., Inc. took advantage of this in the late nineteenth century to promise its readers the "Cheapest Supply House on Earth, The Most Progressive Concern of its Kind in the World," Roberts was able to imbue this promise to the practice of photographic illustration, and

3.8 Page from a c. 1930 H. Armstrong Roberts Company catalog, in which individual sheets were packed into pocket folders. Courtesy Robertstock/Classicstock.

in turn, the available illustration as commodity becomes a genre of representation in itself.[68]

SIGNAL: THE GENRE OF STOCK AS PHOTOGRAPHIC ALLEGORY

Roberts Sr.'s style evolved in tandem with changes in advertising photography, the status of the commercial photographer, and his own production conditions. He learned how to convey expertise to his potential clients through marketing materials and copywriting that emphasized the ability of his photographs to convey ideas quickly and wordlessly to a distracted consumer. He tailored his aesthetics for halftone printing, utilizing dramatic contrast and exaggerated gestures.[69] His classification scheme, which emerged from the overlapping interests of marketing and practical storage and retrieval needs, produced categories of image-making that reflected the careful production of a scene, specifically through the categories of "story" (recognizable scenes with models in domestic, outdoor, or professional settings) and "symbolic" (primarily consisting of scenes constructed with props or illustrating abstract concepts). All of these developments resulted in a particular genre of image that is recognizable as stock. With a mixture of theatricality and realism, the genre of the stock photograph uses people and props as units in a semiotic statement that seeks to tell a short story in a single image. Looking at Roberts Sr.'s photography throughout the 1920s and 1930s reveals how the genre develops and is fully consolidated in the 1930s catalogues. Ultimately, I argue that this genre of image, a product of a machinic system of production with feedback measured in sales, functions as Benjaminian allegory to reveal that the commercial, circulating image *produces* a way of seeing and interpreting the photographic image. The early stock photograph is ultimately both allegory for the act of photographic communication and a premonition of what is now referred to as the algorithmic image.

Initially, Roberts Sr. drew on his persona as an adventurer to market his photographs. In a 1924 *Studio Light* profile, he emphasizes his extensive outdoor work and the long expeditions required to achieve the perfect shot.[70] These outdoor shots, often featuring people engaging in healthful activities or in athletic action, were used in ad campaigns such as Campbell's soup and featured on the covers of magazines like *Keystone Motorist* and *Forest & Stream* (figure 3.9). As such, most of

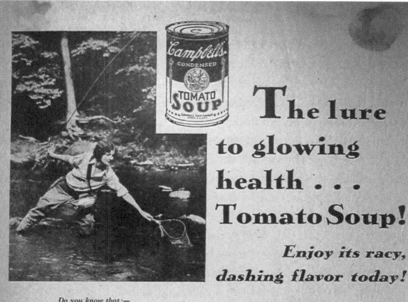

3.9 Circa 1920s Campbell's soup advertisement using photography by H. Armstrong Roberts. Courtesy Robertstock/Classicstock.

the earliest categories were action based: Angling, Duck Hunting, and Camping, for instance.

In addition to this library of travel and outdoor photography, by the time of the 1924 article, Roberts Sr. had also built a collection of "over two thousand studies of babies in every imaginable activity."[71] The popularity of pictures of Roberts Sr.'s own children, who were used in advertisements such as a Quaker Oats campaign in the early 1920s, may have alerted him to the lucrative market for images of babies (figure 3.10). Early on, he built a large library of shots of babies with a variety of settings and props and frequently used his skill with shooting babies in his marketing materials. The 1924 profile insists, perhaps dubiously, that the baby pictures "sell readily because they are perfectly natural and never posed."[72] By the 1930s, he had hired photographer Doris Day, who was also an accomplished photographer of babies, to support this work, though her photographs appeared under the H. Armstrong Roberts name as with any other staff photographer.[73]

Roberts Sr.'s babies were in considerable demand, gracing the pages of numerous advertising campaigns from the 1920s that encompassed national brands, including Bloomingdale's, Squibbs Castor Oil, Alpine Sun Lamp, Ten-Test Insulating Boards, Johnson's Baby Powder, and Listerine Tooth Paste (figure 3.11). This range of campaigns represents some of the largest national brands at the time and advertising agencies from all over the country, from J. Walter Thompson and Newell Emmett Co. in New York, to Williams and Cunnyngham in Chicago, to Young & Rubicam nearby in Philadelphia. In these ads, the naturalism of the setting ranges—some appear like casual snapshots, others are more staged studio shots, and a few feature Ruth Malcomson, 1924 Miss America and one of Roberts Sr.'s regular models, cradling and playing with the baby (figure 3.12). Both the Alpine Sun Lamp and Listerine advertisement employ a similar format: a headline addressing itself directly to mothers concerned with "little bodies" and "children's teeth," respectively, paragraphs of text extolling the virtue of the product, inset photographic images of the product itself, and a large image of a baby engaged in quiet activity, suggesting contentment and domestic tranquility. The image chosen for the Alpine Sun Lamp advertisement uses a composition that is increasingly common as Roberts Sr.'s library grows: a baby playing with a single prop against a blank background, with strong lighting creating a sharp contour. The composition reflects the efficiency

"Just Kids"

But remarkably bright, amazingly well and strong — a lesson in pictures of what right eating is doing for American children

Growing children need the excellently balanced breakfasts these youngsters get. That's Quick Quaker. Cooks in 3 to 5 minutes

HERE are children—physically active, seldom ill, mentally keen beyond their years. Right diet was not the only thing that did it. Other factors, too, played important parts.

But upon *what* children eat depends much of what they are, both today and in later years.

For that reason, "Quaker Oats and milk" for children has become a national dietetic urge. A dish, attractive and enticing, that supplies an excellently balanced breakfast, combining body-building protein, carbohydrates and minerals with essential vitamines — plus the roughage that makes laxatives seldom needed.

Too seldom served

Because of limited time for cooking... you may have been serving oats too seldom; letting less nourishing foods supplant them.

If so, please start now with Quick Quaker. It's as easy as plain toast. Cooks perfectly in 3 to 5 minutes. No kitchen muss or cooking bother.

And famous Quaker flavor — the rich flavor you want

Quick Quaker has all that rare Quaker flavor which you already know — the rich flavor that oats must have to be at their best. No other oats in this country has that flavor.

Grocers have two kinds, Quick Quaker which cooks in 3 to 5 minutes, and Quaker Oats, the kind you have always known.

Photos of children—all taken from those which were sent in response to a recent ad in women's magazines

Why Quaker Oats "stand by" you through the morning

DO YOU feel hungry, tired, hours before meals? Don't jump to the conclusion of poor health. Much of the time you'll find it is largely brought on by an ill-balanced diet.

To feel right you must have well-balanced complete food. At most meals you get it. That is, at luncheon and dinner. But the great dietetic mistake is usually made at breakfast—a hurried meal, often badly chosen.

That is why Quaker Oats is so widely urged today. The oat is the best balanced of all cereals grown.

Contains 16% protein, food's great tissue builder; 58% carbohydrates, the great energy element; is well supplied with minerals and vitamines. Supplies, too, the roughage essential to a healthful diet that makes laxatives seldom needed!

Few foods have its remarkable balance. That is why it stands by you through the morning.

THE QUAKER OATS COMPANY, 80 East Jackson Street, Chicago

3.10 Circa 1920s Quaker Oats advertisement featuring photographs of John Alexander and H. Armstrong Roberts Jr., taken by H. Armstrong Roberts Sr. Courtesy Robertstock/Classicstock.

3.11 Spread from c. 1930 H. Armstrong Roberts portfolio showing advertisements for E. R. Squibbs & Sons and Alpine Sun Lamp. Courtesy Robertstock/Classicstock.

of the stock photography shoot—capturing one baby against a background with a variety of props.

Another popular subject throughout the 1920s and 1930s was a specific prop: the telephone. Roberts III recalls the volume of telephone shots from this period, in a variety of settings, from domestic to business, with men, women, and children, explaining simply, "It was shot because people were going to buy those prints.... If you were going to be modern, you were going to buy a telephone."[74] First developed in 1876, by the 1920s, telephones were more and more common as household items but still restricted to middle- and upper-class homes—in 1922, only 33 percent of households in American had a telephone.[75] Using a telephone in an advertisement in the 1920s thus represented multiple stories: modernity, as Roberts III suggests, the modern upper-middle-class household, and newsworthiness. As an example, a 1929 studio shoot of regular models Ruth and Lorna Malcomson, senior staff and frequent model Rebecca Edmunds, and another model gathered around a telephone quickly yielded a variety of

"YOUR STORY IN PICTURES LEAVES NOTHING UNTOLD" 167

Baby's health and your own depend upon a comfortable, even temperature. Why slave at the furnace, and let so much heat leak through *non-insulated* walls and roof?

Insulation *means cheery comfort...*
glowing health...right through the year!

LIVABILITY and comfort, every hour of the day... these are essentials in the modern home. Houses that "cool off" on biting winter nights, draughty rooms that are practically impossible to heat, are unknown in the *insulated* home. For insulation... TEN/TEST insulation... seals your home snugly against winter cold and summer heat.

TEN/TEST comes in strong, solid sheets that are built right into the roof, the walls and floors of your home. It is easier and less costly to handle than lumber. Even in homes that are already constructed, TEN/TEST can be applied at a comparatively small cost... a cost that is more than absorbed in the fuel it saves and in the increased comfort and value of the home.

Whether you rent, or own your own home write for this FREE book

You can safeguard your family's health, make your home far more livable both winter and summer, save practically a third of your fuel bills, by insulating with TEN/TEST. Talk to your architect, your builder or landlord about it. And write for "TEN/TEST *and the Most Wonderful Adventure in the World*," the FREE book that answers every insulation question

INSULATING BUILDING BOAR

TTH
INTERNATIONAL FIBRE BOARD LIMITED, 1111 BEAVER HALL HILL, MONTREA

3.12 Circa 1930 Ten-Test Insulation advertisement featuring photograph by H. Armstrong Roberts. Courtesy Robertstock/Classicstock.

advertising sales (figure 3.7). Photographs from this shoot were used in an Ex-Lax advertisement and an advertisement for Grape-Nuts, among others (figure 3.13). In this case, four women and one prop created an opportunity to sell a wide range of stories, illustrating the significance of a particular prop. Telephones were, and continue to be, a powerful symbolic sign. In the Ex-Lax advertisement, a closeup of three women dominates the top of the advertisement. The women huddle around a candlestick telephone, while the headline below announces, "All over America, mothers got this news." The advertisement goes on to extol the benefits of Ex-Lax and its appeal to children, in a three-column format that imitates a newspaper layout. The Grape-Nuts advertisement builds off of the tagline, "However you look at it, 'There's a Reason!'" Inset photographic images by Roberts Sr. surround a central color shot of Grape-Nuts cereal with milk in a bowl, accompanied by blurbs that represent the motivations of various types to recommend Grape-Nuts. A smiling model holding the candlestick phone, this time with her sisters cropped out, is accompanied by a blurb supporting the "dentist's point of view": that Grape-Nuts provide a "beautifying aid to modern teeth." In this shot, the women's hair and style, the sitting room, setting, and the candlestick phone work in concert to convey a range of associations with modern communication, consumption, and a well-ordered home.

Early advertising photography (pre-1920) served a straightforward function, illustrating the product in question. But the popularity of athletes, babies, and the telephone demonstrates the way in which advertising photography evolved to communicate based on associations and suggestive imagery. Babies are representative of a constellation of related and distinct concepts that can be widely adapted to different products, from domesticity and health to innocence and fragility. Advertising historian Juliann Sivulka highlights how babies were used in early illustrated ads, which "capitalized on the popular picture of a healthy, happy child. If women exclaimed 'How darling!' and children were interested, it was a winner."[76] More broadly, Sivulka identifies the way that new products and markets were created in the early twentieth century through advertising that targeted personal hygiene and health—new products like deodorant, toilet paper, and toothpaste, as well as products like soap that had long been the object of marketing campaigns. These advertisements frequently focused

3.13 Circa 1920s Ex-Lax advertisement featuring photograph by H. Armstrong Roberts. Courtesy Robertstock/Classicstock.

on the hazardous results of not using the product question, with imagery that would conjure either sickness or health depending on the focus of the ad. The use of athletes, babies, and even the telephone can each work to communicate aspects of what these new products needed to sell: health, modernity, and newsworthiness. These values appealed to an American public steeped in what T.J. Jackson Lears has referred to as the "therapeutic ethos," a cultural shift in the United States at the turn of the twentieth century toward the widespread belief system that increased consumption could lead to better health and quality of life.[77]

The ubiquity of advertisements that promised health and protection against various ills of modern life affected Roberts Sr.'s growing collection of themes and concepts; Roberts III noted the early category "Ailments" was likely a response to advertisers making requests for specific subjects.[78] Paul Frosh has highlighted the importance of catalogues to the stock industry, focusing on the large, glossy catalogues of the 1980s and 1990s, observing that they are at once "chief functional tools of the stock industry, one of the system's key products, and productive agents in their own right." Through this curious constellation of function, they "constrain and generate certain kinds of image production and formation."[79] Among his earliest catalogues in the early 1930s, Roberts Sr. promoted the collection with a catalogue divided into themes abstractly related to the requests of the advertising business: "Human Interest," "Ideas and Charm," "Juvenile photographs that radiate action, story, health, and the joy of living," and "Vacation and Outdoor." By the 1940s, these types had become even more pronounced in their straightforwardness: Vacation and Outdoor, Back to School, Holidays, Seasons, The Home, Food and Eating, and Children. These are un-coincidentally oriented around personal hygiene, health, and products for the home.

Within these themes, props became a prominent means for anticipating advertisers' requests and desires. The use of the telephone as an iconic symbol for a concept like "news" demonstrates the function of props and their effectiveness as shorthand for longer stories. By the 1930s, Roberts Sr.'s use of props increasingly disassociated his work from the naturalistic scenes that he originally claimed to be known for. This can be seen most clearly in Roberts Sr.'s growing library of babies. The baby shots used in 1920s campaigns captured babies in a variety of naturalistic settings—putting on

"YOUR STORY IN PICTURES LEAVES NOTHING UNTOLD" 171

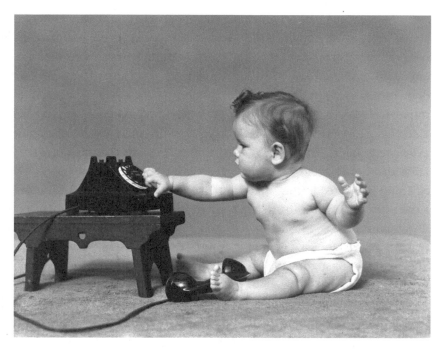

3.14 B8924. Circa 1940s H. Armstrong Roberts shoot incorporating telephone. Courtesy Robertstock/Classicstock.

shoes, playing with a toy, or taking a bath. By the late 1930s, this repertoire had expanded to include anachronous props—like a pipe, a stethoscope, or an adding machine—used as semiotic building blocks to layer additional associations (figure 3.14). While in 1924, Roberts Sr. promoted his skills with baby photography by asserting that his shots were "perfectly natural and never posed," the later work performs playfully for the viewer: these shots were not candid but actively produced for an advertising client looking to balance multiple connotations in an impactful image.[80] Yet, "realism" and authenticity continued to be a trope of his marketing. Specifically, in promotional materials, the signifiers of "realism" in his photographs shifted from his method of capture (direct, in-the-moment) to other qualities such as the "naturalness" of the chubby, mostly white models.[81] This demonstrates the way in which the perceived realism of photography was integrated with the machinic logic of the production line of images and the cultural assumptions of "natural."

In the early twentieth century, photographers used contradictory claims about "realism" to convince the advertising industry to use photography rather than illustrations in their campaigns, resulting in a specific aesthetic embraced by Roberts Sr. in which naturalistic scenes are heightened for dramatic effect.[82] On the one hand, photography can "tell your story as unprejudiced eyewitness,"[83] but on the other, a skilled photographer can "literally 'paint' with the lens."[84] "Buyers do not question photographic evidence of merit. They believe what the camera tells them because they know that nothing tells the truth so well," as the Photographers Association of America asserted in the 1920s.[85] An article in *Printer's Ink* in 1922 urged advertisers, "The one thing that advertisers must combat is the tendency of illustrations to seem too commercial, too much a part of the entire scheme of many campaigns," a tendency that could be corrected by photography.[86] These alternating arguments about photography mirror discussions about indexicality familiar throughout photographic theory, in which photography is alternately heralded as a direct representation of reality or as a scene that cannot escape its own staging and intervention by the photographer.[87]

Echoing these arguments, Roberts Sr. capitalized on the advertisers' desire to exploit the perceived authenticity of photography, while asserting his ultimate control. In the 1924 profile, Roberts Sr. is quoted as saying, "I have never manipulated a negative to obtain an effect. I stick to my medium. It is straightforward photography."[88] Notably, Roberts Sr. is drawing on the language of medium-specificity and "straightforward" photography that was also embraced by modernist photographers like Alfred Stieglitz and Paul Strand. Whether intentional or not, Roberts Sr. uses almost identical language to a 1917 essay by Strand reprinted in the last issue of Stieglitz's influential magazine *Camera Work*, where Strand advocates for a photographic approach "accomplished without tricks of process or manipulation, through the use of straight photographic methods."[89] In the 1920s, "straightforward photography" indicated a hierarchy of value for photography that depended on embracing the technological affordances of the camera: straight capture that could freeze a significant scene. The successful photographer is the one who best leverages and showcases the affordances of the camera's technology.

The assertion of straightforward photography did not preclude theatricality, a quality that Roberts increasingly married with his claim to

realism. As the 1924 profile goes on to state, "Mr. Roberts is unusually successful in his line of work because he gets the publishers' and advertisers' point of view. His pictures are interesting because they are full of realism, poetry, or dramatic action."[90] Realism, poetry, and dramatic action. While realism was the first quality used to sell photography to advertisers, by the end of the 1920s, poetry and dramatic action—the ability of photographs to tell a story as a constructed piece of art—was used as a primary selling point.[91] This was a significant shift, according to historian Michele Bogart, as photographers emphasized the art of what they did in contrast to the indexical qualities of the medium itself.[92] In this way, promoters of advertising photography could argue from two perspectives: photographs are both more real *and* more dramatic than illustration. Through skillful photography, realism is transmuted into something that can be highly stylized. In his earliest marketing, realism is about the "straightforward" approach that prized the mastery of camera technology. In a 1942 profile, he describes it differently: "What I try to get is a certain pictorial realism which is natural and which will strike a chord in people's experiences."[93] In this way, the meaning of Roberts Sr.'s "realism" and its effectiveness for advertising changes over the course of the decade from the straightforward approach to a dramatic pictorialism.

This paradoxical use of realism is entwined with a word that was essential to the growth of the H. Armstrong Roberts Company: story. For Roberts Sr., adventure writer and aspiring film writer, the word "story" signified scenes of people interacting with one another. Once he began shooting in the studio rather than action shots outside, he started using the category heading of "Story"—a category that encompassed scenes such as children playing or couples arguing and was subdivided to indicate the ages and genders of models shown (for instance, Story-Juvenile, in which scenes of children interacting could be found, and Story-Juvenile-Men, a category where one might find any number of representations of father–son interactions). Only certain nonhuman subjects—notable ones being telephone, food, or ailments—were shot often enough to warrant their own category. In this way, categories were a reflection of depth, which itself was a product of both speculation and a record of successful sales.

Story is also a marketing term. A 1930 advertisement placed in the advertising magazine *Printer's Ink* promotes the "natural, human-interest,

3.15 A 1930 advertisement for H. Armstrong Roberts Company. Courtesy Robertstock/Classicstock.

story-telling quality" of Roberts Sr.'s work (figure 3.15). In an advertisement that ran in *Printer's Ink* the following year, the company touts "more than 75,000 photographs on almost as many subjects, made with the idea of telling a realistic story, and telling it attractively." The words "realistic story" are key here. Roberts Sr.'s photographs are not meant to be documentary, or art, but to be something closer to literature, cinema, or theater. The accompanying examples in both of these ads illustrate the storytelling

"YOUR STORY IN PICTURES LEAVES NOTHING UNTOLD" 175

capacity of the still photograph: a man with a gun and hunting dog, a yawning baby, a couple in robes drinking milk by a fire, a woman in the shower, a nurse with a sick child, and two men in business suits sitting in an office environment. The "naturalness" of these settings is questionable, but their storytelling potential is clear. Throughout the 1930s, story continues to be central to Roberts Sr.'s advertising. In a 1935 catalogue, copy reads "Photographic illustrations solve the problem of telling a big story in a small space." Using "story" as a subject heading and marketing device orients Roberts Sr., his staff photographers, and his sales staff toward an artistic aim and defines the commodity they are producing. It is also a prescription for production; story involves actors, props, and settings.

Conceived for the printed page, Robert Sr.'s repertoire soon moved beyond domestic mise-en-scènes, extending further into the symbolic and allowing him to hone his marketing approach. In a 1939 copy of the H. Armstrong Roberts catalogue series titled *Roughs* ("roughs" being advertising vernacular for a rough layout), the company advertises its expertise thusly:

Our files embrace almost every activity; not conventional stock pictures, so frequently the discards and by-products of regular studio operations, but a service of ideas and good taste coupled with artistry, *realism*, and technical excellence, and imbued with a thorough knowledge of merchandising problems. We are the originators of this type of service, established many years. (italics added)[94]

Realism is once again invoked, this time in tandem with "knowledge of merchandising problems," and positioned against the concept of stock as studio by-product. Here, the company is making an argument for their expertise and, by extension, the specialization of stock photography within the broader field of photography. This particular issue of *Roughs* highlighted a category of images that were entirely staged: closeups of hands doing various tasks (figure 3.16). "Photographs of hands are increasingly popular. In magazines, newspapers, trade journals, direct mail (editorially as well as in advertising), HANDS are being used to illustrate a wide variety of products and themes. There's a lot to recommend them too. Well-made photographs of HANDS are eloquent storytellers. Above all, they tell their story F-A-S-T." In the photographs advertised in this brochure, hands are displayed with various props—a mousetrap, a ruler, and handcuffs—and various suggested advertising taglines—"nibbles at your profits," "made to

3.16 Spread from 1939 *Roughs*, distributed by H. Armstrong Roberts Company. Courtesy Robertstock/Classicstock.

measure," and "shackled—to old-fashioned methods," respectively. The hands, carefully posed so as to display the prop, appear stiff and hardly natural. Their association with generic advertising taglines that could be applied to a range of products demonstrates that they are specifically designed for advertising. The surreal space of advertising allows for images like these to be conceived within the rubric of the "realistic." The brochure also demonstrates the way in which Roberts Sr. addressed himself to the advertisers—as both an expert on advertising who could inspire their creatives and a service business ready to supply images on demand.

The next issue of *Roughs* captures a larger slice of the "Symbolic" file (figure 3.17). On the cover, a skeleton sits in the driver's seat of a car, an empty liquor bottle at its side. The catalogue explains that in these images, "associated ideas are the basis of this work." The catalogue presents a wide range of the types of images that fall under Roberts Sr.'s "S-Symbolic" category.[95] Some are clearly staged with a narrative in mind (in the case of the cover image, the narrative might be the dangers of drunk driving). In one, a hand with a knife is about to slice a pie with a dollar sign on it; in another, a balance scale is arranged with a bag labeled with a dollar sign

3.17 Spread from 1939 *Roughs*, distributed by H. Armstrong Roberts Company. Courtesy Robertstock/Classicstock.

on one plate and a sign lettered "Health" on the other. Some staged images are perhaps more ambiguous on first viewing, such as a men's shirt and tie stuffed with straw and sitting upright in an office chair (a "straw man"). Still others are not staged tableaux but simply objects that are laden with suggestive meaning, such as a stack of coins or a weathervane. Roberts III further recalls his father and grandfather mining *Bartlett's Familiar Quotations* for ideas for "symbolic" shoots. The category makes ever more stark the nature of stock photography's "storytelling" and the careful arrangement of models, props, and settings to complete the story.

The content of the symbolic file is the product of a production model in which new images are generated on a daily basis out of a finite set of resources, constrained within a media-technical storage system in which images that sell well prompt reshoots and variations, to be marketed toward an industry that views images as tools to access the mind of the viewer in a state of distracted attention. Both "story" and "symbolic" are notably metacommunicative rather than descriptive of content itself: that is, they are subject terms that describe how the pictures should be interpreted. They announce what they do. Through this announcement, they

invite the viewer to decode the scene as a short narrative, treating props and settings in the same way as a photographer with a shooting script.

Typically, genre is interpreted as the presence or result of artistic codes or aesthetic decisions. In this case, I argue that the machinic logic of the catalogue and index, along with the networked travel of the pictures across the world, produced the genre of stock photography. As John Frow states, genre "shapes strategies for occasions; it gets a certain kind of work done."[96] He quotes Janet Giltrow, elaborating that genre "flourishes at the thresholds of communities of discourse, patrolling or controlling individuals' participation in the collective, foreseeing or suspecting their involvements elsewhere, differentiating, initiating, restricting, inducing forms of activity, rationalizing and representing the relations of the genre to the community that uses it."[97] For a "border activity" like stock, which seems to exist outside of or in contrast to photographic discourse, genre's basic functions still apply: the genre of stock photography dictates unspoken instructions for looking and interpreting that are understood by viewers.

The genre of stock photography is direct and explicit in the way it instructs viewers to see. So explicit in fact that what makes stock photography distinct is the way it allegorizes the process of seeing machinically. For Walter Benjamin, understanding how allegory functioned in Baroque art (specifically German tragic drama) offered the key to understanding cultural experience centuries later. He argues that allegorical expression, in which "any person, any object, any relationship can mean absolutely anything else," gives form not to underlying emotion (the way that symbolic communication works) but to the structures of convention themselves.[98] Craig Owens takes up Benjamin's argument, which challenged the way allegorical art had been dismissed by critics since the eighteenth century, to argue that allegorical expression is the ascendant postmodern mode of expression.[99] Allegory "arrests narrative in place," allowing for "one text to double as another."[100] This notion of the allegory as the expression of conventions themselves, seemingly freed from linear time, is essential to the genre of stock. Bainard Cowan's description of Benjamin's theory of allegory could just as easily be applied to the metacommunicative functions of Roberts's symbolic file: "Transforming things into signs is both what allegory does—its technique—and what it is about—its content."[101]

The stock photography library promises the buyer that it can turn allegory into a commodity, thus making its technique of producing anchorless narratives into its primary selling point.

Advertising imagery has been associated with another key concept in visual cultural studies—Roland Barthes's discussion of mythology. For Barthes, myth is a second order of signification in which images communicate dominant ideology. Myth conceals its own production, however, transforming "history into nature" such that the viewer accepts the myth as natural.[102] Stock photographs are essential engines of myth. They are offered in catalogues divided by concept and types (people, places, and things) as if the catalogue itself was representative of a world of signs, objects, and symbols. Yet, the ideology transmitted through stock is not *just* around fantasies of domesticity and consumerism. Stock also transmits the meta-message of the codes of the genre itself—the constructedness, the invitation to decode—under the projection of realism. Through the genre of image that prizes the "realistic story," in which the viewer is required to interpret the signs of the composition to put together the narrative, the everyday viewer is turned into a semiotician and provided with the keys of deconstruction. For Benjamin, allegorical images deconstruct myth by exploiting symbolic communication to represent the story of the allegorist, thereby removing the power of the symbol. Through their bald mode of address and open use of coding and framing conventions, stock uses symbolic communication as a tool. By arranging people and objects as symbols for use to tell unrelated stories, stock is not merely the Barthesian engine of myth for the unsuspecting public. Rather, stock could serve as an "antidote" to myth, in the way that Benjamin argues that Baroque allegory does.[103] In the face of totalizing narratives about race, class, and gender upheld by advertising or other mass media, the essential lesson of the stock photograph is that meaning is arbitrary and flexible.

The genre of stock is defined by the instrumentalization of images through their machinic processing. Perhaps the clearest way to illustrate this argument is by exploring the parodies of the stock photograph. The "madness" of genre, as Derrida claims, is that all boundaries that seek to control and police division inevitably invite their transgression.[104] Since the 1960s, artists like Warhol and Martha Rosler have used advertising

photography to critique consumerist ideology and gender and racial stereotypes. As the postmodern gesture of exposing framing apparati migrated from the avant-garde to pop culture, the genre of stock photography has become an object of critical analysis. Now, the humor and news website Buzzfeed has a specific category of articles with titles like "50 Completely Unexplainable Stock Images," "18 People Who Regret Becoming a Stock Photo Model," and "15 WTF Moments in Stock Photography," where editors trawl stock photography services for the most improbable scenes or inapt applications of an image to an advertisement. Twitter account @DarkStockPhotos gathers cartoonishly violent scenarios, and @StockPhotoStories extends Roberts Sr.'s original "story" concept as parody, writing short stories to accompany surreal shots. Reddit has several subreddits of stock photo memes as well, the source of the popular "Distracted Boyfriend" meme in 2017. Here, the essential features of the stock genre—its purposeful lack of anchorage and simultaneous need to suggest a clear narrative— result in bizarre images such as a caged woman listening submissively to a human in a bird suit read from a large book or a pair of underwear stuffed with croissants (two of the first results on a recent Google search for "absurd stock photos"). These stand out because they take the rules of stock—the idea of visual communication as a language and the endless possibilities for recombining costumes, props, and settings—too far.

Stock photography fundamentally alters our understanding of the photographic image. Historian Ullrich Keller has argued that the rise of photojournalism in the early twentieth century reshaped historical reality, as events began to be staged with the expectation of being photographed.[105] Roberts Sr.'s example shows a similar shift with advertising photography. With the growing ubiquity of photographs in advertising, a particular type of visual storytelling became legible to viewers. The expectation that photographs are staged for the space of advertising means that the indexicality of photography is transformed into a claim to realism, while constructedness is expected. Viewers are interpellated as decoders. The idea that photographic statements are constructed and deconstructed is implicit. H. Armstrong Roberts Company images erupt into our present as dialectical images because they demonstrate how this relationship was forged. They demand that we see images as *alienable content*, evergreen commodities, stories in pictures that are written and rewritten again and again.

CONCLUSION: SYSTEM AESTHETICS OF THE DECONSTRUCTED IMAGE

H. Armstrong Roberts Sr. passed away in 1947. By that time, his business was well established as an international stock image library, arguably the first of its kind. The competitors that had sprung up or grown over the decades between 1920 and 1950 produced catalogues that appeared to have been created with Roberts Sr.'s pioneering layout and ordering system in mind, with similar shots and categories of shots.[106] After some complicated legal issues, H. Armstrong Roberts Jr. took over as head of the company, and when he passed away in 1979, H. Armstrong Roberts III took the helm. Through this chain of custody, the biographical conditions that shaped the company have been preserved. This preservation is unique, as other early photo agency collections have been systematically acquired by stock photography conglomerates like Getty and the recently shuttered Corbis, with little regard for preserving early business history. (Chapter 4 will explore how H. Armstrong Roberts Company has adapted to digital conditions and the rapid transformation of business structure over the past three decades.)

This time capsule preserves a case study of the commodification of images and the mechanics and motivations around the circulation of images. Roberts Sr. was influenced by activities ranging from chicken farming to script writing to create a business that formalized the production of commercial images, marketing himself as an adventurer, peddler of stories, and keen observer of those qualities of "human interest." He developed his persona, photographs, and business in concert with the emerging advertising industry. The interactions between actors (clients, models, salespeople, and photographers) and media objects (prints, memos, typewriters, negatives, cabinets) and the growing scale of his collection required the creation of a complex paper machine that took the form of an image database. Out of this machinic network came a genre of image communication. In a stock photograph, a mini-drama is meant to play out instantly on the page. The viewer is expected to decode the narrative, understanding it as "real" only insofar as it relates to the story of the advertisement. This expectation of the suspension of disbelief was based in the theories of photography that were emerging in professional photography journals and advertising trade publications—that photography was both real and constructed.

The argument that a photograph masquerades as reality in such a way as to mask the conditions of its production and framing is a familiar argument in semiotics and photographic theory. As Susan Sontag writes in 1977 in *On Photography*, "Photographed images do not seem to be statements about the world so much as pieces of it."[107] Yet before theorists of photography debated the paradox of photographic image, practitioners in photography and advertising eagerly sought to exploit its ambiguity. In this way, a genre, as a particular set of codes necessary for interpreting the image, was developed. This genre was crafted to tell a quick story to be understood in relation to surrounding ad copy. In the 1970s, Barthes theorizes about anchorage and connotative processes using semiotic theories drawn from linguistics, but Roberts Sr. embraces and commoditizes the idea of the anchorless image in 1920. Barthes further identifies the photographic paradox as the coexistence of two codes within any photographic: the photographic "message without a code" (i.e., what is literally depicted) and the highly coded message interpreted by viewers, or the stories they identify within the picture. Stock photographs turn the paradox inside out, coding the photographic message in advance through the highly staged production of the image, with the expectation of endless new interpretations down the line.[108] In other words, in the successful stock photograph, what is literally depicted is often the process of or potential for coding itself—in an image of a woman on a telephone, the telephone call is a story that can be anchored to other concepts, from telephones themselves, to female friendship, to modern homes, to Ex-Lax, depending on where the image will appear.

The anchorless image is inseparable from the logic of the image database. At the same time as he was developing conventions of visual storytelling through his production techniques, Roberts Sr. conceptualized a structure for managing hundreds of thousands of images whose value depended on them being accessible. He accomplished this with a combination of commercially available office furniture and custom adjustments to create a central illustrated card index. The portability of the contact cards and their interfiling with paper boxes of prints, all indexed by alphanumeric code alphabetically related to a main subject heading, formed a complex system that allowed for worldwide circulation of image licensing. Through the creation of this system, Roberts Sr. produced a complex analog image

database. Like the digital image database, this paper machine was oriented around nonlinear and radically antinarrative logic. These images are meant to be portable, to be commercial, and to be iterative.

Iteration is significant. Prints were churned out in multiple to serve as marketing tools, as reference images for staff, and as shadow collections at satellite offices, but prints were not the commodity that Roberts Sr. made his business selling. Rather, his product was the right to turn those prints into a specified number of copies. Roberts Sr. learned early on that by licensing the publication rights to a photograph for a clearly delineated use, he could resell the same image over and over again. This practice did not originate with him, but he learned how to orient his production model toward the creation of images that would appeal to target clients in a wide variety of applications and how to index and organize his collection so that requested images could readily be found. His business depended on clients knowing that if they came to him with a unique request, he would be able to fill it. As a 1943 writer put it, "If you can find a subject on which H. Armstrong Roberts doesn't have a negative in his files at his Philadelphia studio, this writer will gladly eat an 8×10 gloss print."[109] The perception of scale conveyed by the database form of the collection was a central aspect of the stock genre.

At H. Armstrong Roberts Company, the collection, organized by subjects selected to anticipate the needs of advertisers and tracked by sale, grows organically based on perceived commercial need and past commercial success, in a system that at times seems to deny authorial direction. Roberts III reveals that staff would plan their shoots in part based on current events: post–World War II, they shot multiple iterations of men in uniform entering homes, checking the mail, or embracing family to address the anticipated need to illustrate ads or editorials about returning veterans.[110] While there are images of Black models dating back to 1930s studio shoots and 1920s travel shots, he also acknowledges that the company moved to build out their meager representation only in the context of the civil rights movement, shooting pictures of integrated classrooms, Black family and domestic life, and integrated offices in the 1950s and 1960s as demand increased.[111] Ultimately, as he argued, sales influenced production: the record of image sales would prompt popular scenes and subjects to be reshot. Roberts III's reflexive deflection to the pressures of supply and

demand when confronted with questions about representation has particular resonance when it comes to constructing an image collection at scale.

Specifically, deference to a system that, while constructed by human actors, takes on seemingly independent authority and decision-making powers anticipates the probabilistic search algorithms that use similarity and popularity as markers of value. Stock photography and its archival organization represent a record of perceived consumer desire and expectations about the photographic image, but it also betrays the development of the code itself. That is, it traces a genealogy in which consumer desire is seen as something that can be captured through a feedback system. This model outsources agency to the system itself. The way in which office furniture, catalogues, and photography coordinated machinically to produce commercial imagery thus has a more ominous contemporary resonance than the cheeky 1930s babies that grace the pages of the *New York Times*. Scholar Safiya Noble's trenchant critique of Google, using examples of Google Image results that display racist, sexist, pornographic, or violent imagery as relevant to search terms that specify race, was deflected by Google spokespeople for years by suggesting the search algorithm was merely systemically mirroring "availability and frequency of online content."[112] Noble's work is part of broader investigations into bias in automated systems and in image interpretation in particular.[113] In the case of early stock photography, the limits of Roberts Sr.'s milieu and the automation of various systems helped to reproduce the biases of their founder's environment, producing certain types of scenes, which were then used as prompt for future shoots when they sold. Feedback from clients, using the language of advertisers and laboring to anticipate needs and fulfill them in advance, constrained production. The overwhelmingly white, active, domestic library becomes understood by photographers and staff as a product of the system, rather than a product of any individual decision or artistic voice. Roberts Sr.'s variety was actually a specific image "repertoire," to use Frosh's term.[114] His work both participated in and was influenced by a dominant culture that privileged images of domestic, middle- to upperclass, white life in advertising and mainstream culture.[115] In dialogue with companies, the shorthand for expressing broad concepts and emotions that became tropes of advertising was based on this central fiction: the doting mother, the businessman, the happy baby.

Yet, within this more familiar repertoire, there are also strange and surreal images, disembodied hands, propped skeletons, or stuffed animals arranged in eerie tableaux that speak to Derrida's madness of genre. Others carry a more potent charge. While Black American life was not extensively represented in the files until the 1960s, Black models occasionally posed, and a studio shot from the 1930s stands out, itself a sort of Barthesian punctum amid the studium of the typical poses and domestic mise-en-scènes (figure 3.18). Barthes describes the punctum as that small detail that "rises from the scene, shoots out of it like an arrow, and pierces me."[116] It's an emotional trigger peculiar to the medium of photography, an "accident" that pricks because it was there, existing in the moment of capture, and no longer exists but for its emotional punch to a viewer in another time and place.[117] In this studio shot, two hands, one apparently belonging to a white man and one apparently to a Black man, are handcuffed together. There is a clean symmetry in the composition at first, but differences slowly reveal themselves. The white man's hand hangs slack from a uniformed cuff. The Black man's hand, in a suit cuff, is semi-clenched. Both cuffs would have been costume sleeves, detached from the rest of the garment and pulled on

3.18 Contact card for S5335. C. 1930s photograph from a photography shoot featuring multiple configurations of handcuffed hands. Courtesy Robertstork/Classicstock.

in the studio for ease of quick changes—there are several handcuff shots in the same shooting sequence, only one with a Black model, only one with hand clenched. As contemporary viewers, we don't know whether that decision was the model's or the photographer's or what the intention of either might be. From the perspective of writing in 2022, it reads as potential allegory of Black resistance and the white supremacy that immobilizes progress, anticipating a classic 1970 poster design of handcuffed fists printed in complementary colors by radical Hugo Gellert for the National Black Liberation Commission, declaring, "Racism Chains Both." Ultimately, as with any of the photographs in H. Armstrong Roberts's library, the intention of the photographer is irrelevant, the individual interpretation simply that—individual. The only promise the image makes is that it is available as alienable content and has been for almost hundred years, though its contact card reveals not a single sale until it was licensed for publication here.

This chapter began with a discussion of Benjamin's dialectical image—that image from the past that might have been forgotten but for its ability to detonate in the present. This photo, now digitized and printed in this book, addresses the contemporary viewer with particular charge. But even the popularity of pop surrealist staged babies in venues like *New York Magazine* suggests that contemporary viewers are pricked with the recognition of an aesthetic that migrated from advertising imagery to avant-garde art and back again over the course of the twentieth century. Now, the use of early H. Armstrong Roberts Company images serves as a symbol of metacommunication itself. In an interview with Richard Steedman (founder and president of the popular stock photography business Stock Market from 1981 until it was sold to Corbis in 2000), he insisted to me that literature on semiotics from the 1970s and 1980s was essential to how he approached his business, suggesting the impact of 1970s theories of semiotics on advertising.[118] Throughout this chapter, I have argued that in fact, it is the other way around. Advertising photography and the aesthetic promoted by H. Armstrong Roberts Sr. in the 1930s, which sprang out of specific technical and economic conditions, introduce a way of seeing that anticipates the semiotic deconstruction of visual culture, an allegory of visual communication itself.

4

THE NEW UNIVERSAL COLLECTION: FROM PICTURES TO DIGITAL ASSETS

Truth needs an advocate and it should come in the form of an enormous flock of librarians descending on Silicon Valley to create the internet we deserve, an information ecosystem that serves the people.
—Joan Donovan, "You Purged Racists From Your Website? Great, Now Get to Work," *Wired*, July 1, 2020.

What does this history of libraries, museums, and stock photography agencies bring to bear on the contemporary state of platform capitalism, in which private tech companies increasingly determine how circulating image collections are stored, catalogued, and shared? The voice of one of the muses of this book, librarian Romana Javitz, reaches across the decades. In a 1943 lecture, Javitz argued to an audience of librarians that picture collections are essential archives of knowledge and social life and that librarians must have a role in making them intelligible and accessible to the public. She railed against the primacy of the printed word "as the sole conveyor of knowledge" in library work and warned that, "satisfied with the power of words, [libraries] have slighted the great infiltration of pictures and *left their use to commercial channels of sensationalism and advertising.*"[1] Javitz was painfully aware of both the shifting cultural and intellectual environment that the library could help to shape and the inability to do so without investment. Her warning is prescient: the role of sensationalism

and advertising in public life has only grown stronger since Javitz sounded this alarm, and without resources for libraries to take a leading role in the organization of pictures for public use, the resulting vacuum has been filled with private companies with the technical expertise and resources to manage massive image collections. In the latter half of the twentieth century, libraries, museums, and stock agencies did anticipate, plan for, and undertake digitization, but they did so only with the guidance and mediation of new private companies, in a technical landscape that was rapidly changing by forces over which librarians had little control.

Further, the ways in which image culture is shaped by commercialism and sensationalism have evolved since Javitz's comment. The image as alienable content in the early twentieth-century library, museum, and stock agency was surely an object of exchange value for industries dependent upon illustrations (publishing, advertising, entertainment), but large-scale image collections now produce a new type of commodity: training data for machine learning. Along with all manner of expression and social interaction, pictures are now data points in the archives of human behavior that power an advertising economy measured by impressions and click-throughs and create new and unprecedented opportunities for private and state surveillance. These pictures are scraped, among other places, from massive social media platforms where posting pictures has become a key part of new social rituals and is shaped by new technologically mediated forms of photographic manipulation and annotation. What would it have been like if the New York Public Library or the Museum of Modern Art administered image collections indexed by subject with the same useability and reach as Google Images search? Or if the stock industry was not dominated by the massive conglomerations made up of former competitors' stock—and instead by more companies for whom the stock is also family album?

In the face of the failure of tech companies with the most control over the flow of cultural content to maintain effective content moderation, healthy civic discourse, and commitment to preservation, scholars have drawn attention to the lack of input public institutions have had on their practices. Siva Vaidyanathan diagnoses this problem as an example of "public failure," which occurs when public institutions cannot meet the public's need, creating opportunity for private actors to emerge in the

void. He looks specifically at how Google has taken advantage of public failure to secure an outsized regulatory role in the information economy. "Because we have failed at politics, we now rely on marketing to make our world better . . . Google has taken advantage of both of these externalities. It has stepped into voids better filled by the public sector, which can forge consensus and protect long-term public interests instead of immediate commercial interests."[2] No matter the lofty rhetoric of projects like Google Books or Google Cultural Institute, ultimately the projects are structured by a company motivated by commercial interests and beholden to share-holders. As early as 1996, William Birdsall similarly identified the com-modification of information fomented by deregulated information public policy under the spell of an "ideology of information technology" that "denigrates the value of public institutions such as the library and advo-cates the moving of the services they provide out of the category of public goods and into that of commodities to be traded in the marketplace."[3] In the "ideology of information technology," as Birdsall calls it, information resources are commoditized and libraries are forced to compete and negoti-ate in a market structure where profit rather than public good is prioritized. At the same time, in the "access doctrine," using Daniel Greene's term, libraries are also newly called upon to bridge the "digital divide" and pro-vide technical skills and internet access to those left out of the information economy.[4] In both cases, value is implicitly derived from and determined by technology firms and the ethos of technology startups.

This long trend of commoditization and market solutionism has cre-ated crises of public culture that, ironically, scholars are calling on librar-ians to fix. Joan Donovan argues that one strategy to combat the problem of misinformation on large tech platforms is through drawing on the neglected expertise of librarians, imploring tech companies "to hire 10,000 librarians to get in there and to look at what's on the shelves, to sort, to document and to cull what is not viable, what is not useful, what is not serving the public's interest."[5] Safiya Noble, while cataloguing critiques of the history of bias in classification in library and information science from within and without the profession, nonetheless argues for the necessity of "public search engines, united with public-interest journalism and librari-anship, to ensure that the public has access to the highest quality infor-mation available."[6] These scholars suggest that the circulating collections

of content that make up our public sphere are suffering from the lack of investment in figures like Romana Javitz: their sense of commitment to the public and their understanding of the public as knowledge seekers rather than consumers or alternately raw sources of commodifiable data available for extraction. The success of Emily Drabinski's openly socialist campaign for director of the American Library Association (which she won in 2022), in which she called for workplace organizing to build power and expand libraries' role and services for the public good, suggests that the profession and the public increasingly share these views.

The full scope of the shift to digital platforms for libraries, museums, and stock photography agencies; how these changes transformed picture-work; and the new pressures of twenty-first-century picture-work is outside the purview of this book. Rather, this chapter presents another glossary to bookend the set of terms offered in the introduction. This glossary will comprise the keywords that emerged out of interviews with current or past staff at each case study, seeking to incorporate the viewpoint of the picture-worker who has seen the nature of their work overturned and thoroughly remade in the past three decades. Entries alternate between the accounts of interviewees and existing literature. The glossary is necessarily incomplete and subjective, a patchwork of the recollections and experiences of a particular set of actors. Managing large-scale image collections, whether at a museum, library, or stock business, is a rapidly changing enterprise. Further revolutions are under way as automated indexing solutions using machine learning find greater applications. The conditions at the start of research for this project were drastically different from when I concluded years later. As I wrote, conferences were convened, startups launched, and new technologies released. This chapter necessarily focuses on the major transitions each case went through as it moved from analog to digital forms of storage, organization, and distribution in the 1990s and early 2000s while including some of the predictions and assessments of picture-workers at the time of my interviews in 2015–2017. These more speculative accounts cluster, as technological prognoses tend to do, around utopian promise and dystopian dread, which will be explored in the conclusion.

Taken together, the keywords here represent an account of the halting processes that comprise digitization—a paradigm shift recognized by the workers who built new collections of digital images from the ground up.

Ultimately, these stories offer a glimpse of how the organization of images available for public circulation has become black-boxed, proprietary, and estranged from the picture-work represented in the analog image collection. Even the future visions articulated by some of the interviewees, gathered at the conclusion, depend on new advances in technology, increased processing power and storage, and increased automation. The accounts capture how private companies brought in to consult or implement digitization projects dominated the discourse of those projects. For the user, there is a marked difference between visiting a collection onsite to thumb through paper and clicking through a backlit screen. But rather than substrate, time, or location, I argue that the changes of storage, cataloguing, and circulation wrought by the "ideology of information management" have a greater impact on the sense of estrangement: as rights and reproductions work is outsourced and automated, subject identification shifts to keywords, and interaction with metadata substitutes for interaction with librarians or photo researchers.[7]

The glossary that follows is neither alphabetical nor chronological. Rather, it begins with a juxtaposition between the theoretical discussion around the ontology of the digital image and the professional discourse around the digital asset in the 1990s, before moving back in time to discuss computerization and the role of compact discs in early digitization projects. The rest of the chapter similarly weaves between the theoretical and the practical, before concluding with some of the interviewees' predictions for the circulating image collections to come.

DIGITAL IMAGE

When William J. Mitchell published *The Reconfigured Eye* in 1992, digital photography was still in its infancy. In 1990, two releases marked a new era: Photoshop 1.0, the first popular software for digital photo editing, and the Dycam Model 1, the first commercially available digital camera. Photoshop 1.0's extremely limited tool set is nearly unusable for users today, and the Dycam Model 1 shot in black and white 8-bit grayscale only. At the time, scanners were actively marketed for home offices but cost upward of $1,000, and output was limited by the color display and storage capacities of people's home computers.[8] Yet by 1992, Mitchell and

others hailed the "death of the photography" and had already identified the "post-photographic age," arguing that despite the fact that the image might remain the same, the digital image was ontologically and epistemologically a new object distinct from the analog photograph.[9] In one representative passage, Fred Ritchin argues, "What 'digital photography' obscures is that by changing the architecture of the image—moving from chemically processed grain to discrete electronic pixels—we are not creating another photographic genre, but another medium."[10] These arguments hinged on the interactivity promised by the image, its remixable "undecidability" and ability to be embedded with links to other images or information.[11] While the chemical print is a singular object, the digital photograph becomes "image-information."[12]

Within this literature, the transition to digital images challenges the truth claims of photography as digitization "ruptures not just continuity, but the entire concept of the document as evidence," in Timothy Druckrey's words.[13] Some scholars saw this quality as heralding a new, more democratic engagement with the image, in which it could be loosened from its previous authority structures. In these accounts, the more restrictive authority of the evidentiary photograph is now relaxed into a space of play, in which the constructed and collaborative nature of the image is more openly acknowledged.[14] Most recently, Daniel Rubinstein and Katrina Sluis have expanded on these earlier positions, coining the term "algorithmic image" to describe the interactivity introduced by this material change. They define digital photography as "open-ended, unknowable processuality," which challenges photography's claim to objectivity and indexicality, instead introducing a sense of open-ended meaning, "operating in a constant state of deferral."[15] Their argument centers on this critique of the linguistic, semiotic analysis of photographs as self-contained expressive acts, instead arguing that with the digital image, "there is a shift here away from content to the rhythm, circulation, and proliferation of the utterance."[16] Yet it is precisely this connection to movement and circulation that I argue is inherent to the historical case studies surveyed in this book—the images in the analog picture collections in this book represent the availability, open-ended meaning, and a denial of finitude that Sluis, Rubinstein, and others attribute to digital materiality.

Rather than at the individual level of meaning-making or the multiply sited end uses, the ontological shift to digital image is most consequential at the level of institutional workflow. Publishing industries and cultural heritage organizations that digitized their operations took advantage of speedier production processes, struggled with the ethics of digital editing, and faced new legal challenges to image copyright for digitally manipulated images.[17] When the collections studied in this book were founded, circulation designated the movement of material out from and back into the defined space of the collection. As Roberts III characterized the work of the stock agency: "Volume in, volume out."[18] Digitization complicates the travel narrative, eliminating the need for "volume in" (i.e., return of material) and changing the conditions for "volume out." Where previously one would have to either travel to or make requests for deliveries from three different institutions to bring a NYPL image, a MoMA image, and a H. Armstrong Roberts image together, now the same user can pull up images from all three collections in a moment on the same screen. In this new image world, the pictures brush up against each other, enjoying a new social life. They do not circulate according to a prescribed path but rather sit on servers across the country, ready at hand on any web-enabled screen.

DIGITAL ASSET

Sometime around 1993, software developer Doug Dawirs found himself across the table from representatives of US West, a telecommunications company based in Colorado.[19] He had been hired to help establish filing name conventions to manage their growing library of digital illustrations. Dawirs was well known as an expert on managing collections of digital images—he had created the first searchable database software for multimedia files in the late 1980s, which was widely released as Aldus Fetch in 1992 and is still on the market today as Extensis Portfolio. Yet while talking among themselves, US West staff referred to their graphics using a term that Dawirs hadn't heard before, and he stopped them to ask about it. Dawirs now recalls, "And they said because it costs us money to create, and we make money with it, we now refer to it as an *asset*."[20] From roughly that point on, Dawirs began to refer to the solutions he created as

digital asset management systems (DAMs), a term that quickly went on to define an emerging industry of people who see the efficient management of libraries of digital files as the future of publications, research, communications, commerce, and culture.[21]

The shift from managing analog image collections to managing digital assets, as well as the new pressure it places on questions of metadata, value, expertise, and control, has dramatic implications for the three case studies at the center of this book. By this "shift," I refer to the new constellations of hardware, software, staff, and conventions employed by the various industries concerned with the administration of large collections of digital files. However, I also include in this shift the conceptual implications of porting a term from the financial sector to the management of visual content and cultural heritage. In financial services, asset management typically refers to the management of investments on others' behalf. In corporate finance, asset management more broadly encompasses strategies to "maximize value" through the efficient organization and administration of a company's assets—whether "physical, financial, human, or 'intangible.'"[22] For the NYPL Picture Collection, MoMA, and H. Armstrong Roberts, Inc., the resources that comprised their primary units of value were physical pictures, and their value accrued through circulation. Each had created a system that was optimized for sharing printed pictures. With digitization, value could be "maximized" through liberation from the spatial and temporal limitations of paper and film. But in order to take advantage of these new opportunities, the institutions had to embrace untested and often expensive technology, proprietary software, and the expertise of outside companies or contractors.

While image collection management always required complex networked processes of storage and cataloguing, these solutions had previously been worked out onsite, among small groups of staff working in close proximity to pictures. Now, developing and managing a digital image collection, through the creation of newborn digital images or through scanning paper prints and transparencies, required new groups from outside of the institution to come into contact with the pictures, for storage, organization, or licensing. These new groups were often commercial ventures for whom the sense of the image as the digital asset requiring management was more intuitive than the understanding of the "picture as document"

THE NEW UNIVERSAL COLLECTION 195

that Javitz had promoted for her whole career or the "picture as story," as H. Armstrong Roberts had understood it. The dominance of the commercialized language of assets permeates digitization projects.

Librarians, archivists, and scholars of the information economy address this creep toward commodification of library holdings in their own professional discourse. Cornell librarian Jasmine Burns tracks the process by which commercial vendors like Reed-Elsevier and Gale partner with academic libraries to digitize primary source material in order to commodify its availability as a digital surrogate. She asserts,

Vendors are not interested in obtaining or collecting material archives, they are not interested in being stewards of knowledge or cultural heritage, and they are certainly not interested in preservation (digital or physical). Their ultimate goal is to aggregate, repackage, and control the information contained with the archive (which moves freely and is non-rival) in order to generate capital.[23]

This contrast lays out the distinction between the different expert groups in respect to their understanding of the "asset." Libraries and museums might consider the value of a photograph in terms of its relevance to users, its contribution to cultural heritage, or even its likelihood to generate reproduction requests and potential revenue and recognition for the institution—making asset an apt language choice. Yet this value system is not always aligned with the way in which technologists think of the image as they seek to innovate on the scaling possibilities or disaggregate elements of value within the newly digitized objects.

COMPUTERIZATION

Prior to the digitization of photographic images, other workplace practices were transformed through computerization. Organizational historian JoAnne Yates elucidates the lived experience of the so-called computer revolution in her study of how the insurance industry shaped and was shaped by emerging computerized office products in the 1970s: its slow, embodied, and human-baggage-laden emergence within particular office environments.[24] While differently delayed or implemented, this basic process, tentative, tangled, and enmeshed in human conflict, played out across industries. Looking at the actual practices of computerizing the H. Armstrong Roberts Company in the 1980s is a key case to explore how

computerization of practices like addressing and accounting laid the groundwork for computerization of picture management, just as the original 1915 ledger transitioned from egg count to photography inventory. In 1979, H. Armstrong Jr. passed away, leaving H. Armstrong III in charge of the business. With this change in leadership, two things happened with far-reaching consequences. First, the agency stopped production in their photography studio in favor of exclusively representing other photographers' work along with stock already in their library, fully embracing the role of the distributor. And next, Roberts III began researching how computerization could help streamline business practices, leading to one of the earliest examples of the use of a distributed computer network to facilitate sales and licensing of photography, a history that was attested to in order to establish prior art in a 2012 patent troll lawsuit about the online distribution of images.[25]

As Roberts III quipped, the computer system came about because "We couldn't find another place to put another desk to put another typewriter."[26] The drive toward digitization was not originally a quest for the digital image but rather born from the desire to alleviate the labor of typing. Across case studies, the process of circulating images requires the circulation of vast amounts of paperwork, tracking the movement of prints and transparencies out from and back into the collection. In addition to submissions and returns, at H. Armstrong Roberts Company, this also required tracking information about clients, mailing addresses, and submitting invoices and payments. (Indeed, in interviews, Roberts III repeatedly emphasized that the technological solutions for managing mailing lists were just as important for the development of the business as those developed for organizing the photographic prints.) Just sending out a stack of prints to a client for a potential sale required multiple typed forms, and Roberts III was eager to identify a computer system that could alleviate some of this labor: "It was understood that if you had a lot of repetitive work, the computer could help you with that." At this time, however, there were not off-the-shelf solutions or clear choices for a business his size. He began research and discussions with colleagues and eventually began working with a colleague at Photo Researchers, a stock agency that specializes in technical and scientific images, who was working with a software programmer designing

THE NEW UNIVERSAL COLLECTION 197

software for a Texas Instruments (TI) minicomputer. Given that their data organization was sufficiently similar, they agreed to share the software.

H. Armstrong Roberts, Inc. installed the TI minicomputer in 1980, loaded with the customized software. The computer itself took up the space of "a refrigerator, washer, and dryer" and connected thirteen terminals between Philadelphia, New York, and Chicago through dedicated phone lines. This networked system expanded upon the network of telephones, telegraphs, and mail that had previously knitted the branch offices together. Now, when a package of prints went out to a client, it would be tracked in the computer rather than by a paper memo. The software captured memos out and memos returned, along with the associated photograph ID numbers and some limited information about the photograph itself, such as category and photographer. The company also acquired two printers; now a form could be printed out in multiple copies and formatted so that it could be folded to display a mailing address. After going live for tracking traffic in 1980, Roberts III further invested in the system and went live for invoicing in 1982. He credits the efficiency of the system, eliminating the recurring labor and materials of mailing paperwork, as a key contributing factor leading to the company's highest profits in its history, in the late 1980s. This system hummed along for several years, even after the TI was eventually replaced and the software had to be run on an emulator (the company only transitioned from the legacy software for traffic in 2018).[27]

The introduction of Photoshop 1.0 in 1990 signaled to Roberts III what became increasingly inevitable—that professional work with images, from running a stock agency to a design firm, would be done on computers. Roberts III describes the brief lag between recognizing the inevitability of the transition to digital circulation and being able to digitize his own stock: "Storage was expensive, scanning equipment expensive. There was waiting for this to become affordable to our industry, to people of our size."[28] Once again, Roberts III perused consumer magazines and eagerly traded information with competitors at trade shows and conferences. As his experience with Photo Researchers indicates, digitization frequently required collaboration across agencies, engaging a company to create solutions for multiple firms at once rather than an individual user. This lag between investment and payoff mimics that which Yates identifies in the insurance industry

and also demonstrates the "reciprocal shaping of technology and its use" by the "firms as users."[29]

The shifts Roberts III oversaw in the 1980s signaled major changes for the company, and eventually the industry, as new products such as CD-ROMs, royalty-free images, and e-commerce dramatically changed the nature of stock photography distribution networks over the next few decades. The global, networked image agency anchored by a common control system that H. Armstrong Roberts Sr. originally envisioned in the 1920s and 1930s was realized at such a scale that it completely changed the relationships that make up the industry, eliminating areas of expertise and creating new ones, as well as creating new products and new structures of valuation. This process required involvement of outside experts, customized solutions, the need to create and then maintain new standards, and the ever-present need to chase new technology (pressures that also emerged in the museum and library context). Computerization also encouraged collaborations between companies that led to greater consolidation of resources and aggregated collections. These changes contributed to dramatically new perceptions about the nature of rights, property, value, and expected use of images in the stock industry.

COMPACT DISCS AND DIGITIZATION

As Nanna Bonde Thylstrup observes, mass digitization has become a "cultural and moral imperative" that transforms the politics of cultural memory.[30] Studying large-scale projects, including Google Books and Europeana, Thylstrup is able to elucidate the dynamics by which mass digitization become "infrapolitical process that brings together a multiplicity of interests," fundamentally transforming earlier dynamics of knowledge production and accumulation with layers of commercial and technological frameworks for articulating value.[31] These large-scale projects assert and reify transnational capitalism and contemporary media flows.

Yet, preceding these mass digitization projects of the early twenty-first century, individual libraries, businesses, and museums, whose workplaces had been transformed by computerization, pursued digitization as a means for expanding access. These early projects help to clarify the manner in which, prior to expectations of transnational flow of the digital image,

physical stuff had to be transported, often cross-country, requiring new material assemblages and infrastructures. Each organization under study here collaborated with outside companies to accomplish digitization projects. These new technology startups, including Luna Imaging (founded in 1993 in California) and JJT, Inc. (founded in 1993 in Austin, Texas), promised to perform the physical digitization and create tools for data management of historical material for museums and libraries. Since the companies oversaw the hardware and equipment required for large-scale digitization, photographic material had to be shipped in order to be digitized, to be returned on compact discs. Thus, crucially, early digitization relied on the ability for circulation and distribution on a new media storage technology: the CD. The compact disc changed the marketing, storage, and classification priorities at each organization.

H. Armstrong Roberts Company's first expansion into digital search and marketing was through their participation in a CD project developed by California-based Scott and Daughters, called Stock Workbook. Launched in the late 1970s, Stock Workbook was known for publishing a national paper directory of photographers, illustrators, and stock agencies and expanded into distribution in 1989. In 1992, they released their first CD, Stock Workbook 1. The CD included 2,000 images along with one of the first searchable keyword software for image collections, called Fetch, developed by Doug Dawirs. H. Armstrong Roberts, along with one hundred other companies, purchased space on the CD to show a representative sample of images. Using the Fetch browser, users could scroll through thumbnails or search by filename, keyword, type, or volume. Each image was a 72-DPI PICT file that would open in Photoshop (figure 4.1). The files were thus not large enough to use in print projects—they merely served as an advertisement for the agencies; clients would still have to phone, fax, or mail in their order. Nevertheless, the CD foretold the changes emerging in the industry and educated the first generation of art directors and picture researchers on the processes of digital search. It was also effective for the participating agencies. Roberts III recalls, "Whatever it cost us to put the images in, we recouped the cost in two months."[32] The next year, they purchased 250 images on Stock Workbook 2, and in 1994, they purchased 1,000 images. While according to Roberts III, the industry was in the midst of the "heyday of the paper catalogue" at the time, the Stock Workbook CDs exposed

4.1 Selection of H. Armstrong Roberts images on Stock Workbook 3, 1994. Screenshot by author.

potential clients to an exponentially larger number of images. And instead of being constrained by the thematic divisions of paper catalogues, clients could enter in their own keywords to see results from different agencies. Through his experience with the Stock Workbook CDs, Roberts III became enthusiastic about the possibilities of digital distribution. When Aldus, which had purchased Fetch, merged with Adobe in 1994, he called them up and asked for a license for the software. Adobe and Roberts III agreed on a price for a limited license, which allowed him to go into CD and later DVD catalogue production. His staff produced several discs throughout the 1990s, for H. Armstrong Roberts Company as well as for competitors Grant Heilmann and Camerique.

Scanning began with the first Stock Workbook in 1992 and continued throughout the decade. As Roberts III explained, "Not only for us but for

us and for the whole industry there was a scan and rescan system" as new and better equipment came on the market.[33] While there were companies and services dedicated to large-scale scanning projects, Roberts III decided to pursue in-house scanning, building on the company's history of managing as much of the production process onsite as possible, from shoots to printing. Now, though, Roberts III needed to bring in outside experts, develop partnerships with other companies, invest in experimentation, and make decisions about the limitations of competing proprietary software and hardware. Earliest scanning projects relied on Kodak Photo CDs, a proprietary format that cannot be read by any contemporary programs. In 1999, Robertstock/Classicstock partnered with colleagues at the company the Stock Market, allowing the Stock Market to scan their negatives and distribute them in exchange for the digital files. A large sale of another selection of images, as well as the brand name "Retrofile," to Getty in 2005 allowed them to reinvest in new scanning equipment,[34] and scanning continues to this day, where a recent scanning project proceeded with the goal to first scan the entire "OF" collection (their so-called Old-Fashioned images, vintage shots from the earlier half of the company's history that have proven most lucrative in recent years), then having key staff review to flag which images are worth the additional cleaning expense.

The last Stock Workbook CD that H. Armstrong Roberts participated in was Stock Workbook 8 in 1999; the company's website was launched the following year. Over the seven-year period in which the CDs and DVDs drove business from 1992 to 1999, production methods for their clients had thoroughly shifted to digital. As a marketing tool, these CDs and DVDs served as an essential hinge between paper catalogues and the websites to come. The CDs provided an impetus to begin scanning, a pressure to figure out digital search, and an introduction to the alternative logics of digital search and cataloguing. While H. Armstrong Roberts and other agencies used these as an extension of the catalogue, in which clients would still have to go through the company to license an image, the popularity of another type of disc had created a more dramatic disruption.

With the advent of CDs, DVDs, and computers with built-in disk drives and burners, a new type of product and a new type of seller of stock emerged. Smaller startups could acquire or produce a selection of hundreds of images and market them as "royalty free" (RF)—that is, with just one

purchase of a disc, the user could use any of the images an unlimited number of times, rather than having to license a particular image for a particular use. This type of product was an extension of the "clip art" that had been available for computer graphics for years, but now that computers could render high-resolution photographic images, the stock photograph had new competition, as RF CDs were marketed toward directors who had been used to working with stock agencies. For these professionals, a $399 disc with 100 images for use however they wanted was a considerable discount. Some stock agencies tentatively entered the RF field, but many companies that exclusively produced RF discs were seen as outsiders, "clever entrepreneurs" leveraging new technology.[35] Throughout the 1990s, the popularity of RF images boomed, with a greater share of the market growth going to RF images rather than traditional rights-managed images (RM, as it became known).[36] As more and more RF products entered the market, the quality of images went up, while prices stayed the same.[37] Roberts III sees these CDs as the primary turning point for the reconfiguration of valuation and pricing in the industry. If 100 images could be purchased for $399, it brought the price for a single image down to a few dollars. This is a familiar story across other cultural industries (including music and home video) and is due to specific affordances of the digital. As the scale of content that can be delivered is massively increased—with hundreds of images on a CD that can be mailed in one standard envelope—units of measure and their correlation with value are revised. Production methods for stock photography clients—including the ease of altering a digital image—also invited a new type of digital photographic product, which could be more freely manipulated. Designers no longer saw stock exclusively as a collection of readymade images but also as a supply of graphic elements that could be extracted and manipulated in editing software. Stock photography was predicated upon the idea that photographs could be used as recombinable signs within an infinite number of ads. Digitized production in which the images themselves can be more easily manipulated and taken apart further dissolves the perception of the cohesive photographic image.

Compact discs were crucial early storage and distribution devices for MoMA as well. From 1964 until new construction in 2002, the museum maintained a photographic studio onsite. From the 1960s through the 1990s, photographers continued to document collections and exhibitions

THE NEW UNIVERSAL COLLECTION 203

in the same manner: the darkroom processed black and white prints, while color film was sent out to local labs for processing. Reference images were kept locally by each department, and experimentation with visual cataloguing comprised finding new ways to include small photographic prints with cards. But in the 1990s, as opportunities around digital photography, digital scanning, and digital storage began to expand, rapid changes were underfoot. Retired archives specialist and staffer in the Department of Rights and Reproductions since 1978, Thomas Grischowsky, recalls that the move to digital happened quickly.[38] Research into digitization began in the mid-1990s, and the staff was thrilled when Luna Imaging, a California-based company, demonstrated they were able to produce high-resolution scans of color transparencies.[39] Luna Imaging, the product of a collaboration between the J. Paul Getty Trust and Eastman Kodak, was explicitly founded in 1993 to solve for information standards as well as digitization workflow for museum and academic clients.[40] At this point, "the writing was on the wall that analog was going to start going away. And it moved at an ever-quickening pace," Grischowsky notes.[41]

Erik Landsberg, who began at MoMA as a temporary photographer in 1995 and was director of imaging and visual resources upon his departure in 2016, was a key actor in MoMA's journey toward digitization and digital asset management, researching and then establishing workflows and standards within the museum and across the broader cultural heritage community. In 1996, after accepting a full-time position within the department (then called the Department of Photographic Services and Permissions), Landsberg and chief photographer Kate Keller were tasked with researching the best technology available for producing digital photography. Later that year, Landsberg presented their research to a panel of experts convened by Peter Galassi, chief curator of photography at that time, which included representatives from other museums and from IBM. The panel collectively concluded that digital capture was sufficient for offset reproduction, and Landsberg began implementing a digital photography operation in parallel with the traditional work on film.[42]

The shift from a totally analog mode of producing images to an all-digital mode was not abrupt. Rather, the process took place over time. The team began with an exhibition catalogue for Lazlo Moholy-Nagy that consisted of mostly works on paper and then began to capture the photography

collection, which was well suited to a digitization project. Specifically, compared to other departments, photographs were smaller and in a relatively standardized format that could be efficiently photographed on the same copy stand. Also, black and white photography could be captured without as much concern for color correction as the painting collection.[43] This project initiated what became known among Landsberg and his team as the "photo dig" project, with the goal to eventually provide digital photography of the entire collection. This prompted a redirection of resources and development of new practices: additional staff were brought in, standards for dealing with retouching and color were established, and a "workflow" was established. After the image was captured, it had to be processed and archived. At first, files were collected on a hard drive and then sent out to Luna Imaging to be burned onto a CD.[44] Later, CDs and then DVDs were burned in-house, where three separate files would be saved (RAW, color-corrected, and color-corrected and cropped) and the file name and CD number noted on a growing Excel spreadsheet. Again, bureaucracy betrays how complex ontological arguments are embedded within seemingly practical decisions about standardization, as these three types of files represent transparency about the relationship between the photographic image and the reality that it captured—the color-"corrected" file is potentially truer to life, but the RAW, unaltered file is saved as a safeguard. With this system, when a staff person from another department requested a photograph from the photographic services department, staff would consult the spreadsheet, locate the CD, burn a copy CD, and send it via interoffice mail (though email and networked computers were in use, network traffic and storage capacities prohibited sharing images via email or network transfer).

Thus, the first wave of digitization required a jumble of things: CDs and burners, hard drives and cords, paper and boxes. It was hardly a move toward dematerialization. Digitization also took a lot of time. With the first generation of digital cameras used at MoMA, it took from five to fifteen minutes to make a capture with large digital scanback cameras, which carefully scanned line by line of pixels. The process of transferring the files to hard drives and processing them, not to mention the hard drives' trips back and forth to California for burning CDs at Luna Imaging, took additional hours. Converting from film to digital was expensive and required a

THE NEW UNIVERSAL COLLECTION 205

significant amount of labor, investment, expertise, and faith in the future utility of the digital file.

At the New York Public Library, early photographic digitization also involved the shipment of boxes of paper prints to a company across the country, in exchange for the return of boxes of plastic CDs. Between 1993 and 1995, NYPL participated in the Digital Image Access Project (DIAP), sponsored by Research Libraries Group, in collaboration with seven other libraries, including the Library of Congress, an early experiment in developing a union collection online (see "union collection" below). Participating institutions were instructed to select photographs that fit the theme "urban landscape" for digitization; the images would be collected in an experimental interface called Photologue. Both the digitization and the interface were developed by the company JJT, Inc. (now Stokes Imaging, Inc.) in Austin. Stokes Imaging had built their niche through the development of specialized digital camera equipment for scanning. Founded by John R. Stokes, who had previously run a slide duplication service in the 1970s and 1980s, Stokes promised data management alongside a proprietary system for image capture.[45] The NYPL team, which included Julie van Haaften (curator of photographs at the NYPL from 1980–2001) and Anthony Troncale (head of the Digital Imaging Unit from 1996–2000), selected what is now known as the Romana Javitz Collection, a collection of photographs by prominent photographers that had been pulled from circulation in the Picture Collection. The 35-mm intermediates were produced and shipped to Austin; digitized files were returned on CDs.[46] Throughout the process, Troncale recalls that he and other library staff were "learning a lot from vendors—what is a jpeg, pixel array, bit depth, color space."[47] At that time, Stokes seemed to Troncale like a "genius," and the scarcity of this kind of expertise, along with the physical nature of his digital camera and scanning setup, *required* this movement of material around the country, just as MoMA had committed to ship to California. Through Troncale's direct work interfacing with Stokes, the packing of prints and unpacking of plastic CDs, and the reintegration of the newly digitized files into library systems, he took on the role of intermediary explaining the technology to library staff in other departments. He further notes that this role often required smoothing out the tension between librarians, curators,

and technologists, which he diagnosed as due to the fact that "all three are tasked with congregating and describing information," though "they all have different agendas and different needs."[48] The confrontation with new materials was also a confrontation with new knowledge regimes.

In many ways, the management and storage of newly digitized images on CDs mirrored earlier forms of storage, with encased media that could be organized and stacked. But the files encoded on the plastic CDs presented a new challenge. Julie van Haaften, reflecting on the DIAP project for NYPL in a presentation on the history of digitization projects at the library, noted, "Imaging was easy. Data was hard. Data structure was harder."[49] The structure of these organizing systems required a combination of data entry and software (and thus labor, technology, and material) that comes together in the digital asset management system.

DIGITAL ASSET MANAGEMENT SYSTEMS

Here it is worth pausing to reflect on the significance of Fetch and other "multimedia databases" as they were first marketed, or "digital asset management systems" as they became known by 1995. Just as H. Armstrong Roberts Sr. developed his stock photography business out of his experience with syndicated publishing, Dawirs's specialization creating digital asset management solutions grew out of his work with a national periodical— the coupons and classifieds magazine *PennySaver*.[50] In the early 1980s, PennySaver staff cut out hundreds of clippings a day, waxing them down on paper to create a Photostat that could be turned into a plate for printing, and Dawirs was hired to streamline the process with computerized processes. After five years of work and a partnership with the company Multi-Ad Services, he developed a robust publishing and layout program called Presto. As proud as he was of a program that allowed staff to "lay out a magazine in 8 seconds," the component that garnered the most attention was the image management utility, Fetch. While he sold it through Multi-Ad Services for three years, by 1991, he decided to shop the program around to other major companies, taking pitches from Aldus, Adobe, and Kodak and eventually licensing the software to Aldus. At the time, the practices involving the management of multimedia files on a computer were expanding rapidly. QuickTime was released in 1992, which allowed

management of multimedia files. Kodak Photo CD was also launched that year, allowing for the commercial scanning and distribution of photographs. While digital-born photography was still in early stages, the publishing and design industry was undergoing major changes buoyed by the release of these key products. Fetch was among the best reviewed of the several multimedia management applications that came out in 1992.[51] Dawirs went on to work with numerous stock agencies globally, and his involvement in the professional organization PACA (Picture Archive Council of America, now Digital Media Licensing Association), building their online search platform, working directly with many of their members, and coordinating conferences, has left a major impact on the industry.

New technological systems tend consolidate power and control across discursive and material vectors; even in the mundane shift in office processes, new configurations of value and power are arrayed. Digital asset management systems, even in the allusion to efficiency in their name, promise to complete the long twentieth-century project of making information "standardized, atomized, and stripped of context," as Craig Robertson defines the "ascendancy of information as a defining aspect of contemporary society."[52] Just as Robertson explores the filing cabinet as an key structure by which "classification became a problem of efficiency, a problem of labor, and when storage became a problem of rapid retrieval," the digital asset management system similarly organizes information in the name of efficiency in ways that reflect particular raced, classed, and sexed forms of labor and knowledge; rearrange relationships within an office; introduce new architectures; and invite new models of expertise. Robertson highlights the way that early filing cabinet advertising and patent applications claimed innovations in design that promised to alleviate labor of office work (understood as a skilled and masculine job) to allow for female office clerks (implicitly understood as unskilled).[53] Through this discourse, one domain of expertise (the office worker) was substituted for another (the office furniture designer). Moving from the paper machine of the card catalogue to the digital asset management system introduces new institutional collaborations that similarly name new expertise. In this case, expertise is claimed by the designer of the digital asset management system, asserting the value of technological solutions to the problem of access and space. The image, now an asset, is estranged from embodied filing

work and now called up by keystroke. Maintaining these systems puts new pressure on technical staff and allows the management of these systems to be newly estranged from the institutional knowledge building involved in getting to know legacy systems, replacing the slow work of relationship building with hard skills that are newly portable across jobs.

At MoMA, the need for a digital asset management system was clear when the spreadsheet tracking digital images that started in the Department of Imaging Services grew to almost 25,000 rows, the information outgrowing its quarters. After researching the handful of businesses offering digital asset management systems at the time, Landsberg and staff decided to work with Portland-based company NetXposure, who touted their track record with other cultural heritage projects (most companies at that time, as Landsberg recalled, were oriented toward commercial enterprises). Between 2005 and 2009, NetXposure produced a DAM system that required collaboration between Landsberg's department and the IT department. Ultimately, Landsberg's team was responsible for loading the DAM with digital assets and with the creation of metadata, while IT was responsible for maintaining the servers and software. This represents an expanded role for the IT department, which was previously concerned with office equipment maintenance only. Labor at the museum was thus reorganized around the new ontology of the image-as-asset. NetXposure's case study about the DAM system includes a note from MoMA's chief information officer, using the language of the tech industry, and reveals much about how the discourse had shifted: "The bottom line is that our technology strategy is to grow our digital asset collection and to leverage it to better achieve the Museum's mission."[54] Better leverage meant more opportunities for interaction with other management systems—as digital asset management systems interact with the backend platforms that populate website content or communicate with legacy museum collections management software. It opens up opportunities for further image management to be outsourced outside the museum's walls, including copyright management. Part of the development of the DAM also helped to streamline communication with MoMA's outside licensing partner, Art Resource/SCALA (see Copyright Management section below). With images explicitly defined as assets to be managed through technological solutions, and growth and leverage as the stated goals, third-party image management is inevitable. Rather than the

office visits that Pearl Moeller and Elodie Courter recalled, the gatekeeper to reproductions is now an interface, the image more explicitly understood as alienable content.

COPYRIGHT MANAGEMENT

The transformation of materiality, digital content creation, and distribution has changed the nature of the copy, which lies at the heart of issues of copyright. In a 2000 report by the National Research Center, the authors acknowledged this fact: "In the digital world, even the most routine access to information invariably involves making a copy."[55] Theorist Johanna Drucker echoes this from a theoretical perspective: "The existence of the image depends heavily on the display, the coming into matter, in the very real material sense of pixels on the screen."[56] Both the theorist and the legislator agree that the event-based nature of digital files changes the nature of copying for every internet user. With copying now made into a routine and functional part of broad cultural experience, the traditional understanding of image property has to be actively maintained.

At the same time, it was the consolidation of artists' rights, prior to digitization, that established the virtual image as distinct from the ownership of an actual artwork. This can be explored most effectively through MoMA's history with copyright. As opposed to the library, where the Picture Collection has historically deferred on issues of copyright, with notices warning users they are responsible for research copyright, and to the stock agency, which foregrounds copyright as the primary product of the image, the museum must confront complex dimensions of image authorship. The management of virtual images, in which the virtual image is not the picture itself but rather the right to reproduce that image, begins with the circulation of paperwork. MoMA had always taken an active role in shaping museum approaches to living artists' rights. Pearl Moeller, first head of the rights and reproductions department at MoMA, recalled strong support of artists by MoMA leadership, particularly for photographers, whose rights claims were often murky. Moeller even suggested that MoMA's support of artists' rights encouraged the expansion of rights marked by the 1976 Copyright Act, which updated forms of media and broadened protection for creators: "I mean, they [Steichen, Newhall, and leading photographers]

got the clause in the U.S. law for photos . . . I think this ought to be mentioned because a lot of that was started right here in the Museum of Modern Art."[57] There are many motives behind MoMA's stance—support for the remuneration of artists they worked with honored artists' authorial control and was thus compatible with the discourse of modern art that MoMA promoted. Later, when the United States joined the Berne Convention in 1989, copyright was retroactively extended to the authors of any fixed work, whether it had been registered with the US Copyright Office or not, giving protection to American artists that European artists had had since 1906. This roughly coincides with the development of the Artists Rights Society, founded in 1987 to represent artists, advocating for legislation to strengthen artists' rights and going after infringements.

MoMA's support of artists' rights confirms the idea of the image as property, which can extend to the museum's role as a producer of images. MoMA claims copyright to photographs produced by their staff of exhibitions and works in the collection. Thus, in order to assert their own role as author without encroaching upon the artist, MoMA staff embrace the idea of multiple layers of property concentrated in a single image. Photographs shot by their photographers were given copyright notices to the museum, even as the rights and reproductions department would require image requestors to additionally clear rights with living artists (and later sought nonexclusive licensing agreements with artists so that they could use images for MoMA education and publication purposes). This management of property acknowledges that each request for reproduction involved the physical movement of image as material (the transparency or print), the image as an abstraction (the reproducibility represented by the transparency or print, captured by MoMA), and the image as a piece of art (the original work fixed by the artist). With each request, paperwork and rules governed these three forms of images—the transparency itself could be rented for a limited period of time before returning to museum files, and the legal right to reproduce the image was delineated by the form of a license. MoMA owns the photography it commissioned, but the artist owns the immaterial image. These layers break down legally, but they also reflect the active "roles" that an image takes on in different contexts.

Managing copyright to their own documentation images required extensive licensing, and MoMA ultimately allowed the flow of virtual images

out of museums to be facilitated by an outside company. In 2002, MoMA began outsourcing the rights management of the images of works in its collection or exhibitions within its walls to Scala Instituto Fotografico Editoriale, a Florence, Italy-based picture archive, and their US representative, Art Resource, Inc., located just a few miles away from MoMA in New York's Soho neighborhood. These art photography agencies, which function as intermediaries for museums and artists, are also key institutions that create conditions under which photography is understood as art, commodity, and documentation at once, a process accelerated with digitization. The history of Art Resource demonstrates the growing importance of this business model since the 1960s.

Art Resource was founded in 1968 when Theodore Feder, an art history graduate student teaching at Columbia University and writing about Renaissance Dutch artist guilds, decided to form a photo archive. Initially called Editorial Photocolor Archive, Feder's company began by representing the photography produced by student newspapers in universities across the country, selling the photographs to national news outlets that were newly interested in student political movements.[58] He soon shifted his focus to art illustrations. In 1978, on a visit to Florence, the young entrepreneur convinced Scala and Alinari (the largest and oldest fine art image archives, respectively) to allow Art Resource to be their representative in the United States. Since then, Art Resource has systematically enrolled museums and collections around the world and now represents over 6,000 museums and archives worldwide (and was one of the primary agencies I had to work with to clear the rights to reproduce the images in this book). Predigitization, this service required the moving of transparencies, negatives, slides, and black and white prints to Art Resource offices, where the material was interfiled and incorporated into their cataloguing system. Now, the company can manage most of their image traffic through web-enabled databases. The growth of this company thus coincided with the legal shift in the definition of images as property in the 1970s with the Copyright Act of 1976 that encouraged artists to take an active role in their image rights management and the technical shift toward digitization in the early 2000s. Feder acknowledges that most museums joined Art Resource between 1995 and 2012.[59]

In order to take over MoMA's image management in 2002, rather than moving boxes of transparencies and slides, Art Resource staff merely

had to gain access to MoMA's digital resources. By 2009, access to digital images and metadata was further streamlined when MoMA's database team launched a strategy that enabled web-accessed DAM software designed by NetXposure to communicate with the museum's legacy collections software, ensuring that digital files along with corresponding metadata were updated automatically to match the data that curatorial and collections staff entered at the museum and that these data were accessible via remote locations. Now, as requests come in, Art Resource staff simply consult the database, send the required forms, and share fees with MoMA. And yet, despite the potential seamlessness of Art Resource's access, the museum maintains control. As of my 2017 interviews, Art Resource staff had read-only permissions: in order to download the high-resolution file to share with licensing applicants, a MoMA staff member must review the request and approve the download, demonstrating the checks in power.[60] While digitization opened up opportunities for the rise of organizations like Art Resource, who can facilitate billing and the movement of files, the property structure that preceded and enabled this shift is maintained through the museum's continued control.

STRUCTURED DATA: METADATA AND KEYWORDING

The shift to digital distribution threatens the control these institutions had over the movement and usages of the images, necessitating new tactics for reasserting control over their property.[61] This coincides with a shift in the nature of research: researchers, librarians, and curators who used to serve as intermediaries or gatekeepers to materials onsite have given way to automated forms of reference work, with a resultant responsibility placed on the classification systems and software solutions that make it easier for users to find what they need without an intermediary and easier for institutions to track how their resources are being used. Van Haaften's words echo here: "Imaging was easy. Data was hard. Data structure was harder."[62] In turn, metadata emerges as increasingly important: though it was always the organizing infrastructure of large-scale collections, digital databases allow metadata to be more detailed, more networked, and more portable— in theory. For instance, subject description allows users to find images not only through a collection website but also through Google Images or

through links from other sites. Images that once had to be filed under a single term (subject heading at the library or artist name at the museum) can now be tagged with extensive keywords offering multiple points of access. Using Application Programming Interfaces (APIs), information management systems can communicate with each other, exchanging collection data. The promise of metadata that link collections, increase accessibility, and promote scholarship is dependent upon increasingly dispersed forms of labor. Yet the more estranged experience of the researcher interacting with a database rather than a person belies the work that librarians, stock agency workers, and curatorial departments put into populating the metadata fields and the more subjective decisions that help make an image findable. Because of this expanded role—the increased labor required to produce it and the greater amount of utility once it has been created—metadata becomes an object of value in itself.

The importance of metadata and the way in which it defines the networked image is representative of a new ontological configuration of older conditions. Where, for example, data tracked by paperwork and cards at a stock agency did constrain and track movement, metadata can be linked with the image in a more material way, embedded within the file, and it introduces the idea of the machine reader. Metadata was first introduced in a 1968 paper by computer scientist Philip Bagley on programming for the US Air Force, arguing that programming languages must be able to associate secondary data elements with primary data elements such that the second can contain information or instructions about the first (i.e., data about data).[63] In other words, metadata, in its first formulation, was not written by a librarian for a human reader; it was written by a computer programmer for a new reader: another machine. The connection with programming and machine reading is fundamental to the concept of metadata.

Also in 1968, the Library of Congress released a final report about their pilot program for MARC (Machine Readable Cataloging), which has since become the most pervasive and longstanding metadata standard. The project's architect was Henriette Avram, who came to be referred to as the "Mother of MARC."[64] Avram was a systems analyst who was among the small group of computer programmers writing programs for the IBM 701 when she worked at the National Security Agency from 1952–1959 before working for private industry.[65] In 1965, despite her lack of a library degree,

she took a job at the Library of Congress in 1965 to analyze cataloging data to propose a system for making it manipulable by a computer.[66] By 1966, she had released the MARC Pilot program, which created a framework for computers to interpret bibliographic information, primarily by creating numeric markers for standard fields. The result "enabled metadata to become *interoperable*, a malleable flexible object which would allow disparate catalogues to communicate and work together automatically."[67] The standard was quickly adopted nationally and internationally and is currently used as the foundation of bibliographic communication across the world.[68] I dwell on this example of an essential metadata standard because it illustrates three important aspects of metadata: (1) metadata requires collaboration of different expert groups (in this case inviting a computer programmer into the library to do the work of translation), (2) metadata is meant for both human and machine readers, and (3) metadata involves the linking of multiple levels of data together—that is, metadata is not a list. Ultimately, metadata is not just data about data—but the data about data that is required by large-scale technological systems in which machines participate as readers.

Digital distribution also allows users to more directly interact with this metadata. As Rubinstein and Sluis observe, metadata allows "users with no programming skills to have some control over the visibility and aggregation of images and influence output of algorithms deployed to sort, sift and supply images for the web interface."[69] Users who search "Shark" in Google Images, then filter for color or size depending on their needs, are interacting with multiple layers of metadata. Roberts III states the effect for the user plainly: "The job to be an editor has been transferred to the client. Because the client now has to wade through tons of crap."[70] Users might avoid the experience of gatekeeping or barriers to access, but they are subject to new expectations of labor.

The visibility of images on the web is constrained by metadata—both by what the computer "sees" and how that vision translates into the materialization of the image in front of web users' eyes.[71] Stock libraries maintained by librarians, curators, and photo agencies promoted a certain kind of visibility for images: controlled, authoritative, and commoditized. When web users use image search on a daily basis, and when web designers acquaint themselves with search engine optimization, they are training themselves

in a new type of visibility, constrained and enacted by metadata. The conditions of Google Images search are an "illustration of the way algorithmic and computational aspects of the image takes precedence over the visual."[72] Practically, this produces a shift in expertise, in which specialized work done by programmers, database administrators, and software creates the perception that image research itself is unprofessionalized, something that anybody can do. Users are expected to educate themselves on Boolean search logic and leverage the features of search engines, rather than consulting a librarian or professional image researcher.

At the NYPL Picture Collection, an early web project illustrates the way in which metadata work is transformed in an online environment. In 2002, 30,000 images from the Picture Collection were digitized as the first digital collection to be launched by the NYPL branch libraries (notably, the first digitization project by the research libraries was the digitization of the Romana Javitz Photography Collection in 1993). The Library pursued the project, funded by a major grant from the Institute of Museum and Library Services (IMLS), to explore the possibilities for visual resources on the web. Two years of planning went into the initial launch, and an advisory committee of librarians and users was convened with much care put into the design of an interface that would reflect the experience of browsing files onsite (figure 4.2).[73] Once the design was agreed upon and images scanned, they had to be incorporated into the library catalogue.

The resulting site represents a clash of two different epistemological value systems: the specificity of the Picture Collection with the standardization of the online collection. The characteristics of the Picture Collection noted through chapter 1—the flexible, idiosyncratic subject heading list (what is known in library science as a "local" indexing system), the lack of an electronic catalogue for item-by-item tracking—served as stumbling blocks that vexed the librarians who sought to incorporate the holdings of the Picture Collection into the larger web of resources at the NYPL and beyond. Each digitized image had to be incorporated into the Library's digital catalogue, where metadata fields were different from the metadata captured on the hard copies. Most significantly, the subject headings that organized the physical collection were not always translatable to the subject terms required by the digital catalogue, which followed the Library of Congress and Getty, a problem highlighted by librarian Lucia Chen in her report

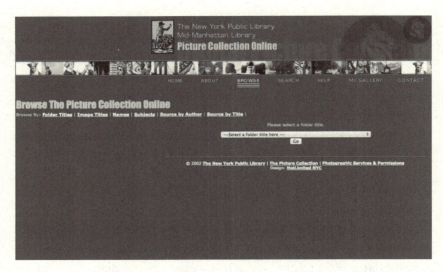

4.2 Detail of "Picture Collection Online" website launched in 2002, showing "browse by folder" option. Screenshot by author, 2017. http://digital.nypl.org/mmpco/.

about the digitization project: "How to make the Picture Collection Online compatible, and at the same time, maintain the flexibility and responsiveness of the local indexing system?"[74] The solution took advantage of the layering of data that is possible in digital cataloguing environment.

The team broke down the metadata and indexing into multiple levels. Library of Congress headings and Thesaurus of Graphic Materials were used for subject fields, while the Picture Collection subject headings were used in the title fields. With this decision, the Picture Collection pictures become machine-readable, newly opened up to a world of data. That is, because they are catalogued digitally with standardized subject terms in standardized field, their data could be incorporated into any future aggregation of data from other collections. Title fields, on the other hand, represent a freer space—there is no expectation of standardized terms for titles and thus no expectation they would be used to group objects in a database. In addition, in this new regime, multiple terms could be appended as subject terms, and they no longer dictated the physical location of the image but rather represented multiple access points.

That said, something of the legacy of the Picture Collection's attention to subject indexing and public librarianship persists in the digital space. Senior librarian Raymond Khan has worked on every digitization project

of the Picture Collection's holdings since the first and describes how the practice of working with the public on subject-based inquiries in the physical collection informs his approach to cataloguing the digital object:

> I think this department, when it comes to metadata, we tend to expend a lot more effort in doing the subject tagging than any other divisions, which often will just import maybe the subjects from the catalogue and that's it. If they digitize a mass of stuff, they'll maybe just include the data that's from the old catalogue record and that's it. Whereas when we digitize something we basically look at each item and try to tag it. And we do that on the basis of our experience out there, of what people ask for, so that we can try to make our materials more discoverable. More *public* really.[75]

For example, in a search for images of "Central Park," one particularly compelling photograph of children playing with donkeys published by the Detroit Photographic Company was scanned by the Picture Collection (figure 4.3). In addition to Central Park, other catalogued topics

4.3 "Donkeys in Central Park, New York." Art and Picture Collection, New York Public Library Digital Collections. The penciled subject heading is visible on the bottom left. Art and Picture Collection, The New York Public Library.

include Baby Carriages, Donkeys, Clothing and Dress—1900–1909, and Children—Social Life. By contrast, an equally lively shot of children playing in a Central Park fountain (which also includes a baby carriage) from the Irma and Paul Milstein Division of United States History, Local History and Genealogy, is simply tagged Central Park, Manhattan, and New York (figure 4.4). In the quote above, Khan uses the word "public" to implicitly mean findable, with findability defined by the range of subject tags informed by history of engaging with public in picture research.

Like the earlier DIAP project Troncale helped supervise, the standalone Picture Collection website represented a siloed collection interface that was not extensible with other NYPL digital collections. When the NYPL Digital Gallery launched in 2005, it was designed with the support of external advisory groups and consultants to be a longer-term solution, running on hierarchical, open, extensible architecture designed by the

4.4 "Manhattan: Central Park—[Wading pool]." Irma and Paul Milstein Division of United States History, Local History and Genealogy, The New York Public Library. New York Public Library Digital Collections.

Digital Library Program.[76] Within the new environment, Picture Collections holdings are not visually distinct from those of other collections, but their cataloguing still stands out. Susan Chute, managing librarian of the Picture Collection and Art Division from 2005–2011, confirms the relative accessibility of Picture Collection items on the Digital Gallery site, noting that though as a department they had fewer images available online, they received a disproportionate number of requests for reproduction through the online system, indicating that web users were encountering their images more readily, perhaps due to more extensive tagging.[77] Looking at the impact of digitization on image archives, I have suggested that the mediating input of the librarian is vanishing from the experience of image research. Nina Lager Vestberg has similarly argued that "digitized catalogue and the keyword-based search engine have all but replaced the visual memory and expertise previously held by picture librarians and archivists."[78] Yet despite the undeniable changes in how users access pictures, these keywords, topics, and subject descriptions are entered by picture-workers and archivists, who continue to shape how material is accessed, so long as their expertise is sought out and valued.

A primary element of structured data is the subject keyword, which plays a particular role in the newly digitized stock industry, where an image's "publicness" or findability translates directly into sales. With the rise of digital distribution and web commerce in the 1990s, the makeup of the stock image market was transformed by radical consolidation. In 1997, Getty Investments and Photo Disc, Inc. merged to form Getty Images (in part to take advantage of Photo Disc's online database[79]), and Corbis, which had been furiously buying up rights to historical image collections, changed management and began to explicitly focus on image licensing through the web. By 1999, Getty and Corbis, along with two other companies later acquired by Getty (Image Bank and Visual Communications Group), were estimated to control over 45 percent of the industry sales.[80] In the wake of their growth, smaller agencies banded together through partnerships, and the importance of the role of distributor grew. H. Armstrong Roberts Company entered into multiple distribution arrangements over the course of the 2000s. In 2016, the company

was working with seventeen other agencies.[81] These agencies range from smaller—like the London-based Diomedia, which provided very few sales to H. Armstrong Roberts Company, primarily in Eastern Europe—to the larger—like Getty and Alamy Photos, their second-highest seller in 2016.

These partnerships require H. Armstrong Roberts Company to make their digital images available for distribution through multiple different sites. Initially, Roberts III had to load auxiliary drives for shipment out to other companies but now is able to share files and metadata via FTPs, using packages created in FileMaker Pro. Aside from the transfer of files, an essential medium of translation among collections is the keyword, as each image file is tagged with extensive descriptive keywords that can be used by other companies' interfaces. Newly incorporated into larger aggregated collection, the keyword becomes a place to distinguish one's images. Future availability, defined by well-populated metadata, must be encoded and produced in advance. Like the librarian who defines the goal of thoughtful indexing as making the image more "public," stock industry workers similarly use keywording to increase the reach of the image in order to create more opportunities for sales.

While subject classification always constrained processes of retrieval, the researcher onsite acted as a mediator between the stored images and the client. Researchers at H. Armstrong Roberts Company would spend months getting to know the subject classification system through filing and directly interacting with the physical prints and card catalogue and could interpret a client's brief and pull from the library on their behalf. Under the new information regime, the process of keywording at the outset facilitates the client finding the image at an unspecified later date. In this way, producing keywords on spec is almost analogous to Roberts Sr.'s initial gamble of producing content on spec. Like the latter gamble, quantity and scale are key, and software solutions increase efficiency. At Robertstock/Classicstock, a thesaurus program called Keychain allows synonyms for words (like man, men, male) to be automatically filled in, while they use a program called Typinator to automatically fill in keywords if they enter an abbreviation (thus guarding against typos).

The process of keywording requires attention to detail and persistence but also imagination. Groves echoes Romana Javitz when she insists, "I always want the keywording to be the way people talk and the way I know

people ask for things. I always put idiosyncratic things in for keywording."[82] For example, Groves recalls her proposal to add the keyword "OMG" to a photograph of a baby with a particularly surprised face. At the same time, standardization is also important for their work with distributors, as some distributors provide preset categories of keywords to be checked off for images to be distributed through their system.

The use of keywording and collaboration with multiple distributors changes both user experience and the experience of the picture-worker. Longtime picture-workers like Roberts III and Groves express ambivalence. From Roberts III's point of view, valuable relationships between client and stock agency have eroded: "My argument is that over time there has evolved a vocabulary, which may be nowadays falling apart. Because there's not that much communication, verbal communication between the clients and the agents."[83] At the same time, Roberts III has attempted to extend client-oriented thinking about keywords. When they first started keywording, Roberts III convened large discussions with staff about how to codify the vocabulary that had been built up interactionally over time, emphasizing the need to echo what clients used when they requested images. His directive was to be specific, descriptive, and to the point, the same way he would if offering a photographer a shooting script: "So as we went and looked at each picture, what probably evolved was a verbal description of the picture, and then we matched that to the known file categories for the picture. . . . Don't worry about the details, just get the main things. *What is it.* I would say that to a degree, that description, that way of dealing with the picture is still the basic way that we keyword today." In this way, he aimed to address the client in the same way he would if they were on the phone: "So that, you're just converting the opportunity to talk to a client into a discussion through your keywording." Keywording is a stand-in: what was once a discussion between people became a discussion between technical systems, increasing scale and reach while inviting all kinds of noise.

UNION COLLECTION

Digital forms of organization and circulation offer new opportunities for making connections across vast groups of images. The average web user

creates collections of their own every time they navigate the internet, momentarily downloading images to their own hard drive as the click through websites. Deirdre Donohue, managing research librarian of the Art and Architecture Division at the NYPL, which now oversees the Picture Collection, observes that the primary effect this has for the stewards of traditional collections is the realization that no one collection needs to be universal. Where the nineteenth-century library collection sought to replicate the same core collection across networks of branches, now librarians can operate under the assumption that essential texts can be accessed remotely and shared through networks. Instead, institutional collections now seek to collect the unique. This change in outlook depends on the expectation across fields that aggregate sites and databases currently or will soon be able to pull together collections worldwide. Instead of a local museum, library, or stock collection needing to provide the role of the encyclopedic image collection, they must instead focus on properly documenting and cataloguing so that the image can participate in a global collection; the priority is now on making images findable in this new context. This collaboration between organizations to make content more widely available is not new. A union collection or union catalogue is a traditional method by which libraries have collaborated to share records in order to create a centralized interface for searching multiple collections, and digitization has opened up new possibilities for the union collection.

In the twenty-first century, against the backdrop of the rise of expensive commercial journal aggregators and Google's attempt to partner with libraries on a massive digitized book database, regional consortiums have formed to pursue the promise of aggregation and open access.[84] These include the Digital Public Library of America in the United States (launched 2013); La Referencia in South and Central America, formed after a cooperation agreement signed in 2012; ASREN, a pan-Arab research network founded in 2010; Europeana in Europe (launched 2008); and WACREN, a West and Central African network that began organizing in 2006, among others. Each of these helps to coordinate access to a variety of materials, including digitized visual material. Museums have also participated in image-specific union collections, including ARTSTOR, a paid digital imaging and repository marketed toward universities and museums that was founded by the Andrew Mellon Foundation and launched in 2004. Smaller

THE NEW UNIVERSAL COLLECTION 223

consortiums funded by Mellon include the New York Art Resource Consortium, founded in 2006, which pools resources for MoMA, The Brooklyn Museum, and the Frick Collection.

A common theme across the keywords surveyed in this chapter, from metadata standardization and keywording and the circulation of compact discs, is that these are practices undertaken in order to create such union collections. Both metadata and keywords are tools for the human user to access images but are also designed for a new machine reader that will allow for greater interoperability between collections. Here, I refer to a new type of vision defined by artist Trevor Paglen as an "invisible visual culture" constructed by "machine-to-machine seeing apparatuses."[85] That is, the condition under which digital images are constructed to be machine readable. For cultural heritage institutions and stock agencies alike, in order for records or images to be available to be incorporated into aggregate collection websites, they must be catalogued according to machine-readable standards, or MARC standards. As libraries, archives, museums, and galleries adopt MARC standards and open their API to other sites, the Museum Without Walls meets the "Semantic Web," "a utopian vision of a machine-readable web in which the automatic processing of information by non-human actors becomes possible."[86] Where nonprofits see these kinds of partnerships as extensions of their cultural heritage missions, the stock industry has long explored aggregation as a way to increase reach and profits. The result is that smaller companies like H. Armstrong Roberts Company are more accessible without the need for physical branch offices but less findable within the torrent of search results. And the practical experience for picture-workers is Sisphyean: interviewees discussed the challenge of layering multiple standards or shifting from one to another. MARC language was developed in the 1960s in the United States for libraries to exchange metadata, but this older format has been replaced or supplemented with multiple different standards that require active maintenance and development. Early web projects prompted revised approaches, as metadata schemes that were readable on closed systems were not readable on the web.[87]

The International Image Interoperability Framework (IIIF), which began at Stanford University, is a community of museum and library workers working together to establish software, standards, and initiatives to

promote interoperability between different museum and library databases: creating the protocols to allow for multiple museum databases to communicate through a single interface, so that one could search collections worldwide rather than searching through each siloed collection. Their 2021 conference schedule is a snapshot of what using IIIF standards seeks to enable: projects focused on facilitating user annotations and user reuse, projects driven by the development of specific applications, or tools that allow digital manipulation of IIIF collections.[88] The conference presentations are studded through with the language of Silicon Valley, touting possibilities of augmented reality or deep learning models. Here, the "ideology of information technology," as Birdsall coined the term in the 1990s, meets the intersection of the long tail of Web 2.0 interactivity and distributed structure of Web3 to define the primary role of cultural heritage as material to be made available for remix.

The goal of interoperability between museum collections is related to another microtrend in museum transparency and outreach: publishing metadata. Following in the footsteps of the Cooper Hewitt Design Museum, which published all of their collection metadata to GitHub in 2012, MoMA released the metadata for more than 125,000 works from MoMA's collection on GitHub using Creative Commons Zero (CC0) in July 2015.[89] This decision marked a major cultural shift from the perspective of the museum's traditional gatekeepers. A museum curator's role has typically been to carefully research objects within the collection and ensure that any published data (either through wall texts or in print) have been assiduously fact-checked. Once the museum decided to put the entire collection online, curators had to accept that not all of the basic tombstone information (listing artist, title, date, dimensions, etc.) would be correct; the GitHub release offers even more of the potentially incomplete or incorrect data to circulate. In a post by Fiona Romeo, MoMA's director of digital content and strategy at the time (a position she originated in 2014), she argues that the possibility of circulating incorrect information is outweighed by a greater value: the increased accessibility for researchers but also an invitation to artists to "make something."[90] Where Malraux's museum without walls originally extracted new value from the work of art in the form of the cropped detail, metadata is recast as raw material to produce "something."

THE NEW UNIVERSAL COLLECTION

Outside of libraries and museums, commercial agencies too enact a kind of union collection, as the infrastructure required to host and index images for online search stretches the capacity of a smaller firm like H. Armstrong Roberts. Their images are now stored using Amazon Web Services as their cloud storage system, with a server of backup files onsite. Their website is also hosted by Amazon Web Services, and its images are organized and stored on the backend by the company IPNstock.com, which provides search engine services to a variety of photographers and stock agencies. Companies can work with IPN by sending them images indexed using standardized fields, then routing their domain name through the IPNstock servers. IPNstock also aggregates the images of all its members through their website search engine.[91] Though H. Armstrong Roberts Company had always centralized operations and has historically sought intricate systems for control of their collection, the contingencies of the digital require these kinds of partnerships. From the earliest computerization project to the present, digitization has meant a continuous opening up, allowing the images to travel into new spaces. The search to eliminate repetitive labor led working with other agencies to outsource aspects of work, including programming, scanning, and marketing, and to more and more distributed circulation.

Moreover, the control that institutions once exercised through copyright is now being loosened. Museums such as the Rijksmuseum offer high-resolution images of their entire collections for free downloads (photography that museums previously tried to make the argument they owned because they arranged production of the high-resolution file), allowing users to create whatever they like from the files. Movements such as the European group OpenGLAM (an acronym of Galleries, Libraries, Archives, and Museums) encourage an approach to visual content in which content is open when "anyone is free to use, reuse, and redistribute it—subject only, at most, to the requirement to attribute and/or share-alike."[92] MoMA, with deep commitments to the property rights of living artists, would be unlikely to pursue such an approach, but the attitude toward the availability of images and the encouragement toward remixing them affects their own digital projects, as well as the work of the contemporary artists they promote, such as in the 2014 exhibition *Cut to Swipe*, featuring

"works that appropriate and manipulate images and sound drawn from electronic media like television, cinema, the recording industry, and the Internet."[93] For stock, this kind of openness toward image property produces a crisis. With the increased availability of images, Roberts III wondered aloud in 2022 about the future viability for photographers to make a living selling stock, "The idea of some person with a camera taking a picture and deriving anything other than some satisfaction, I don't know."[94] In an industry that rewards the controlled spread of images, technological developments that have increased spread at the expense of control require requisite technological solutions. Just as automation offers new opportunities for aggregation, it promises new forms of control. Dawirs spoke to me with great enthusiasm in 2017 about the automated future he saw for the stock industry, particularly in the area he called "post-usage licensing," collecting usage fees for images after they have already been illegally used by threatening legal action. The practice of pursuing parties that have used copyrighted images without a license has been going on as long as images have been copyrighted, but the culture of the web has made obtaining images without permission easier—and also locating the infringers. Now that software called "image crawlers," which crawl the web identifying copies of images that they have been given in advance, has become robust enough, and licensing history and metadata are increasingly easier to share, multiple companies have been founded to take advantage of the possibilities of "post-usage licensing."[95] In exchange for a percentage of recouped funds, if an agency engages one of these businesses and gives them access to their own API, the systems will automatically locate infringing usages by identifying images and tracking them, identify those that are most likely to pay, and send out letters and follow-up requesting payment for a retrospective license.

The twenty-first-century union collection is thus a collaboration of overlapping initiatives, collaborations between groups and algorithms, web crawlers, digitized images of the past and images created entirely by AI, imagined and actual users, forces that embrace open culture, and those that seek to shut it down. For those seeking to predict the exact shape and nature of the union collections that will define the next century, little is certain about how these forces will resolve.

CONCLUSION: AN UNCERTAIN FUTURE

Throughout this book, I have argued that architects of the circulating image collection across industries and across time are driven by a common fantasy: an endless supply of indexed pictures. For those who worked through the transitions at their respective institutions, conditions that seemed like dreams or nightmares at the outset of the 1990s quickly became reality. And the transformations that digitization has left in its wake open up new possibilities, which administrators, programmers, and librarians are struggling to predict. Meanwhile, original material gathers dust or awaits certain death in cold storage.

Each of the institutions now grapples with new dreams, new nightmares. At the heart of these fantasies and fears for the future are questions of circulation, communication, and control. How can a digital image's movement be tracked? What information travels with it? How can use be constrained? What new uses are opened up? How can an image communicate with other images? How can indexed images be used to train new forms of artificial intelligence? The rapid pace of change over the past two decades expands the horizon of what seems possible. After the experience of overseeing digitization and relatively quick consolidation of new technology and new standards, MoMA's Erik Landsberg estimated in 2017 that museums were likely a few years away from an international archive of three-dimensional representations of museum objects around the world, an art historical metaverse. At NYPL, director of digital department NYPL Labs Ben Vershbow expressed a similar commitment to making as much public domain content available in the highest resolution possible and available to international aggregators, creating "a common resource base that everyone can draw on and repurpose very freely, leading to all kinds of new uses and illuminating projects."[96] Finally, at the 2017 Digital Media Licensing Association conference, Tomas Speight, whose experience as CEO of a crowd-sourced royalty-free stock website attuned him to the revolutionary impact of a single technology, like the camera sensor on a mobile phone, speculated, without irony, "What if in five years, 95% of stock images are rendered by an AI?" This idea seems plausible to an industry currently invested in exploring the many applications of automated image recognition and management. Four years after this prediction, in 2022, OpenAi

released DALL-E, an open-source AI that can draw a photographic image based on any text prompt. Following DALL-E, the possibility for generating AI-driven imagery for advertising or editorial purposes seems vast, but the informational or documentary capabilities of the Picture Collection is evaporated. When I prompted DALL-E mini to show me "the color of a flea's eye," an image request that had vexed Javitz in 1930 and was adopted by Taryn Simon as the title for her Picture Collection series, it returned a grid of eerily electrified eyes (figure 4.5).

As these images convey, these dreams are thus also forms of nightmares. Different modes of extinction threaten each institution studied here as each face encroachment by new forms of image collections. Circulation, which always brought images outside of their collection, now defines the collection in storage, as files are backed up and stored on various servers across the country, and access to these files is provided across multiple portals. Are we, perhaps, moving closer to the universal image archive envisioned by people like Romana Javitz, Alfred Barr, or H. Armstrong Roberts Sr.? If so, what has it replaced?

Even as new changes lurk on the horizon, the broader outlines of the contemporary image collection are in place: it is automated through repetitive labor by people and machines, it is catalogued in a way to be legible to machinic processing, and it is accessible within a system in which users are empowered to locate and use images without interfacing directly with traditional gatekeepers. In the meantime, the film, slides, negatives, and paper prints that made up older collections are preserved for now, but who knows for how much longer. Roberts III, at eighty years of age, is looking for a purchaser of the assets of the corporation. When the H. Armstrong Roberts, Inc. archive is inevitably incorporated into a larger company, like Getty, it is unlikely the card catalogue will be transferred. MoMA's slide library is being preserved in storage but is not accessible to researchers; in the words of Tom Grischowsky, "They have served their purpose. And there's no need for them to be presented to researchers when they've been digitized. They get to be happy in the dark and left alone."[97] And it will take passionate communities of users and librarians within NYPL to advocate for the long-term continued maintenance of the Picture Collection in the face of digital alternatives, as NYPL announced in August 2021 that the collection would be moved to offsite storage and removed from circulation

THE NEW UNIVERSAL COLLECTION 229

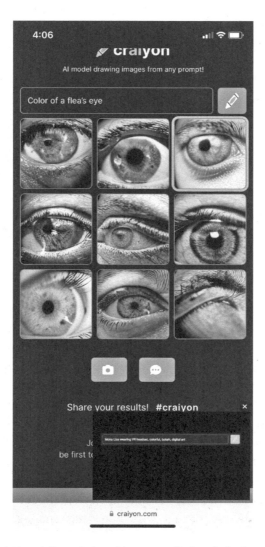

4.5 DALL-E mini AI model's rendering of the prompt "color of a flea's eye," July 25, 2022. craiyon.com. Screenshot by author.

(before walking back the decision after public outcry).[98] In explaining this decision, William P. Kelly, NYPL director of research libraries, insisted, "Either [the Picture Collection] is ephemera and doesn't belong in a research library, or else it is an archive that should be preserved."[99] This quote highlights exactly the divide in library discourse that Javitz sought

to challenge: the idea that ephemera, living documents that circulate and move through the world, must be sealed off and preserved once they enter the sacred library space.

So how is it possible to hold figures like Romana Javitz at the center of the future of the twenty-first-century circulating picture collection? How can we balance the promise of increased access while guarding against the perils of the blind faith in techno-solutionism?[100] In a series of lectures to library science students in a class she taught at the Pratt Institute in 1970, Javitz expounds more extemporaneously on her philosophy of managing picture collections, which is defined by her focus on a practical understanding of use and an openness to engage with the public. She sets these goals against any claims to universal systems, logical reasoning, or even the practice of "classification" itself: "Now what I want you to realize with me today is that there is no logical system of classification for pictures. I'm not sure that there is a logical classification for books but we sort of accept the idea that there are logical systems of classification. . . . So maybe throw logic out the window and let's see what we can do about arranging pictures for usefulness because this is what it is, use, use, and use."[101] Inherent to this focus on use is the demand that users be respected for their expertise and a rejection of the premise that expertise is concentrated in technical systems, abstract training, or physical infrastructure. Picture collection staff gain knowledge through interacting with people, looking at pictures, and doing their work "at the files," in the words of librarian Charles H. Gibbs-Smith.[102] Javitz, as a public librarian, understood deeply that building collections is also always cultivating community. The circulating image collection can best serve the public and the future by embracing Javitz's call: create systems that invite knowledge sharing, that seek inclusion, that reject the inflexible, that promote human interaction, and that build coalitions.

CODA: ANGELS OF HISTORY

The image escapes in every direction, and those images that survive the growing pile of debris and destruction in front of the *Angelus Novus* are ones that are legible, separated from the artist's intention.
—R. H. Quaytman, R. H. Quaytman, קקק, *Chapter 29* (New York: Miguel Abreu Gallery, 2015), 41

As I worked on this book, it seemed that there were popular pieces everywhere that echoed the stakes of the theory of the image that these collections posit. Farhad Manjoo at the *New York Times* insists, "Welcome to the Post-Text Future," finding evidence of our image-centrism in the contemporary political meme and Instagram with as much conviction as Romana Javitz invoked in 1940 when she warned that "the radio, the moving picture, and the still photographic picture in magazine and newspapers have cut down dependence on words alone as a medium for the communication of ideas."[1] In *New York Magazine*, Brian Feldman asserts "Every Image is a Meme Now," suggesting that the scale and availability of images on the web have created a shorthand in which highlighting the conceptual and visual links between pictures (for example, creating anachronistic pairs between similar art historical and contemporary images or tweaking a popular meme in Photoshop to produce endless new versions) is celebrated as the highest form of wit. As Feldman writes, "The

acceleration of this trend—the uniquely human talent of pattern recognition now distributed at scale—does more than break down the barrier between high art and kitsch even further. . . . It overloads our images with meaning."[2] Throughout this book, I have argued that this overloading of meaning is inherent in the production of large-scale image collections, in the accumulation, cataloguing, and making available of images for different uses. It is present in the philosophy of Javitz at the Picture Collection, where she sought to allow users to create their own meaning, present in the way that MoMA was able to invest photographs with auratic value not in spite of but through circulation, and present in the production process of H. Armstrong Roberts Sr. and his endless recombination of props for new stock photography.

Among these articles about the unrestricted referentiality of contemporary image culture, there were also those on machine vision, artificial intelligence–generated images, and the commercial use of public domain image collections, all of which extended or amplified concerns of this book project. Yet above all, I found myself haunted by an installation I'd seen years earlier, at the beginning of my research. R. H. Quaytman is a painter who works in series that she calls "chapters," which plumb intricate relationships between sets of images, connections that are subconscious and felicitous as much as material and entrenched. She uses painting, photography, and silkscreen on board to realize her works and is as likely to use another artist's image as her own. In her series, קבּק, *Chapter 29*, which I saw installed at the Miguel Abreu Gallery in New York in 2015, she reflected upon a mystery she had discovered in a research trip to Israel, when she visited the storage room of the Israel Museum to view Paul Klee's *Angelus Novus*, 1920 (figure 5.1). This picture had famously been purchased by Walter Benjamin, who wrote about it frequently over his life, most memorably in "Theses on the Philosophy of History":

His eyes are wide, his mouth is open, his wings are spread. This is how the angel of history must look. His face is turned toward the past. Where a chain of events appears before *us, he* sees one single catastrophe, which keeps piling wreckage upon wreckage and hurls it at its feet. The angel would like to stay, awaken the dead, and make whole what has been smashed. But a storm is blowing from Paradise and has got caught in his wings; it is so strong that the angel can no longer close them. This storm drives him irresistibly into the future, to which

CODA

his back is turned, while the pile of debris before him grows towards the sky. What we call progress is *this* storm.[3]

This passage holds a special charge for all those study history, from the history of war to the history of art to the history of media: the debris that makes up the objects of our study, the impossibility of reconstruction, and the inexorable pull away from that which we seek to hold in our sight define the historical project. Benjamin's words have been interpreted and quoted by countless scholars, with Klee's angel often reproduced alongside. What does not appear in many of these reproductions, and what immediately caught Quaytman's eye in storage, is the dark border Klee framed the drawing with, by affixing one sheet of paper to another (visible in figure 5.1). At the museum, Quaytman could clearly see that the dark paper beneath Klee's drawing was in fact the back of an old engraving, apparently a portrait of a sitter wearing robes. When she asked museum staff about it, she was surprised to find out she was apparently the first to ask the question—the work was so rarely examined in person, and no one had previously inquired what she had. She, along with museum staff and outside experts, spent the next year and half pursuing the identification of the mystery engraving. A tantalizing puzzle, it seemed to symbolically represent that future from which Benjamin's storm was blowing.

The search that followed demonstrates the limits of a certain kind of scientific seeing. At Quaytman's request, and in part using funding supported by a donation of one her paintings, the Israel Museum probed the drawing through X-ray and had it brought to a special facility in Rome to be subjected to thermography, a technique developed to read the texts hidden in the binding of ancient books that had been constructed from the scraps of sacked libraries.[4] Yet, neither technique was able to reveal more of the underlying image. At the same time, every day, Quaytman spent hours searching online databases of museums or websites of old engravings for sale.

Where material science failed, the accumulated knowledge represented by the worldwide image collection accessible through the web succeeded. One evening, Quaytman was searching a site run by the region of Lombardia, Italy, that aggregated the cultural heritage of the region, including the scanned print collections of several libraries. She skimmed through

5.1 Paul Klee, *Angelus Novus*, 1920. Oil transfer and watercolor on paper, 31.8 × 24.2 cm; Israel Museum, Jerusalem.

thousands of images before glancing at a portrait with the appropriate dimensions and type of robes, then downloading it to her own desktop. When she laid the image file (made partly transparent using digital tools) on top of a high-resolution image of *Angelus Novus* in Photoshop, "it slid right on like Cinderella's slipper," lining up exactly with the faint outline of the engraving.[5] She had solved the mystery: behind the *Angelus Novus*

5.2 R. H. Quaytman, חקק, Chapter 29, 2015. Oil, silkscreen ink, and gesso on wood, 24¾ × 40 × 1 inches (62.9 × 101.6 × 2.5 cm).
© R. H. Quaytman Courtesy Miguel Abreu Gallery. Photo by Christian Erroi.

was an 1838 engraving by an obscure engraver, Fr. Mueller, of a 1521 Lucas Cranach painting of Martin Luther (figure 5.2).

The conceptual implications of this discovery are rich. As Mark Godfrey writes, "This was an astonishing discovery, for many reasons, not least because Klee, by obscuring the print with his drawing, could be said to destroy an image of the historical figure most associated with the critique of images in the Reformation."[6] Or, one could say, by obscuring a print with his drawing, he was destroying one media form with another. Or perhaps destroy is not the right word: through the joining of the two sheets, Klee merged their fates: the Angel of History with the architect of the Reformation, the twentieth-century avant-garde oil-transfer drawing with the nineteenth-century engraving.

More important, for me, Quaytman's project captures the life of the many forms of the reproducible image and the ethos of circulation, from the sixteenth century to the present. First, the painting by Lucas Cranach, a court painter in Germany in the sixteenth century. Cranach had painted religious subjects for the Catholic Church before befriending Martin

Luther and becoming swept up in the Reformation. Together, the men leveraged the emergent power of mass reproduction by designing, printing, and distributing pamphlets that spread across Germany, transforming the political, religious, cultural, and media landscape.[7] Cranach's workshop embraced the mass reproduction and circulation of the image, producing multiple versions of painted portraits and woodcut engravings of Martin Luther (quite paradoxically, considering that Luther famously attacked the adoration of images).

Next, the copper engraving created in 1838 as a reproduction of a painting shows the desire for the portable image that enabled the artwork image to travel and to be accessible to a mass public well before photography. Almost a century later, that print was ready at hand in Klee's studio. Klee most likely grabbed the print arbitrarily in order to stabilize the wet page of his drawing (he used an experimental oil-transfer process to create the drawing, which is essentially a monoprint). It was likely cheaper than using a new blank sheet. By that time, in the early twentieth century, engravings were an old-fashioned form of a mass-produced image; having reached the apex of commercial popularity in the early nineteenth century, they had been replaced by forms of lithography and photography as preferred modes of quick reproduction.[8] Perhaps Klee had the engraving as a reference image of some kind; perhaps it came as part of a collection of other pictures from an old bookshop. The act of an artist literally drawing, painting, or pasting over the work of another is and has always been part of the artistic process.

Then, the subsequent photographic reproduction of the Klee drawing itself, so familiar to generations of scholars, demonstrates how an image can become invested with meaning beyond what its author intended, as the picture has become inseparable from the text often printed alongside it. After Benjamin wrote about it, the picture was not only Klee's *Angelus Novelus* but now always and also the "angel of history." While the drawing itself was inherited by Benjamin's friend Gershom Scholem and gifted to the Israel Museum after his death, its photographic reproduction—sometimes in black and white, sometimes color, often cropped to eliminate that telltale border that betrayed its secret history of the reproducible image—had a life of its own.

CODA

Finally, Quaytman, clicking through images on her backlit computer screen, represents the most contemporary development of the ethos of circulation. Each of the images she clicked past had been scanned in massive digitization projects, part of an emerging global consensus on the value of making such images available digitally. This consensus, as well as the resources and standards required to realize these digitization projects, was predicated upon the visions of global, accessible image collections in the twentieth century. When Quaytman found the image in question, all it took was a few clicks to download, make transparent, and rejoin it with the *Angelus Novus*, a process that she routinely engaged in as part of her art practice and an extension of the copying, cutting, and pasting done by the users of the large-scale image collections surveyed here over the past century.

By pasting over the back of Martin Luther with a drawing of his angel, Klee inadvertently created a metaphor for the manner in which the secularization of images transmuted one kind of sacredness into another. To extend the Benjaminian metaphor, the storm that is pulling the angel forward from behind turned out to be a print glued to its back. The angel, the auratic monoprint, is dissolving into the condition of reproducibility, driven ever forward by its promise. This occurs literally through reproduction in books, prints, and now websites and other artworks and metaphorically through the figure of Benjamin's Angel of History and the theory of his work of art "in the age of its technological reproducibility."[9]

And though it seems grandiose, I cannot help but think of someone like Anita, who opened this book, as another form of the Angel of History or, rather, to think of the Angel of History as a picture-worker. Watching the material accumulate as ruins at their feet as they tumble backward, blind, into a future that insistently beckons with the promise of "progress." As digitization has transformed cultural heritage and visual communication, we find ourselves constantly on the brink of a world that it seems will be totally unlike that which came before. This book project was one attempt to take stock of some of the ruins left in its wake.

NOTES

PROLOGUE

1. Flora Miller Biddle, *The Whitney Women and the Museum They Made* (New York: Arcade Publishing, 1999), 228.

INTRODUCTION

1. "From Edward Steichen to Members of the PICTURE DIVISION," *Picturescope* 3, no. 2 (July 1955): 7.

2. "New York Group," *Picturescope* 3, no. 1 (March 1955): 3.

3. "Pictures and Public Relations," *Picturescope* 2, no. 1 (March 1954): 5.

4. "Detroit Convention Highlights," *Picturescope* 3, no. 3 (October 1955): 1. "Miniaturizing Life's Picture Files," *Picturescope* 5, no. 3 (October 1957): 23.

5. Another important journal from this period was *Eye to Eye*, published 1953–1956 by the Graphic History Society of America.

6. Thank you to Lisa Gitelman, who suggested this term in relation to the treatment of the stock image in my dissertation, *Picture-Work: On the Circulating Image Collection* (New York University, 2018). Gitelman and Thomas Mullaney explore how information was construed as alienable content through nineteenth-century media technologies in *Information: A Historical Companion*, eds. Ann Blair, Paul Duguid, Anja-Silvia Goeing, and Anthony Grafton (Princeton, NJ: Princeton University Press, 2021), 174.

7. A 1930 advertisement in c. 1930s bound portfolio, unprocessed archives of H. Armstrong Roberts, Inc., Philadelphia, PA.

8. By using the term "digital culture," I recognize that that I am introducing a "gaping catchall" similar to "print culture," which media scholars, including Lisa Gitelman,

240 NOTES TO PAGES 6–8

have challenged as "insufficient and perhaps even hazardous to our thinking." (See Lisa Gitelman, *Paper Knowledge: Toward a Media History of Documents* [Durham, NC: Duke University Press, 2014], 6–10). "Digital culture" potentially compounds the ambiguity and lack of reflexivity with which both "digital" and "culture" are used within the history of communication and reduces a broad range of social, technological, economic, artistic, philosophical, and political changes to a single cultural shift toward "digitality." I do not wish to rely on the wide usage of the term "digital culture" to serve as evidence for its existence. (As does Charlie Gere, *Digital Culture*, 2nd ed. [London: Reaktion Books, 2009], 16). That said, there is an undeniable consequence to the digitization of processes and objects that has taken place over the past several decades. For the purposes of this book, I define digital culture loosely as the expectations, practices, and processes involved in the distribution of cultural objects through digital means (encompassing the technologies, social processes, and knowledge and physical infrastructures).

9. A 1930 annual report confirms that one-third of the Picture Collection's users were from the design industry, specified as "theatres, publishers, advertising agencies, printers, barbers, wigmakers." 1930 Annual Report, box 7, folder 5, Picture Collection Records 1896–1999, The New York Public Library, Manuscripts and Archives Division.

10. Romana Javitz, "The Public Interest," *Work for Artists: What? Where? How? A Symposium by Walter Baermann*, edited by Elizabeth McCausland (New York: American Artists Group, 1947), 30.

11. For more on this exhibition and the related publications and marketing, see Jennifer Tobias, *The Museum of Modern Art's 'What Is Modern?' Series 1938–1969* (PhD dissertation, The City University of New York, 2012). This is also discussed further in chapter 2.

12. H. Armstrong Roberts III (grandson of H. Armstrong Roberts), in discussion with author, June 17, 2015.

13. Paul Otlet and Ernest de Potter founded the International Institute of Photography in 1905, with the mission to centralize the study of photography and documentation. In addition to its photography collections, the institute developed the Universal Iconographic Repertory, which consists of documentation files of images filed using the Universal Decimal Classification system. The collection is still accessible through the Mundaneum Archives in Brussels. The Kunsthistorisches Institute was founded in 1897 to build up a centralized collection for the study of modern art history, and the photo library still comprises an international resource for the study of Italian art. The Photothek at the Kunsthistoriches Institut continues to facilitate art historical study, the study of the photograph as a material object, and a critical interrogation of archives and digitization, sponsoring the series *Photo Archives*, an international series of scholarly activities that has produced conferences and publications since 2009 exploring the nature of the photographic archive. The Hulton Picture Post Library was the picture archive for the Hulton Picture Post founded in 1937 by British publishing magnate Sir Edward Hulton and consisted of 4 million negatives by the time the *Picture Post* ceased publication and the archive was purchased by the BBC (see

NOTES TO PAGES 8–10 241

Charles H. Gibbs-Smith, "The Hulton Picture Post Library," *Journal of Documentation* 6, no. 1 [1950]: 12–24). Nina Lager Vestberg explores the Hulton Picture Post Library and its visionary cataloguing system by Charles Gibbs-Smith in the forthcoming *Picture Research: The Work of Intermediation from Pre-Photography to Post-Digitization* (Cambridge, MA: MIT, 2023).

14. Time Inc. was founded in 1922 by Henry Luce and Briton Hadden and would go on to publish 100 magazine brands, including *Life* magazine, which Luce relaunched in 1936 as a venue to showcase photography and photo-essays. As of 2022, the *Life* Picture Collection is represented by Shutterstock through an exclusive editorial partnership with Meredith Corporation, which acquired the archive as part of its acquisition of Time Inc. in 2017. The Bettmann Archive was a commercial photo archive founded in 1936 by German refugee Otto Bettmann. It was acquired by Corbis in 1995 and is now represented by Getty Images after Getty and Visual China Group partnered to acquire Corbis in 1995. See Estelle Blaschke, *Banking on Images: The Bettmann Archive and Corbis* (Leipzig, Germany: Spector Books, 2015). The Frick Art Reference Library's Photoarchive was founded in 1920 by Helen Clay Frick with a mission to commission and collect a massive library of reproductions of works of art. The Frick sent photographic expeditions to capture unpublished artworks, and indexed by subject as well as artist, amassing 1.2 million reproductions. The Frick is currently one of fourteen European and North American art historical photo archives in the international consortium PHAROS, which seeks to create an open-access platform for comprehensive consolidated access to photo archive images.

15. Gregg Mitman and Kelley Wilder, "Introduction," *Documenting the World: Film, Photography, and the Scientific Record* (Chicago: University of Chicago Press, 2016).

16. See Craig Robertson, *The Filing Cabinet: A Vertical History of Information* (Minneapolis: University of Minnesota Press, 2021); Anke Te Heesen, *The Newspaper Clipping: A Modern Paper Object* (Manchester: Manchester University Press, 2014); Cornelia Vismann, *Files: Law and Media Study* (Palo Alto, CA: Stanford University Press, 2008); Lisa Gitelman, *Paper Knowledge: Toward a Media History of Documents* (Durham, NC: Duke University Press, 2014); Markus Krajewski, *Paper Machines* (Cambridge, MA: MIT Press, 2011); Ted Striphas, *The Late Age of Print: Everyday Book Culture from Consumerism to Control* (New York: Columbia University Press, 2009).

17. Robertson, *The Filing Cabinet*, 2.

18. Michelle Henning, *Unfettered Images* (New York: Routledge, 2018): 7.

19. Thy Phu and Matthew Brower, "Editorial," *History of Photography* 32, no. 2 (2008): 105.

20. Thierry Gervais, "Introduction," *The 'Public' Life of Photographs* (Cambridge, MA/ Toronto: MIT Press/Ryerson Image Centre, 2016), 11.

21. Walead Beshty, ed. *The Picture Industry: A Provisional History of the Technical Image* (Geneva, Switzerland: JRP editions, 2018).

22. Elizabeth Edwards and Sigrid Lien, eds., *Uncertain Images: Museums and the Work of Photographs* (Farnham: Ashgate, 2014). Edwards extends this project with *What Photographs Do: The Making and Remaking of Museum Cultures*, edited by Edwards and

Ella Ravilious (London: UCL Press, 2022), which crucially brings together workers across the museum (photographer, cataloger, digital content team leader, among others), as well as curators and historians, to reflect on museum photographic practices through the prism of the Victoria and Albert Museum, London.

23. Nadya Bair, *The Decisive Network: Magnum Photos and the Postwar Image Market* (Berkeley, CA: UC Press, 2020).

24. Zeynep Gursel, *Image Brokers: Visualizing World News in the Age of Digital Circulation* (Berkeley: University of California Press, 2016), 2.

25. Vanessa Schwartz and Jason E. Hill, eds. *Getting the Picture: The Visual Culture of News* (New York: Routledge, 2015).

26. Paul Frosh, *The Image Factory: Consumer Culture, Photography and the Visual Content Industry* (New York: Bloomsbury, 2003), 2.

27. Blaschke, *Banking on Images*.

28. Vestberg, *Picture Research*.

29. Stanley Wolukau-Wanambwa, ed. *The Lives of Images, Vol. 1: Repetition, Reproduction, and Circulation* (New York: Aperture, 2021); *The Lives of Images, Vol. 2: Analogy, Attunement, and Attention* (New York: Aperture, 2021); *The Lives of Images, Vol. 3: Archives, Histories, and Memory* (New York: Aperture, 2022).

30. Among other publications, see Costanza Caraffa, "The photo archive as laboratory. Art history, photography, and materiality," *Art Libraries Journal* 44, no. 1 (January 2019): 37–46; and *Photo-Objects: On the Materiality of Photographs and Photo-Archives in the Humanities and Science*, edited by Julia Bärnighausen, Costanza Caraffa, Stefanie Klamm, Franka Schneider, and Petra Wodtke (Berlin: MaxPlanck-Gesellschaft zur Förderung der Wissenschaften, 2019). See Kunsthistorisches Institut in Florenz website for latest projects, https://www.khi.fi.it/en/index.php.

31. Carolyn Marvin, *When Old Technologies Were New: Thinking about Electric Communication in the Late 19th Century* (New York: Oxford University Press, 1988), 8.

32. Richard E. Rubin, *Foundations of Library and Information Science*, 3rd ed. (New York: Neal-Schuman Publishers, Inc., 2010), 167.

33. W. J. T. Mitchell, *What Do Pictures Want? The Lives and Loves of Images* (Chicago: University of Chicago Press, 1995), 85. This discussion moves on into an extended metaphor of the picture as organism and the image as species, which I find of limited use in the linguistic distinction I am making here, though the symbiogenesis of images is an idea that will be explored further.

34. Douglas Crimp, "Pictures," *October* 8 (Spring 1979): 75.

35. As an anecdotal example, in the museum curatorial department in which I worked from 2006–2008, "picture" was a somewhat old-fashioned term: the older generation of curators used "picture," frequently with each other, whereas their younger colleagues would use a medium-specific term, like painting, or a general term, like object or image. Two of the case studies for this project reflect this evolution as well, as the commercial picture house H. Armstrong Roberts is now the "global image resource"

NOTES TO PAGES 13–16 243

RobertStock, and a selection from Picture Collection of the New York Public Library can now be seen as one of "800,000 images" at the library's Digital Gallery online.

36. "Dematerialization" is introduced into art criticism by Lucy Lippard in Lippard and John Chandler, "The Dematerialization of the Art Object," *Art International* 12, no. 2 (February 1968): 31–36.

37. For examples of the former, see Lorraine Daston and Peter Galison, *Objectivity* (New York: Zone Books, 2010); Anke Te Heesen, *The World in a Box* (Chicago: University of Chicago Press, 2002); Horst Bredekamp, *The Lure of Antiquity and the Cult of the Machine* (Princeton, NJ: Markus Wiener, 1995); and Susan M. Pearce, *Museums, Objects and Collections: A Cultural Study* (Leicester, UK: Leicester University Press, 1992). For the latter, see texts collected in John Elsner and Roger Cardinal, eds. *The Cultures of Collecting* (London: Reaktion Books, 1994), including classic texts by Walter Benjamin, "Unpacking My Library," and Jean Baudrillard, "Systems of Collecting"; and Susan Stewart, *On Longing: Narratives of the Miniature, the Gigantic, the Souvenir, the Collection* (Durham, NC: Duke University Press, 1993).

38. Couze Venn, "The Collection," *Theory, Culture & Society* 23, no. 2–3. Special Issue on Problematizing Global Knowledge (May 2006): 40.

39. Michael Gorman, "Technical Services Today," in *Technical Services Today and Tomorrow*, 2nd ed., edited by Michael Gorman (Englewood, CO: Libraries Unlimited, 1998), 1–7.

40. Mattern identifies how "intellectual furnishings" put into conversation "fields including archival and library science, intellectual history, organizational studies, business history, management, design history and design practice, furniture manufacturing and retail, architectural history, sociology, anthropology, philosophy, and the list goes on." ("Intellectual Furnishings," working paper presented as part of the Graduate Institute of Design, Ethnography, and Social Thought Bi-Weekly Seminar, November 7, 2014, *Medium*, accessed March 1, 2018, https://medium.com/@shan nonmattern/intellectual-furnishings-e2076cf5f2de). She has written further about intellectual furnishings in "A Brief History of the Shelf," *Harvard Design Magazine* 43, "Shelf Life" Special Issue on Storage, December 2016; "Sharing Is Tables: Furniture for Digital Labor," *e-flux architecture*, last modified October 9, 2017, https://www.e -flux.com/architecture/positions/151184/sharing-is-tables-furniture-for-digital-labor /; and "Closet Archive," *Places Journal* (July 2017).

41. Liam Cole Young, *List Cultures: Knowledge and Poetics from Mesopotamia to BuzzFeed* (Amsterdam: Amsterdam University Press, 2017), 16.

42. Oxford English Dictionaries, "Index," accessed March 1, 2018, https://en .oxforddictionaries.com/definition/index.

43. Rosalind Krauss, "Photography in the Service of Surrealism," in *L'Amour Fou: Photography and Surrealism*, edited by Krauss and Jane Livingston (New York: Abbeville Press, 1985), 31.

44. For critiques of Google search, bias, and corporate control of knowledge production, see Siva Vaidhyanathan, *The Googlization of Everything (And Why We Should*

Worry) (Berkeley: University of California Press, 2012) and Safiya Noble, *Algorithms of Oppression* (New York: New York University Press, 2018). Google's algorithmic decision-making was scrutinized in the popular press in Kirsten Grind et al., "How Google Interferes with Its Search Algorithms and Changes Your Results," *Wall Street Journal*, November 15, 2019, https://www.wsj.com/articles/how-google-interferes -with-its-search-algorithms-and-changes-your-results-11573823753.

45. Nina Lager Vestberg, "Ordering, Searching, Finding," *Journal of Visual Culture* 12, no. 3 (2013): 478.

46. Jens-Erik Mai, "Semiotics and Indexing: An Analysis of the Subject Indexing Process," *Journal of Documentation* 57, no. 5 (September 2001): 620.

47. Sara Shatford, "Analyzing the Subject of a Picture: A Theoretical Approach," *Cataloging & Classification Quarterly* 6, no. 3 (1986): 39–62.

48. Vismann, *Files*, 8.

49. Vismann, *Files*, 10.

50. Gitelman, *Paper Knowledge*, 1.

51. Beaumont Newhall, "Documentary Approach to Photography," *Parnassus* 10, no. 3 (March 1938): 6.

52. See Marita Sturken and Lisa Cartwright, *Practices of Looking: An Introduction to Visual Culture*, 3rd ed. (New York: Oxford University Press, 2018), chap. 2, "Viewers Make Meaning."

53. Edwards and Lien, eds., *Uncertain Images*.

54. Allan Sekula, "The Body and the Archive," *October* 39 (Winter 1986): 58.

55. The term "visual content industry" is coined by Frosh, *The Image Factory*.

56. 1936 Annual Report, box 7, folder 5, Picture Collection Records 1896–1999, The New York Public Library, Manuscripts and Archives Division (hereafter cited as Picture Collection Records).

CHAPTER 1

1. Christopher Bonanos, "Change of Plans, You'll Still Be Able to Browse the NYPL's Picture Collection," *Nymag.com*, September 17, 2021, https://www.curbed.com/2021 /09/nypl-picture-collection-saved.html. I wrote a letter to the editor at the *New York Times* (published in the August 7, 2021, print issue with heading "Pictures at the Library") and an editorial piece for Artforum.com in opposition to the plan to archive ("Total Recall," August 30, 2021, https://www.artforum.com/slant/diana -kamin-on-the-new-york-public-library-s-picture-collection-86403).

2. Quoting the title of an essay by Romana Javitz: "From Abacus to Zodiac," in *The Story of Our Time: An Encyclopedic Yearbook* (New York: Grolier Society, 1955), 334–35.

3. See "Pictures as Documents" section for detailed history of Javitz's use of this phrase.

4. As three representatives, see M. G. Siegler, "The End of the Library," *TechCrunch*, October 13, 2013, https://techcrunch.com/2013/10/13/the-end-of-the-library/; "The

NOTES TO PAGES 30–31 245

End(s) of the Library," exhibition curated by Jenny Jaskey at the Goethe-Institut, October 30, 2012–June 21, 2013; and Wayne Bivens-Tatum, "Technological Change, Universal Access, and the End of the Library," *Library Philosophy and Practice* 9 (Fall 2006): 1.

5. Biographical details culled from Romana Javitz Papers, Manuscripts and Archives Division, NYPL (subsequently referred to as the Javitz Papers). Anthony Troncale, former librarian in the Arts, Prints, and Photographs Division at the NYPL and founding head of the Digital Imaging Unit, has been researching and publishing on Javitz's life as well. I'm grateful for his research and extensive discussions about Javitz. See Anthony Troncale, "Worth beyond Words: Romana Javitz and The New York Public Library's Picture Collection," *Biblion: The Bulletin of The New York Public Library* 4, no. 1 (Fall 1995): 115–138, and Anthony Troncale, ed., *Words on Pictures: Romana Javitz and the New York Public Library's Picture Collection* (New York: Photo | Verso Publications, 2020).

6. John Cotton Dana is invoked as the pioneer of circulating picture collections in the following sources: John Austin Parker, "A Brief History of the Picture Collection," *Wilson Library Bulletin* 30 (November 1955): 257–264, and Antje Lemke "Education and Training," in *Picture Librarianship*, edited by Helen P. Harrison (Phoenix, AZ: Oryx Press, 1981), 229. Another librarian working with circulating art reference collections in the early 1890s was Charles Cutter, at the Forbes Library of Northampton, Massachusetts (Charles Ammi Cutter, *Notes from the Art Section of a Library* [Boston: American Library Association, 1905], 4).

7. Dana publishes influential manuals for organizing libraries and picture collections through his family's publishing press Elmtree Press, founded in 1907. Several editions of *The Picture Collection* that included a list of suggested subject headings were published, beginning in 1910 (J. C. Dana, *The Picture Collection* [Woodstock, VT: Elmtree Press, 1910]).

8. As just one example, a short 1903 article in *Public Libraries* on circulating pictures inspired a series of letters to the editor about cataloguing by librarians using a slightly customized version of the Dewey decimal system that allowed for geographical and biographical indicators to be further specified: M. W. Plummer, "Circulation of Mounted Pictures," *Public Libraries* 8 (1903): 107; Ange V. Milner, "Cataloguing Mounted Pictures," *Public Libraries* 9 (1904): 11; Albert F. Carter, "Cataloguing Pictures," *Public Libraries* 9 (1904): 116. For later publications about the administration of picture collections, see J. C. Dana and Blanche Gardner, *The Picture Collection, Revised* (Woodstock, VT: Elm Tree Press, 1917); J. C. Dana and Marjary L. Gilson, *Large Pictures, Educational and Decorative* (Woodstock, VT: Elm Tree Press, 1912); William J. Dane, *The Picture Collection Subject Headings*, 6th ed. (Hamden, CT: The Shoe String Press, Inc., 1968); Norma O. Ireland, *The Picture File in School, College, and Public Libraries*, rev. ed. (Boston: F. W. Faxon, 1952); and Helen Harrison, ed., *Picture Librarianship*.

9. M. E. Dousman, "Pictures and How to Use Them," *Public Libraries* 4 (1899): 400.

10. Melvil Dewey, "Library Pictures," *Public Libraries* 11 (1906): 10.

11. Circulation numbers drawn from annual reports between 1928 and 1968, Picture Collection Records.

12. On initiating policy of encouraging non-English users to draw requests, see Picture Collection Annual Report for 1931, box 7, folder 5, Picture Collection Records.

13. See correspondence with Ernst Boas referencing time spent with Rukeyser in box 1, folder 4, series 1: Correspondence, Javitz Papers.

14. There are decades of correspondence with Ernst and Franziska Boas in series 1: Correspondence, Javitz Papers.

15. She references this work in Romana Javitz, Typewritten transcript, n.d., in box 4 "Audio tape transcriptions—Javitz class at Pratt[?] n.d.," Picture Collection records; "A Report on the Picture Collection for Mr. Ralph A. Beals" (July 1951), in box 3, folder 21, series 1, Picture Collection Records; and "An Interview with Romana Javitz 23 February 1965," *Archives of American Art Journal* 41, no. 1/4 (2001): 8. See also Javitz to Arthur Schomburg, May 25, 1937, in Arthur A. Schomburg Papers, Schomburg Center for Research in Black Culture.

16. James V. O'Gara, "Admen Haunt N.Y. Public Library's Storeroom of 6,000,000 Pictures," *Advertising Age*, December 24, 1951. Clipping in box 3, folder 6, Picture Collection Records.

17. "Library Not Art Snob, Picture Chief Says," *Toronto Globe and Mail*, November 30, 1965. Clipping in box 3, folder 6, Picture Collection Records.

18. In one Annual Report, she describes how a single FSA image (perhaps the famous "Migrant Mother" image by Dorothea Lange) was used by "a religious organization to solicit funds for the poor . . . a birth control society for propaganda, a visiting European used it to comment disparagingly on life in a democracy, and a mental hygienist used a detail of the mother's face to demonstrate the link between insecurity and mental illness." 1940 Annual Report, box 7, folder 6, Picture Collection Records.

19. In 1917, Dana notes, "We have had many requests from libraries and other institutions for a complete list of these [subject] headings. Information has perhaps been more often asked for by librarians and others on our picture collection than on any other subject" (Dana and Gardner, *The Picture Collection*, 3).

20. Romana Javitz, letter to Helen Oelke, American Library Associations, November 2, 1937, box 1, folder 28, Picture Collection Records.

21. 1930 Annual Report, box 7, folder 5, Picture Collection Records.

22. See W. B. Rayward, "The Origins of Information Science and the International Institute of Bibliography/International Federation for Information and Documentation (FID)," *Journal of the American Society for Information Science* 48, no. 4 (1997): 289–300.

23. Rayward rehearses the avalanche of references in "H. G. Wells's Idea of a World Brain: A Critical Reassessment," *Journal of the American Society for Information Science* 50, no. 7 (May 1999): 557–573.

24. H. G. Wells, *World Brain* (Garden City, NY: Doubleday, Doran & Co., 1938), eBook edition by Project Gutenberg Australia, accessed May 12, 2014, http://gutenberg.net

NOTES TO PAGES 38–43

.au/ebooks13/1303731h.html. Significantly, in Well's vision, microphotography would be used to realize this dream.

25. From a description of the Picture Collection included with a letter from Romana Javitz to Dorothea Lange, dated December 11, 1956, box 1, folder 25, Picture Collection Records.

26. "On Pictures in a Public Library," manuscript, 1939, in box 3, folder 7, Picture Collection Records.

27. "Rough Draft, August 9, 1956," manuscript, in box 3, folder 15 ("Projects-Future"), Picture Collection Records, 3.

28. Ibid., 6.

29. Alex Wright, *Cataloguing the World: Paul Otlet and the Birth of the Information Age* (New York: Oxford University Press), 10.

30. Jessica Lee discusses this exchange in *Off the Clock: Walker Evans and the Crisis of American Capital, 1933–38* (PhD dissertation, UC Berkeley, 2010).

31. Javitz, letter to "Mr. Hopper," April 27, 1842, box 1, folder 10, Picture Collection Records, and Romana Javitz, "Images and Words," *Wilson Library Bulletin* 18, no. 3 (November 1943): 218.

32. Romana Javitz, transcript, n.d. "Audio Tape Transcriptions—Javitz Class at Pratt," box 4, Picture Collection Records, 341.

33. John Hollingshead, *My Lifetime, vol. 1* (London: William Clowes & Sons, 1895), 61.

34. Untitled, *The Academy,* no. 1449, February 10, 1900, 117. Reprint from *Scribner's* February 1900.

35. Javitz, undated memorandum, c. 1940, box 1, folder 10, Picture Collection Records.

36. Tim Berners-Lee and Robert Cailliau, *WorldWideWeb: A Proposal*, 1990, accessed May 16, 2014, http://www.w3.org/Proposal.html.

37. "browser, *n.*" *OED Online*, March 2001, accessed May 15, 2014, oed.com, and J. H. Williams, Jr. "BROWSER: An Automatic Indexing On-Line Text Retrieval System. Annual Progress Report," abstract accessed May 15, 2014, http://eric.ed.gov/?id=ED038981.

38. Abstract for J. H. Williams, "Functions of a Man-Machine Interactive Information Retrieval System," *Journal of American Society for Information Science* 22 (1971): 311–317.

39. 1931 Annual Report, box 7, folder 5, Picture Collection Records.

40. 1932 Annual Report, box 7, folder 5, Picture Collection Records.

41. Romana Javitz, "Influence and Function: Pictures in Print," n.d. manuscript, box 3, folder 28, Picture Collection Records.

42. Donald Foster, "The Classification of Non-Book Materials in Academic Libraries: A Commentary and Bibliography," *Occasional Papers* 104 (September 1972): 3.

43. 1942 Annual Report, box 7, folder 6, Picture Collection Records.

44. Jerry Bonfield, "Just Ask For It!" TW, November 26, 1944. Clipping in box 3, folder 6, Picture Collection Records.

45. Jessica Cline, supervising librarian for the Picture Collection, in discussion with author, May 31, 2022.

46. 1936 Annual Report, box 7, folder 5, Picture Collection Records.

47. Jay Vissers, in discussion with author, April 23, 2014. Jay Vissers and Penny Glenar in discussion with author, August 5, 2015. Vissers and Glenar had worked at the Picture Collection since the early 1990s and 1998, respectively. Glenar retired in 2016. Vissers still works at the Picture Collection as of 2022. The Picture Collection has moved twice since this interview, and with staff and hour limitations during the COVID-19 pandemic, clipping was further limited. Still, in 2022, supervising librarian Jessica Cline indicated that they continue to clip pictures at the rate of about 500 per month in discussion with author, May 31, 2022.

48. Celestine Frankenburg, "Specialization: Pictures A Dialogue about the Training of Picture Librarians. Mrs. Celestine Frankenberg Interviewing Romana Javitz," *Special Libraries*, January 1965, 17.

49. Using the example of the iconic image of Marilyn Monroe holding down her dress while standing on top of a subway grate in the *Seven Year Itch*, Glenar and Vissers explained that after a copy was placed in a Marilyn Monroe folder, duplicate images could be added to poses, subway, moving pictures, emotions, wind, or facial expressions.

50. "Glossary of Terms: Transgender," *GLAAD Media Reference Guide 11th Edition*, last modified April 21, 2022 (https://www.glaad.org/reference/trans-terms), notes that "transgenderism" is a term to avoid.

51. Cline, in discussion with author, May 31, 2022.

52. Romana Javitz, "Organization of Still Pictures as Documents," n.d., box 3, folder 8, Picture Collection Records, 48–49.

53. As Vissers noted, "Clipping is also interesting because barring somebody destroying it or losing it, you're adding something to the files. You're putting your take on it, your annotation of what it is, you have an input into the collection that will last long after you're gone. And so, it's sort of fulfilling to know that some of it will still be there." Vissers in discussion with author, August 5, 2015.

54. Isabella Peters, *Folksonomies: Indexing and Retrieval in Web 2.0* (Berlin: Walter de Gruyter, 2009), 3.

55. Cameron Marlow, Mor Naaman, Danah Boyd, and Marc Davis, "HT06, Tagging Paper, Taxonomy, Flickr, Academic Article, to Read," in *Proceedings of the 17th Conference on Hypertext and Hypermedia* (Odense, Denmark, 2006), 1. http://www.danah.org/papers/Hypertext2006.pdf.

56. James Estrin, "A Historic Photo Archive Re-emerges at the New York Public Library," *New York Times*, June 6, 2012, https://lens.blogs.nytimes.com/2012/06/06/a-historic-photo-archive-re-emerges-at-the-new-york-public-library/.

57. N. Katherine Hayles, *Writing Machines* (Cambridge, MA: MIT Press, 2002), 33.

58. Johanna Drucker, "Entity to Event: From Literal, Mechanistic Materiality to Probabilistic Materiality," *Parallax* 15, no. 4 (2009): 8.

59. Lev Manovich, *Software Takes Command* (New York: Bloomsburg Academic Publishing, 2013), 33.

60. Daniel Rubinstein and Katrina Sluis, "Algorithmic Photography and the Crisis of Representation," in *The Photographic Image in Digital Culture*, 2nd ed., edited by Martin Lister (London: Routledge, 2013): 22–40.

61. Robin Kelsey, *Archive Style: Photographs and Illustrations for U.S. Surveys 1850–1890* (Berkeley: University of California Press, 2007), 16.

62. Ronald E. Day, *Documentarity: Evidence, Ontology, and Inscription* (Cambridge, MA: MIT Press, 2019).

63. I'm grateful for discussions with Anthony Troncale, who first alerted me to the relationship with the Boas family and helped me think through the intellectual impact of these personal relationships.

64. For just two projects exploring this legacy, see *Reconsidering the Documentary and Contemporary Art* (Berlin: Sternberg Press, 2008), published in connection with a multiyear research project initiated by Maria Lind and Hito Steyerl, and Julian Stallbrass, ed., *Documentary* (Cambridge, MA: MIT Press, 2013).

65. For an excellent overview of the history of the uses of the terms "document" and "documentation" in librarianship see Michael K. Buckland, "What Is a 'Document'?" *Journal of the American Society for Information Science* 48, no. 9 (September 1997): 804–809. In the same volume, Robert V. Williams discusses the documentation and special libraries movement in the United States, arguing that the special libraries movement of 1900–1930 (notably, a picture collection would be considered under the rubric of special library) was the practical and conceptual correlate to the documentation movement in Europe (Williams, "The Documentation and Special Libraries Movements in the United States, 1910–1960," *Journal of the American Society for Information Science* 48, no. 9 [September 1997]: 775–781). Ronald E. Day gives a critical history of the documentation movement in *Indexing It All: The Subject in the Age of Documentation* (Cambridge, MA: MIT Press, 2015).

66. Day, 2015, looks closely at both Briet and Otlet to outline the indexical relationship posited by indexing practices in documentation work.

67. Suzanne Briet, *What Is Documentation? English Translation of a Classic French Text* (Lanham, MD: Scarecrow Press, 2006 [1951]), 10.

68. David Shumaker, "Special Libraries," in *Encyclopedia of Library and Information Sciences*, 3rd ed. (New York: Taylor and Francis, 2009), 4966–4974.

69. Williams, "The Documentation and Special Libraries Movements in the United States, 1910–1960," 775.

70. Ibid.

71. See *Picturescope* 1, no. 1 (1953): 1.

72. Romana Javitz, "Care of Documentary Photographs," *New York Times* (February 18, 1953), 30. Italics added.

73. Javitz's writing is gathered in the invaluable collection edited by former NYPL librarian Anthony Troncale, *Words on Pictures: Romana Javitz and the New York Public Library's Picture Collection* (New York: Photo Verso Publications LLC, 2020).

74. 1935 Annual Report, box 7, folder 5, Picture Collection Records.

75. Walter Benjamin, "The Work of Art in the Age of Technological Reproducibility, Second Version," translated by Edmund Jephcott and Harry Zohn, in *Walter Benjamin: Selected Writings, Volume 3*, edited by Howard Eiland and Michael W. Jennings (Cambridge, MA: Harvard University Press, 2005), 105. Written late December 1935 to the beginning of February 1936; unpublished in his lifetime.

76. Ibid.

77. Romana Javitz, "Accent on Pictures," 1949 manuscript of text published in *Library Journal* 15 (September 1949), box 1, folder 1, Picture Collection Records.

78. Romana Javitz, "Influence and Function: Pictures in Print," n.d. manuscript, box 3, folder 28, Picture Collection Records, 5.

79. Benjamin, "The Work of Art in the Age of Technological Reproducibility," 104.

80. Javitz, transcript, 372.

81. Walter Benjamin, "Eduard Fuchs: Collector and Historian," translated by Howard Eiland and Michael W. Jennings, in *Walter Benjamin: Selected Writings, Volume 3*, edited by Howard Eiland and Michael W. Jennings (Cambridge, MA: Harvard University Press, 2005): 260–302. First appeared as "Edward Fuchs: der sammler und der Historiker," *Zeitschrift für Sozialforschung* 6 (1937): 346–380.

82. Walter Benjamin, "Little History of Photography," translated by Edmund Jephcott and Kingsley Shorter, in *Walter Benjamin: Selected Writings Volume 2 1927–1934* (Cambridge, MA: Harvard University Press, 1999), 518. First published in *Die literarische Welt* (September–October 1931).

83. Benjamin, "Little History of Photography," 507.

84. John Szarkowski, *Atget* (New York: Museum of Modern Art, 2000), 212.

85. Benjamin, "Little History of Photography," 518.

86. See Beaumont Newhall, *The History of Photography: From 1839 to the Present Day*, 4th ed. (New York: Museum of Modern Art, 1978), 137. Newhall, Atget, and MoMA's shaping of documentary photography will be discussed further in chapter 2.

87. Rosalind Krauss, "Photography's Discursive Spaces," *Art Journal* 42, no. 4 (Winter 1982): 311–319.

88. Molly Nesbit carefully traces the networks of Atget's production, including his clients and collections, in *Atget's Seven Albums* (New Haven, CT: Yale University Press, 1994).

89. Krauss, "Photography's Discursive Spaces," 317.

90. Ibid.

91. John Tagg, "The Archiving Machine; or the Camera and the Filing Cabinet," *Grey Room* 47, (Spring 2012): 33.

92. Romana Javitz, letter to Helen Oelke, American Library Associations, November 2, 1937, box 1, folder 28, Picture Collection Records. The "Newark list" refers to a list of subject headings for the picture collection published by the Newark Library in numerous editions since 1910, which will be discussed further in the "Living Collection" selection.

93. 1939 Annual Report, box 7, folder 5, Picture Collection Records.

94. Romana Javitz, "Memorandum," n.d., box 1, folder 10 ("Carnegie Grant 1940–1943"), Picture Collection Records.

95. Romana Javitz, "An Interim Report on the Progress of the Work of Preparing a Manual on the Classification of Documentary Pictures," October 1941, box 1, folder 10, Picture Collection Records.

96. Romana Javitz, "Organization of Still Pictures as Documents," n.d. manuscript, box 3, folder 8, Picture Collection Records, 68.

97. Ibid., 27.

98. Ibid., 23.

99. Romana Javitz, "Words on Pictures: An Address by Romana Javitz, Superintendent of the Picture Collection, New York Public Library Before the Massachusetts Library Association, January 28, 1943," box 3, folder 34, Picture Collection Records.

100. Lincoln Kirstein, "Walker Evans's Photographs of Victorian Architecture," *Bulletin of the Museum of Modern Art* 4 (December 1933): n.p.

101. Kelsey, *Archive Style*, 2007. Like Krauss, Kelsey suggests the photographic archive is a structuring aesthetic, but he develops the idea further to describe the network of social, technical, and political forces that make up this structure and act in relation with each other. For both writers, "subject"-based photography, where "subject" refers to an institutional subject heading list rather than authorial actor, produces an aesthetic style that comes to be recognized as documentary. It may look like modernism, but only within a certain discursive space.

102. Oral history interview with Walker Evans, October 13–December 23, 1971, Archives of American Art, Smithsonian Institution.

103. The influence of MoMA and Walker Evans on the development of documentary style will be explored further in chapter 2.

104. Belinda Rathbone, *Walker Evans: A Biography* (Boston: Houghton Mifflin Harcourt, 2000), 84.

105. Alfred Kazin, *On Native Grounds: An Interpretation of Modern American Prose Literature* (New York: Reynal and Hitchcock, 1942), 487.

106. Mark Goble, *Beautiful Circuits: Modernism and the Mediated Life* (New York: Columbia University Press, 2010), 245.

107. From series of reports in box 3, folder 32, Picture Collection Records.

108. Richard Doud, "An Interview with Romana Javitz 23 February 1965," *Archives of American Art Journal* 41, no. 1/4 (2001): 8.

109. Roy Stryker, letter to Romana Javitz, n.d., box 2, folder 12, Picture Collection Records.

110. Doud, "Interview with Romana Javitz," 8.

111. Ibid.

112. Estrin, "A Historic Photo Archive Re-Emerges at the New York Public Library."

113. See Mary Jane Appel, "The Duplicate File: New Insights into the FSA The Duplicate File: New Insights into the FSA," *Archives of American Art Journal* 54, no. 1 (Spring 2015): 4–27. Artists and critics have commented on the perceived violence of the act. As just one example, artist William E. Jones has completed a series of works using the images, including his 2017 film *Rejected*, which zooms in and out of 3,048 punctured holes on a seven-hour continuous loop, emphasizing what he describes as an "institutional failure" and bringing the haunting results into dialogue with the present.

114. "[Stryker] was thus the target of constant criticism, of complaints; he was looked upon by Walker Evans as a philistine, an obstructer, and by Ben Shahn as a vandal." From Hank O'Neal, *A Vision Shared: A Portrait of America 1935–1943* (reprint, Göttingen, Germany: Steidl, 2017), 7.

115. Mary Panzer, "Romana Javitz, Arturo Schomburg, and the Farm Security Administration Search for Usable Pictures of African American Life," panel presentation for Special Libraries Association, New York Chapter, March 23, 2021. Panzer also introduces this argument in "Pictures at Work: Romana Javitz and the New York Public Library Picture Collection," in *The 'Public' Life of Photographs,* edited by Thierry Gervais (Cambridge/Toronto: MIT Press/Ryerson Image Centre, 2016), 144.

116. In a 1937 letter to Roy Stryker, Javitz supplied a full list of extant numbers of photographs showing African American life from the Farm Security Administration and suggested that he send prints of whatever available photographs of African American life to Dr. Schomburg for the "Harlem collection," concluding, "I need not reiterate their importance to us and to our public both from the point of view of document and of interest" (Romana Javitz, letter to Roy Stryker, May 14, 1937, box 2, folder 12, series 1, Picture Collection Records). Javitz further references this work in Romana Javitz, Typewritten transcript, n.d., in box 4 "Audio Tape Transcriptions—Javitz Class at Pratt[?] n.d.," Picture Collection records; "A Report on the Picture Collection for Mr. Ralph A. Beals" (July 1951), in box 3, folder 21, series 1, Picture Collection Records; and "An Interview with Romana Javitz, 23 February 1965," *Archives of American Art Journal* 41, no. 1/4 (2001): 8. See also Javitz to Arthur Schomburg, May 25, 1937, in Arthur A. Schomburg Papers, Schomburg Center for Research in Black Culture.

117. Goble, *Beautiful Circuits*, 289.

118. This history, and Javitz's role, is confirmed by Holger Cahill's introduction to *The Index of American Design*, by Erwin O. Christensen (New York: Macmillan, 1950). Javitz had discussed interest in American design, and the dearth of materials to support the budding demand, with many artist-users of the collection. One, Ruth Reeves,

NOTES TO PAGES 66–72 253

had contacts at the New York City Emergency Relief Administration and relayed Javitz's idea for a comprehensive source index of American design. A proposal was solicited from Javitz in 1935, and the project was realized over the seven years that followed.

119. Goble, *Beautiful Circuits*, 293.

120. See James Scott, *Seeing Like a State: How Certain Schemes to Improve the Human Condition Have Failed* (New Haven, CT: Yale University Press, 1999), for the former critique and Martha Rosler, "In, Around, and Afterthoughts (on Documentary Photography)," in *The Contests of Meaning: Critical Histories of Photography*, edited by Richard Bolton (Cambridge, MA: MIT Press, 1992), 303–333, for the latter.

121. Martha Rosler, "In, Around, and Afterthoughts (on Documentary Photography)," 306.

122. Ibid., 317.

123. Jonathan Kahana, *Intelligence Work: The Politics of American Documentary* (New York: Columbia University Press, 2008), 26.

124. Okwui Enwezor, "Documentary/Verite: Bio-Politics, Human Rights, and the Figure of 'Truth' in Contemporary Art," in *Reconsidering the Documentary and Contemporary Art*, edited by Maria Lind and Hito Steyerl (Berlin: Sternberg Press, 2008), 95.

125. This is a key intervention of visual culture studies. See "Viewers Make Meaning," chap. 2 in Marita Sturken and Lisa Cartwright, *Practices of Looking: An Introduction to Visual Culture*. 3rd ed. (New York: Oxford University Press, 2018).

126. Mitchell, *What Do Pictures Want?* 87.

127. Hal Foster, "An Archival Impulse," *October* 110 (Fall 2004): 3–22, and Okwui Enwezor, *Archive Fever: Uses of the Document in Contemporary Art* (New York: ICP, 2008).

128. "Audio Tape Transcriptions—Javitz Class at Pratt[?] n.d." Picture Collection Records, 66.

129. Joseph Cornell, letter to Romana Javitz, January 16, 1947, box 1, folder 29, Picture Collection Records.

130. Matthew Affron and Sylvie Ramond, eds., *Joseph Cornell and Surrealism* (Charlottesville, VA: Fralin Museum of Art, 2015). See Ramond and François Rene Martin, "Museums, Muses: Notes on Joseph Cornell," in that volume.

131. Blake Gopnik, *Warhol* (New York: Ecco/HarperCollins Publishers, 2020), 138.

132. Ibid.

133. Thank you to Susan Chute for initially pointing this out to me, as well as the greeting card. Chute wrote a blog post about her discovery in 2010, "POP! Goes the Picture Collection: Warhol at NYPL," *NYPL.org*, September 9, 2010, http://www.nypl.org/blog/2010/09/09/pop-goes-picture-collection-warhol.

134. Contemporary users are interviewed in Arthur Lubow, "The Treasures in the Stacks," *New York Times*, August 4, 2021, section C, 1.

135. Eric Timothy Carlson, in discussion with author, October 3, 2017.

136. Tim Griffin, "An Unlikely Futurity," in *Taryn Simon: The Color of a Flea's Eye: The Picture Collection*, edited by Taryn Simon (Paris, France: Cahiers D'Art, 2020).

CHAPTER 2

1. "Table of Contents: Museums on the Web: An International Conference," *Museumsontheweb.com*, last modified January 7, 1998, accessed December 15, 2017, https://www.museumsandtheweb.com/mw97/mw97toc.html.

2. Anna Maria Antonini, Sara Chiesa, and Dante Bartoli, "Archeowiki: When Open-Source Strategies Attract Visitors' Presence in Museums. A Project for the Enhancement of Archaeological Heritage in Lombardy," in *Museums and the Web 2013*, edited by N. Proctor and R. Cherry (Silver Spring, MD: Museums and the Web, published online May 31, 2014), https://mwf2014.museumsandtheweb.com/proposals/archeowiki-when-open-source-strategies-incentive-visitors-presence-in-museum-a-project-for-the-enhancement-of-archaeological-heritage-in-lombardia/.

3. MoMA's release of all of their exhibition documentation through a dedicated web portal is one of the most recent examples of the durability of this mission. "The Museum of Modern Art Launches Comprehensive Online Exhibition History," press release (New York: MoMA), September 14, 2016.

4. Groys, *Art Power*.

5. Tony Bennett, "The Exhibitionary Complex," *New Formations* 4 (Spring 1988), 73–102; James Clifford, *The Predicament of Culture: Twentieth-Century Ethnography, Literature, and Art* (Cambridge, MA: Harvard University Press, 1988) and *Routes: Travel and Translation in the Late Twentieth Century* (Cambridge, MA: Harvard University Press, 1997) (especially chap. 7, "Museums as Contact Zones").

6. Douglas Crimp, *On the Museum's Ruins* (Cambridge, MA: MIT Press, 1995).

7. Mary Anne Staniszewski, *The Power of Display: A History of Exhibition Installations at the Museum of Modern Art* (Cambridge, MA: MIT Press, 1998).

8. Carol Duncan, *Civilizing Rituals: Inside Public Art Museums* (London: Routledge, 1995).

9. Terence Riley and Stephen Perrella, *The International Style: Exhibition 15 and the Museum of Modern Art* (New York: Rizzoli, 1992); Eric J. Sandeen, *Picturing an Exhibition: The Family of Man and 1950s America* (Albuquerque: University of New Mexico, 1995); Fred Turner, *Democratic Surround: Multimedia and American Liberalism from World War II to the Psychedelic Sixties* (Chicago: University of Chicago Press, 2013); Jenny Tobias, *The Museum of Modern Art's "What Is Modern?" Series, 1938–1969* (PhD dissertation, The City University of New York, 2012).

10. Haidee Wasson, *Museum Movies: The Museum of Modern Art and the Birth of Art Cinema* (Berkeley: University of California, 2005); Christopher Phillips, "Judgment Seat of Photography," *October* no. 22 (1982).

11. Sybil Gordon Kantor, *Alfred H. Barr, Jr. and the Intellectual Origins of the Museum of Modern Art* (Cambridge, MA: MIT, 2002); Russell Lynes, *Good Old Modern: An Intimate*

NOTES TO PAGES 82–86

Portrait of the Museum of Modern Art (New York: Atheneum, 1973); Alice Goldfarb Marquis, *Alfred H. Barr, Jr.: Missionary for the Modern* (Chicago: Contemporary, 1989); Helaine Ruth Messer, *MoMA: Museum In Search of an Image* (PhD dissertation, Columbia University, 1979); Robert Sitton, *Lady in the Dark: Iris Barry and the Art of Film* (New York: Columbia University Press, 2014); Margaret Whitehead, *The Making of the Museum of Modern Art's Photography Canon: Beaumont Newhall and the Rejection of 1930s Modernity in New York* (PhD dissertation, George Washington University, 2007).

12. Robert S. Nelson, "The Slide Lecture, or the Work of Art History in the Age of Mechanical Reproduction," *Critical Inquiry* 26, no. 3 (Spring 2000): 414–434.

13. Annemarie Mol's *The Body Multiple: Ontologies in Medical Practice* (Durham, NC: Duke University Press, 2002) uses the lens of multiple ontologies theory. For "iterative ontology learning," see Jens Lehmann, and Johanna Voelker, *Perspectives on Ontology Learning* (Tokyo: AKA/IOS Press, 2014).

14. See Christopher Brewster; José Iria, Ziqi Zhang, Fabio Ciravegna, Louise Guthrie, and Yorick Wilks, "Dynamic Iterative Ontology Learning," in 6th International Conference on Recent Advances in Natural Language Processing. Borovets, Bulgaria (September 27, 2007–September 29, 2007).

15. Edwards and Lien, *Uncertain Images*, 3.

16. Allan Sekula has argued for the continued legacy of photography's two contradictory impulses: the scientific and objective against the aesthetic and subjective. Sekula, "Reading an Archive: Photography between Labor and Capital," in *Blasted Allegories: An Anthology of Artists' Writings*, edited by Brian Wallis (New York and Cambridge, MA: The New Museum of Contemporary Art and MIT Press, 1987), 114–128. John Tagg's central intervention in *The Burden of Representation. Essays on Photographies and Histories* (London: Macmillan, 1988) is that institutional archives, rather than artistic aims, are central to the development of photography. Rosalind Krauss challenges how aesthetic ideology is applied to photography in "Photography's Discursive Spaces" (1982).

17. Douglas Crimp, "The Museum's Old, the Library's New Subject," in *On the Museum's Ruins* (Boston: MIT Press, 1993), 75.

18. See Kantor, *Alfred H. Barr, Jr.*

19. The role of the artwork reproduction in consolidating art history as a discipline is well acknowledged (Nelson, "The Slide Lecture"). In addition to Nelson, photography's role in art history was observed as early as the nineteenth century by art historians like Bernard Berenson and Anton Springer. This literature is reviewed in Costanza Caraffa, "From 'Photo Libraries' to 'Photo Archives.' On the Epistemological Potential of Art-Historical Photo Collections," in *Photo Archives and the Photographic Memory of Art History*, edited by Costanza Caraffa (Berlin: Deutcher Kunstverlag 2011), and Frederick N. Bohrer "Photographic Perspectives: Photography and the Institutional Formation of Art History," in *Art History and Its Institutions: The Nineteenth Century* (London: Routledge, 2002), 246–259. Another key scholar who has explored this relationship is Heinrich Dilly, though his work has not yet been translated. See

Die Bildwerfer: "128 Jahrekunst wissenschaftliche Dia-Projektion" [The Projection-Lantern: 128 Years of Art-Historical Slide Projection], in Kai-Uwe Hemken, ed., *ImBann derMedien* (Weimar: VDG-Verlag und Datenbank fur Feisteswissenschaften, 1995).

20. Biographical information in this section is drawn from Kantor unless otherwise noted.

21. The Index continues to this day as a major research tool. It has been digitized over the last few decades, but it was exclusively a print resource until 1991, centered at Princeton with copies placed at Dumbarton Oaks Research Library, Washington, D.C.; the Biblioteca Apostolica Vaticana, Rome; and the Getty Research Center, Los Angeles. For an early history of the Index, see Isa Ragusa, "Observations of the History of the Index: In Two Parts," *Visual Resources* 13 (1998): 215–251. While outside the scope of this book, the Index alone is a case study rich with implications for the nature of photographic databases and the study of art. Ragusa notes the gendered role of many of its practitioners and the transition from the widespread belief that the Index would eventually encompass all documented objects of the medieval period to the postwar realization that this would be an impossible goal, two ideas rich for future study. Andrew E. Hershberger has written on the myth of photographic objectivity and the Index, pointing out how little attention was given to photographic standardization in comparison to the organization of the subject cards, as well as how the objectivity of photography was assumed by Morey and Index staff through the present day. Andrew E. Hershberger, "The Medium Was the Method: Photography and Iconography at the Index of Christian Art," in *Futures Past: Twenty Years of Arts Computing*, edited by Anna Bentkowska-Kafel, Trish Cashen, and Hazel Gardiner (London: Intellect, 2007).

22. See chap. 1 in Kantor, *Alfred H. Barr, Jr.*

23. At Wellesley College, titled "Contemporary Painting in Relation to the Past, to the Other Arts, to Aesthetic Theory and Modern Civilization."

24. Quoted in Kantor, *Alfred H. Barr, Jr.*, 101.

25. *Living Art* contained thirty plates, with ten black and white photographs of sculpture, two renderings of paintings, and eighteen "facsimiles" of watercolors and tempera works. These facsimiles were color collotypes, a labor-intensive method of printing from a gelatin surface in a lithographic manner, which produces high-quality prints from a photographic negative.

26. Quoted in Kantor, *Alfred H. Barr, Jr.*, 94.

27. While in Europe, Barr met with the Bauhaus faculty, which was known for its embrace of industrial design, architecture, film, and photography alongside the traditional arts. Later, he reflected his multidepartmental plan was "inspired by Rufus Morey's class in Medieval art . . . and equally important, the Bauhaus of Dessau" (quoted in Kantor 155). In Russia, he encountered wall labels at the Tretyakov Gallery that related the objects on view to the catalogue and described the whole room rather than a single work; he wrote excitedly about this innovation, insisting, "There are none in America" (Kantor, *Alfred H. Barr, Jr.*, 188).

NOTES TO PAGES 89–96 257

28. From installation instructions for the circulating version of exhibition, "Circulating Exhibition of Cubism and Abstract Art," The Museum of Modern Art Exhibition Records, 46.2, The Museum of Modern Art Archives, New York (hereafter MoMA Archives, NY).

29. The only other painting represented by a photograph in the exhibition was Alexander Rodchenko's photograph of Kazimir Malevich's *Black on Black* ("Circulating Exhibition of Cubism and Abstract Art," MoMA Archives, NY).

30. MoMA, "Museum of Modern Art, New York, and Art Institute of Chicago will Cooperate in Showing Largest Exhibition of Works by Picasso Ever Held in This Country," press release, January 20, 1939.

31. Hal Foster, *Recordings: Art, Spectacle, Cultural Politics* (Port Townsend, WA: Bay Press, 1985), 184.

32. See Simon Gikandi, "Picasso, Africa, and the Schemata of Difference," *Modernism/Modernity*, 10, no. 3 (September 2003): 455–480.

33. Leo Steinberg, "Philosophical Brothel," *October* 44 (Spring 1988): 20.

34. John Cotton Dana, *The Gloom of the Museum* (Woodstock, VT: Elm Tree Press, 1917), 28.

35. "Circulating Exhibitions 1931–1954," *The Bulletin of the Museum of Modern Art* 21, no. 3/4 (Summer, 1954): 4.

36. MoMA, "Survey of Modern Painting," press release, July 6, 1932.

37. Alfred H. Barr Jr., *A Brief Survey of Modern Painting* (New York: Museum of Modern Art, 1934), 2.

38. He wrote at the time to Harvard art historian Paul Sachs, "Such a label eliminates individual titles for each picture and makes the picture readily located thru the plan of the wall above the inscription and relates the wall label to the catalogue . . . There are none in America" (quoted in Kantor, *Alfred H. Barr, Jr.*, 188)

39. Kantor, *Alfred H. Barr, Jr.*, 221.

40. Alfred H. Barr Jr., *A Brief Survey of Modern Painting*, 18.

41. Ibid., 1.

42. "For Your Own Collection of Modern Paintings," pamphlet, 1932, Department of Circulating Exhibitions Records, series II, folder 1.42.2, MoMA Archives, NY.

43. "The Art of Printing Color Reproductions," Department of Circulating Exhibitions Records, series II, folder 1.42.2.1, MoMA Archives, NY.

44. "For Your Own Collection of Modern Paintings."

45. In a letter dating from 1932, Raymond & Rissling proposed taking responsibility for all shipping and handling, sending bills on museum letterhead. "Extracts from Letter from Raymond & Rissling August 15, 1932," Department of Circulating Exhibitions Records, series II, folder 1.42.2.1, MoMA Archives, NY.

46. The first noncirculating exhibition that included photography at MoMA was *Murals by American Painters and Photographers* in May 1932. This exhibition looked

at the "increasing interest in mural decoration" and commissioned dozens of artists to participate (MoMA, "American Mural Exhibit to Open New Home of MoMA," press release, April 23, 1932). Thirty-five painters contributed, as did eight photographers, including Edward Steichen, Berenice Abbott, and Charles Sheeler. Despite acknowledging the exciting possibilities of the medium of photomurals, MoMA's press release carefully noted, "These [photographic] exhibits will be hung in a room to themselves so as not to compete unnecessarily with the actual mural paintings" (MoMA "Photographic Murals," press release, 1932).

47. See Phillips, "Judgement Seat," 30; Lynes, *Good Old Modern*, 107.

48. Oral history interview with Walker Evans, October 13–December 23, 1971. Archives of American Art, Smithsonian Institution (hereafter Evans Oral History, AAA).

49. Barnaby Haran examines the conceptual confusion around the definition of photography illustrated by this exhibition in "Homeless Houses: Classifying Walker Evans's Photographs of Victorian Architecture," *Oxford Art Journal* 33, no. 2 (June 2010): 189–210.

50. MoMA, "First One-Man Photography Exhibit—Walker Evans American Photographs," press Release, September 19, 1938.

51. Ibid.

52. Phillips, "Judgement Seat," 28.

53. See Whitehead, *The Making of the Museum of Modern Art's Photography Canon.*

54. This is a primary argument in Whitehead as well as in John Tagg, "Melancholy Realism: Walker Evans's Resistance to Meaning," *Narrative* 11, no. 1 (January 2003): 3–77. Trudy Wilner Stack also examines Evans's role in the consolidation of photography discourse at MoMA in "The Museological Mise en Scène: Walker Evans, American Photographs, and The Museum of Modern Art," *Art Documentation: Journal of the Art Libraries Society of North America* 13, no. 4 (Winter 1994): 13–18.

55. Evans Oral History, AAA.

56. MoMA, "First One-Man Photography Exhibit—Walker Evans American Photographs," press release, September 13, 1938.

57. I am indebted to the research of Virginia-Lee Webb, who in her article "Art as Information: The African Portfolios of Charles Sheeler and Walker Evans" (*African Arts* 24, no. 1 [January 1991]: 56–63, 103–104) and her exhibition catalogue *Perfect Documents: Walker Evans and African Art* (The Metropolitan Museum of Art, 2000) carefully documented the iterations of Evans's photography, the portfolios, and the circulating exhibitions that emerged from this encounter.

58. MoMA, "African Negro Exhibit to Open," press release, March 6, 1935.

59. Gikandi, "Picasso, Africa, and the Schemata of Difference," 457.

60. Rasheed Araeen, "From Primitivism to Ethnic Arts," *Third Text* 1 (1987): 11.

61. Hal Foster, "The 'Primitive' Unconscious of Modern Art," *October* 34 (Autumn 1985): 47.

62. Multiple scholars have explored how the history of photography is intimately entwined with social and technological efforts to legitimize colonial worldviews.

Photography's ability to exoticize, aestheticize, and naturalize violence and to subject and discipline bodies through incorporation into an archive or exhibition has been surveyed by, among others, Anne Maxwell, *Colonial Photography & Exhibitions: Representations of the "Native" People and the Making of European Identities* (London: Leicester University Press, 1999), as well as in classic texts by John Tagg, Allan Sekula, and others (Tagg, *The Burden of Representation*; Sekula, "The Body and the Archive," October 39 [Winter 1986]: 3–64).

63. Alfred H. Barr, letter to David H. Stevens, director of humanities, The Rockefeller Foundation, February 18, 1935, cited in Webb, *Perfect Documents*, 28.

64. Webb, *Perfect Documents*, 33.

65. Recipients of the free portfolios are Atlanta University, Fisk University, Hampton Institute, Tuskegee Normal Industrial Institute, Howard University, Dillard University, and Schaumburg Center for Research in Black Culture. Two more were gifted to MoMA and Sweeney, and the rest were purchased for a nominal fee by institutions around the world. Purchasers of the portfolio were New York University, Harvard University, Musée de l'Homme, Paris, University of Chicago, Dartmouth College, Robert Goldwater, and Frederick Rhodes Pleasants. Goldwater had 35-mm slides of the photographs made for teaching purposes.

66. In a critique of the 1984 exhibition *Primitivism in 20th Century Art: Affinity of the Tribal and the Modern*, Clifford has also discussed at length the discourse of affinities promoted by MoMA. He argues that the origin story of modern art depends on the discourse of affinities, which has a particular chronotope of "tribal" and "modernity" embedded within it: it requires artifacts to be outside of modernity in order to be redeemable within it. Crucially, he argues that this is achieved through modern technology of the camera. "Histories of the Tribal and the Modern," in *The Predicament of Culture: Twentieth-Century Ethnography, Literature, and Art* (Cambridge, MA: Harvard University Press, 1988), 189–214.

67. Clifford, "On Collecting Art and Culture," in *The Predicament of Culture: Twentieth-Century Ethnography, Literature, and Art* (Cambridge, MA: Harvard University Press, 1988), 217.

68. Lynes, *Good Old Modern*, 118.

69. Gregory J. Downey, "Making Media Work," in *Media Technologies*, edited by Tarleton Gillespie, Pablo J. Boczkowski, and Kirsten A. Foot (Cambridge, MA: MIT Press, 2014), 152.

70. Lynes, *Good Old Modern*, 261.

71. "Circulating Exhibitions Department—General Routine for Circulation Manager," Department of Circulating Exhibitions Records, I.7.6.7, MoMA Archives, NY.

72. Ibid.

73. MoMA, "New Technique of Multiple Circulating Exhibitions on Display at the Museum of Modern Art," press release, March 6, 1945.

74. Ibid.

75. An early, yet undated memo about library fundraising notes that the collection of the 2,000 lantern slides was the most popular service in the library ("An Effort

to Raise $10,000 for the Museum of Modern Art Library," undated memo, Beaumont Newhall Papers, I.1, MoMA Archives, NY). By the 1960s, however, the service had fallen into disrepair as the slide material deteriorated. In 1961, the museum entered into an agreement with the color slide company Sandak, in which Sandak produced, stored, and sold color slides of MoMA collection works and select exhibitions. ("Agreement between the Museum of Modern Art and Sandak Incorporated," July 1960, Reports and Pamphlets, series 5, folder 9, MoMA Archives, NY.) After this, the slide rental service seems to have ceased.

76. Bernard Karpel, "The Library," *The Bulletin of the Museum of Modern Art* 11, no. 3 (January 1944): 4.

77. Oral History Program, interview with Pearl Moeller, 1991, 40. MoMA Archives, NY.

78. See Lynes, *Good Old Modern*, 347–348; "Bernard Karpel Dies; A Bibliographer of Art," *New York Times*, January 21, 1986. His longtime staffer and colleague Pearl Moeller recalled, "Many of the things that are done on computer with pictures now, Bernard foresaw. He was way ahead of the game" (Oral History Program, interview with Pearl Moeller, 1991, 25. MoMA Archives, NY). I contrast Karpel's innovative ideas about visual cataloguing with those of Romana Javitz in Diana Kamin, "Mid-Century Visions, Programmed Affinities: The Enduring Challenges of Image Classification," *Journal of Visual Culture* 16, no. 3 (December 2017): 310–36.

79. Oral History, Moeller, 73, MoMA Archives, NY.

80. Ibid., 31.

81. Ibid., 36. This mention of advertisers indicates the overlap in industries that are surveyed throughout this book. For much of the twentieth century, the same advertiser might visit the NYPL Picture Collection at 5th Avenue and 42nd Street, MoMA on 53rd Street between 5th and 6th Avenues, and H. Armstrong Roberts at the Graybar building on Lexington Avenue and 44th Street.

82. 1962 Photography Report, Reports and Pamphlets, 5.13, MoMA Archives, NY, 41–42.

83. Oral history, Moeller, 46.

84. See, among others, Mar Hicks, *Programmed Inequality: How Britain Discarded Women Technologists and Lost Its Edge in Computing* (Cambridge, MA: MIT Press, 2017); Gregory Downey, "Virtual Webs, Physical Technologies, and Hidden Workers: The Spaces of Labor in Information Internetworks," *Technology and Culture* 42, no. 2 (2001): 209–235; Venus Green, *Race on the Line: Gender, Labor, and Technology in the Bell System, 1880–1980* (Durham, NC: Duke University Press, 2001); Jennifer Light, "When Computers Were Women," *Technology and Culture* 40, no. 3 (1999): 455–483; Heidi I. Hartmann, Robert E. Kraut, and Louise A. Tilly, eds., *Computer Chips and Paper Clips: Technology and Women's Employment*, 2 vols. (Washington, D.C.: National Research Council, 1986–1987).

85. Biographical note and personal memoir of Soichi Sunami, typescript, 1975, MoMA Library Special Collections.

NOTES TO PAGES 111–119

86. MoMA was likely the first museum to systematically produce installation photographs. Yet, up until the 1960s, only about three-quarters of the exhibitions on view were photographed, due to budgetary concerns. http://www.moma.org/explore/inside _out/author/tgrischk.

87. Oral History, Moeller, 39.

88. Oral history, Moeller, 72.

89. Oral history, Moeller, 42.

90. Ibid., 25.

91. Ibid., 42.

92. Already in 1946, Wheeler reported that book sales had increased 300 percent in the past three years. In addition to book sales, Wheeler oversaw sales of color reproductions and postcards. ("The Minutes of the Sixteenth Annual Meeting of the Board of Trustees and Members of the Corporation of the Museum of Modern Art Held on Thursday, November 15, 1945 at 5 o'Clock in the Trustees' Room," *The Bulletin of the Museum of Modern Art*, vol. 13, no. 3, The Minutes of the Sixteenth Annual Meeting [February 1946], 11). A 1944 publication reveals his strategy to make larger editions in order to make book publishing more cost-effective. Also significant was that at that time, selling color reproductions was "more remunerative" (Monroe Wheeler, "The Art Museum and the Art Book Trade," *Museum News* 24, no. 2 [1946]: 8).

93. Oral history, Moeller, 42.

94. Alain Pottage and Brad Sherman, *Figures of Invention: A History of Modern Patent Law* (Oxford: Oxford University Press, 2010), 32.

95. Anita Duquette, manager of rights and reproduction, Whitney Museum of American Art, in discussion with author, January 14, 2014.

96. Bridgeman Art Library Ltd. v. Corel Corp., 36 F. Supp. 2d 191 (S.D.N.Y. 1999).

97. 1962 Photography Report, Reports and Pamphlets, series 5, folder 13, The Museum of Modern Art Archives, New York.

98. Ibid., 40.

99. 1962 Photography Report, 17.

100. Memo from John Szarkowski to Dick Koch, January 29, 1963, Reports and Pamphlets, 5, no. 13, MoMA Archives, NY.

101. Philip Gefter, "John Szarkowski, Curator of Photography, Dies at 81," *New York Times*, July 9, 2007.

102. Newhall, *The History of Photography: From 1839 to the Present Day* (New York: Museum of Modern Art, 1949), 140, 143. Italics by author. Newhall's use of the passive voice to describe the state of aesthetic discourse is telling: of course, it was primarily MoMA that was exploring functional architecture, machine art, and the moving picture; this linguistic framing betrays MoMA's self-image as mere barometer for intellectual currents churning outside the museum, rather than a key player setting the terms.

103. Ibid.

262 NOTES TO PAGES 119–122

104. Sophie Hackett traces the intellectual currents around straight photography and the machine aesthetic in "Beaumont Newhall and a Machine: Exhibiting Photography at the Museum of Modern Art in 1937," translated by Marine Sangis, *Études photographiques* 23 (May 2009), https://journals.openedition.org/etudesphotographiques /2656.

105. See discussion of Atget and "simple documents" in chapter 1.

106. This is the number most frequently cited, most likely based on a c. 1968 circular from Abbott about her collection. It appears in Beaumont Newhall, "Berenice Abbott 1898–1991," *American Art* 6, no. 1 (Winter 1992): 111–13, among other citations. However, George Eastman House cites 5,000 original prints, http://notesonphotographs .org/index.php?title=Eug%C3%A8ne_Atget/Provenance_and_Significant_Collections.

107. Berenice Abbott, *The World of Atget* (New York: Horizon Press, 1964), x.

108. This was a decision she later regretted; see Hank O'Neal, *Berenice Abbott* (New York: Thames and Hudson, 2010), 7. Interestingly, Levy gave an entirely different report to Russell Lynes during his research for *Good Old Modern*. Levy claimed that Abbott sought out Atget at his suggestion and purchased the material on his behalf. Levy at that time was showing Surrealist artists and was one of the only galleries to consistently exhibit photography. Lynes, 329–330.

109. Berenice Abbott, ed., *Atget: Photographe de Paris*, preface Pierre Mac-Orlan (New York: E.Weyhe, 1930); Abbott, "Eugène Atget," *Creative Art* V (1929): 651–659; Abbott, "Eugène Atget; Forerunner of Modern Photography," pt. 1, *U.S. Camera* I (November 1940): 21–23, 48–49, 76; "Eugène Atget; Forerunner of Modern Photography," pt. 2, *U.S. Camera* I (December 1940), 68–71; Abbott, *New Guide to Better Photography*, rev. ed. (New York: Crown Publishers, 1956); Abbott, *20 Photographs by Eugène Atget*, portfolio with introduction (New York, 1956); Abbott, ed. and introd., *The World of Atget* (New York: Horizon Press, 1964).

110. Nesbit, *Atget's Seven Albums*, 7.

111. Abbott, "Eugène Atget: Forerunner of Modern Photography," *U.S. Camera* I (November 1940): 76.

112. Abbott, *The World of Atget*, viii.

113. Quoted in John Russell, "Atget," *New York Times Magazine*, September 13, 1981, 55–58.

114. Exhibition checklist notes nineteen prints, three scrapbooks, and an album. Matthew Brady is the only photographer with more prints, with twenty-one in total.

115. "Atget at the Museum of Modern Art," press release, November 1969.

116. This baldly commercial service was only possible at a particular historical juncture and would be discouraged today, as museums are expected to operate without the influence of market factors: there are troubling opportunities for speculation if patrons and curators collaborate on purchases (a problem that has been more acute in the past two decades, as the art market has soared to vertiginous heights). At mid-century, however, MoMA curators frequently encouraged the sale of contemporary works on view, mostly through casual correspondence with patrons. As an example,

NOTES TO PAGES 123–127

Dorothy Miller's papers related to the organization of her series of "Americans" shows, which showcased contemporary American artists between 1942 and 1963, are littered with assurances to artists that she thinks their works will sell and correspondence with interested collectors offering to help facilitate sales.

117. Jacob Deschin, "Museum Takes in $2,200 on Sale of Pictures," *New York Times*, October 30, 1960, X14.

118. Departmental questionnaire and responses, 1960, Art Lending Service and Art Advisory Service Records, I.C.3, MoMA Archives, NY.

119. See correspondence from Arthur M. Bullowa to John Szarkowski, 1963–1964, Art Lending Service and Art Advisory Service Records, I.C.4, MoMA Archives, NY. Note—unlike painting and sculpture, there were no rental fees for photography; the photographs seem to have been offered for outright purchase only.

120. Statistics, August 1965, Art Lending Service and Art Advisory Service Records, I.C.5, MoMA Archives, NY.

121. See Committee minutes from 4.23.68, 5.28.68, and 7.31.68, Art Lending Service and Art Advisory Service Records, I.C.6, MoMA Archives, NY.

122. MoMA, "Eugene Atget Archive," press release, September 29, 1968. (Once again, passive voice elides the active role of MoMA in defining the course of this "direction.")

123. "Contemporary Photographs by Obsolete Processes at Art Institute," exhibition, Art Institute of Chicago, 1967.

124. Ibid.

125. Brochure n.p., 1979, Art Lending Service and Art Advisory Service Records, I.C.8, MoMA Archives, NY.

126. Ibid.

127. Ibid.

128. "Atget Sales," c. 1979, Art Lending Service and Art Advisory Service Records, I.C.8, MoMA Archives, NY.

129. Andy Grundberg, "Photography: A 'Modern' Atget Portfolio," *Art in America* 67, no. 1 (January/February 1979): 42–43.

130. Grundberg goes on to endorse MoMA's aesthetic decision by comparing the MoMA portfolio to a contemporaneous printing in France in which the publisher used the most modern paper available in order to reveal more information in the prints than Atget's previous prints could produce. Though the latter was done in order to honor Atget's intent as a documentarian, Grundberg finds the prints lacking: "dull and lumpish, whereas the Modern's are airy, expressive, and convincing." Ibid., 49.

131. Krauss, "Photography's Discursive Spaces"; Nesbit, *Atget's Seven Albums*; and Wolfgang Brückle, "On Documentary Style: 'Anti-Graphic Photography' between the Wars," *History of Photography* 30, no. 1 (2006): 68–79.

132. Nesbit, *Atget's Seven Albums*, 81.

133. See notes 10, 11 in this chapter.

134. Lynes, *Good Old Modern*, 261.

135. Sekula, "Reading an Archive," 123.

136. Oral History Program, interview with Richard Tooke, 1991, 19. MoMA Archives, NY.

137. Kirstein, "Walker Evan's Photographs of Victorian Architecture."

CHAPTER 3

1. David Brooks, "Does Decision Making Matter?" *New York Times*, November 26, 2016, https://www.nytimes.com/2016/11/25/opinion/does-decision-making-matter.html.

2. Amanda Kill as told to Juno DeMelo, "I Breastfed an Adopted Baby for 7 Months," *New York Magazine*, October 7, 2016, https://www.thecut.com/2016/10/i-breastfed-an-adopted-baby-for-7-months.html.

3. As Susan Buck-Morss writes, "It was the Baroque poets who demonstrated to Benjamin that the 'failed material' of his own historical era could be 'elevated to the position of allegory.' What made this so valuable for a dialectical presentation of modernity was that allegory and myth were 'antithetical.' Indeed, allegory was the 'antidote' to myth, and precisely this was 'to be demonstrated' in the Pasagen-werk" (Susan Buck-Morss, *The Dialectics of Seeing: Walter Benjamin and the Arcades Project* [Cambridge, MA: MIT Press, 1991]), 164.

4. Please note that throughout this chapter, when referring to the agency, I will use H. Armstrong Roberts Company. The founder of the agency and the primary subject of this study is referred to as Roberts Sr., his son as Roberts Jr., and his grandson and current president as Roberts III.

5. Since Getty Images was founded in 1995 with the purchase of Tony Stone Images, they have steadily bought up major stock agencies. Significant acquisitions include the purchase of The Image Bank from Eastman Kodak in 1999, Visual Communications Group in 2000, and Jupiterimages in 2008. Corbis Corporation, founded by Bill Gates in 1995 with the purchase of the Bettmann Archive, was Getty's largest rival, acquiring agencies like The Stock Market in 2000, before the Visual China Group, a partner of Getty Images, acquired it in 2016.

6. Stock Images and Videos Market—Global Outlook and Forecast 2019–2024, September 2019, https://www.researchandmarkets.com/reports/4841565/stock-images-and-videos-market-global-outlook.

7. For the contemporary treatment of stock photographs as an Internet meme, see http://knowyourmeme.com/memes/stock-photography. For the Leanin.org/Getty partnership, see Claire Cain Miller, "LeanIn.org and Getty Aim to Change Women's Portrayal in Stock Photos," *New York Times*, February 10, 2014, B3. For startups, see Kate Knibbs, "Instastock Wants to Turn Your Selfies into a Business Model," *Digital Trends*, August 26, 2015, https://www.digitaltrends.com/social-media/is-instagram-changing-stock-photography-instastock/. For art exhibitions, see *Ordinary Pictures*, Walker Art Center, Minneapolis, MN, February 27–October 2, 2016.

8. Erwin Goffman, *Gender Advertisements* (New York: Harper & Row), 1979.

9. Anne Collier is known for her deadpan rephotography of commercial images. In a 2013 series, she shoots several spreads of stock photography selections under categories like "social issues" and "gestures." In *Unbranded: Reflections in Black Corporate America* (2005–2008), artist Hank Willis Thomas reveals the commodification of racial identity in commercial photography by stripping text and logos from decades of advertisements featuring Black models, highlighting the stereotypical representation.

10. Sarah Hartshorne, "I Was a Woman Laughing Alone with Salad, It's Really Not That Funny," *The Guardian*, March 5, 2014, https://www.theguardian.com/women -in-leadership/2014/mar/05/woman-laughing-alone-with-salad.

11. "The Gender Spectrum Collection: Stock Photos Beyond the Binary," https:// genderphotos.vice.com/, last modified January 21, 2020.

12. Paul Frosh, "Is Commercial Photography a Public Evil? Beyond the Critique of Stock Photography," in *Photography and Its Publics*, edited by Melissa Miles and Edward Welch (London: Bloomsbury, 2020), 188.

13. J. Abbott Miller, "Pictures for Rent," *Eye* 14, no. 4 (Autumn 1994), http://www .eyemagazine.com/feature/article/pictures-for-rent.

14. There are notable exceptions to this. Within the history of photography, Elspeth H. Brown explores the careers of early advertising photographers in the 1910s and 1920s, including Lejaren à Hiller, in the chapter "Rationalizing Consumption: Photography and Commercial Illustration," in *The Corporate Eye: Photography and the Rationalization of American Commercial Culture, 1884–1929* (Baltimore: John Hopkins University Press, 2005). Michele H. Bogart's exceptional study *Advertising, Artists, and the Borders of Art* (Chicago: University of Chicago Press, 1995) explores the field of commercial art from 1900–1950, capturing the emerging field of commercial advertising photography. Within media studies, in addition to Frosh, *The Image Factory*, see Frosh, "Rhetorics of the Overlooked: On the Communicative Modes of Stock Advertising Images," *Journal of Consumer Culture* 2, no. 2 (July 1, 2002): 171–196; Frosh, "Digital Technology and Stock Photography: And God Created Photoshop," in *Image Ethics in the Digital Age*, edited by Larry Gross et al. (Minneapolis: University of Minnesota Press, 2003); Frosh, "Beyond the Image Bank: Digital Commercial Photography," in *The Photographic Image in Digital Culture*, 2nd ed., edited by Martin Lister (Routledge: London, 2013), 131–148. Other media theoretical work on stock photography has appeared first in German. Estelle Blaschke, *Banking on Images: The Bettmann Archive and Corbis* (Leipzig: Spector Books, 2015), originally published in German, was translated in 2015. See also Diethard Krebs, Walter Uka, and Brigitte Walz-Richter, *Die Gleishschaltung der Bilder. Zur Geschichte der Pressefotografie 1930–1936* (Berlin: Froelich & Kaufmann, 1983); Matthias Bruhn, *Bildwirtschaft: Verwaltung und Verwertung der Sichtbarkeit* (Weimar: Verlag und Datenbank für Geisteswissenschaften, 2003).

15. Frosh, *The Image Factory*, 36.

16. Blaschke argues that the 1920s are an essential decade for the consolidation of a new type of conception of the image as an industrial product. For her study, she looks to the German example of Otto Bettmann, who amassed a library of

reproductions in Berlin by purchasing collections from other photographers or acquiring photographs of images held in public collections. He moved with this collection to the United States in 1935 and made a significant impact on the stock industry here. Corbis purchased his collection, the Bettmann Archive, in 1995. See Blaschke, *Banking on Images*.

17. A 1931 profile notes that branch offices operated in "principal cities in Europe" ("H. Armstrong Roberts: He Holds a Mirror," *The Home of Today* 3, no. 10 [Williams Oil-O-Matic Heating Corporation, May 1931]: 4).

18. H. Armstrong Roberts III in discussion with author, April 26, 2016.

19. Michael Twyman, *Printing 1770–1970: An Illustrated History of Its Development and Uses in England* (London: Eyre & Spottiswoode, 1970). As historian Neil Harris puts it, due to halftone printing, "The single generation of Americans living between 1885 and 1910 went through an experience of visual reorientation that had few earlier precedents." Neil Harris, "Iconography and Intellectual History: The Halftone Effect," in *Cultural Excursions: Marketing Appetites and Cultural Tastes in Modern America* (Chicago: University of Chicago, 1990), 307.

20. Mia Fineman, "Kodak and the Rise of Amateur Photography," *The Heilbrunn Timeline of Art History*, October 2004, http://www.metmuseum.org/toah/hd/kodk/hd_kodk.htm.

21. Form 272, Army Transport Service, August 10, 1902, in H. Armstrong Roberts Company Archives, Philadelphia, CA (unprocessed, hereafter cited at HARC Archive, PA). H. Armstrong Roberts III in discussion with author, April 26, 2016.

22. "Returns from 2500 Mile Ride in Mexico," c. 1907; "Writer and Artists on 10,000 Mile Walk," *Philadelphia Evening Post*, 1908. Newspaper clippings located in HARC Archive, PA.

23. This biographical fact and the others in this section are drawn from the following biographical pieces published about Roberts Sr.: "The Pictures and the Man Who Made Them," *Studio Light: A Magazine of Information about the Profession*, Eastman Kodak, November 1924, 10–16; "H. Armstrong Roberts: He Holds a Mirror," *The Home of Today* 3, no. 10 (Williams Oil-O-Matic Heating Corporation, May 1931): 2–5; Frank Cunningham, "H. Armstrong Roberts: Specialist in 'Stock Photographs,' Part 1," *The Commercial Photographer* 18, no. 11 (August 1943): 351–356; and Frank Cunningham, "H. Armstrong Roberts: Specialist in 'Stock Photographs,' Part 2," *The Commercial Photographer* 18, no. 12 (September 1943): 387–390.

24. Hannah Higgins, *The Grid Book* (Cambridge, MA: MIT Press, 2009), 134.

25. H. Armstrong Roberts III in discussion with author, April 26, 2016.

26. Kate Peters, "Collector's Pictures Cover the World," c. 1940s. Newspaper clipping located in HARC Archive, PA.

27. Brown, *The Corporate Eye*, 208.

28. H. Armstrong Roberts III in discussion with author, June 17, 2015.

29. See Bogart, *Advertising, Artists*.

NOTES TO PAGES 146–157

30. See Daniel Pope, *Making of Modern Advertising* (New York: Basic Books, 1983), 139–40.

31. At H. Armstrong Roberts Company, they have a specific term for this usage for their licensing agreements, deemed "Artist Reference."

32. Bogart, *Advertising, Artists*, 183.

33. See Vicki Goldberg, *Margaret Bourke-White: A Biography* (New York: HarperCollins, 1986).

34. Bogart, *Advertising, Artists*, 171.

35. "The Pictures and the Man Who Made Them," *Studio Light: A Magazine of Information about the Profession*, Eastman Kodak, November 1924, 10–16; "H. Armstrong Roberts: He Holds a Mirror," *The Home of Today* 3, no. 10 (Williams Oil-O-Matic Heating Corporation, May 1931): 2–5.

36. "The Pictures and the Man Who Made Them," 10.

37. "H. Armstrong Roberts: He Holds a Mirror," 4.

38. Text from advertisement for *Life* that ran in December 1936 issue of *Fortune*.

39. Quoted in Loudon Wainwright Jr., *The Great American Magazine: An Inside History of Life* (New York: Knopf, 1986), 94.

40. Goldberg, *Margaret Bourke-White*, 98–99.

41. From the original prospectus of *Life*, excerpted in "Life Reports to Its Readers with Great Thanks," *Life*, July 11, 1938, n.p.

42. H. Armstrong Roberts III, in conversation with author, April 26, 2016.

43. Markus Krajewski, *Paper Machines: About Cards & Catalogues 1548–1929* (Cambridge, MA: The MIT Press, 2011).

44. Krajewski, *Paper Machines*, 137.

45. Mattern, see note 40 in Introduction.

46. Robertson, *The Filing Cabinet*, 105.

47. Ibid.

48. H. Armstrong Roberts III, in conversation with the author, June 17, 2015.

49. Robertson, *The Filing Cabinet*, 6.

50. Krauss, "Photography's Discursive Spaces"; Tagg, "The Archiving Machine."

51. Lev Manovich, "Database as a Symbolic Form," *Convergence: The Journal of Research into New Media Technologies* 5, no. 2 (Summer 1999): 80–99.

52. Wolfgang Ernst, *Digital Memory and the Archive* (Minneapolis: University of Minnesota Press, 2012).

53. This is discussed in detail in Markus Krajewski, "Paper as Passion: Niklas Luhmann and His Card Index," in *"Raw Data" Is an Oxymoron*, edited by Lisa Gitelman (Cambridge, MA: MIT Press, 2013), 103–120.

54. H. Armstrong Roberts III, in conversation with author, June 17, 2015.

55. Shannon Mattern, "The Spectacle of Data: A Century of Fairs, Fiches, and Fantasies," *Theory, Culture & Society* 37, nos. 7–8 (2020), https://doi.org/10.1177/026327642095805.

56. Roberta Groves, in conversation with author, May 23, 2016. Addresses confirmed by New York City Telephone Directories, 1979.

57. Advertisement in HARC Archive, PA.

58. H. Armstrong Roberts III, in conversation with author, August 21, 2017.

59. Ibid.

60. Mitchell, *What Do Pictures Want?*

61. Igor Kopytoff, "The Cultural Biography of Things: Commoditization as Process," in *The Social Life of Things*, edited by Arjun Appadurai (Philadelphia: University of Pennsylvania Press, 1986), 74.

62. Arthur C. Martinez, *The Hard Road to the Softer Side: Lessons from the Transformation of Sears* (New York: Crown Business, 2001), 39. See also Boris Emmet and John E. Jeuck, *Catalogues and Counters: A History of Sears, Roebuck and Company* (Chicago: University of Chicago Press, 1950).

63. Matthew Hockenberry, "The Supply House: Catalogues and Commerce," *Thresholds* 49 (2021): 43.

64. Alain Pottage and Brad Sherman, *Figures of Invention: A History of Modern Patent Law* (Oxford: Oxford University Press, 2010), 37. Thank you to Matthew Hockenberry for pointing me toward this analysis.

65. The first catalogue that Roberts III has identified is from 1930 and consisted of an embossed, custom-made file folder that would hold several sheets printed as brochures, with a selection of images surrounding a marketing blurb.

66. Roberts III, in discussion with author, August 21, 2017.

67. Catalogue dated July 28, 1939, HARC Archive, PA.

68. 1897 Sears catalogue, quoted in Martinez, 39.

69. Pictures bound "for ink," as photography curator John Szarkowski has put it, tend to produce a certain aesthetic in advance: "Each method of transmitting information has its own structural prejudices, its own favorite kinds of information, which are those it describes most easily and most precisely" (John Szarkowski, "Photographs in Ink," *MoMA Bulletin* 2, no. 3 [Winter 1990]: 9).

70. "The Pictures and the Man Who Made Them." There is no byline for the article, and according to the speculation of H. Armstrong Roberts III, in conversation with author, April 26, 2016, Roberts might have written the copy himself. The article discusses Roberts Sr.'s "three months photographing winter sports and snow scenes, traveling on skis, snowshoes, and by dog sled," and how one group of photos was the result of "a two months trip by horse and canoe to provide pictures for folders and booklets" ("Pictures and the Man Who Made Them," 14).

71. "The Pictures and the Man Who Made Them," 12.

72. Ibid.

NOTES TO PAGES 164–173

73. Pay stubs dated 1930 show Doris Day on the payroll, HARC Archives, PA.

74. Roberts III, in discussion with author, April 25, 2016.

75. Census of Telephones, 1922, Department of Commerce, Bureau of the Census.

76. Juliann Sivulka, *Soap, Sex, and Cigarettes: A Cultural History of American Advertising* (Belmont, CA: Wadsworth, 2011), 64.

77. T. J. Jackson Lears, "From Salvation to Self-Realization: Advertising and the Therapeutic Roots of the Consumer Culture, 1880–1930," in *The Culture of Consumption: Critical Essays in American History*, edited by Lears and Richard Wightman Fox (New York: Pantheon Books, 1983).

78. Roberts III, in discussion with author, April 27, 2016.

79. Frosh, *The Image Factory*, 84.

80. "Pictures and the Man Who Made Them," 12.

81. A 1947 catalogue promises: "Real people populate the files of H. Armstrong Roberts. This is one of the reasons why art buyers in such large numbers prefer our work. They know that the likable, believable people who appear in Roberts photographs provide an important note of realism which pays off in reader interest." Catalogue in HARC Archives, PA.

82. This argument began as early as 1913, when Eastman Kodak produced a booklet encouraging commercial photographers to take up advertising photography (previously a sliver of the commercial photography trade) (Brown, *The Corporate Eye*, 171).

83. *Printer's Ink*, May 16, 1929, 137. Quoted in Bogart, *Advertising, Artists*, 198.

84. "The Camera in Advertising," *Abel's Photographic Weekly*, May 13, 1922, 526. Quoted in Bogart, *Advertising, Artists*, 197.

85. Roland Marchand, *Advertising the American Dream: Making Way for Modernity 1920–1940* (Berkeley: University of California Press, 1985), 150.

86. "Commercial Illustrations with an Uncommercial Atmosphere," *Printer's Ink*, August 17, 1922, 49.

87. See André Bazin, "The Ontology of the Photographic Image," translated by Hugh Gray, *Film Quarterly* 13, no. 4 (Summer 1960); Susan Sontag, *On Photography* (New York: Rosetta Books, 2005 [1973]); and Roland Barthes, *Camera Lucida* (New York: Farrar, Straus, Giroux, 1980). For a contemporary reckoning with indexicality, see Mary Anne Doane, ed., "Indexicality: Trace and Sign," a special issue of *Differences: A Journal of Feminist Cultural Studies* 18, no. 1 (Spring 2007).

88. "The Pictures and the Man Who Made Them," 10.

89. Paul Strand, "Photography," *Seven Arts* 2, 524–525 (Aug. 1917), reprinted in *Camera Work* 49–50 (June 1917), 3.

90. Ibid.

91. Elspeth H. Brown has argued that the success of pictorialist photographer Lejaren à Hiller as an advertising photographer in the late teens demonstrates that the embrace of narrative in photography happened earlier than acknowledged in

other accounts of this period (such as Bogart, *Advertising, Artists*). I see Hiller as a unique example of a photographer who was hired for a particular aesthetic to produce commissioned work, as opposed to Roberts who made a career on building a library of abstracted concepts and subjects . . . or other commercial photographers seeking a career in advertising photography.

92. Bogart, *Advertising, Artists*, 197–98.

93. Frank Cunningham, "H. Armstrong Roberts, Specialist in 'Stock Photographs,'" *Commercial Photographer* XVIII, no. 11 (August 1943): 352.

94. In each issue of *Roughs*, a few dozen images on a particular topic are spread out over a folded photostatted broadside, with negative numbers listed. Clients could then mail in, phone in, or send telegraph orders for the specific image they saw in the mailer or might request to see similar images on the theme.

95. In general, subcategories were created for the broad category headings in an unscientific way—when the number of prints warranted multiple boxes. Images of hands were such a large subcategory of the Symbolic file that Symbolic-No-Hands became its own subject subheading. Another large subheading was Symbolic-Currency (H. Armstrong Roberts III, interview with the author, August 21, 2017).

96. John Frow, *Genre* (New York: Routledge, 2006), 14.

97. Janet Giltrow, "Meta-Genre," in *The Rhetoric and Ideology of Genre: Strategies for Stability and Change*, edited by Richard Coe, Lorelai Lingard, and Tatiana Teslenko (Cresskill, NJ: Hampton Press, 2002), 203. Giltrow is talking specifically about "meta-genre" here, the way that we talk about genre as that which shapes discourse.

98. Walter Benjamin, *The Origin of German Tragic Drama*, translated by John Osborne (New York: Verso, 1998), 175. As Benjamin writes, "If the 'power of the framework,' as it has appropriately been called, is really one of the essential features which distinguish the ancient attitude from the modern, in which the infinite and varied range of feelings or situations seems to be self-evident, then this power cannot be separated from tragedy itself" (Benjamin, *The Origin of German Tragic Drama*, 115). Susan Buck-Morss has written the critical theory of the dialectical image and interpretation of Benjamin's treatment in *The Dialectics of Seeing*.

99. Craig Owens, "The Allegorical Impulse: Toward a Theory of Postmodernism" (*October* 12 [Spring 1980]: 67–86). The Benjamin quote that opened this chapter was also used as the epigraph of this Owens article (and later used as an epigraph to Sekula, "Reading an Archive"). These are intentional references. The concept of allegory and Owens's gloss on Benjamin are an essential aspect of my interpretation of the genre of the stock image.

100. Owens, "The Allegorical Impulse," 72, 68.

101. Bainard Cowan, "Walter Benjamin's Theory of Allegory," *New German Critique* no. 22, Special Issue on Modernism (Winter 1981): 110.

102. Roland Barthes, *Mythologies* (New York: Macmillan, 1972), 240.

103. Buck-Morss, *The Dialectics of Seeing*, 164.

104. Jacques Derrida, "The Law of Genre," translated by Avital Ronnell, *Critical Inquiry* 7, no. 1 (Autumn 1980): 55–81.

105. Ulrich Keller, "Photojournalism around 1900: The Institutionalization of a Mass Medium," in *Shadow and Substance: Essays on the History of Photography in Honor of Heinz K. Henisch*, edited by Kathleen Collins (Bloomfield Hills, IN: Amorphous Press, 1990), 283–303.

106. One competitor, Harold Lambert, worked for H. Armstrong Roberts as a staff photographer in the 1930s before starting his own business roughly in 1940. The Lambert Studios catalogues he produced follow the same layout and thematic organization, suggesting that he adopted Roberts's catalogue design and negative numbering system.

107. Susan Sontag, *On Photography* (New York: Farrar, Straus & Giroux, 1977), 4.

108. Frosh makes a similar argument, that the intentional and indexical meanings of photography are inverted with stock photography. See Frosh, *The Image Factory*, 63.

109. Cunningham, "H. Armstrong Roberts, Specialist in 'Stock Photographs,'" 351.

110. Roberts III, in conversation with author, April 26, 2016.

111. Roberts III, in conversation with author, June 24, 2020.

112. Safiya Noble, *Algorithms of Oppression* (New York: New York University Press, 2018). Quote from Google from Ben Guarino, "Google faulted for racial bias in image search results for black teenagers," *Washington Post*, June 16, 2016.

113. See Timnit Gebru and Joy Buolamwini, "Gender Shades: Intersectional Accuracy Disparities in Commercial Gender Classification," Proceedings of the 1st Conference on Fairness, Accountability and Transparency, *Proceedings of Machine Learning Research* 81 (2018): 77–91; Kate Crawford and Trevor Paglen, "Excavating AI: The Politics of Images in Machine Learning Training Sets," www.excavating.ai, among others.

114. See chap. 4 of Frosh, *The Image Factory*.

115. Roberts III insists that this is a function of their clients' requests rather than the decision of the photographer, citing their depth of their representation of Black models throughout subjects, previously gathered under the "Negro" file. In 1979, when he took over the company, he integrated the contents of that file with relevant subjects. Roberts III, in discussion with author, June 24, 2020.

116. Barthes, *Camera Lucida*, 26.

117. Ibid.

118. Richard Steedman, in conversation with author, July 12, 2015.

CHAPTER 4

1. Romana Javitz, "Words on Pictures. A Speech to the Convention of the Massachusetts Library Association, Boston, Massachusetts, January 28, 1943," *The Massachusetts Library Association Bulletin* 33 (1943): 19. Italics added.

2. Siva Vaidhyanathan, *The Googlization of Everything (And Why We Should Worry)* (Berkeley: University of California Press, 2012), 44.

3. William F. Birdsall, "A Political Economy of Librarianship?" *Progressive Librarian* 18 (Summer 2001): 1. Birdsall first discussed the ideology of information technology in "The Internet and the Ideology of Information Technology: The Inter-Net: Transforming Our Society Now, INET 96," in Proceedings of the Annual Meeting of the Internet Society, June 25–28, 1996, Montreal, http://www.crim.ca/inet96/papers/e3/e3_2.htm.

4. Daniel Greene, *Technology, Inequality, and the Political Economy of Hope* (Cambridge, MA: MIT Press, 2021).

5. Brandy Zadrozny, "These Disinformation Researchers Saw the Coronavirus 'Infodemic' Coming," *NBC News*, May 14, 2020, https://www.nbcnews.com/tech/social-media/these-disinformation-researchers-saw-coronavirus-infodemic-coming-n1206911.

6. Noble, *Algorithms of Oppression*, 152.

7. Birdsall, "A Political Economy."

8. Steve Morgenstern, "Scanners: Not a Black and White Choice Anymore," *Home Office Computing* 10, no. 2 (1992): 70.

9. See Geoffrey Batchen, "Phantasm: Digital Imaging and the Death of Photography," in Metamorphoses: Photography in the Electronic Age, *Aperture* no. 136 (Summer 1994): 46–51; Batchen, "Burning with Desire: The Life and Death of Photography," *Afterimage* 17, no. 6 (January 1990): 8–11; Anne-Marie Willis, "Digitisation and the Living Death of Photography," in *Culture, Technology and Creativity in the Late Twentieth Century*, edited by Philip Hayward (London: John Libbey, 1990), 197–208; David Tomas, "From the Photograph to Postphotographic Practice: Toward a Postoptical Ecology of the Eye," *SubStance* 17, no. 1 (1988): 59–68; and Fred Ritchin, *In Our Own Image: The Coming Revolution in Photography: How Computer Technology Is Changing Our View of the World* (New York: Aperture, 1990).

10. Ritchin, *In Our Own Image*, xii.

11. Daniel Rubinstein and Katrina Sluis, "Concerning the Undecidability of the Digital Image," *Photographies* 6, no. 1 (2013): 151–158.

12. Kevin Robins, *Into the Image: Culture and Politics in the Field of Vision* (London: Routledge, 1996), 156.

13. Timothy Druckrey, "L'Amour Faux," in *Digital Photography: Captured Images, Volatile Memory, New Montage*, edited by Marnie Gillett and Jim Pomeroy (San Francisco: Camerawork, 1988), 4.

14. See Tomas, "From the Photograph," 1988; Ritchin, *In Our Own Image*, 1990; and David D. Perlmutter, "The Internet: Big Pictures and Interactors," in *Image Ethics in the Digital Age*, edited by Larry Gross, John Stuart Katz, and Jay Ruby (Minneapolis: University of Minnesota Press, 2003), 1–25.

15. Daniel Rubinstein and Katrina Sluis, "The Digital Image in Photographic Culture: Algorithmic Photography and the Crisis of Representation," in Lister, *The Photographic Image* 28, no. 20.

16. Ibid., 31.

NOTES TO PAGES 193–201 273

17. See Gross et al., *Image Ethics in the Digital Age*, and Thomas H. Wheeler, *Phototruth or Photofiction? Ethics and Media Imagery in the Digital Age* (London: Routledge, 2002). For discussion of a landmark lawsuit challenging the legality of using stock photography to create digital collages, see Akiko Busch, "Stock and Security: FPG vs. Newsday," *Print*, November/December 1995, 48.

18. Roberts III, in discussion with author, February 23, 2018.

19. Doug Dawirs, in discussion with author, September 19, 2017.

20. Ibid.

21. Dawirs attested to the fact that he had not heard any company refer to "digital asset management" before he started using the term (September 19, 2017). Reviewing trade literature, digital asset management is a legible commercial area of activity by 1995 but does not appear widely before then. (A 2002 article in *Macworld* notes that digital asset management "has become something of a buzzword in publishing circles over the last couple of years" [Bruce Fraser, "Digital-Asset Managers," *Macworld* 19, no. 7 (July 2002): 28], and the earliest article located was 1995 ["Hollywood, Silicon Valley Unite for Animated World," *Multimedia Week* (August 21, 1995): 1].)

22. "What Is Asset Management?" *ISO Standards for Asset Management*, accessed October 3, 2017, http://www.assetmanagementstandards.com/.

23. Jasmine E. Burns, "Information as Capital," *VRA Bulletin* 45, no. 1 (October 2018): 7.

24. See JoAnne Yates, *Structuring the Information Age: Life Insurance and Technology in the Twentieth Century* (Baltimore: John Hopkins University Press, 2009).

25. See Uniloc USA, Inc. et al v. DREAMSTIME.COM, LLC. Testimony was provided to Ellen Boughn, who served as an expert witness on early online practices for the attorneys.

26. Roberts III, in discussion with author, May 23, 2016.

27. Roberts III, in discussion with author, June 24, 2020.

28. Roberts III, in discussion with author, August 15, 2016.

29. Yates, *Structuring the Information Age*, 5, 2.

30. Nanna Bonde Thylstrup, *The Politics of Mass Digitization* (Cambridge, MA: MIT Press, 2019), 3.

31. Ibid., 5.

32. Roberts III, in discussion with author, August 15, 2016.

33. Roberts III, in discussion with author, February 23, 2018.

34. Retrofile was a joint venture between Xenofile Images Inc. and H. Armstrong Roberts Company marketing vintage stock photography from the H. Armstrong Roberts collection. The sale to Getty included the Retrofile brand name and trademark, the entire Black Box collection of 10,000 retro stock images that had been made available on Retrofile.com, and two thousand additional stock images from the H. Armstrong Roberts collection, for $3 million. Jim Pickerell, "Retrofile Sold to Getty," July 29,

2005, *Selling Stock*, https://www.selling-stock.com/PrintArticle.aspx?id=5d0b9dd1-b9fe-4bc3-9d0e-58286680281f.

35. Jim Zuckerman, *Shooting & Selling Your Photos* (Cincinnati, OH: Writer's Digest Books, 2003), 98.

36. Jim Pickerell, "Size of Market for Stock," *Selling Stock*, November 31, 1996, http://www.selling-stock.com/Article/size-of-market-for-stock.

37. Zuckerman, *Shooting & Selling*, 98.

38. Thomas Grischowsky, in discussion with author, March 21, 2016. Grischowsky was the archives specialist at the time of the interview and retired later that year.

39. Erik Landsberg, in discussion with author, September 21, 2017.

40. Suzanne Muchnic, "Technoarts in Cyberspace," *Los Angeles Times*, April 3, 1994, 4.

41. Ibid.

42. The first digital cameras used were digital scanback cameras—either Phase One or Better Light, in Landsberg's recollection. Scanback cameras function like nineteenth-century large-format cameras, in that an image is captured along a plane positioned at the back of a view camera with bellows. The scanback similarly has bellows with a large receptive surface at the back, but the difference is that the scanback captures a linear array of pixels row by row as it moves across the image plane, meaning each shot could take minutes to capture.

43. Landsberg was careful to mention that they did photograph black and white photography in color and that preserving subtle tonal differentiations in gelatin silver prints was important.

44. At the outset, these were burned onto Kodak Photo Discs, a proprietary format that became unsupported. Those early CDs were migrated to a more modern and nonproprietary format several years later. Landsberg, September 21, 2017.

45. See "About" page, StokeImaging.com, http://stokesimaging.com/about.html, accessed June 21, 2021.

46. Anthony Troncale, in discussion with author, December 17, 2020. Also confirmed by Nancy Melin Nelson and John Gabriel, "Searching, Retrieving, and Failing within Our Deadlines," *Information Today* 10, no. 11 (December 1993): 15.

47. Troncale, in discussion with author, December 17, 2020.

48. Ibid.

49. Julie van Haaften, "Digital Projects at the NYPL: Historical Overview," PowerPoint presentation, September 2005.

50. Dawirs, in conversation with the author, September 19, 2017.

51. Jim Benson, "Getting the Picture," *Macworld* 10, no. 10 (October 1993): 130.

52. Robertson, *The Filing Cabinet*, 6.

53. See Robertson, *The Filing Cabinet*, chap. 5.

54. "Technology Case Study: DAM+TMS Art Database Integration," *Netx.net*, 2010, accessed April 20, 2016, http://netx.net/moma-presents-netxposure-dam-tms-integration-2/.

NOTES TO PAGES 209–219

55. National Research Council, "The Digital Dilemma: Intellectual Property in the Information Age," *Ohio State Law Journal* 62, no. 2 (2001): 956.

56. Johanna Drucker, "Digital Ontologies: The Ideality of Form in/and Code Storage: Or: Can Graphesis Challenge Mathesis?" *Leonardo* 34, no. 2 (2001): 144.

57. Oral History Program, interview with Pearl Moeller, 1991, 48. MoMA Archives, NY.

58. Theodore Feder, in discussion with author, March 21, 2016.

59. Ibid.

60. Erik Landsberg, in discussion with author, September 21, 2017.

61. See Ted Striphas, *The Late Age of Print: Everyday Book Culture from Consumerism to Control* (New York: Columbia University Press, 2011), for parallel argument about the publishing industry.

62. van Haaften, "Digital Projects at the NYPL."

63. Richard Gartner, *Metadata: Shaping Knowledge from Antiquity to the Semantic Web* (New York: Springer, 2016), 2.

64. Ling-yuh W. (Miko) Pattie, "Henriette Davidson Avram, the Great Legacy," *Cataloging & Classification Quarterly* 25 (1998): 2–3, 67–81.

65. Pattie, "Henriette Davidson Avram," 68.

66. Lucia J. Rather and Beacher Wiggins, "Mother Avram's Remarkable Contribution," *American Libraries* 20, no. 9 (October 1989): 860.

67. Gartner, *Metadata*, 29.

68. MARC became American National Standards Institute (ANSI) standard in 1971 and an International Standards Organization (ISO) standard in 1973. Rather and Wiggins, "Mother Avram's Remarkable Contribution," 857.

69. Daniel Rubinstein and Katrina Sluis, "Notes of the Margins of Metadata: Concerning the Undecidability of the Digital Image," *Photographies* 6, no. 1 (2013): 152.

70. Roberts III, in discussion with author, June 17, 2015.

71. Rubinstein and Sluis, "The Digital Image in Photographic Culture."

72. Rubinstein and Sluis, "Notes on the Margins of Metadata," 153.

73. See http://digital.nypl.org/mmpco/browse.cfm and Lucia S. Chen, "From Picture Collection to Picture Collection Online," *Collection Building* 23, no. 3 (2004): 139–146.

74. Chen, "From Picture Collection to Picture Collection Online," 144.

75. Raymond Khan, in discussion with author, August 5, 2015. Italics added.

76. New York Public Library, "Report to the Digital Library Foundation," April 2005.

77. Susan Chute, in discussion with author, July 25, 2015.

78. Nina Lager Vestberg, "The Photographic Image in Digital Archives," in *The Photographic Image in Digital Culture*, edited by Martin Lister (London: Routledge, 2013), 122.

79. Jim Pickerell, "Getty & PhotoDisc Merge" *Selling Stock*, September 24, 1997, https://www.selling-stock.com/Article/getty-photodisc-merge.

80. Jim Pickerell, "Impact of Major Agency Consolidation," *Selling Stock*, January 6, 1999, https://www.selling-stock.com/Article/impact-of-major-agency-consolidation. Since Getty Images was founded in 1995 with the purchase of Tony Stone Images, they have steadily bought up major stock agencies. Significant acquisitions include the purchase of the Image Bank from Eastman Kodak in 1999, Visual Communications Group in 2000, and Jupiterimages in 2008. Corbis Corporation, founded by Bill Gates in 1995 with the purchase of the Bettmann Archive, was Getty's largest rival, acquiring agencies like the Stock Market in 2000, before the Visual China Group, a partner of Getty Images, acquired Corbis in 2016.

81. As of August 16, 2016: AKG-Images.co.uk, Alamy, London, AMP Photos, Netherlands, AuroraPhotos.com, Diomedia, Everett Collection, Fotosearch, Glass House Images, ImageWorks, Interfoto.de, Mary Evans Picture Library, London, Masterfile, Toronto, Mauritius-images.com, Science Source, Manhattan, Superstock, TopFoto, Getty.

82. Roberta Groves, in discussion with author, August 16, 2016.

83. Roberts III, in discussion with author, August 15, 2016.

84. See Robert Darnton, "Library, Books, and the Digital Future," in *Libraries and Archives in the Digital Age*, edited by Susan L. Mizruchi (London: Palgrave MacMillan, 2020), 13–26. On Google Books, see Vaidhyanathan, *The Googlization of Everything*.

85. Trevor Paglen, "Invisible Images (Your Pictures Are Looking at You)," *The New Inquiry*, December 8, 2016, https://thenewinquiry.com/invisible-images-your-pictures-are-looking-at-you/.

86. Rubinstein and Sluis, "Notes of the Margins of Metadata," 151–2.

87. Troncale, in discussion with author, December 17, 2020.

88. "2021 IIF Annual Conference," June 22–24, 2021. Online. Program available at https://iiif.io/event/2021/annual_conference/#program-committee, accessed July 20, 2021.

89. Fiona Romeo, "Thousands of Exhausted Things, or Why We Dedicated MoMA's Collection Data to the Public Domain," *Medium.com*, July 27, 2015, https://medium.com/digital-moma/thousands-of-exhausted-things-or-why-we-dedicated-moma-s-collection-data-to-the-public-domain-7e0a7165e99.

90. Ibid.

91. For more information, see http://www.ipnstock.com.

92. "Frequently Asked Questions," *Openglam*.org, accessed December 1, 2017, https://openglam.org/faq/.

93. "Cut to Swipe," exhibition description, https://www.moma.org/calendar/exhibitions/1466.

94. Roberts III, in discussion with author, August 2, 2022.

95. The topic was discussed on a panel at the 2017 Digital Media Licensing Association conference, with representatives from the companies ImageProtect, COPYTRACK, and ImageRights.

96. Julie Leibach, "The New York Library has just released a treasure trove of incredible archive images to the Internet," *Public Radio International*, January 14, 2016, https://www.pri.org/stories/2016-01-14/new-york-library-has-just-released-treasure -trove-incredible-archive-images.

97. Grischowsky, in discussion with author, March 21, 2016.

98. Arthur Lubow, "The Treasures in the Stacks," *New York Times*, August 4, 2021, section C, 1.

99. Ibid.

100. See Greene, *The Promise of Access*.

101. "Audio Tape Transcriptions—Javitz Class at Pratt[?] n.d.," Picture Collection Records, 225, 227.

102. Charles H. Gibbs-Smith, "The Hulton Picture Post Library," *Journal of Documentation* 6, no. 1 (1950): 14.

CODA

1. Farhad Manjoo, "Welcome to the Post-Text Future," *New York Times*, February 14, 2018, https://www.nytimes.com/interactive/2018/02/09/technology/the-rise-of-a -visual-internet.html; Romana Javitz, "Organization of Still Pictures as Documents," n.d., box 3, folder 8, Picture Collection Records.

2. Brian Feldman, "Every Popular Image Is a Meme Now," *New York Magazine*, February 13, 2018, http://nymag.com/selectall/2018/02/obamas-presidential-portrait -looks-like-homer-simpson-gif.html.

3. Walter Benjamin, "On the Concept of History," translated by Harry Zohn, in *Walter Benjamin, Selected Writings, Vol. 4: 1938–1940* (Cambridge, MA: Harvard University Press, 2003), 392–93.

4. Quaytman details the sequence of events in "Engrave" in חקק, *Chapter 29* (New York: Miguel Abreu Gallery, 2015), 31–41.

5. Ibid., 39.

6. Mark Godfrey, "Angels, Boulders, and Tongues: *Haqqaq, Chapter 29*," in חקק, *Chapter 29*.

7. See Andrew Pettegree, *Brand Luther: How an Unheralded Monk Turned His Small Town into a Center of Publishing, Made Himself the Most Famous Man in Europe—and Started the Protestant Reformation* (New York: Penguin Press, 2015).

8. Stephen Bann, *Distinguished Images: Prints in the Visual Economy of 19th Century France* (New Haven, CT: Yale University Press, 2013).

9. Benjamin, "The Work of Art in the Age of Its Technological Reproducibility."

BIBLIOGRAPHY

INTERVIEWS

Carlson, Eric Timothy. Interview by author. October 3, 2017.

Chute, Susan. Interview by author. July 25, 2015.

Dawirs, Doug. Interview by author. September 19, 2017.

Donohue, Deirdre. Interview by author. October 4, 2017.

Duquette, Anita. Interview by author. January 14, 2014.

Feder, Theodore. Interview by author. March 21, 2016.

Glenar, Penny. Interview by author. August 5, 2015.

Groves, Roberta. Interview by author. May 23, 2016.

Groves, Roberta. Interview by author. August 16, 2017.

Grischowsky, Tom. Interview by author. March 21, 2016.

Khan, Raymond. Interview by author. August 5, 2015.

Landsberg, Erik. Interview by author. September 21, 2017.

Parrott, Billy. Interview by author. August 5, 2015.

Roberts III, H. Armstrong. Interview by author. June 17, 2015.

Roberts III, H. Armstrong. Interview by author. April 23, 2016.

Roberts III, H. Armstrong. Interview by author. August 21, 2017.

Roberts III, H. Armstrong. Interview by author. February 23, 2018.

Roberts III, H. Armstrong. Interview by author. June 24, 2020.

Steedman, Richard. Interview by author. July 12, 2015.

Troncale, Anthony. Interview by author. December 17, 2020.

Vissers, Jay. Interview by author. April 23, 2014.

Vissers, Jay, and Glenar, Penny. Interview by author. August 5, 2015.

ARCHIVES

H. Armstrong Roberts Archive, Philadelphia, PA.

Museum of Modern Art Archives, New York.

Picture Collection Records 1896–1999. The New York Public Library. Manuscripts and Archives Division.

BIBLIOGRAPHY

Abbott, Berenice. "Eugène Atget." *Creative Art* V (1929): 651–659.

Abbott, Berenice, ed. *Atget: Photographe de Paris*. New York: E. Weyhe, 1930.

Abbott, Berenice. "Eugène Atget; Forerunner of Modern Photography." *U.S. Camera* I (November 1940): 21–23, 48–49.

Abbott, Berenice. *New Guide to Better Photography*, revised edition. New York: Crown Publishers, 1956.

Abbott, Berenice. *20 Photographs by Eugène Atget*. New York, 1956.

Abbott, Berenice. *The World of Atget*. New York: Horizon Press, 1964.

The Academy. Untitled, no. 1449. February 10, 1900, 117. Reprint from *Scribner's*. February 1900.

Affron, Matthew, and Sylvie Ramond, eds. *Joseph Cornell and Surrealism*. Charlottesville, CA: Fralin Museum of Art, 2015.

Antonini, Anna Maria, Sara Chiesa, and Dante Bartoli. "Archeowiki: When Open-Source Strategies Attract Visitors' Presence in Museums. A project for the Enhancement of Archaeological Heritage in Lombardy." In *Museums and the Web 2013*, edited by N. Proctor and R. Cherry. Silver Spring, MD: Museums and the Web, published May 31, 2014. Consulted October 19, 2015.

Araeen, Rasheed. "From Primitivism to Ethnic Arts." *Third Text* 1 (1987): 6–25.

BIBLIOGRAPHY

Archives of American Art. "Oral History," interview with Walker Evans, October 13–December 23, 1971. Smithsonian Institution.

Bair, Nadya. *The Decisive Network: Magnum Photos and the Postwar Image Market.* Berkeley, CA: UC Press, 2020.

Bann, Stephen. *Distinguished Images: Prints in the Visual Economy of 19th Century France.* New Haven, CT: Yale University Press, 2013.

Bärnighausen, Julia, Costanza Caraffa, Stefanie Klamm, Franka Schneider, and Petra Wodtke, eds. *Photo-Objects: On the Materiality of Photographs and Photo-Archives in the Humanities and Science.* Berlin: MaxPlanckGesellschaft zur Förderung der Wissenschaften, 2019.

Barthes, Roland. *Mythologies.* New York: Macmillan, 1972.

Barthes, Roland. *Camera Lucida.* New York: Farrar, Straus, Giroux, 1980.

Batchen, Geoffrey. "Burning with Desire: The Life and Death of Photography." *Afterimage* 17, no. 6 (January 1990): 8–11.

Batchen, Geoffrey. "Phantasm: Digital Imaging and the Death of Photography in Metamorphoses: Photography in the Electronic Age." *Aperture* 136 (Summer 1994): 46–51.

Bazin, André. "The Ontology of the Photographic Image." Translated by Hugh Gray. *Film Quarterly* 13, no. 4 (Summer 1960).

Benjamin, Walter. "Unpacking My Library." *Illuminations.* Translated by Harry Zohn. New York: Schocken Books, 1969.

Benjamin, Walter. *The Origin of German Tragic Drama.* Translated by John Osborne. New York: Verso, 1998.

Benjamin, Walter. "Little History of Photography." In *Walter Benjamin: Selected Writings Volume 2, Part 2,* edited by Howard Eiland, Michael W. Jennings, and Gary Smith, 507–530. Cambridge, MA: Harvard University Press, 1999.

Benjamin, Walter. "The Work of Art in the Age of Technological Reproducibility." In *Walter Benjamin: Selected Writings, Vol. 3,* edited by Howard Eiland and Michael W. Jennings, 101–133. Cambridge, MA: Harvard University Press, 2005.

Benjamin, Walter. "Eduard Fuchs: Collector and Historian." In *Walter Benjamin: Selected Writings, Vol. 3,* edited by Howard Eiland and Michael W. Jennings, 260–302. Cambridge, MA: Harvard University Press, 2005.

Bennett, Tony. "The Exhibitionary Complex." *New Formations* 4 (Spring 1988): 73–102.

Benson, Jim. "Getting the Picture." *Macworld* 10, no. 10 (October 1993): 130.

Berners-Lee, Tim, and Robert Cailliau. *WorldWideWeb: A Proposal* (1990). Accessed May 16, 2014. http://www.w3.org/Proposal.html.

Beshty, Walead, ed. *The Picture Industry: A Provisional History of the Technical Image*. Geneva, Switzerland: JRP editions, 2018.

Birdsall, William F. "A Political Economy of Librarianship?" *Progressive Librarian* 18 (Summer 2001): 1–8.

Bivens-Tatum, Wayne. "Technological Change, Universal Access, and the End of the Library." *Library Philosophy and Practice* 9, no. 1 (Fall 2006).

Blaschke, Estelle. *Banking on Images: The Bettmann Archive and Corbis*. Leipzig: Spector Books, 2015.

Bogart, Michele H. *Advertising, Artists, and the Borders of Art*. Chicago: University of Chicago Press, 1995.

Bohrer, Frederick N. "Photographic Perspectives: Photography and the Institutional Formation of Art History." In *Art History and Its Institutions: The Nineteenth Century*, 246–259. London: Routledge, 2002.

Bredekamp, Horst. *The Lure of Antiquity and the Cult of the Machine: The Kunstkammer and the Evolution of Nature, Art and Technology*. Princeton, NJ: Markus Wiener Publishers, 1995.

Brewster, Christopher, José Iria, Ziqi Zhang, Fabio Ciravegna, Louise Guthrie, and Yorick Wilks. "Dynamic Iterative Ontology Learning." In *6th International Conference on Recent Advances in Natural Language Processing*. Borovets, Bulgaria. September 27–29, 2007.

Briet, Suzanne. *What Is Documentation? English Translation of a Classic French Text*. Lanham, MD: Scarecrow Press, 2006 [1951].

Brooks, David. "Does Decision Making Matter?" *New York Times*, November 26, 2016. https://www.nytimes.com/2016/11/25/opinion/does-decision-making-matter.html.

Brown, Elspeth H. *The Corporate Eye: Photography and the Rationalization of American Commercial Culture, 1884–1929*. Baltimore: John Hopkins University Press, 2005.

Brückle, Wolfgang. "On Documentary Style: 'Anti-Graphic Photography' between the Wars." *History of Photography* 30, no. 1 (2006): 68–79.

Bruhn, Matthias. *Bildwirtschaft: Verwaltung und Verwertung der Sichtbarkeit*. Weimar: Verlag und Datenbank für Geisteswissenschaften, 2003.

Buck-Morss, Susan. *The Dialectics of Seeing: Walter Benjamin and the Arcades Project*. Cambridge, MA: MIT Press, 1991.

Buck-Morss, Susan. "What Is a 'Document'?" *Journal of the American Society for Information Science* 48, no. 9 (September 1997): 804–809.

The Bulletin of the Museum of Modern Art. "Circulating Exhibitions 1931–1954." 21, no. 3/4 (Summer, 1954): 4.

BIBLIOGRAPHY

Burns, Jasmine E. "Information as Capital." *VRA Bulletin* 45, no. 1 (October 2018): Article 9.

Busch, Akiko. "Stock and Security: FPG vs. Newsday." *Print* (November/December 1995): 48.

Caraffa, Costanza. "From 'Photo Libraries' to 'Photo Archives'. On the Epistemological Potential of Art-Historical Photo Collections." In *Photo Archives and the Photographic Memory of Art History*, edited by Costanza Caraffa. Berlin: Deautcher Kunstverlag, 2011.

Caraffa, Constanza. "The Photo Archive as Laboratory: Art History, Photography, and Materiality." *Art Libraries Journal* 44, no. 1 (January 2019): 37–46.

Chen, Lucia S. "From Picture Collection to Picture Collection Online." *Collection Building* 23, no. 3 (2004): 139–146.

Christensen, Erwin O. *The Index of American Design*. New York: Macmillan, 1950.

Chute, Susan. "POP! Goes the Picture Collection: Warhol at NYPL." *NYPL.org*, September. Accessed July 27, 2015. http://www.nypl.org/blog/2010/09/09/pop-goes -picture-collection-warhol.

Clifford, James. *The Predicament of Culture: Twentieth-Century Ethnography, Literature, and Art*. Cambridge, MA: Harvard University Press, 1988.

Clifford, James. *Routes: Travel and Translation in the Late Twentieth Century*. Cambridge, MA: Harvard University Press, 1997.

Cowan, Bainard. "Walter Benjamin's Theory of Allegory." *New German Critique* 22, Special Issue on Modernism (Winter 1981): 109–122.

Crawford, Kate, and Trevor Paglen. *Excavating AI: The Politics of Images in Machine Learning Training Sets*. 2019. www.excavating.ai.

Crimp, Douglas. *On the Museum's Ruins*. Cambridge, MA: MIT Press, 1995.

Cunningham, Frank. "H. Armstrong Roberts: Specialist in 'Stock Photographs,' Part 1." *The Commercial Photographer* 18, no. 11 (August 1943): 351–356.

Cunningham, Frank. "H. Armstrong Roberts: Specialist in 'Stock Photographs,' Part 2." *The Commercial Photographer* 18, no. 12 (September 1943): 387–390.

Cutter, Charles Ammi. *Notes from the Art Section of a Library*. Boston: American Library Association, 1905.

Dana, John Cotton. *The Picture Collection*. Woodstock, VT: Elm Tree Press, 1910.

Dana, John Cotton. *The Gloom of the Museum*. Woodstock, VT: Elm Tree Press, 1917.

Dana, John Cotton, and Blanche Gardner. *The Picture Collection, Revised*. Woodstock, VT: Elm Tree Press, 1917.

Dana, John Cotton, and Marjary L. Gilson. *Large Pictures, Educational and Decorative*. Woodstock, VT: Elm Tree Press, 1912.

Dane, William J. *The Picture Collection Subject Headings*. 6th ed. Hamden, CT: The Shoe String Press, Inc., 1968.

Darnton, Robert. "Library, Books, and the Digital Future." In *Libraries and Archives in the Digital Age*, edited by Susan L. Mizruchi, 13–26. London: Palgrave MacMillan, 2020.

Daston, Lorraine, and Peter Galison. *Objectivity*. New York: Zone Books, 2010.

Day, Ronald E. *Indexing It All: The Subject in the Age of Documentation*. Cambridge, MA: MIT Press, 2015.

Day, Ronald E. *Documentarity: Evidence, Ontology, and Inscription*. Cambridge, MA: MIT Press, 2019.

Derrida, Jacques. "The Law of Genre." Translated by Avital Ronnell. *Critical Inquiry* 7, no. 1 (Autumn 1980): 55–81.

Deschin, Jacob. "Museum Takes in $2,200 on Sale of Pictures." *New York Times*, October 30, 1960, X14.

Dewey, Melvil. "Library Pictures." *Public Libraries* 11 (1906): 10–11.

Dilly, Heinrich. Die Bildwerfer: "128 Jahrekunst wissenschaftliche Dia-Projektion" [The Projection-Lantern: 128 Years of Art-Historical Slide Projection], in Kai-Uwe Hemken, ed., *ImBann derMedien* (Weimar: VDG-Verlag und Datenbank fur Feisteswissenschaften, 1995).

Doane, Mary Anne, ed. "Indexicality: Trace and Sign." Special issue. *differences: A Journal of Feminist Cultural Studies* 18, no. 1 (Spring 2007).

Donovan, Joan. "You Purged Racists from Your Website? Great, Now Get to Work." *Wired*, July 1, 2020. https://www.wired.com/story/you-purged-racists-from-your-website-great-now-get-to-work/.

Dousman, M. E. "Pictures and How to Use Them." *Public Libraries* 4 (1899): 399.

Downey, Gregory J. "Making Media Work." In *Media Technologies*, edited by Tarleton Gillespie, Pablo J. Boczkowski, and Kirsten A. Foot, 141–166. Cambridge, MA: MIT Press, 2014.

Downey, Gregory J. "Virtual Webs, Physical Technologies, and Hidden Workers: The Spaces of Labor in Information Internetworks." *Technology and Culture* 42, no. 2 (2001): 209–235.

Drucker, Johanna. "Entity to Event: From Literal, Mechanistic Materiality to Probabilistic Materiality." *Parallax* 15, no. 4 (2009): 7–17.

Drucker, Johanna. "Digital Ontologies: The Ideality of Form in/and Code Storage: Or: Can Graphesis Challenge Mathesis?" *Leonardo* 34, no. 2 (2001): 141–145.

Druckrey, Timothy. "L'Amour Faux." In *Digital Photography: Captured Images, Volatile Memory, New Montage*, edited by Marnie Gillett and Jim Pomeroy, 4–9. San Francisco: Camerawork, 1988.

Duncan, Carol. *Civilizing Rituals: Inside Public Art Museums*. London: Routledge, 1995.

Edwards, Elizabeth and Ella Ravilious, eds. *What Photographs Do: The Making and Remaking of Museum Culture*. London: UCL Press, 2023.

Edwards, Elizabeth and Sigrid Lien, eds. *Uncertain Images: Museums and the Work of Photographs*. Farnham: Ashgate, 2014.

Elsner, John, and Roger Cardinal, eds. *The Cultures of Collecting*. London: Reaktion Books, 1994.

Emmet, Boris, and John E. Jeuck. *Catalogues and Counters: A History of Sears, Roebuck and Company*. Chicago: University of Chicago Press, 1950.

Enwezor, Okwui. "Documentary/Verite: Bio-Politics, Human Rights, and the Figure of 'Truth' in Contemporary Art." In *Reconsidering the Documentary and Contemporary Art*, edited by Maria Lind and Hito Steyerl, 62–102. Berlin: Sternberg Press, 2008.

Ernst, Wolfgang. *Digital Memory and the Archive*. Minneapolis: University of Minnesota Press, 2012.

Estrin, James. "A Historic Photo Archive Re-emerges at the New York Public Library." *New York Times*, June 6, 2012. https://lens.blogs.nytimes.com/2012/06/06/a-historic-photo-archive-re-emerges-at-the-new-york-public-library/.

Fineman, Mia. "Kodak and the Rise of Amateur Photography." *The Heilbrunn Timeline of Art History*, October 2004. http://www.metmuseum.org/toah/hd/kodk/hd_kodk.htm.

Foster, Donald. "The Classification of Non-Book Materials in Academic Libraries: A Commentary and Bibliography." *Occasional Papers* 104 (September 1972): 3.

Foster, Hal. "An Archival Impulse." *October* 110 (Fall 2004): 3–22.

Foster, Hal. "The 'Primitive' Unconscious of Modern Art." *October* 34 (Autumn, 1985): 45–70.

Frankenburg, Celestine. "Specialization: Pictures A Dialogue about the Training of Picture Librarians. Mrs. Celestine Frankenberg interviewing Romana Javitz." *Special Libraries*, January 1965, 16–17.

Fraser, Bruce. "Digital-Asset Managers." *Macworld* 19, no. 7 (July 2002): 28.

Frosh, Paul. "Beyond the Image Bank: Digital Commercial Photography." In *The Photographic Image in Digital Culture*, 2nd ed., edited by Martin Lister, 131–148. Routledge: London, 2013.

Frosh, Paul. "Digital Technology and Stock Photography: And God Created Photoshop." In *Image Ethics in the Digital Age*, edited by Larry Gross et al., 183–216. Minneapolis: University of Minnesota Press, 2003.

Frosh, Paul. *The Image Factory: Consumer Culture, Photography and the Visual Content Industry*. New York: Bloomsbury Academic, 2003.

Frosh, Paul. "Rhetorics of the Overlooked: On the Communicative Modes of Stock Advertising Images." *Journal of Consumer Culture* 2, no. 2 (July 1, 2002): 171–196.

Frow, John. *Genre*. New York: Routledge, 2006.

Gartner, Richard. *Metadata: Shaping Knowledge from Antiquity to the Semantic Web*. Springer: New York, 2016.

Gebru, Timnit, and Joy Buolamwini. "Gender Shades: Intersectional Accuracy Disparities in Commercial Gender Classification." Proceedings of the 1st Conference on Fairness, Accountability and Transparency. *Proceedings of Machine Learning Research* 81: 77–91.

Gefter, Philip. "John Szarkowski, Curator of Photography, Dies at 81." *New York Times*, July 9, 2007.

Gere, Charlie. *Digital Culture*. 2nd ed. London: Reaktion Books, 2009.

Gervais, Thierry, ed. "Introduction." In *The 'Public' Life of Photographs*. Cambridge, MA/Toronto: MIT Press/Ryerson Image Centre, 2016.

Gibbs-Smith, Charles H. "The Hulton Picture Post Library." *Journal of Documentation* 6, no. 1 (1950): 12–24.

Giltrow, Janet. "Meta-Genre." In *The Rhetoric and Ideology of Genre: Strategies for Stability and Change*, edited by Richard Coe, Lorelai Lingard, and Tatiana Teslenko, 187–205. Cresskill, NJ: Hampton Press, 2002.

Gikandi, Simon. "Picasso, Africa, and the Schemata of Difference." *Modernism/Modernity* 10, no. 3 (September 2003): 455–480.

Gitelman, Lisa. *Paper Knowledge: Toward a Media History of Documents*. Durham, NC: Duke University Press, 2014.

Gitelman, Lisa, and Thomas Mullaney. "Nineteenth-Century Media Technologies." In *Information: A Historical Companion*, edited by Ann Blair, Paul Duguid, Anja-Silvia Goeing, and Anthony Grafton. Princeton, NJ: Princeton University Press, 2021.

Goble, Mark. *Beautiful Circuits: Modernism and the Mediated Life*. New York: Columbia University Press, 2010.

Goffman, Erwin. *Gender Advertisements*. New York: Harper & Row, 1979.

Goldberg, Vicki. *Margaret Bourke-White: A Biography*. New York: HarperCollins, 1986.

Goodrich, Lloyd. "'The Arts' Magazine: 1920–1931." *American Art Journal* 5, no. 1 (May 1973): 79–85.

BIBLIOGRAPHY

Gopnik, Blake. *Warhol*. New York: Ecco/HarperCollins, 2020.

Gorman, Michael. "Technical Services Today." In *Technical Services Today and Tomorrow*, 2nd ed., edited by Michael Gorman, 1–7. Englewood, CO: Libraries Unlimited, 1998.

Green, Venus. *Race on the Line: Gender, Labor, and Technology in the Bell System, 1880–1980*. Durham, NC: Duke University Press, 2001.

Greene, Daniel. *The Promise of Access: Technology, Inequality, and the Political Economy of Hope*. Cambridge, MA: MIT Press, 2021.

Griffin, Tim. "An Unlikely Futurity." In *Taryn Simon: The Color of a Flea's Eye: The Picture Collection*, edited by Taryn Simon, 27–43. Paris, France: Cahiers D'Art, 2020.

Grind, Kirsten, Sam Schechner, Robert McMillan, and John West. "How Google Interferes with Its Search Algorithms and Changes Your Results." *Wall Street Journal*, November 15, 2019. Accessed August 15, 2022. https://www.wsj.com/articles/how-google-interferes-with-its-search-algorithms-and-changes-your-results-11573823753.

Groys, Boris. *Art Power*. Cambridge, MA: MIT Press, 2008.

Grundberg, Andy. "Photography: A 'Modern' Atget Portfolio." *Art in America* 67, no. 1 (January/February 1979): 42–43.

Guarino, Ben. "Google Faulted for Racial Bias in Image Search Results for Black Teenagers." *Washington Post*, June 16, 2016.

Gürsel, Zeynep. *Image Brokers: Visualizing World News in the Age of Digital Circulation*. Berkeley: University of California Press, 2016.

Hackett, Sophie. "Beaumont Newhall and a Machine: Exhibiting Photography at the Museum of Modern Art in 1937." Translated by Marine Sangis. *Études photographiques* 23 (May 2009). https://journals.openedition.org/etudesphotographiques/2656.

Haran, Barnaby. "Homeless Houses: Classifying Walker Evans's Photographs of Victorian Architecture." *Oxford Art Journal* 33, no. 2 (June 2010): 189–210.

Harris, Neil. "Iconography and Intellectual History: The Halftone Effect." In *Cultural Excursions: Marketing Appetites and Cultural Tastes in Modern America*. Chicago: University of Chicago Press, 1990.

Harrison, Helen P., ed. *Picture Librarianship*. Phoenix, AZ: Oryx Press, 1981.

Hartmann, Heidi I., Robert E. Kraut, and Louise A. Tilly, eds. *Computer Chips and Paper Clips: Technology and Women's Employment*. 2 vols. Washington, D.C.: National Research Council, 1986–87.

Hayles, N. Katherine. *Writing Machines*. Cambridge, MA: MIT Press, 2002.

Henning, Michelle. *Unfettered Images*. New York: Routledge, 2018.

Hershberger, Andrew E. "The Medium Was the Method: Photography and Iconography at the Index of Christian Art." In *Futures Past: Twenty Years of Arts Computing*,

edited by Anna Bentkowska-Kafel, Trish Cashen, and Hazel Gardiner, 63–76. London: Intellect, 2007.

Hicks, Mar. *Programmed Inequality: How Britain Discarded Women Technologists and Lost its Edge in Computing*. Cambridge, MA: MIT Press, 2017.

Hockenberry, Matthew. "The Supply House: Catalogues and Commerce." *Thresholds* 49 (2021): 40–48.

Hollingshead, John. *My Lifetime, vol. 1*. London: William Clowes & Sons, 1895.

The Home of Today. "H. Armstrong Roberts: He Holds a Mirror." Williams Oil-O-Matic Heating Corporation, 3, no. 10 (May 1931): 2–5.

International Image Interoperability Framework. "2021 IIF Annual Conference." June 22–24, 2021. Online. Accessed July 20, 2021. Program available at https://iiif.io/event/2021/annual_conference/#program-committee.

Ireland, Norma O. *The Picture File in School, College, and Public Libraries*. Revised ed. Boston: F. W. Faxon, 1952.

ISO Standards for Asset Management. "What Is Asset Management?" Accessed October 3, 2017. http://www.assetmanagementstandards.com/.

Jaskey, Jenny. "The End(s) of the Library." Exhibition. New York: Goethe-Institut: October 30, 2012–June 21, 2013.

Javitz, Romana. "Care of Documentary Photographs." *New York Times*, February 18, 1953, 30.

Javitz, Romana. "Images and Words." *Wilson Library Bulletin* 18, no. 3 (November 1943): 217–221.

Javitz, Romana. "The Public Interest." In *Work for Artists: What? Where? How? A Symposium by Walter Baermann*, edited by Elizabeth McCausland, 27–35. New York: American Artists Group, 1947.

Javitz, Romana. "Words on Pictures. A Speech to the Convention of the Massachusetts Library Association, Boston, Massachusetts, January 28, 1943." *The Massachusetts Library Association Bulletin* 33 (1943): 19–23.

Kahana, Jonathan. *Intelligence Work: The Politics of American Documentary*. New York: Columbia University Press, 2008.

Kamin, Diana. "Mid-Century Visions, Programmed Affinities: The Enduring Challenges of Image Classification." *Journal of Visual Culture* 16, no. 3 (December 2017): 310–336.

Kamin, Diana. "Total Recall." *Artforum*. August 30, 2021. https://www.artforum.com/slant/diana-kamin-on-the-new-york-public-library-s-picture-collection-86403.

Kantor, Sybil Gordon. *Alfred H. Barr, Jr. and the Intellectual Origins of the Museum of Modern Art*. Cambridge, MA: MIT, 2002.

Karpel, Bernard. "The Library." *The Bulletin of the Museum of Modern Art* 11, no. 3 (January 1944): 3–9.

Keller, Ulrich. "Photojournalism around 1900." In *Shadow and Substance: Essays on the History of Photography*, edited by Kathleen Collins, 283–303. Bloomfield Hills, MI: The Amorphous Institute Press, 1990.

Kelsey, Robin. *Archive Style: Photographs and Illustrations for U.S. Surveys 1850–1890*. Berkeley: University of California Press, 2007.

Krebs, Diethard, Walter Uka, and Brigitte Walz-Richter. *Die Gleishschaltung der Bilder. Zur Geschichte der Pressefotografie 1930–1936*. Berlin: Froelich & Kaufmann, 1983.

Kirstein, Lincoln. "Walker Evans's Photographs of Victorian Architecture." *Bulletin of the Museum of Modern Art*, December 4, 1933.

Knibbs, Kate. "Instastock Wants to Turn Your Selfies into a Business Model." *Digital Trends*, August 26, 2015. https://www.digitaltrends.com/social-media/is-instagram -changing-stock-photography-instastock.

Kopytoff, Igor. "The Cultural Biography of Things: Commoditization as Process." In *The Social Life of Things*, edited by Arjun Appadurai, 64–91. Philadelphia: University of Pennsylvania Press, 1986.

Krajewski, Marcus. *Paper Machines: About Cards & Catalogues 1548–1929*. Cambridge, MA: The MIT Press, 2011.

Krauss, Rosalind. "Photography's Discursive Spaces: Landscape/View." *Art Journal* 42, no. 4 (Winter 1982): 311–319.

Krauss, Rosalind. "Photography in the Service of Surrealism." In *L'Amour Fou: Photography and Surrealism*, edited by Krauss and Jane Livingston, 15–42. New York: Abbeville Press, 1985.

Lears, T. J. Jackson. "From Salvation to Self-Realization: Advertising and the Therapeutic Roots of the Consumer Culture, 1880–1930." In *The Culture of Consumption: Critical Essays in American History*, edited by Lears and Richard Wightman Fox, 1–38. New York: Pantheon Books, 1983.

Lee, Jessica. *Off the Clock: Walker Evans and the Crisis of American Capital, 1933–38*. PhD dissertation. Berkeley: UC Berkeley, 2010.

Lehmann, Jens, and Johanna Voelker. *Perspectives on Ontology Learning*. Tokyo: AKA/ IOS Press, 2014.

Leibach, Julie. "The New York Library Has Just Released a Treasure Trove of Incredible Archive Images to the Internet." *Public Radio International*. January 14, 2016. https://www.pri.org/stories/2016-01-14/new-york-library-has-just-released-treasure -trove-incredible-archive-images.

Lemke, Antje. "Education and Training." In *Picture Librarianship*, edited by Helen P. Harrison, 229–234. Phoenix, AZ: Oryx Press, 1981.

Licklider, J. C. R. *Libraries of the Future*. Cambridge, MA: MIT Press, 1965.

Light, Jennifer. "When Computers Were Women." *Technology and Culture* 40, no. 3 (1999): 455–483.

Lind, Maria, and Hito Steyerl, eds. *Reconsidering the Documentary and Contemporary Art*. Berlin: Sternberg Press, 2008.

Lippard, Lucy, and John Chandler. "The Dematerialization of the Art Object." *Art International* 12, no. 2 (February 1968): 31–36.

Lister, Martin, ed. *The Photographic Image in Digital Culture*. 2nd ed. London: Routledge, 2013.

Lubow, Arthur. "The Treasures in the Stacks." *New York Times*, August 4, 2021, Section C, 1.

Lynes, Russell. *Good Old Modern: An Intimate Portrait of the Museum of Modern Art*. New York: Atheneum, 1973.

Mai, Jens-Erik. "Semiotics and Indexing: An Analysis of the Subject Indexing Process." *Journal of Documentation* 57, no. 5 (September 2001): 591–622.

Malraux, André. *Museum without Walls*. The Bollingen Series, XXIV. New York: Pantheon Books, 1949.

Manjoo, Farad. "Welcome to the Post-Text Future." *New York Times*, February 14, 2018. https://www.nytimes.com/interactive/2018/02/09/technology/the-rise-of-a-visual-internet.html.

Manovich, Lev. *Software Takes Command*. New York: Bloomsburg Academic Publishing, 2013.

Manovich, Lev. "Database as a Symbolic Form." *Convergence: The Journal of Research into New Media Technologies* 5, no. 2 (Summer 1999): 80–99.

Marchand, Roland. *Advertising the American Dream: Making Way for Modernity 1920–1940*. Berkeley: University of California Press, 1985.

Marlow, Cameron, Mor Naaman, Danah Boyd, and Marc Davis. "HT06, Tagging Paper, Taxonomy, Flickr, Academic Article, to Read." In *Proceedings of the 17th Conference on Hypertext and Hypermedia*. Odense, Denmark, 2006. Accessed May 15, 2014. http://www.danah.org/papers/Hypertext2006.pdf.

Marquis, Alice Goldfarb. *Alfred H. Barr, Jr.: Missionary for the Modern*. Chicago: Contemporary, 1989.

Marvin, Carolyn. *When Old Technologies Were New: Thinking about Electric Communication in the Late 19th Century*. New York: Oxford University Press, 1988.

Martinez, Arthur C. *The Hard Road to the Softer Side: Lessons from the Transformation of Sears*. New York: Crown Business, 2001.

BIBLIOGRAPHY

Mattern, Shannon. "A Brief History of the Shelf." *Harvard Design Magazine* 43, "Shelf Life" Special Issue on Storage, December 2016.

Mattern, Shannon. "Closet Archive." *Places Journal*, July 2017. https://placesjournal .org/article/closet-archive/.

Mattern, Shannon. "Intellectual Furnishings." Working paper presented as part of the Graduate Institute of Design, Ethnography, and Social Thought Bi-Weekly Seminar, November 7, 2014. *Medium*. Accessed March 1, 2018. https://medium.com/@ shannonmattern/intellectual-furnishings-e2076cf5f2de.

Mattern, Shannon. "Sharing Is Tables: Furniture for Digital Labor." *e-flux architecture*, October 9, 2017. https://www.e-flux.com/architecture/positions/151184/sharing-is -tables-furniture-for-digital-labor/.

Mattern, Shannon. "The Spectacle of Data: A Century of Fairs, Fiches, and Fantasies." *Theory, Culture & Society* 37, nos. 7–8 (2020). https://doi.org/10.1177/026327642095805.

Maxwell, Anne. *Colonial Photography & Exhibitions: Representations of the "Native" People and the Making of European Identities*. London: Leicester University Press, 1999.

Messer, Helaine Ruth. *MoMA: Museum in Search of an Image*. PhD dissertation. New York: Columbia University, 1979.

Miller, Claire Cain. "LeanIn.org and Getty Aim to Change Women's Portrayal in Stock Photos." *New York Times*, February 10, 2014, B3.

Miller, J. Abbott. "Pictures for Rent." *Eye* 14, no. 4 (Autumn 1994). http://www .eyemagazine.com/feature/article/pictures-for-rent.

Milner, Ange V. "Cataloguing Mounted Pictures." *Public Libraries* 9 (1904): 115.

Mitchell, W. J. T. "'Ut Pictura Theoria': Abstract Painting and the Repression of Language." *Critical Inquiry* 15, no. 2 (Winter 1989): 348–371.

Mitchell, W. J. T. *What Do Pictures Want? The Lives and Loves of Images*. Chicago: University of Chicago Press, 1995.

Mitman, Gregg and Kelley Wilder, eds. *Documenting the World: Film, Photography, and the Scientific Record*. Chicago: University of Chicago Press, 2016.

Mol, Annemarie. *The Body Multiple: Ontologies in Medical Practice*. Durham, NC: Duke University Press, 2002.

MoMA. "African Negro Exhibit to Open." MoMA press release, March 6, 1935.

MoMA. "Eugene Atget Archive." MoMA press release, September 29, 1968.

MoMA. "First One-Man Photography Exhibit—Walker Evans American Photographs." MoMA press release, September 13, 1938.

MoMA. "The Museum of Modern Art Launches Comprehensive Online Exhibition History." MoMA press release, September 14, 2016.

MoMA. "Museum of Modern Art, New York, and Art Institute of Chicago Will Cooperate in Showing Largest Exhibition of Works by Picasso Ever Held in This Country." MoMA press release. January 20, 1939.

MoMA. "New Technique of Multiple Circulating Exhibitions on Display at the Museum of Modern Art." MoMA press release, March 6, 1945.

MoMA. "Biographical Note and Personal Memoir of Soichi Sunami," typescript, 1975. The Museum of Modern Art Library, Special Collections, New York.

MoMA. "Oral History Program," interview with Pearl Moeller, 1991. The Museum of Modern Art Archives, New York.

MoMA. "Oral History Program," interview with Richard Tooke, 1991. MoMA Archives.

Morgenstern, Steve. "Scanners: Not a Black and White Choice Anymore." *Home Office Computing* 10, no. 2 (February 1992): 70.

Muchnic, Suzanne. "Technoarts in Cyberspace." *Los Angeles Times*, April 3, 1994, 4.

Multimedia Week. "Hollywood, Silicon Valley Unite for Animated World." August 21, 1995, 1.

Museums on the Web. "Table of Contents: Museums on the Web: An International Conference." *Museumsontheweb.com* (last modified January 7, 1998). Accessed December 15, 2017. https://www.museumsandtheweb.com/mw97/mw97toc.html.

National Research Council. "The Digital Dilemma: Intellectual Property in the Information Age." *Ohio State Law Journal* 62, no. 2 (2001): 951–971.

Nelson, Robert S. "The Map of Art History." *The Art Bulletin* 79, no. 1 (March 1997): 28–40.

Nelson, Robert S. "The Slide Lecture, or the Work of Art History in the Age of Mechanical Reproduction." *Critical Inquiry* 26, no. 3 (Spring 2000): 414–434.

Nesbitt, Molly. *Atget's Seven Albums*. New Haven, CT: Yale University Press, 1992.

NetX. "Technology Case Study: DAM+TMS Art Database Integration." Netx.net, 2010. Accessed April 20, 2016. http://netx.net/moma-presents-netxposure-dam-tms -integration-2/.

NetX. "MoMA." NetX.net, 2010. Accessed December 15, 2017. https://www.netx .net/portfolio/museum-digital-asset-management-moma.

New York Times. "Bernard Karpel Dies: A Bibliographer of Art." January 21, 1986.

Newhall, Beaumont. "Berenice Abbott 1898–1991." *American Art* 6, no. 1 (Winter 1992): 111–113.

Newhall, Beaumont. "Documentary Approach to Photography." *Parnassus* 10, no. 3 (March 1938): 2–6.

BIBLIOGRAPHY

Newhall, Beaumont. *The History of Photography: From 1839 to the Present Day*. 4th ed. New York: Museum of Modern Art, 1978.

Noble, Safiya. *Algorithms of Oppression*. New York: New York University Press, 2018.

O'Neal, Hank. *Berenice Abbott*. New York: Thames and Hudson, 2010.

O'Neal, Hank. *A Vision Shared: A Portrait of America 1935–1943*. Reprint. Göttingen, Germany: Steidl, 2017.

OED Online. "browser, *n.*" March 2001. Accessed May 15, 2014. oed.com.

OpenGLAM. "Frequently Asked Questions." *Openglam.org*. Accessed December 1, 2017. https://openglam.org/faq/.

Owens, Craig. "The Allegorical Impulse: Toward a Theory of Postmodernism." *October* 12 (Spring 1980): 67–86.

Paglen, Trevor. "Invisible Images (Your Pictures Are Looking at You)." *The New Inquiry*, December 8, 2016. https://thenewinquiry.com/invisible-images-your-pictures -are-looking-at-you/.

Panzer, Mary. "Pictures at Work: Romana Javitz and the New York Public Library Picture Collection." In *The "Public" Life of Photographs*, edited by Thierry Gervais, 129–151. Cambridge/Toronto: MIT Press/Ryerson Image Centre, 2016.

Panzer, Mary. "Romana Javitz, Arturo Schomburg, and the Farm Security Administration Search for Usable Pictures of African American Life." Panel presentation for Special Libraries Association, New York Chapter, 2021.

Parker, John Austin. "A Brief History of the Picture Collection." *Wilson Library Bulletin* 30 (November 1955): 257–264.

Pattie, Ling-yuh W. (Miko). "Henriette Davidson Avram, the Great Legacy." *Cataloguing & Classification Quarterly* 25 (1998): 2–3, 67–81.

Pearce, Susan M. *Museums, Objects and Collections: A Cultural Study*. Leicester, UK: Leicester University Press, 1992.

Peters, Isabella. *Folksonomies: Indexing and Retrieval in Web 2.0*. Berlin: Walter de Gruyter, 2009.

Pettegree, Andrew. *Brand Luther: How an Unheralded Monk Turned His Small Town into a Center of Publishing, Made Himself the Most Famous Man in Europe—and Started the Protestant Reformation*. New York: Penguin Press, 2015.

Phillips, Christopher. "Judgment Seat of Photography." *October* 22 (Autumn 1982): 27–63.

Phu, Thy, and Matthew Brower. "Editorial." *History of Photography* 32, no. 2 (2008): 105–109.

Pickerell, Jim. "Getty & PhotoDisc Merge." *Selling Stock*, September 24, 1997. Accessed August 15, 2017. https://www.selling-stock.com/Article/getty-photodisc-merge.

Pickerell, Jim. "Impact of Major Agency Consolidation." *Selling Stock*, January 6, 1999. Accessed August 15, 2017. https://www.selling-stock.com/Article/impact-of -major-agency-consolidation.

Pickerell, Jim. "Retrofile Sold to Getty." *Selling Stock*, July 29, 2005. https://www .selling-stock.com/PrintArticle.aspx?id=5d0b9dd1-b9fe-4bc3-9d0e-58286680281f.

Pickerell, Jim. "Size of Market for Stock." *Selling Stock*, November 31, 1996. Accessed September 14, 2017. http://www.selling-stock.com/Article/size-of-market-for-stock.

Picturescope. "Notes on Work with Pictures—Issued by the Committee for an Association of Picture Librarians." 1, no. 1 (1952): n.p.

Picturescope. "Pictures and Public Relations." 2, no. 1 (March 1954): 5.

Picturescope. "New York Group." 3, no. 1 (March 1955): 3.

Picturescope. "From Edward Steichen to Members of the PICTURE DIVISION." 3, no. 2 (July 1955): 7.

Picturescope. "Detroit Convention Highlights." 3, no. 3 (October 1955): 1.

Picturescope. "Miniaturizing Life's Picture Files." 5, no. 3 (October 1957): 23.

Picturescope. "New York Picture Group." 17, no. 3/4 (1970): 47.

Plummer, M. W. "Circulation of Mounted Pictures." *Public Libraries* 8 (1903): 107.

Pomerantz, Jeffrey. *Metadata*. Cambridge, MA: MIT Press, 2015.

Pope, Daniel. *Making of Modern Advertising*. New York: Basic Books, 1983.

Pottage, Alain, and Brad Sherman. *Figures of Invention: A History of Modern Patent Law*. Oxford: Oxford University Press, 2010.

Printer's Ink. "Commercial Illustrations with an Uncommercial Atmosphere." August 17, 1922, 49.

Quaytman, R. H. *"חקק."* *Chapter 29*. New York: Miguel Abreu Gallery, 2015.

Ragusa, Isa. "Observations of the History of the Index: In Two Parts." *Visual Resources* 13 (1998): 215–251.

Rathbone, Belinda. *Walker Evans: A Biography*. Boston: Houghton Mifflin Harcourt, 2000.

Rather, Lucia J., and Beacher Wiggins. "'Mother Avram's Remarkable Contribution': Henriette D. Avram." *American Libraries* 20, no. 9, (October 1989): 855–857, 859–861.

Rayward, W. Boyd. "H. G. Wells's Idea of a World Brain: A Critical Reassessment." *Journal of the American Society for Information Science* 50, no. 7 (May 1999): 557–573.

BIBLIOGRAPHY

Rayward, W. Boyd. "The Origins of Information Science and the International Institute of Bibliography/International Federation for Information and Documentation (FID)." *Journal of the American Society for Information Science* 48, no. 4 (1997): 289–300.

Riley, Terence, and Stephen Perrella. *The International Style: Exhibition 15 and the Museum of Modern Art.* New York: Rizzoli, 1992.

Ritchin, Fred. *In Our Own Image: The Coming Revolution in Photography: How Computer Technology Is Changing Our View of the World.* New York: Aperture, 1990.

Ritchin, Tomas, and David D. Perlmutter. "The Internet: Big Pictures and Interactors." In *Image Ethics in the Digital Age*, edited by Larry Gross, John Stuart Katz, and Jay Ruby, 1–25. Minneapolis: University of Minnesota Press, 2003.

Robertson, Craig. *The Filing Cabinet: A Vertical History of Information.* Minneapolis: University of Minnesota Press, 2021.

Robins, Kevin. *Into the Image: Culture and Politics in the Field of Vision.* London: Routledge, 1996.

Romeo, Fiona. "Thousands of Exhausted Things, or Why We Dedicated MoMA's Collection Data to the Public Domain," *Medium.com*, July 27, 2015. Accessed September 30, 2017. https://medium.com/digital-moma/thousands-of-exhausted-things-or -why-we-dedicated-moma-s-collection-data-to-the-public-domain-7e0a7165e99.

Rosler, Martha. "In, Around, and Afterthoughts (on Documentary Photography)." In *The Contests of Meaning: Critical Histories of Photography*, edited by Richard Bolton, 303–333. Cambridge, MA: MIT Press, 1992.

Rubin, Richard E. *Foundations of Library and Information Science.* 3rd ed. New York: Neal-Schuman Publishers, Inc., 2010.

Rubinstein, Daniel, and Katrina Sluis. "Concerning the Undecidability of the Digital Image." *Photographies* 6, no. 1 (2013): 151–158.

Rubinstein, Daniel, and Katrina Sluis. "The Digital Image in Photographic Culture: Algorithmic Photography and the Crisis of Representation." In *The Photographic Image in Digital Culture*, 2nd ed., edited by Martin Lister, 22–40. London: Routledge, 2013.

Rubinstein, Daniel, and Katrina Sluis. "Notes of the Margins of Metadata: Concerning the Undecidability of the Digital Image." *Photographies* 6, no. 1 (2013): 151–158.

Russell, John. "Atget." *New York Times Magazine*, September 13, 1981.

Sandeen, Eric J. *Picturing an Exhibition: The Family of Man and 1950s America.* Albuquerque: University of New Mexico, 1995.

Schwartz, Vanessa and Jason E. Hill, eds. *Getting the Picture: The Visual Culture of News.* New York: Routledge, 2015.

Scott, James. *Seeing Like a State: How Certain Schemes to Improve the Human Condition Have Failed.* New Haven, CT: Yale University Press, 1999.

Sekula, Allan. "The Body and the Archive." *October* 39 (Winter 1986): 3–64.

Sekula, Allan. "Reading an Archive: Photography between Labor and Capital." In *Blasted Allegories: An Anthology of Artists' Writings*, edited by Brian Wallis, 114–128. New York and Cambridge, MA: The New Museum of Contemporary Art and MIT Press, 1987.

Shatford, Sara. "Analyzing the Subject of a Picture: A Theoretical Approach." *Cataloguing & Classification Quarterly* 6, no. 3 (1986): 39–62.

Shumaker, David. "Special Libraries." In *Encyclopedia of Library and Information Sciences*, 3rd ed., edited by Marcia J. Bates and Mary Niles Maack, 4966–4974. New York: Taylor and Francis, 2009.

Siegler, M. G. "The End of the Library." *TechCrunch*, October 13, 2013. https://techcrunch.com/2013/10/13/the-end-of-the-library/.

Sitton, Robert. *Lady in the Dark: Iris Barry and the Art of Film*. New York: Columbia University Press, 2014.

Sivulka, Juliann. *Soap, Sex, and Cigarettes: A Cultural History of American Advertising*. Belmont, CA: Wadsworth Publishing, 2011.

Sontag, Susan. *On Photography*. New York: Rosetta Books, 2005 [1973].

Special Libraries. "Specialization: Pictures A Dialogue about the Training of Picture Librarians. Mrs. Celestine Frankenberg interviewing Romana Javitz." (January 1965): 17.

Stack, Trudy Wilner. "The Museological Mise en scène: Walker Evans, American Photographs, and The Museum of Modern Art." *Art Documentation: Journal of the Art Libraries Society of North America* 13, no. 4 (Winter 1994): 13–18.

Stallbrass, Julian, ed. *Documentary*. Cambridge, MA: MIT Press, 2013.

Staniszewski, Mary Anne. *The Power of Display: A History of Exhibition Installations at the Museum of Modern Art*. Cambridge, MA: MIT Press, 1998.

Steinberg, Leo. "Philosophical Brothel." *October* 44 (Spring 1988): 7–74.

Stewart, Susan. *On Longing: Narratives of the Miniature, the Gigantic, the Souvenir, the Collection*. Durham, NC: Duke University Press, 1993.

Strand, Paul. "Photography," *Seven Arts* 2 (August 1917): 524–525.

Strand, Paul. "Photography and the New God." *Broom: An International Magazine of the Arts* 3, no. 4 (November 1922): 252–258.

Striphas, Ted. *The Late Age of Print: Everyday Book Culture from Consumerism to Control*. New York: Columbia University Press, 2011.

Studio Light: A Magazine of Information about the Profession. "The Pictures and the Man Who Made Them." Eastman Kodak, November 1924, 10–16.

Sturken, Marita, and Cartwright, Lisa. *Practices of Looking: An Introduction to Visual Culture*. 3rd ed. New York: Oxford University Press, 2018.

Szarkowski, John. *Atget*. New York: Museum of Modern Art, 2000.

Szarkowski, John. "Photographs in Ink." *MoMA Bulletin* 2, no. 3 (Winter 1990): 6–12.

Tagg, John. "The Archiving Machine; or the Camera and the Filing Cabinet." *Grey Room* 47 (Spring 2012): 24–37.

Tagg, John. *The Burden of Representation. Essays on Photographies and Histories*. London: Macmillan, 1988.

Tagg, John. "Melancholy Realism: Walker Evans's Resistance to Meaning." *Narrative* 11, no. 1 (January 2003): 3–77.

Te Heesen, Anke. *The Newspaper Clipping: A Modern Paper Object*. Manchester: Manchester University Press, 2014.

Te Heesen, Anke. *The World in a Box: The Story of an Eighteenth-Century Picture Encyclopedia*. Translated by Ann M. Hentschel. Chicago: University of Chicago Press, 2002.

Teichman, Jason. "The Age of the Content Paradox: How Technology Is Reshaping Media Creation." Keynote presented at Digital Media Licensing Association 2017 Conference, October 23, 2017, New York.

Thayer, Scofield. *Living Art: Twenty Facsimile Reproductions after Paintings, Drawings and Engravings and Ten Photographs after Sculpture by Contemporary Artists*. New York: Dial Pub. Co., 1923.

Thylstrup, Nanna Bonde. *The Politics of Mass Digitization*. Cambridge, MA: MIT Press, 2019.

Tobias, Jennifer. *The Museum of Modern Art's "What Is Modern?" Series, 1938–1969*. PhD dissertation. New York: The City University of New York, 2012.

Tomas, David. "From the Photograph to Postphotographic Practice: Toward a Post-optical Ecology of the Eye." *SubStance* 17, no. 1 (1988): 59–68.

Toronto Globe and Mail. "Library Not Art Snob, Picture Chief Says." November 30, 1965.

Troncale, Anthony. "Worth Beyond Words: Romana Javitz and The New York Public Library's Picture Collection." *Biblion: The Bulletin of The New York Public Library* 4, no. 1 (Fall 1995): 115–138.

Troncale, Anthony, ed. *Words on Pictures: Romana Javitz and the New York Public Library's Picture Collection*. New York: Photo | Verso Publications, 2020.

Turner, Fred. *Democratic Surround: Multimedia and American Liberalism from World War II to the Psychedelic Sixties*. Chicago: University of Chicago Press, 2013.

Twyman, Michael. *Printing 1770–1970: An Illustrated History of Its Development and Uses in England*. London: Eyre & Spottiswoode, 1970.

Vaidhyanathan, Siva. *The Googlization of Everything (And Why We Should Worry)*. Berkeley: University of California Press, 2012.

Vanderbilt, Paul. *Eye to Eye: Bulletin of the Graphic History Society of America (1953–1956)*. Washington, D.C.: Graphic History Society of America, 1953.

Venn, Couze. "The Collection." *Theory, Culture & Society* 23, no. 2–3. Special Issue on Problematizing Global Knowledge (May 2006): 35–40.

Vestberg, Nina Lager. "The Photographic Image in Digital Archives." In *The Photographic Image in Digital Culture*, edited by Martin Lister, 113–130. London: Routledge, 2013.

Vestberg, Nina Lager. *Picture Research: The Work of Intermediation from Pre-Photography to Post-Digitization*. Cambridge, MA: MIT Press, 2023.

Vestberg, Nina Lager. "Ordering, Searching, Finding." *Journal of Visual Culture* 12, no. 3 (2013): 472–89.

Vismann, Cornelia. *Files: Law and Media Study*. Palo Alto, CA: Stanford University Press, 2008.

Wainwright, Loudon, Jr. *The Great American Magazine: An Inside History of Life*. New York: Knopf, 1986.

Wardrip-Fruin, Noah, and Nick Montfort. *The New Media Reader*. Cambridge, MA: MIT Press, 2003.

Wasson, Haidee. *Museum Movies: The Museum of Modern Art and the Birth of Art Cinema*. Berkeley: University of California Press, 2005.

Webb, Virginia-Lee. "Art as Information: The African Portfolios of Charles Sheeler and Walker Evans." *African Arts* 24, no. 1 (January 1991): 56–104.

Webb, Virginia-Lee. *Perfect Documents: Walker Evans and African Art*. New York: The Metropolitan Museum of Art, 2000.

Wells, H. G. *World Brain*. Garden City, NY: Doubleday, Doran & Co., 1938, eBook edition by Project Gutenberg Australia. Accessed May 12, 2014. http://gutenberg.net.au/ebooks13/1303731h.html.

Wheeler, Monroe. "The Art Museum and the Art Book Trade." *Museum News* 24, no. 2 (1946): 8.

Wheeler, Thomas H. *Phototruth or Photofiction? Ethics and Media Imagery in the Digital Age*. London: Routledge, 2002.

Whitehead, Margaret. *The Making of the Museum of Modern Art's Photography Canon: Beaumont Newhall and the Rejection of 1930s Modernity in New York*. PhD dissertation. St. Louis, MO: George Washington University, 2007.

BIBLIOGRAPHY

Williams, J. H., Jr. "BROWSER: An Automatic Indexing On-Line Text Retrieval System. Annual Progress Report." Accessed May 15, 2014. http://eric.ed.gov/?id=ED038981.

Williams, J. H., Jr. "Functions of a Man-Machine Interactive Information Retrieval System." *Journal of American Society for Information Science* 22 (1971): 311–317.

Williams, Robert V. "The Documentation and Special Libraries Movements in the United States, 1910–1960." *Journal of the American Society for Information Science* 48, no. 9 (September 1997): 775–781.

Willis, Anne-Marie. "Digitisation and the Living Death of Photography." In *Culture, Technology and Creativity in the Late Twentieth Century*, edited by Philip Hayward, 197–208. London: John Libbey, 1990.

Wolukau-Wanambwa, Stanley, ed. *The Lives of Images, Vol. 1: Repetition, Reproduction, and Circulation.* New York: Aperture, 2021.

Wolukau-Wanambwa, Stanley, ed. *The Lives of Images, Vol. 2: Analogy, Attunement, and Attention.* New York: Aperture, 2021.

Wolukau-Wanambwa, Stanley, ed. *The Lives of Images, Vol. 3: Archives, Histories, and Memory.* New York: Aperture, 2022.

Wright, Alex. *Cataloguing the World: Paul Otlet and the Birth of the Information Age.* New York: Oxford University Press, 2014.

Yates, JoAnne. *Structuring the Information Age: Life Insurance and Technology in the Twentieth Century.* Baltimore: John Hopkins University Press, 2009.

Young, Liam Cole. *List Cultures: Knowledge and Poetics from Mesopotamia to BuzzFeed.* Amsterdam: Amsterdam University Press, 2017.

Zadrozny, Brandy. "These Disinformation Researchers Saw the Coronavirus 'Infodemic' Coming." *NBC News*, May 14, 2020. https://www.nbcnews.com/tech/social-media/these-disinformation-researchers-saw-coronavirus-infodemic-coming-n1206911.

Zuckerman, Jim. *Shooting & Selling Your Photos.* Cincinnati, OH: Writer's Digest Books, 2003.

INDEX

Page numbers followed by *f* indicate figures.

Abbott, Berenice, 55, 120–123
Adams, Ansel, 119, 121
Advertisements
 as art inspiration, 70–71
 as mythology, 179
 stock photos in, 164–171
Advertising industry, 136, 146
 adoption of photography by, 146–147
African art objects
 colonialist view of, 93, 98–99
 Cubism and, 89, 91
 photographic reproductions of, 100f,
 101f
African Negro Art (exhibition)
 circulation of images from, 102–104
 curation of, 98–99
 photography and, 99, 102
Alienable content
 defined, 4
 examples, 28, 137, 159, 180, 186, 188,
 209
Allegory, 162, 178–179, 264n3
American Index of Design, 65–66

Anchorless image, 182
Angels of History, 231–237
Angelus Novus, 231–237, 234f, 235f
APIs (Application Programming Inter-
 faces), 213
Architecture, 96, 98, 102, 127, 133,
 222
Archive style, 48, 60–61, 66
Artificial intelligence, 23, 188, 227–229
Artists Rights Society, 210
Art Resource, Inc., 211–212
Artstor, 222–223
Assets, digital, 193–195
Atget, Eugène
 circulation of photos by, 118–119
 discussed by art theorists, 54–55, 119
 Femme de Verrières, 114, 115f
 influence on modern art, 121–123
 introduction to American audiences,
 119–121
 reprints, 124–127
Aura, 53–55, 80, 93, 95, 127
Avram, Henriette, 213–214

INDEX

Barr, Alfred, 93
 African Negro Art (exhibition), 98–99
 Cubism and Abstract Art, 88–92
 influences on, 85–86
 on the misuse of reproductions,
 114–116
 teaching practices, 87–88, 93–95, 107
Barry, Iris, 108
Barthes, Roland, 67, 179, 182
Benjamin, Walter, 12
 on allegorical images, 178–179, 264n3
 on Klee's *Angelus Novus,* 232–233,
 236
 "Little History of Photography," 54–55
 on the value of images, 103, 127,
 131–133 (*see also* Aura)
 "Work of Art in the Age of Its Techno-
 logical Reproducibility, The," 52–54
Bettman Archive, 8, 10, 241n14, 264n5,
 265n16
Blaschke, Estelle, 10, 135, 265n16
Boas, Franz, 32, 49
Bourke-White, Margaret, 98, 147, 148
Brief Survey of Modern Painting, A (exhi-
 bition), 7, 93–96
Briet, Susan, 50
Browsing, 35–37, 39–41, 68, 215

Card catalogues, 35, 56, 106, 110, 136,
 151–156, 220
Carlson, Eric Timothy, 70–73, 73f
Catalogues, mail-order, 159–162
Cataloguing
 artificial intelligence and, 23, 190, 227
 bias in, 44, 189
 digitization and, 194–195, 201, 203,
 212–221
 at MoMA, 104, 106, 108–109
 at NYPL, 32–49, 63, 215–218
 of stock photography, 150–157,
 159–162, 182–183, 219–221, 225
 user-centered, 32–35, 39–43, 46,
 220–221

Chute, Susan, 219
Circulating collection style, 68–78
Circulating image, 3–4, 7, 13, 19. *See also*
 Ethos of the circulating image
Circulating image collections, 4–5,
 12–15.
Classicstock. *See* H. Armstrong Roberts,
 Inc.
Classification. *See* Cataloguing
Clifford, James, 80, 93, 103, 259n66
Cline, Jessica, 44–45
Collection, 14–15
Collier, Anne, 134, 265n9
Commodification
 of images, 181–182
 of information, 187–189, 195
Compact discs (CDs), 198–206
Compression, 136
Computerization, 195–198
Copyright. *See also* Licensing
 Act of 1976, 116–117, 211
 of documentation photos, 116–117,
 209–212
 infringement, 210, 226
 management, 209–212
Corbis Corporation, 10, 181, 186, 219,
 241n14, 264n5
Cornell, Joseph, 69
Courter, Elodie, 21, 104–107, 105f,
 128
Cranach, Lucas, 235–236, 235f
Crimp, Douglas, 13, 80, 84, 117, 129

DALL-E, 228–229, 229f
Dana, John Cotton, 31, 33, 42, 51,
 57, 92
Dawirs, Doug, 193–194, 199, 206–207,
 226
Day, Doris (photographer), 164
Day, Ronald, 48–49
Dematerialization, 4–5, 13, 20
Derrida, Jacques, 179, 185
Dewey, Melvil, 31

INDEX

Dial, The, 85, 87
Dialectical images, 133, 180, 186, 270n98
Digital asset management systems (DAMS), 206–209
Digital image, 191–193
Digital Image Access Project (DIAP), 205–206
Digitization, 22–23, 190–191
 art enabled by, 233–237
 collaboration and, 197–198, 201, 205, 221–227
 copyright and, 209, 211–212
 distribution and, 219–221
 at H. Armstrong Roberts, Inc., 195–201
 mass, 198
 at MoMA, 202–204
 at NYPL, 205–206, 215–219
 scholarship on, 191–192, 198, 209, 219
Distribution, 12–13, 136, 158, 196, 199–202, 214, 219–221
Distributors
 digital, 211–213, 219–221
 librarians as, 12–13
 museums as, 23
 photographers as, 22
Document, 17–18
Documentarity, 48–49
Documentary
 and art history, 55–56
 critiques of, 66–67
 social, 49–50
 style, 17, 59–63
Documentation
 of art exhibits, 100–103, 111–115
 copyright and, 116–117, 209–212
 defined, 50–51
Donohue, Deirdre, 222
Drucker, Joanna, 47, 209
Duquette, Anita, 237, 261n95

Edwards, Elizabeth, 9–10, 19, 83
Enwezor, Okwui, 67

Ernst, Wolfgang, 155–156
Ethos of the circulating image, 27–30, 56, 110, 235
Evans, Walker
 American Photographs (exhibition), 96–97
 circulation of photos by, 102, 128
 photo by, 101f
 Photographs of 19th Century Houses (exhibition), 96
 Photographs of African Negro Art (exhibition), 93, 99–104

Family of Man (exhibition), 2, 110
Farm Security Administration (FSA) photography project, 63–66
Feder, Theodore, 211
Fetch (software), 193, 199–200, 206–207
Filing cabinets, 154–155, 207
Findability, 20, 218–219
Fogg Method (of art appreciation), 86–87
Folksonomies, 46
Frick Art Library, 8, 223, 241n14
Frosh, Paul, 10, 134–135, 170

Galassi, Peter, 203
Gender Spectrum (photo library), 134
Genre, 136–137, 162, 178–181, 184–185
Getty Images, 134–135, 219, 241n14, 264n5
Gikandi, Simon, 99
Glenar, Penny, 44, 46–47
Goble, Mark, 61–63, 65–66
Google, 16, 184, 188–189, 198, 222
Google Images, 4, 14, 188, 212, 215
Grischowsky, Thomas, 203, 228
Groves, Roberta, 136, 220–221
Groys, Boris, 79, 80
Grundberg, Andy, 126, 263n130
Gursel, Zeynep, 10

H. Armstrong Roberts, Inc.
 cataloguing system, 151–157
 computerization at, 195–198
 early days, 138–141
 global reach, 157–159
 offices, 142–143, 150, 157–158
 production studio, 142–146,
 148–150
Hayles, N. Katherine, 47
Hulton Picture Post Library, 8, 240n13

Image
 defined, 13
 digital, 191–193
 as property, 210
 theories of, 3
 uses of, 7–8
 virtual, 82, 209
Index, 15–16
Index cards, 15, 150, 155–159
Indexicality, 15–16, 137, 172, 192
Indexing. *See* Cataloguing
Index of American Design, The
 (Erwin O. Christensen), 63, 65,
 252n118
Index of Christian Art, 86
Infrastructures, media, 22, 48, 104, 136,
 146, 225
 card index as, 150–162
 contact cards as, 151–155
 ledger as, 137, 138–142, 154
 photo studio as, 136, 142–150
Intellectual property, 114–117. *See also*
 Copyright
International Image Interoperability
 Framework (IIIF), 223–224
International Institute of Photography,
 8, 240n13
Interoperability, 22–23, 223–224
IPNstock, 225
Iterative ontologization
 defined, 82–83
 examples of, 102–103, 126–128

Javitz, Romana, 6–7, 20, 24, 29f, 187–188,
 230
 global vision, 38–39
 influences, 30–32
 philosophy of the image, 20, 28–30,
 48–53, 57–59, 68
 role in New Deal art programs, 63–66
 user-centered approach, 33–35, 39–43,
 45–46, 69, 77, 230
J. Walter Thompson (company), 6, 146,
 164

Karpel, Bernard, 109
Kelsey, Robin, 48, 60, 251n101
Keywording, 219–221. *See also*
 Cataloguing
Khan, Raymond, 216–218
Kirstein, Lincoln, 60, 96, 129
Klee, Paul, 232–237, 234f
Kodak, 114, 138, 201, 203, 206–207
Krajewski, Markus, 150, 154, 156
Krauss, Rosalind, 55–56, 84, 126

Landsberg, Erik, 203–204, 208, 227
Lange, Dorothea, 68, 77, 246n18
Les Demoiselles D'Avignon, 88–92, 90f, 99
Levy, Julian, 120–121
Leyda, Jay, 32, 38, 68
Library of Congress, 38, 64, 66, 205,
 213–214
Licensing
 of artwork reproductions, 114, 117,
 127, 208, 210, 212
 of historical images, 219
 post-usage, 226
 of stock photos, 138, 148, 158–159,
 182–183, 196
Lien, Sigfrid, 9, 19, 83
Life (magazine), 57, 147–148, 149f, 218,
 241n14
Living collection, 44–49, 68
Luna Imaging, 203–204
Lynes, Russell, 128

INDEX

Malcolmson, Lorna, 151, 153f
Malcolmson, Ruth, 151, 153f
Malraux, André, 79–80, 224
Management (of image collections),
190, 193–198, 206–209
Manovich, Lev, 47, 155–156
MARC (Machine Readable Cataloging),
213–214, 223
Marketing catalogue (as medium), 136
Marvin, Carolyn, 10–11
Mattern, Shannon, 16, 155, 157
Mayer, Grace, 122
Media defined, 10–11
Medium specificity, 4, 13, 24, 172,
242n35. *See also* Alienable content
Memes, 134, 180, 231–232
Metadata
creation of, 35, 45–46, 208, 215–218,
xiv
defined, 15
digitization and, 212–219
Picture Collection, NYPL and,
215–219
as resource, 23
subject keywords, 219–221
user interaction with, 191
Miller, Dorothy, 100, 263n116
Mitchell, W. J. T., 13, 67–68, 158,
191–192
Moeller, Pearl
albums kept by, 113–114
approach to rights management,
114–117
as conduit for image circulation,
110–111
on copyright, 209–210
early days at MoMA, 109–110
report on photographic technology,
117–118
Moholy-Nagy, Lazlo, 203–204
Morey, Rufus, 86
Mueller, Fr., 235
Mundaneum, 37, 38, 157

Museum of Modern Art (MoMA)
Art Lending Service (ALS), 122–123
Department of Circulating Exhibi-
tions, 104–107
Department of Imaging Services,
208–209
Department of Rights and Reproduc-
tions, 109–110, 114–118, 203–204
digitization at, 202–204, 208–209
library, 107–109
photography department, 84–85
sale of art reproductions, 122–127
Museums and the Web Conference, 79
Museum without walls, 79–80, 113,
129

Nesbit, Molly, 120–121, 126
Neumann, J. B., 87
Newark system of subject classification,
33, 57
New Deal arts programs, 59, 61–66
Newhall, Beaumont, 17, 55, 89f, 96–98,
97f, 108–109, 119, 209, 261n102
New York Public Library (NYPL), 25–27,
27f, 34f, 36f, 77f, 205. *See also* Pic-
ture Collection, NYPL
Noble, Safiya, 184, 189
NYPL Digital Gallery, 218–219

Ontology (of the photograph), 82–83
OpenAI, 227–228
Otlet, Paul, 8, 37–38, 49, 50, 240n13

Paglen, Trevor, 223
Panzer, Mary, 65
Peterson, Rolf, 118
*Photographs of African Negro Art by
Walker Evans* (exhibition), 98–104
Photography, 84
in art history, 83–84
commercial, 146–148 (*see also* Stock
photography)
digital, 191–192

Photography (cont.)
as documentation, 17, 49–50, 55–60, 118, 129
histories of, 9–11
in journalism, 147, 180
paradox of, 84
Photoshop, 191, 197, 231, 234
Picasso, Pablo, 88–91, 99, 113
Picture Collection, NYPL, 3, 19, 25–78
acquisition practices, 25–26, 38, 63–666
as artistic inspiration, 60–62, 68–78
digitization of, 205–206, 215–219, 227–228
documentary function of, 49–68
as living collection, 30–49
military use of, 38–39
organization of, 32–37, 40–41, 44–47
philosophy of, 25–28, 57–60, 67
preservation of, 228–230
worker activity, 25–26, 44–45, 46–47, 63 (*see also* Javitz, Romana)
Picture Division (of the Special Libraries Association), 1–2, 51
Pictures as data points, 188
Pictures-as-documents
documentary (genre) and, 67
Javitz on, 20, 28–30, 48–53, 57–59, 68
photography and, 49–50, 61
Picturescope (publication), 1–2
Picture-work defined, 18–19
Picture-workers
activities of, 2, 8–10, 18, 23, 219, 223
defined, 1, 18
epistemological consequences of, 8–9
philosophies of the image articulated by, 3, 20, 28
terminology used by, 13, 15, 221
Platform capitalism, 187–190
Postmodernism, 19, 30, 178–180
Post-usage licensing, 226
Preservation (of image collections), 229

Primitivism, 91, 98–99, 128
Punctum, 185

Quaytman, R. H., 231, 232–237, 235f

Ray, Man, 55, 120
Realism, 121, 137, 142, 171–173, 175, 179–180
Reproducibility (of artworks), 52–54, 58, 93, 210, 237
Reproductions (of artworks)
Atget's photos, 123–127
for education, 80, 86–94, 102, 107
examples, 89–90, 235–236
insurance policies for, 106
MoMAs slide library, 108
for museum revenue, 110, 116–117
value and, 103–104, 106, 123–124
Rivera, Diego, 26, 68
Roberts, H. Armstrong, III, 135–137, 150–151, 157, 193, 196–202, 220–221, 226, 228
Roberts, H. Armstrong, Jr., 135, 165f, 181
Roberts, H. Armstrong, Sr., 6–8, 22.
See also H. Armstrong Roberts, Inc.
advertisements, 161f, 163f, 165f, 166f, 167f, 169f, 174f
biography, 137–141, 162–164, 181
classification scheme, 162, 176–178
photos, 132f, 144f, 145f, 149f, 152f, 153f, 171f
on realism, 173–175
record-keeping, 139–142
style, 162–164, 170–173
use of props, 143–144, 170–171
use of symbolism, 176–178
Robertson, Craig, 9, 155, 207
Robertstock/Classicstock. *See* H. Armstrong Roberts, Inc.
Rosler, Martha, 67, 179–180
Royalty-free (RF) images, 201–202
Rubinstein, Daniel, 47, 192, 214
Rukeyser, Muriel, 32

INDEX

Schomburg, Arturo Alfonso, 32, 65
Sekula, Allan, 21, 84, 128
Semiotics, 15–16, 162, 171, 179, 182, 186
Shahn, Ben, 63, 64
Simon, Taryn, 72–77, 74f, 75f, 76f, 77f
Slides, photographic, 83, 86–87 104, 107–110, 120, 205, 211, 228, 259n75
Sluis, Katerina, 47, 192, 214
Snyder, Joel, 124–125
Social media, 2, 15, 188, 231
Sontag, Susan, 1, 182, 259n62
Special Libraries Association (SLA), 1, 51
Speight, Tomas, 227
Steedman, Richard, 186
Steichen, Edward, 2, 110, 114, 122, 146, 209, 258n46
Stock Market (stock photo company), 186, 201, 264n5
Stock photography
 babies in, 138, 149f, 152f, 161f, 164, 166f, 167f, 168, 170–171, 171f
 as commodity, 158–162
 current events in, 183
 defined, 131–133
 digitization and, 197–203
 as genre, 162, 178–183
 hands in, 175–176, 176f
 parodies of, 180
 scholarship on, 134–135
 symbolic, 176–179
 telephones in, 153f, 166–170
Stock photography industry, 4, 10, 12, 133–135, 158, 181
 digital asset management and, 198–208
 keywording and, 221
 semiotics and, 186
Stock Workbook, 199–202
Stokes, John R., 205
Stokes Imaging, Inc., 205
Storage (of image collections), 150–151, 228

Storytelling, visual, 147–148, 173–175, 177, 182
Straight photography, 7, 83, 98, 118–119, 121, 170–173
Structured data, 212–221
Stryker, Roy, 63–66
Subject (in art history), 56
Subject indexes, 56, 58. *See also* Cataloguing
Sunami, Soichi, 100f, 111–115, 112f, 113f, 129
Sweeney, James Johnson, 98–99, 102
Symbolism, 162, 168, 175–178
Syndication, 137. *See also* Licensing
Szarkowski, John, 84, 118, 121–125, 268n69

Tagg, John, 9, 56, 84, 155, 255n16
Tech industry, 5, 187–189, 224
Technical image, 9
Thomas, Hank Willis, 134, 265n9
Traveling art exhibitions
 developed by MoMA, 92–95, 98–102
 logistics of, 104–107
Troncale, Anthony, 205–206

Union collection, 221–227
Universal image collection, 23–24, 37–38, 221–226
Universality of images, 147–148, 158
Users (of image collections)
 as content providers, 43
 informing cataloguing decisions, 32–35, 39–43, 46, 220–221
 labor of, 214–215
 professional *vs.* general public, 6–7

Van Haaften, Julie, 206, 212
Venn, Couze, 14
Vestberg, Nina Lager, 10, 16, 219, 241n13
Virtual image, 82, 209

Vissers, Jay, 44, 46–47
Vogue, 61, 62f, 111

Walker Evans: American Photographs
 (exhibition), 96–98
*Walker Evans: Photographs of
 19th Century Houses* (exhibition), 96
Warhol, Andy, 69–70, 71f, 77–78, 78f
Wells, H. G., 37–38
Wheeler, Monroe, 106, 116, 261n92
Whiteness, bias towards, 171, 184
Willers, Carlton Alfred, 70
Williams, J. H. Jr., 41
Wolukau-Wanambwa, Stanley, 10
Works Progress Administration (WPA),
 47, 58, 63, 65